Adobe Photoshop Elements 4.0 A–Z

Tools and features illustrated ready reference

Philip Andrews

ELSEVIER

AMSTERDAM • BOSTON • HEIDELBERG • LONDON • NEW YORK • OXFORD
PARIS • SAN DIEGO • SAN FRANCISCO • SINGAPORE • SYDNEY • TOKYO
Focal Press is an imprint of Elsevier

Focal Press

How to use this book...

In order to make the most out of this book, take a couple of minutes to read the following. This will let me introduce a few of the special features that I have included to help you find the information that you need fast. Apart from the basic A–Z structure that lists the topics, features and tools alphabetically, I have also used the following design devices to make 'search and locate' missions speedier and more productive.

Feature summary

Each feature and tool entry is headed with a summary table that details the menu where it can be found, any keyboard shortcuts associated with the tool, the version of Photoshop Elements that contains the feature and any other options that are linked to its use.

New feature entries

Those features that are new to Elements 4.0, or have undergone a revision for the new edition, now get their own red colored heading for locating quickly.

Edge tabs

The colored edge tabs change for each letter section. They can be used in conjunction with the contents page to quickly thumb through the book to locate a particular group of entries.

Before and after examples

The before and after examples illustrate how features, tools and techniques can be used to change the way that your pictures look.

Tips and Reminders

Important ideas and techniques are highlighted with the Remember icon and the tips and tricks used by working professionals are noted with the 'Pro's Tip' ticked box.

Online extensions

Don't forget about the book's website – **www.elementsa-z.com**. Here you will find video tutorials on how to use the top new features in Photoshop Elements 4.0, the example pictures used in the step-by-step guides, links to all the featured plug-in vendors and much more.

Step-by-step application

Selected features include step-by-step guides designed to demonstrate how to use the tool or feature. These mini-tutorials can be used to extend your understanding as well as build your editing and enhancement skills.

Accented Edges filter

Menu: Filters > Brush Strokes > Accented Edges		
Shortcut: Ctrl F	**OS:** Mac, Windows	
Version: 1, 2, 3, 4	**See also:** Ink Outlines filter	

The Accented Edges filter searches out the edges within a picture and then highlights them with a line.

The size of the line is controlled by the Edge Width slider (1) in the filter's dialog. The dark or lightness of the line is determined by the Edge Brightness slider (2). A high value produces a lightly colored edge that appears like chalk and a low value, like the one used in the illustration here, creates an ink-like outline.

The Smoothness slider (3) is used to even out the rough jagged edges of the line.

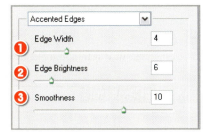

Active layer

Menu: Window > Layers (to show the Layers palette)		
Shortcut: -	**OS:** Mac, Windows	
Version: 1, 2, 3, 4	**See also:** Layers palette, Layers	

The Layers feature is great for creating pictures that are made up of a variety of parts. Each section is stored on its own layer and can be easily altered independent of the rest of the photograph.

But the way in which the feature works means that it is only possible to edit or enhance one layer at a time. You must select or activate the layer first before applying the changes. To select the layer click on its thumbnail in the Layers palette. At this point the layer will change to a different color from the rest in the stack.

This layer is now the selected or active layer and can be edited in isolation from the others that make up the picture.

Pro's Tip With the Move tool selected, you can also choose or change the active layer from the context menu via a Control-click (Mac) or right mouse-click (Win).

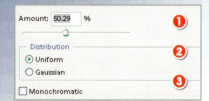

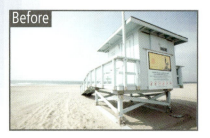

Before

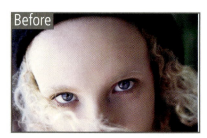

Before

After

After

© www.ablestock.com 2005

© www.ablestock.com 2005

Add Noise filter

Menu: Editor: Filter > Noise > Add Noise		
Shortcut: Ctrl F	**OS:** Mac, Windows	
Version: 1, 2, 3, 4	**See also:** Grain filter, Texturizer filter	

Many photographers like to replicate the look of film grain in their digital photographs. The grittiness provides a texture that is reminiscent of fast (high ISO), big grain films. Using the Add Noise filter is one way to introduce this texture into your digital pictures. Applying the filter adds random speckled pixels to your picture. Another common use for the filter is to add small amounts of noise to gradients to prevent banding when printed.

The filter uses a single Amount slider (1) to control the strength of the texture effect. The higher the setting the more obvious the results will be. Two different types of texture are provided – Uniform and Gaussian (2). The Uniform option (6) adds the noise evenly across all the tones in the picture. In contrast the Gaussian setting (5) concentrates the noise in the midtones, with less changes being applied to the highlight and shadow areas.

Selecting the Monochrome option (3) restricts the noisy pixels added to white, black and gray only.

Pro's Tip Be sure to view the preview at 100% when applying this filter to ensure that you have a good balance of texture and detail and always keep a copy of the original picture without the noise added.

>>> Add Noise examples: (4) Original picture detail; (5) Gaussian setting; (6) Uniform setting; and (7) Gaussian and Monochrome setting.

Adjust Backlighting

Menu: Editor: Enhance > Adjust Lighting > Adjust Backlighting		
Shortcut: -	**OS:** Mac, Windows	
Version: 1, 2	**See also:** Shadows/Highlights	

The Adjust Backlighting feature found in versions 1 and 2 of Elements is designed to darken the lighter tones in the image without flattening the highlights or moving the black point.

Moving the Darker slider (1) to the right will reduce the value of these tones.

This feature along with Fill Flash has been replaced in version 3.0 with the new Shadow/Highlights feature.

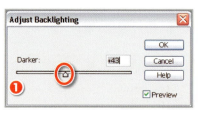

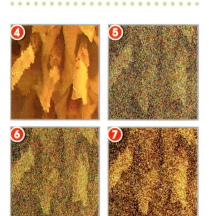

Adjust Skin tones

Menu: Editor: Enhance > Adjust Color > Adjust Color for Skin Tone		
Shortcut: Shft Ctrl M	**OS:** Windows	
Version: 4	**See also:** Color Variations	

Adobe has added a new color control feature in Elements 4.0 that is designed to allow you to adjust the skin tones within your picture.

Making changes is a two-step process. When the feature first opens you need to use the Eyedropper tool to select a typical section of skin within the photo. Next you can adjust the color of the skin using the Tan and Blush sliders (1) and the overall color of the picture with the Temperature control (2).

The picture can be reverted back to its original hues by selecting the Reset button or the changes applied by pressing the OK button.

As the Skin Tone tool averages tones as it works, multiple clicks around different parts of a person's face will often refine the results. Holding down the Ctrl key while clicking turns off averaging and will resample with each click.

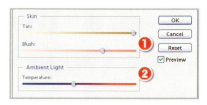

Original

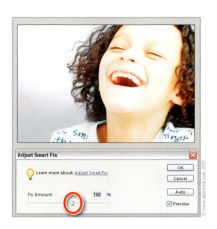

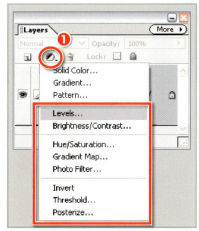

Levels

Adjust Smart Fix

Menu: Editor: Enhance > Adjust Smart Fix
Shortcut: Shft Ctrl M **OS:** Windows
Version: 3, 4 **See also:** Auto Smart Fix

The Adjust Smart Fix version of the Auto Smart Fix feature provides the same control over color, shadow and highlight detail but with the addition of a slider control that determines the strength of the enhancement changes.

Moving the slider from left to right will gradually increase the amount of correction applied to your picture. This approach provides much more control over the enhancement process and is a preferable way to work with all but the most general photos.

The Auto button, also located in the dialog, automatically applies a fix amount of 100% and provides a similar result to selecting Enhance > Auto Smart Fix.

Adjustment layers

Menu: Editor: Layer > New Adjustment Layer
Shortcut: Layers palette button **OS:** Mac, Windows
Version: 1, 2, 3, 4 **See also:** Fill Layer

These special layers alter the look of the layers that are arranged below them in the stack. They act as a filter through which the lower layers are viewed. You can use adjustment layers to perform many of the enhancement tasks that you would normally apply directly to an image layer without changing the image itself.

Elements contains eight different types of adjustment layers which are grouped together with the Fill layers under the Create Adjustment Layer button in the Layers palette. They are:

Levels – Adjusts the tones in the picture.

Brightness/Contrast – Lightens, darkens and controls contrast.

Hue/Saturation – Changes the color and strength of color in photos.

Gradient Map – Changes the photo so that all the tones are mapped to the values of a selected gradient.

Invert – Reverses all the tones in a picture, producing a negative effect.

Threshold – Converts the picture to pure black and white with no grays present at all.

Photo Filter – Reproduces the color changes of traditional photo filters.

Posterize – Reduces the total number of colors in a picture and creates a flat paint (or poster)-like effect.

Placing an adjustment layer at the top of a stack of layers will ensure that the editing changes will be applied to the content of all the layers beneath.

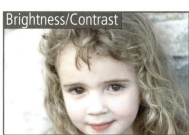
Brightness/Contrast

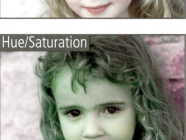
Hue/Saturation

Non-destructive editing

Changing the way that your image looks using adjustment layers is called 'non-destructive' editing. This means that the appearance of the picture changes but the original photograph still remains intact. Most professionals prefer to apply non-destructive changes to their images wherever possible.

Gradient Map 1

Background

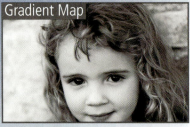
Gradient Map

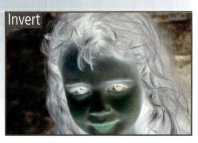
Invert

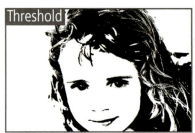
Threshold

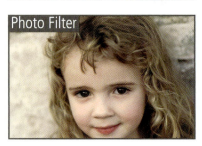
Photo Filter

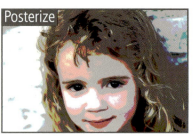
Posterize

Continued from the previous page:
To restrict the adjustment layer changes to the layer immediately beneath, add the adjustment layer and then click the border line between the two layers whilst holding down the Alt/Opt key. This groups the adjustment layer with the picture layer. To ungroup repeat the process.

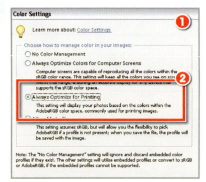

Adobe RGB

Menu: -		
Shortcut: -	**OS:** Windows	
Version: 4	**See also:**	Color Settings, Convert to color profile, Assign color profile

In version 4.0 of Elements Adobe completely revamped the color-management system to make it easier to understand and more logical to use.

The controls and settings use two different ICC profiles (or color spaces) as a basis for the color management throughout the program. The two color space options available are widely used industry standards. **AdobeRGB** encompasses a range of colors (color gamut) that more closely matches the characteristics of both desktop and commercial printers, whereas **sRGB** is a profile that is very closely aligned with the gamut of the average computer screen. Choosing which profile to use as your standard will depend largely on what will be the final outcome of the majority of your work.

By selecting one of the output options in the Color Settings dialog (1) you are indirectly setting the color profile that will be used throughout the program.

For instance, choosing the **Always Optimize For Printing** (2) option attaches the AdobeRGB color space to photos without a profile and uses AdobeRGB as the working space but maintains any attached profiles when opening images.

Advanced Blending

Menu: Editor: File > New > Photomerge Panorama		
Shortcut: -	**OS:** Mac, Windows	
Version: 1, 2, 3, 4	**See also:** Photomerge	

The Advanced Blending option in the Photomerge workspace provides an automatic approach to balancing the color and tone of sequential pictures in a composition.

The feature is designed to even out slight exposure or color differences that can occur when creating source images. When used in conjunction with the Preview button the results can be reviewed on screen before proceeding to the creation of the full panorama.

On some occasions it is difficult to assess the accuracy of the blending action via the preview. If this occurs then create several different panoramas applying different Blending, Perspective and Mapping settings for each.

Aliased text

Anti-aliased text

Left align

The left align, or justification, feature will arrange all text to the left of picture. When applied to a group of sentences the left edge of the paragraph is organized into a straight vertical line whilst the right-hand edge remains uneven or ragged. Right align works in the opposite fashion, straightening the right-hand edge of the paragraph and leaving the left ragged. Selecting the Center Text option will align the paragraph around a central line and leave both left and right edges ragged.

Center align

The left align, or justification, feature will arrange all text to the left of picture. When applied to a group of sentences the left edge of the paragraph is organized into a straight vertical line whilst the right-hand edge remains uneven or ragged. Right align works in the opposite fashion, straightening the right-hand edge of the paragraph and leaving the left ragged. Selecting the Center Text option will align the paragraph around a central line and leave both left and right edges ragged.

Right align

The left align, or justification, feature will arrange all text to the left of picture. When applied to a group of sentences the left edge of the paragraph is organized into a straight vertical line whilst the right-hand edge remains uneven or ragged. Right align works in the opposite fashion, straightening the right-hand edge of the paragraph and leaving the left ragged. Selecting the Center Text option will align the paragraph around a central line and leave both left and right edges ragged.

Before

Aliasing

Menu:	-	
Shortcut:	-	OS: Mac, Windows
Version:	1, 2, 3, 4	See also: Anti-aliasing

Even though the lettering system in Photoshop Elements is based on smooth-edged (vector) technology, when type layers are flattened into the background, or the PSD file is saved in the JPEG format, the type is converted to pixels. One of the drawbacks of using a system that is based on pixels is that circles, diagonal lines and curves are made up of a series of pixel steps. When viewed closely, or printed very large, these steps can become obvious and appear as a saw-tooth pattern. This is called 'aliasing'.

Anti-aliasing is a system where the effects of these 'jaggies' are made less noticeable by partially filling in the edge pixels. This technique produces smoother looking type overall and should be used in all print circumstances and web applications.

The only exceptions to this rule are where file size is critical, as anti-aliased web text creates larger files than the standard text equivalent, and when you are using font sizes less than 10 points for web work.

Aligning type

Menu:	-	
Shortcut:	-	OS: Mac, Windows
Version:	1, 2, 3, 4	See also: -

The terms Alignment and Justification are often used interchangeably and refer to the way that a line or paragraph of text is positioned on the image.

The Left Align feature will arrange all text to the left of text frame. When applied to a group of sentences the left edge of the paragraph is organized into a straight vertical line whilst the right-hand edge remains uneven or ragged.

Right Align works in the opposite fashion, straightening the right-hand edge of the paragraph and leaving the left ragged.

Selecting the Center Text option will align the paragraph around a central line and leave both left and right edges ragged.

All command

Menu:	Editor: Select > Select All	
Shortcut:	Ctrl A	OS: Mac, Windows
Version:	1, 2, 3, 4	See also: Selection

The Select All command, found under the Select menu, encompasses the whole picture with a selection marquee. This command is the first step in a simple border creation technique that also uses the Stroke feature. See below.

Open a suitable photo into the Editor workspace. Use the Select > All command to place a marquee around the whole canvas.

With the selection still active choose Edit > Stroke (Outline) Selection. In the Stroke dialog that appears, pick the width of the stroke (line) and its color. Next select the Inside option as the location. Click OK to draw the colored border.

After

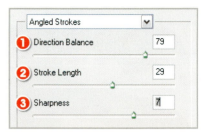

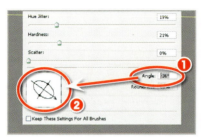

Angle gradient tool

Menu: -
Shortcut: G (Gradient tool) **OS:** Mac, Windows
Version: 1, 2, 3, 4 **See also:** Gradients

Photoshop Elements has no less than five gradient types for you to play with. All the gradient options gradually change color and tone from one point in the picture to another.

The Angle gradient (1) gradually changes the color in a counter-clockwise direction around the starting point.

Angle option – Brush

Menu: -
Shortcut: B (Brush tool) **OS:** Mac, Windows
Version: 2, 3, 4 **See also:** Brush Options

One of the strengths of Photoshop Elements as a drawing package is the flexibility of its brush engine. Rather than just supplying a series of pre-made brushes Adobe includes the ability to create and save custom brushes.

The More Options dialog, which is opened with the More Options button on the Brushes options bar, contains controls for changing seven different brush characteristics. The brush angle is one of these custom characteristics.

Changing the angle will rotate the brush tip resulting in a diagonal stroke when dragged across canvas (3). To make the brush tip slant, alter the angle value (1). The change in brush shape is previewed on the bottom left of the dialog (2).

Angled Strokes Filter

Menu: Editor: Filter > Brush Strokes > Angled Strokes
Shortcut: Ctrl F **OS:** Mac, Windows
Version: 1, 2, 3, 4 **See also:** -

The Angled Strokes filter, as one of the group of Brush Strokes filters, repaints the picture using diagonal strokes. The brush strokes in the light area of the photo are drawn in one direction and those in the darker parts in the opposite direction.

The Direction Balance (1), Stroke Length (2) and Sharpness (3) of the brush effect are controlled by the sliders in the Filter dialog.

Frame 1

Frame 2

Frame 3

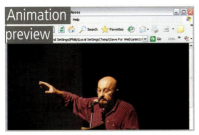

Animation preview

1

Animated GIFs

Menu:	Editor: File > Save for Web	
Shortcut:	Alt/Opt Shft Ctrl/Cmd S (Save for Web)	**OS:** Mac, Windows
Version:	1, 2, 3, 4	**See also:** GIF format

One of the characteristics of the GIF file format is that it is capable of storing and displaying simple animations. To take advantage of this feature Adobe has merged traditional techniques with the multi-layer abilities of its PSD file structure to give Elements users the chance to produce their own animations.

Essentially, the idea is to make an image file with several layers, the content of each being a little different from the one before.

The file is then saved in the GIF format. In the process, each layer is made into a separate frame in an animated sequence.

As the GIF is a format used for small animations on the Net, the moving masterpiece can be viewed with any web browser, or placed on the website to add some action to otherwise static pages.

The easiest way to save a GIF file is via the Save for Web feature. The Save for Web dialog contains the original image and a GIF compressed version of the picture.

By ticking the Animate checkbox you will be able to change the frame delay setting and indicate whether you want the animation to repeat (loop) or play a single time only. This dialog also provides you with the opportunity to preview your file in your default browser. The final step in the process is to click OK to save the file.

Create an Elements file with several layers of differing content. Select Editor: File > Save for Web. Ensure that the GIF setting is selected in the Settings section of the dialog. Tick the Animate checkbox.

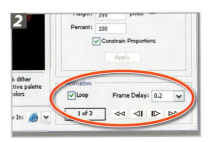

2

Adjust the Frame Delay option to control the length of time each individual image is displayed. Tick the Loop check box if you want the animation to repeat.

3

Preview the animation by clicking the browser Preview button. Close the browser to return to the Save for Web dialog. Select OK to save the file.

Anti-aliasing, fonts

Menu:	-	
Shortcut:	-	**OS:** Mac, Windows
Version:	1, 2, 3, 4	**See also:** Aliased

To make the edge of text appear less jagged, switch on the anti-aliasing feature via the button in the Type tool option bar. This feature smooths out the saw-tooth edges that appear on letter shapes that have diagonal or circular sides.

Anti-aliasing, selections

Menu:	-	
Shortcut:	-	**OS:** Mac, Windows
Version:	1, 2, 3, 4	**See also:** Feather, Aliased

Selections can be created with sharp or soft edges. You can soften the edge in two ways – by feathering, or by using the anti-aliasing feature in the Selection tool's options bar (which is activated by default when the tool is first selected).

Like the anti-aliasing effect for typefaces this feature softens the edges of the selection by smoothing the transition between selected and non-selected areas. The option must be selected before making the selection. Unlike feathering it cannot be applied later on. Use this feature to help conceal the edges of pasted picture parts in newly created compositions.

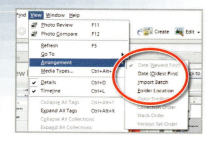

Date (Newest First)

Date (Oldest First)

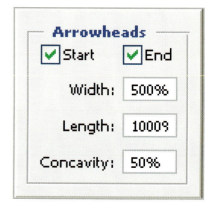

Arrangement menu

Menu: Photo Browser: View > Arrangement	
Shortcut: -	**OS:** Windows
Version: 3, 4	**See also:** -

The Photo Browser provides several ways in which to view the thumbnails of the photos you have imported into Elements. They are:

Date (Newest First) – Displays the most recently taken or imported photos first.

Date (Older First) – Shows the oldest photos first or in chronological order.

Import Batch – Displays pictures based on the batches or groups in which they were imported ('Get Photos'). This option also shows where the pictures were imported from.

Folder Location – Shows the thumbnails alongside the folders where they are stored. This view option is similar to the File Browser in the standard editor work-space.

The arrangement view can also be changed via the drop-down menu at the bottom left of the screen.

Import Batch

Folder Location

Arrowhead options

Menu: -	
Shortcut: U (Line tool)	**OS:** Mac, Windows
Version: 1, 2, 3, 4	**See also:** Shape tools

The Line tool is one of the vector-based or sharp-edged shape tools in Elements. Along with settings for color, weight and style the Line tool's option bar also contains a drop-down menu with controls for creating arrowheads on the lines you draw.

From within the dialog you can select to apply the head to the start or end of the line, adjust the width and length of the arrow as well as control its concavity. The percentages used here are based on the line weight.

These options need to be set before drawing the line on the canvas surface. The example arrows below are drawn with the following settings:

(1) End, Width 500%, Length 1000%

(2) End, Width 500%, Length 1000%, Concavity 50%

(3) Start and End, Width 500%, Length 1000%, Concavity 50%

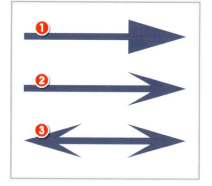

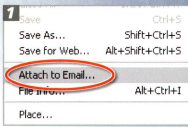

You can elect to use a photo that is currently open in the Editor workspace or multi-select images from inside the Photo Browser. Select the File > Attach to E-mail to start the feature and display the new dialog.

Add or delete photos from the thumbnail list of those to include with the buttons at the bottom left of the dialog.

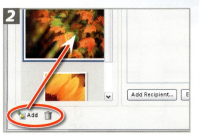

Select an existing recipient from the contacts list or add a new contact. Choose the format that the pictures will appear in from the drop-down menu.

For the Photo Mail (HTML) option select the stationery to use as a background for the e-mail. Add in your message and click OK. When your e-mail program displays the new message, click Send to E-mail in the usual manner.

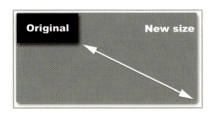

Aspect ratio

Menu:	-	
Shortcut:	-	OS: Mac, Windows
Version:	1, 2, 3,4	See also: Constrain Proportions

The aspect ratio or Constrain Proportions option is usually found in dialog boxes concerned with changes of image size and refers to the relationship between width and height of a picture.

The maintaining of an image's aspect ratio means that this relationship will remain the same even when the image is enlarged or reduced.

For example, failing to select the Constrain Proportions option in the Image > Resize > Image Size dialog will result in pictures that are squashed or stretched out of proportion.

Assign color profile

Menu:	Editor: Image > Convert Color Profile	
Shortcut:	Ctrl	OS: Windows
Version:	4	See also: Color Settings, Convert Color Profile

Selecting one of the options in the Image > Convert Color Profile menu will convert the picture's color to the selected color space. However if you press Ctrl when selecting a new profile, it will apply the profile without converting. This gives the image the appearance that it has been converted but maintains the underlying colors of the original. This option is the same as Photoshop's Assign Profile command.

Attach to E-mail

Menu:	Editor: File > Attach to E-mail or Photo Browser: File > E-mail	
Shortcut:	-	OS: Windows
Version:	2, 3, 4	See also: Slide show

Starting with Elements version 2.0 Adobe included a special Attach to E-mail function designed to add your photos to e-mails with a few simple mouse-clicks. The original feature opened your default mail program and attached your current image to a new e-mail document ready for you to address and send.

During the attachment process you could choose to send the image 'as is' using its current settings or allow Elements to auto convert the picture to a file with medium JPEG compression. For pictures with large pixel dimensions, selecting the Auto Convert option ensured that the attached image was small enough to be able to be sent, received and opened by most e-mail users.

With Elements 4.0 and 3.0 for Windows the feature was upgraded to include a brand new Attach Selected Items to E-mail dialog. Unlike in previous versions, here you can attach photographs as individual files (the way you do through your e-mail program), as a PDF slide show (that Elements makes on the fly for you) or you can add the photos to an HTML e-mail that Elements calls Photo Mail complete with choice of a range of fancy backgrounds and borders.

The images to be attached to the e-mail can be selected in the Photo Browser before opening the feature or can be added or removed via the thumbnail listing on the left of the dialog.

Before

Before

After

After

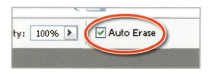

Auto Color Correction

Menu: Editor: Enhance > Auto Color Correction	
Shortcut: Shft Ctrl B	**OS:** Mac, Windows
Version: 2, 3, 4	**See also:** Auto Levels

The Auto Color Correction feature, first seen in version 2.0 of the program, works in a similar way to tools like Auto Levels and Auto Contrast, providing a one-click fix for most color problems.

Unlike these other tools it concentrates on correcting the color in the midtones of the picture and adjusting the contrast by reassigning the brightest and darkest pixels to white and black.

Sometimes such automatic fixes do not produce the results that you expect. In these scenarios use the Undo (Edit > Undo) command to reverse the changes and try one of the manual correction tools.

Auto Contrast

Menu: Editor: Enhance > Auto Contrast	
Shortcut: Alt/Opt Shft Ctrl/Cmd L	**OS:** Mac, Windows
Version: 1, 2, 3, 4	**See also:** Auto Levels

Auto Contrast is designed to correct images that are either too contrasty (black and white) or too flat (dull and lifeless). Unlike the Auto Levels feature, Auto Contrast ensures that the brightest and darkest pixels in the picture (irrespective of their colors) are converted to pure white and black. In doing so all the tones in-between are expanded or contracted to fit. Apply Auto Contrast to grayscale photos like the example or to pictures whose contrast needs improving but which have a strong color tint that you wish to retain. This feature is a good correction option if Auto Levels creates more color cast problems than it corrects.

Auto Erase, pencil

Menu: -	
Shortcut: N (Pencil)	**OS:** Mac, Windows
Version: 1, 2, 3, 4	**See also:** Pencil tool

The Pencil tool draws hard-edged lines using the foreground color. Selecting the Auto Erase feature in the option bar changes the way that the tool applies this color. When drawing on any color other than the foreground color the pencil will draw in the foreground color. In Auto Erase mode starting a drawing on a picture part that is the foreground color will cause the pencil to switch to the background color.

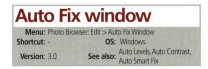

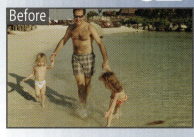
Before

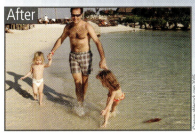
After

© www.ablestock.com 2005

Auto Fix window

Menu:	Photo Browser: Edit > Auto Fix Window		
Shortcut:	-	**OS:**	Windows
Version:	3.0	**See also:**	Auto Levels, Auto Contrast, Auto Smart Fix

The Auto Fix Window feature is made up of two different sections – General fixes (1) and Crop controls (2).

Four General fixes are available with the resultant changes being reflected in the preview image.

Auto Smart Fix – This command corrects general color problems and also adjusts shadow and highlight areas of the picture.

Auto Levels – Use this button to increase the overall contrast of the picture and correct any color cast present in the image.

Auto Contrast – This command limits the changes to the picture to contrast only and ignores any color cast present in the photograph.

Auto Sharpen – Applies a general sharpening of all the details in the picture. This is equivalent to applying a sharpening filter to your photograph. This 'fix' should be applied once and as a last enhancement step before saving and printing.

The Crop options give you a choice of a customized crop or a preset crop that is designed to suit the format (and size) of a range of specific printing papers.

To remove unwanted changes, click the Reset Image button. Apply the Auto Sharpen command as the last step in the process when you are happy with the other picture alterations.

Auto image edits

Menu:	-		
Shortcut:	-	**OS:**	Windows
Version:	4	**See also:**	Auto Smart Fix, Auto Red Eye Fix

Elements provides the user with a variety of levels of enhancement and editing options. These options are skillfully arranged from the automatic, 'press this button now' type tools that provide quick and accurate results for the majority of pictures, through to the more sophisticated and user-controlled features required for completion of more complex, professional-level, correction tasks.

In version 4.0 of the program the user can select from two fully automatic editing and enhancement options – Auto Smart Fix and Auto Red Eye Fix. These features can be applied to individually selected or multi-selected pictures in the Photo Browser workspace by selecting the options either from the Edit menu or via the right-click pop-up menu.

Auto Smart Fix analyzes the colors and tones in the picture before automatically adjusting the brightness, contrast and color cast in the photo.

Auto Red Eye Fix is part of the new red eye correction technology in Elements. You can now automatically remove the red eye effect at the time of downloading your pictures from a memory card or camera, when importing files from a folder or from inside the Photo Browser.

For general images these auto only solutions produce good results but if you are unhappy with the changes simply select the Edit > Undo option to return the picture to its original state and then choose a manual editing approach.

Auto Levels

Menu:	Editor: Enhance > Auto Levels		
Shortcut:	Shft Ctrl L	**OS:**	Mac, Windows
Version:	1, 2, 3, 4	**See also:**	Auto Contrast

The Auto Levels command is similar to Auto Contrast in that it maps the brightest and darkest parts of the image to white and black. It differs from the previous technique because each individual color channel is treated separately.

In the process of mapping the tones (adjusting the contrast) in the Red, Green and Blue channels, dominant color casts can be neutralized. This is not always the case; it depends entirely on the make-up of the image. In some cases the reverse is true; when Auto Levels is put to work on a neutral image a strong cast results. If this occurs, undo (Edit > Undo) the command and apply the Auto Contrast feature instead.

Before

After

Auto Select Layer

Menu: -	
Shortcut: V (Move tool)	**OS:** Mac, Windows
Version: 1, 2, 3, 4	**See also:** Bounding Box

The Move tool is often used for repositioning contents of different layers. The layer to be moved is first selected in the layer stack and then the tool is clicked and dragged to move the layer contents. Picking the Auto Select Layer mode from the Move tool's options bar can make the layer selection process easier and more interactive.

Clicking onto the picture surface whilst in this mode will automatically select the uppermost layer that has a picture part under the pointer.

Auto Smart Fix

Menu: Editor: Enhance > Auto Smart Fix	
Shortcut: Ctrl M	**OS:** Windows
Version: 3, 4	**See also:** Adjust Smart Fix

The new Auto Smart Fix feature enhances both the lighting and color in your picture automatically. The command is used to balance the picture hues and improve the overall shadow and highlight detail.

Most images are changed drastically using this tool. In some cases the changes can be too extreme. If this occurs, the effect should be reversed using the Edit > Undo command and the more controllable version of the tool – Adjust Smart Fix – used instead.

Automation Tools

Menu: Editor: File > Automation Tools	
Shortcut: -	**OS:** Mac, Windows
Version: 3	**See also:** Multi-Page PDF to PSD, PDF Slide Show

In the Windows version (1) of Photoshop Elements 3.0 the Automation Tools menu has one option only – Multi-Page PDF to PSD. This feature imports the individual pages of the PDF file, converts these to pictures and then saves them as separate picture files.

In contrast, the Macintosh version (2) of the release contains the Multi-Page PDF to PSD option along with a presentation creator called PDF Slide Show.

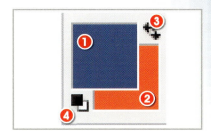

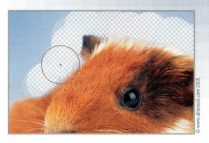

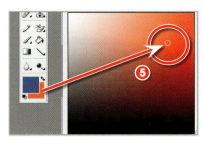

Background color

Menu: -	
Shortcut: -	**OS:** Mac, Windows
Version: 1, 2, 3, 4	**See also:** Foreground color, Eyedropper

Photoshop Elements bases many of its drawing, painting and filter effects on two colors – the foreground and background colors. The currently selected foreground and background colors are shown at the bottom of the toolbox as two colored swatches. The topmost swatch (1) represents the foreground color, the one beneath (2) the hue for the background.

The default for these colors is black and white but it is possible to customize the selections at any time. Click the swatch and then select a new color from the Color Picker Window (5).

To switch foreground and background colors click the double-headed curved arrow at the top right (3) and to restore the default (black and white) click the mini swatches bottom left (4).

Background Eraser tool

Menu: -	
Shortcut: E	**OS:** Mac, Windows
Version: 1, 2, 3, 4	**See also:** Eraser

The Background Eraser is used to delete pixels around the edge of an object. This tool is very useful for extracting objects from their surrounds. The tool pointer is made of two parts – a circle and a cross hair. The circle size is based on the brush size.

To use the tool, the cross hair is positioned and dragged across the area to be erased, whilst at the same time the circle's edge overlaps the edge of the object to be kept. The success of this tool is largely based on the contrast between the edge of the object and the background. The greater the contrast, the more effective the tool.

The Tolerance slider is used to control how different pixels need to be in order to be erased. The Limits options set the tool to erase only those pixels that are linked, or sitting side by side (Contiguous) or all the pixels within the circle that are a similar color.

13

B

Background layer

Menu: -	
Shortcut: -	**OS:** Mac, Windows
Version: 1, 2, 3, 4	**See also:** Layers, Layers palette

An image can only have one background layer. It is the bottom-most layer in the stack. No other layers can be moved or dragged beneath this layer. You cannot adjust this layer's opacity or its blending mode. The background layer is locked (1) from these changes.

You can convert background layers to standard image layers by double-clicking the layer in the Layers palette, setting your desired layer options in the dialog provided and then clicking OK.

If the document that you are working on doesn't contain a background layer, it is possible to change any layer into a background layer by selecting the Layers palette and then choosing Editor: Layer > New > Layer From Background. If the selected layer is not the bottom-most layer, changing it to a background layer will force it to the bottom of the stack and this could dramatically alter the look of the image.

Background matting

Menu: -	
Shortcut: -	**OS:** Mac, Windows
Version: 1, 2, 3, 4	**See also:** Save for Web

Most photos that are optimized for use on the Internet are saved in the JPEG format. As part of the construction process of a web page, the pictures are then placed on top of a colored background. The JPEG format does not contain a Transparency option and so when an irregularly shaped graphic is saved as a JPEG and placed onto a web page it is surrounded by a plain colored box, usually white (1).

Background matting is a technique for adding the web page color to the background of the object at the time of web optimization. When the matted object is then used to create the web page, it appears to be sitting on the background as if it was surrounded by transparency (2). The transparent pixels surrounding the object are replaced with the matte color and the semi-transparent pixels are blended.

The Matte option is located in the settings area of the Editor: File > Save for Web feature (3).

Backup

Menu: Photo Browser: File > Backup	
Shortcut: -	**OS:** Windows
Version: 3, 4	**See also:** Burn

As well as the traditional Save options available in the previous releases of the program, Adobe has also introduced a new Backup feature in the Windows version of Elements 3.0 that is designed for copying your pictures (and catalog files) onto DVD or CD for archiving purposes.

Follow the steps in the wizard to make a copy or backup of all the photos you have currently listed in your Photo Browser.

The wizard includes the option to backup all the photos you currently have catalogued in the Photo Browser, along with the ability to move selected files from your hard disk to CD or DVD to help free up valuable hard disk space. Simply activate the feature and follow the wizard's step-by-step prompts to create your own backup.

To create a matted web image, choose the web page color and then create a picture with a transparent background.

Choose Editor: File > Save for Web. In the dialog select the JPEG option as the file format. Select the web page color from the Matte pop-up menu. Click OK to save.

Now construct the web page and add in the new matted graphic. When the page is displayed the background of the object will seamlessly merge with the page color.

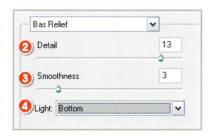

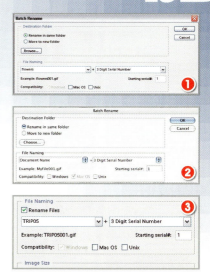

Bas Relief filter

Menu: Editor: Filter > Sketch > Bas Relief
Shortcut: - **OS:** Mac, Windows
Version: 1,, 2, 3 **See also:** Emboss filter

The Bas Relief filter, as one of the group of Sketch filters, simulates the surface texture of the picture using the current foreground and background colors. Changing the colors will result in dramatically different results (1).

The edges in the picture are used as the basis for the effect with the three settings in the dialog providing control over how the colors are applied.

The Detail slider (2) alters the amount of the original photo detail used to create the end result. Higher numbers create more detailed results. The Smoothness slider (3) alters the sharpness of the detail and the Light menu (4) contains a series of options for the direction of the light that is used to create the textured look of highlights and shadows.

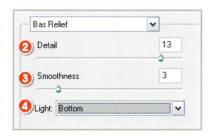

Batch Processing

Menu: Editor: File > Batch Processing
Shortcut: - **OS:** Mac, Windows
Version: 2 **See also:** Process Multiple Files, Batch Rename

In Elements 3.0 the Batch Processing command has been replaced with the enhanced Process Multiple Files feature.

In earlier versions of the program the Batch Processing feature enabled actions like file format conversions (1), image size changes (2) and file renaming (3) to be applied to a folder full of images. The pictures would then be saved to a different folder after the changes had been applied.

The same functions are provided in the new Process Multiple Files feature (4) along with the Quick Fix enhancement options of Auto Levels, Auto Contrast, Auto Color and Sharpen and a special labeling feature.

Batch Rename

Menu: File Browser: Automate > Batch Rename (Mac)
File Browser: File > Rename Multiple Files (Win)
Shortcut: - **OS:** Mac, Windows
Version: 3, 4 **See also:** Process Multiple Files

Several files can be renamed in a single action using the Batch Rename (Mac) or Rename Multiple Files (Win) options in the Standard Editor's File Browser.

After multi-selecting the files in the browser choose File > Rename Multiple Files – Win (1) or Automate > Batch Rename – Mac (2), add in the name and destination settings in the Batch Rename dialog and click OK.

The new Process Multiple Files also contains an option for renaming complete folders of files automatically.

After opening the dialog select source and destination folders and then choose the File Naming option (3). Add in the Document Name and select an additional naming label (i.e. date, sequential number, alphabetical code). Lastly select the computer systems that the file names need to be compatible with. Click OK to apply the name changes.

bB

Bicubic

Low resolution original

Bicubic – Sharper

Bicubic – Smoother

Bilinear

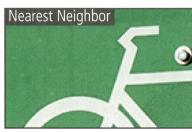
Nearest Neighbor

© www.adstock.com 2005

Bicubic interpolation

Menu: Editor: Image > Resize > Image Size
Shortcut: - **OS:** Mac, Windows
Version: 1, 2, 3, 4 **See also:** Bilinear, Nearest Neighbor

Digital photos are made up of pixels. These are discrete blocks of color and tone arranged in a grid fashion. The number of pixels in a picture is determined when the photo is taken or the print scanned. Occasionally it is necessary to change the number of pixels in the picture to either make it bigger or smaller. This task is usually handled by the Image Size feature where there are controls to increase or decrease the pixel dimensions (1).

The process is often called Resampling or Interpolating the picture, and makes use of a mathematical algorithm to generate the newly-sized picture.

Bicubic is one of the algorithms you can select to resize your picture. It takes the longest to process the file, but provides smooth graduations in the final photo.

Bicubic – Sharper interpolation

Menu: Editor: Image > Resize > Image Size
Shortcut: - **OS:** Mac, Windows
Version: 3, 4 **See also:** Bicubic – Smoother

Adobe added two new interpolation methods to Photoshop Elements 3.0: Bicubic – Sharper; and Bicubic – Smoother. Bicubic – Sharper is specifically designed for occasions when you are reducing the size of a picture. It retains the detail of the original image and sharpens the picture as it resizes. If the sharpening results are too harsh then Edit > Undo the process and try the standard Bicubic approach.

Bicubic – Smoother interpolation

Menu: Editor: Image > Resize > Image Size
Shortcut: - **OS:** Mac, Windows
Version: 3, 4 **See also:** Bicubic - Sharper

Photoshop Elements 3.0 introduced two new approaches for increasing and decreasing the size of your pictures. Both options are based on the Bicubic algorithm but they have been optimized for different picture resizing operations. The Bicubic – Smoother option should be used for increasing the size of photographs, whereas the Bicubic – Sharper option is for making pictures smaller.

Bilinear interpolation

Menu: Editor: Image > Resize > Image Size
Shortcut: - **OS:** Mac, Windows
Version: 1, 2, 3, 4 **See also:** Bicubic, Nearest Neighbor

Apart from the Bicubic options examined here Photoshop Elements can also resize pictures using two other interpolation options – Bilinear and Nearest Neighbor. Nearest Neighbor is the fastest to apply but produces the coarsest results. Bilinear is a compromise in speed and quality between Bicubic and Nearest Neighbor.

Interpolation Quick Guide:

Action	Original	Method
Enlarge (Quality)	Photo	Bicubic – Smoother
Reduce (Quality)	Photo	Bicubic – Sharper
Enlarge (Speed)	Photo	Bilinear
Reduce (Speed)	Photo	Bilinear
Enlarge	Screen shot	Nearest Neighbor
Reduce	Screen shot	Bicubic – Sharper

Before

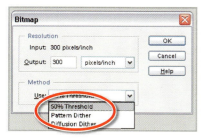

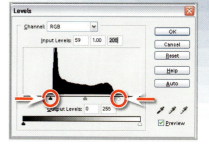

Bitmap color mode

Menu: Editor: Image > Mode > Bitmap	
Shortcut: -	**OS:** Mac, Windows
Version: 1, 2, 3, 4	**See also:** Mode, Threshold

It is possible to change the color mode of your picture by selecting a different mode from the Image > Mode menu. When converting a color photograph to Bitmap mode in Elements the file is changed to a grayscale picture first and from there to pure black and white. In the process you can choose the approach used for this conversion via the Method pop-up menu.

50% Threshold – Creates broad areas of flat black and white with a 50% tone used as the separation point.

Pattern Dither – Uses a black and white dot pattern to simulate tones.

Diffusion Dither – Examines each pixel in the picture before converting it to black or white, resulting in a grain-filled photo.

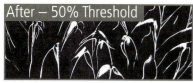
After – 50% Threshold

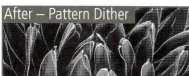
After – Pattern Dither

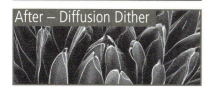
After – Diffusion Dither

Bitmap images

Menu: -	
Shortcut: -	**OS:** Mac, Windows
Version: 1, 2, 3, 4	**See also:** Pixels

Confusingly the term Bitmap images does not refer to the pure black and white pictures that result from converting your photos to Bitmap mode. Instead a bitmap picture is one that is made up of rectangular pixel blocks which could just as easily be in color or grayscale.

In this way all digital photographs are bitmap images as their color, brightness and detail are created from a grid of pixels. In most applications the pixel structure of the photograph is not apparent as the individual blocks are so small that they become invisible to the viewer's gaze.

To see the underlying bitmap structure of your pictures magnify the image on screen using the Editor: View > Zoom In command until the photo is at 1600% magnification.

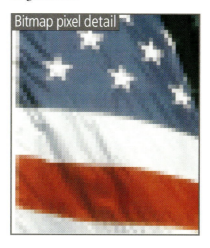
Bitmap pixel detail

Black and white points

Menu: Editor: Enhance > Adjust Lighting > Levels	
Shortcut: Ctrl L	**OS:** Mac, Windows
Version: 1, 2, 3, 4	**See also:** Shadows/Highlights

If you want to take more control of adjusting the brightness and contrast in your pictures than the auto features allow, open the Levels dialog.

Looking very similar to the Histogram, this feature allows you to interact directly with the pixels in your image. As well as a graph, the dialog contains two slider bars. The one directly beneath the graph has three triangle controls for black, midtones and white, and represents the input values of the picture. The slider at the bottom of the box shows output settings, and contains black and white controls only.

To adjust the pixels, drag the input shadow (left end) and highlight (right end) controls until they meet the first set of pixels at either end of the graph. When you click OK, the pixels in the original image are redistributed using the new white and black points.

Altering the midtone control will change the brightness of the middle values of the image, and moving the output black and white points will flatten, or decrease, the contrast. Clicking the Auto button is like selecting Editor: Enhance > Adjust Lighting > Auto Levels from the menu bar.

Before

After

© www.ablestock.com 2005

Standard — Normal / Dissolve

Darken — Darken / Multiply / Color Burn / Linear Burn

Lighten — Lighten / Screen / Color Dodge / Linear Dodge

Overlay — Overlay / Soft Light / Hard Light / Vivid Light / Linear Light / Pin Light / Hard Mix

Difference — Difference / Exclusion

Hue — Hue / Saturation / Color / Luminosity

❶

Black and white photos, creating

Menu: Editor: Image > Mode > Grayscale
Shortcut: - **OS:** Mac, Windows
Version: 1, 2, 3, 4 **See also:** Mode

The simplest way to lose the colors in your picture is to convert the image to a grayscale. This process changes the photograph from having three color channels (red, green and blue) to being constructed of a single channel that contains the picture's detail only.

Sometimes this conversion produces a flat and lacklustre photograph and so a little manipulation of the tones is in order to restore the contrast.

The first point of call to help solve this problem should always be the Levels dialog (Enhance > Adjust Lighting > Levels). Using this control it is possible to make sure that your image tones are spread across the grayscale spectrum.

Most grayscale conversion images can benefit from a general contrast increase. You can achieve this by moving the black and white Input sliders towards the center of the dialog.

Preview the clipping

Holding the Alt key (Windows) or Option key (Macintosh) down whilst you are moving the slider will enable you to preview the pixels that are being converted to pure black or pure white. Your aim is to map the darkest pixels in the picture to black and the lightest ones to white.

Pro's Tip

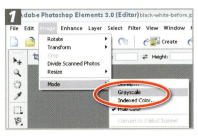

Select the Image > Mode > Grayscale option and then click on the OK button in the Discard Color warning box.

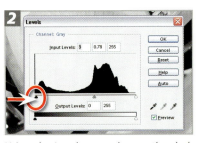

Using the Levels control, map the dark pixels to black by dragging the Black Point slider to the right.

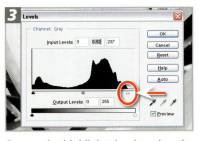

Correct the highlights by dragging the White Point slider to the left.

Blend modes

Menu: -
Shortcut: - **OS:** Mac, Windows
Version: 1, 2, 3, 4 **See also:** -

The way that layers interact with other layers in the stack is determined by the blending mode of the upper layer. By default the layer's mode is set to normal which causes the picture content on the upper layer to obscure the picture parts beneath, but Photoshop Elements has many other ways (modes) to control how these pixels interact.

Called blend modes, the different options provide a variety of ways to control the mixing, blending and general interaction of the layer content.

The modes are grouped into several different categories based on the type of changes that they make (1).

The Layer blend modes are located in the drop-down menu at the top left of the Layers palette (2). Blend modes can also be applied to the painting and drawing tools via a drop-down menu in the tool's options bar (3).

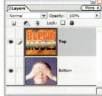

Normal

Dissolve

Darken

>>> In the following blend mode examples the picture has two layers – 'Top' (1) and 'Bottom' (2). In each example the blend mode of the top layer has been changed to illustrate how the two layers blend together.

The pixels in the top layer are opaque and therefore block the view of the bottom layer. Adjusting the opacity of the top layer will make it semi-transparent causing it to blend with the top layer.

Combines the top layer with the bottom using a pattern of pixels. There is no effect if the top layer is at 100% opacity. Reduce the opacity to see the effect. Example set to 80% opacity.

Compares the color of the top and bottom layers and blends the pixels where the top layer is darker than the bottom.

19

B

Multiply

Color Burn

Linear Burn

Lighten

Multiplies the color of the bottom layer with the top layer producing an overall darker result. There is no image change when the top layer is white.

Darkens or 'burns' the image using the contents of the top layer. There is no image change if the top layer is white.

Uses the same approach as the Color Burn mode but produces a stronger darkening effect. There is no image change when the top layer is white.

Compares the color in the top and bottom layers and blends the pixels if the top layer is lighter than the bottom.

Screen

Color Dodge

Linear Dodge

Overlay

The opposite to the Multiply mode as it multiplies the inverse of the top layer with the bottom layer producing a much lighter image.

Makes the picture lighter using the top layer to dodge the bottom layer. There is no effect if the top layer is black.

Similar to the Screen mode but produces a much stronger lightening effect. There is no effect if the top layer is black.

Combines the effect of both the Multiply and Screen modes whilst blending the top layer with the bottom. There is no effect if the top layer is 50% gray.

Soft Light

Similar to the Overlay mode but produces a more subtle effect. There is no change if the top layer is 50% gray.

Hard Light

Uses the same approach as the Overlay mode but the change is more dramatic. Here the top layer is either Screened or Multiplied depending on its color. There is no effect if the top layer is 50% gray.

Vivid Light

Combines the effects of both Color Burn and Color Dodge modes and applies the blend based on the color of the top layer. There is no effect if the top layer is 50% gray.

Linear Light

Similar to the Vivid Light mode but produces a more dramatic result. There is no effect if the top layer is 50% gray.

Pin Light

Blends the light colors in the top layer using the Lighten mode and blends the dark colors using the Darken mode. There is no effect if the top layer is 50% gray.

Hard Mix

Creates a flat toned picture with limited colors and lots of posterization. The luminosity of the top layer is blended with the color of the bottom.

Difference

Displays the tonal difference between the contents of the two layers by subtracting the lighter pixels from either of the layers. This results in a dark and sometimes reversed image.

Exclusion

Similar to the Difference mode but produces less dramatic effects.

Hue

Combines the Hue (color) of the top layer with the Saturation (color vibrancy) and Luminance (tones) of the bottom layer.

Saturation

Combines the Saturation (color vibrancy) of the top layer with the Hue (color) and Luminance (tones) of the bottom layer.

Color

Combines the Hue (color) and Saturation (color vibrancy) of the top layer with the Luminance (tones) of the bottom layer.

Luminosity

Combines the Luminance (tones) of the top layer with the Saturation (color vibrancy) and Hue (color) of the bottom layer.

Before

Before

After

After

Bloat tool, Liquify filter

Menu: Editor: Filter > Distort > Liquify			
Shortcut: B (whilst in Liquify filter)		**OS:** Mac, Windows	
Version: 2, 3, 4		**See also:** Liquify filter	

The Bloat tool is one of several tools in the Liquify filter that allows you to stretch, twist, push and pull your pictures. It spreads the pixels apart in the center of a circle the size of the current brush tip. The result is like the picture part has been blown up or 'bloated'.

To bloat your pictures, select the tool, then adjust the brush size so that it is the same dimensions as the area to be changed; then hold down the mouse button until the picture has changed the required amount. You can drag the mouse across the canvas bloating the pixels as you go.

To reverse the tool's effect either select the Revert button (top right) or paint over the surface with the Reconstruct tool.

Blur filters

Menu: Editor: Filter > Blur			
Shortcut: -		**OS:** Mac, Windows	
Version: 1, 2, 3, 4		**See also:** Gaussian Blur, Motion Blur, Radial Blur, Smart Blur	

Photoshop Elements 3.0 has no less than seven different filters that are designed to blur the content of images. It might seem strange for image makers to actually want to destroy the sharpness of their photos but many interesting enhancement effects make use of these filter options.

Average – Averages all the color in the picture and then fills the canvas with this color.

Blur and Blur More – Smooth transitions and soften details. Blur More is stronger.

Gaussian Blur – Slider-controlled blurring based on the Gaussian distribution of pixel changes.

Motion Blur – Blurs the image in a specific direction. Great for speed enhancing effects.

Radial Blur – Creates either spinning or zooming blur effects.

Smart Blur – Provides more control over the type and placement of blur using Radius, Threshold, Quality and Mode adjustments.

Pro's Tip

Before applying a blur filter to a layer with transparency, make sure that the Lock Transparency option is turned off.

Blur tool

Menu: -			
Shortcut: R		**OS:** Mac, Windows	
Version: 1, 2, 3, 4		**See also:** Blur filters	

Along with the extensive range of blur filters available in Elements, the program also includes a Blur tool. The tool is used like a paintbrush but instead of laying down color on the canvas the image is blurred. The Size (brush tip), Mode (blend mode) and Strength settings for the tool are all controlled in the options bar.

Bounding box, Move tool

Menu: -			
Shortcut: V (Move tool)		**OS:** Mac, Windows	
Version: 1, 2, 3, 4		**See also:** Move tool, Free Transform	

The Show Bounding Box setting is located on the options bar for the Move tool. Selecting this setting displays a bounding box complete with edge and side handles (small boxes) around the currently selected layer. The handles can be used to scale, distort, skew, rotate and apply perspective changes interactively. See Free Transform tool for the keystroke combinations for these changes.

21
B

Before

After

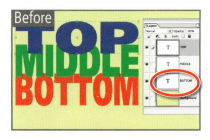

Before

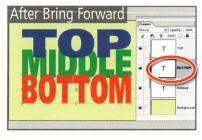

After Bring Forward

22

Borders, printing

Menu: File > Print, File > Print Multiple Photos	
Shortcut: Ctrl P, Ctrl/Cmd Alt/Opt P	**OS:** Mac, Windows
Version: 2, 3, 4	**See also:** Print

You can add a colored border 'on the fly' when making prints with Elements. The Border option is part of the extended print features found in both the Print Preview dialog (2) in both Mac and Windows versions of the program and the Print Multiple Photos window (1) (displayed via the More Options button) in the Windows edition.

The size and color of the border can be set and the final result previewed in each feature.

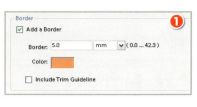

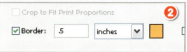

Brightness/Contrast

Menu: Editor: Enhance > Adjust Lighting > Brightness/Contrast	
Shortcut: -	**OS:** Mac, Windows
Version: 1, 2, 3, 4	**See also:** Shadows/Highlights

The Brightness/Contrast command helps you make basic adjustments to the spread of tones within the image.

When opened you are presented with a dialog containing two slider controls. Click and drag the slider to the left to decrease brightness or contrast, to the right to increase the value.

Keep in mind that you are trying to adjust the image so that the tones are more evenly distributed between the extremes of pure white and black. Too much correction using either control can result in pictures where highlight and/or shadow details are lost.

As you are making your changes, watch these two areas in particular to ensure that details are retained.

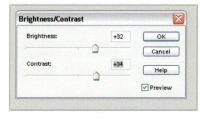

Bring Forward

Menu: Editor: Layer > Arrange > Bring Forward	
Shortcut: Ctrl]	**OS:** Mac, Windows
Version: 1, 2, 3, 4	**See also:** Layers Palette

To change the order of layers in the layer's stack you can either click on the layer in the palette and drag it to the new position or make use of the commands in the Layer > Arrange menu.

Layers can be moved up and down the stack using these options. Here we selected the Bottom layer and then chose Bring Forward. The layer then moves up one place in the stack, positioning the layer in between the Top and Middle layers.

· ·

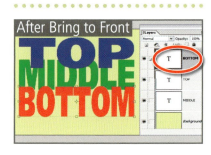

After Bring to Front

Bring to Front

Menu: Editor: Layer > Arrange > Bring to Front	
Shortcut: Shft Ctrl]	**OS:** Mac, Windows
Version: 1, 2, 3, 4	**See also:** Layers Palette

As well as options for moving layers up or down one position at a time, the Layer > Arrange menu also contains items for placing the selected layer at the very top (or bottom) of the stack. Here the Bring to Front option was used to move the Bottom layer to the top of the stack, effectively making it above both the Middle and Top layers.

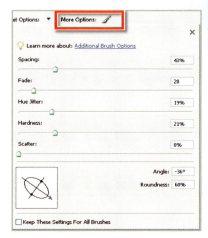

Browse Folders

Menu: Editor: File > Browse Folders
Shortcut: Shift Ctrl O **OS:** Mac, Windows
Version: 1, 2, 3 **See also:** Photo Browser

This option is available for both version 3.0 Macintosh and Windows users and takes the user directly to the Elements File Browser, which displays thumbnail versions of images that you have created at another time and have saved to disk. In the version 4.0 release the feature is superseded by the Photo Browser or Organizer workspace.

Users can navigate between image directories using the folder tree in the top left-hand corner of the dialog. Camera, or scanner, settings and image information can be viewed on the bottom left of the browser in the scrollable text box. Sometimes called EXIF data, these details are stored in the picture file together with the image information.

Users can add their own caption, copyright, author and title information for individual images through the File Info dialog box (File > File Info).

Images can be renamed and folders added or deleted directly in the dialog using the extra options found in the menus in the top left of the dialog box (File, Edit, etc.).

Double-clicking a thumbnail in the browser will open the selected image directly into the program.

The Mac version of the File Browser includes an 'Automate' menu from which you can apply various features found in Elements, such as PDF Slide Show, Contact Sheet II, Picture Package, Process Multiple Files and Photomerge.

Brush Options

Menu: -
Shortcut: B (Brush) **OS:** Mac, Windows
Version: 3, 4 **See also:** Brush tool

The Additional Brush Options palette, displayed via the More Options button, is used to creatively control the following brush characteristics or dynamics:

Spacing determines the distance between paint dabs, with high values producing dotty effects.

The **Fade** setting controls how quickly the paint color will fade to nothing. Low values fade more quickly than high ones.

Hue Jitter controls the rate at which the brushes' color switches between foreground and background hues. High values cause quicker switches between the two colors.

Hardness sets the size of the hard-edged center of the brush. Lower values produce soft brushes.

The **Scatter** setting is used to control the way that strokes are bunched around the drawn line. A high value will cause the brush strokes to be more distant and less closely packed.

Angle controls the inclination of an elliptical brush.

The **Roundness** setting is used to determine the shape of the brush tip. A value of 100% will produce a circular brush, whereas a 0% setting results in a linear brush tip.

Brush tool

Menu: -
Shortcut: B **OS:** Mac, Windows
Version: 1, 2, 3, 4 **See also:** Airbrush, Pencil, Paint Bucket

The Elements Brush tool lays down color in a similar fashion to a traditional paint brush. The color of the paint is set to the current foreground color. The size and shape of the brush can be selected from the list in the Brush Presets list (versions 3.0 and 2.0) or Brush palette (version 1.0) in the options bar. Changes to the brush characteristics can be made by altering the settings in the options bar and the More Options palette.

In addition to changes to the size, blend mode and opacity of the brush, which are made via the options bar, you can also alter how the Paint Brush behaves via the new Additional Brush Options palette.

To draw a straight line click to start the line and hold down the Shift key, then click the mouse button a second time to mark the end of the line.

Brush library

Menu: -		
Shortcut: B (Brush tool)	**OS:** Mac, Windows	
Version: 3, 4	**See also:** Brush tool	

Photoshop Elements is shipped with a wide range of pre-made brushes which are stored in several groups in the Brush Library palette.

To access a specific brush from the library firstly display the pop-up palette by clicking the down arrow next to the brush stroke preview in the options bar. Select a group of brushes from the Brushes drop-down menu. Now scroll through the brush types and click to select the brush you want to use.

Pro's Tip Ready-made Elements brush libraries can be downloaded from sites on the Internet that specialize in providing free imaging resources. After downloading the file, click on the side arrow in the top right of the brush library pop-up and select the Load Brushes item from the menu. Locate the library file and click OK to incorporate the new brushes into the palette.

www.graphicxtras.com

Display the brush library by clicking the down arrow next to the brush stroke preview in the options bar. Select a brush set from the Brushes menu and then click on a specific brush to modify.

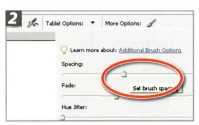

Modify the selected brush by adjusting the various settings in the options bar. For more creative changes alter the slider controls for the brush dynamics in the More Options dialog.

Display the brush library again and select the side arrow in the top right of the pop-up. Choose Save Brush from the menu items. Type a name into the Brush Name dialog and click OK. The newly created brush is added to the bottom of the brush library.

Burn, backup

Menu: Photo Browser: File > Burn		
Shortcut: Ctrl B	**OS:** Windows	
Version: 3, 4	**See also:** Backup	

The Burn feature functions in a similar way to the Backup option. With either feature you can archive, copy and move catalog (thumbnails) and image files from hard drive to hard drive or to portable backup media such as DVD.

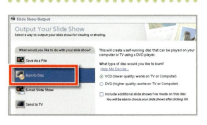

Burn to Disc

Menu: Photo Creations: Slide Show		
Shortcut: —	**OS:** Windows	
Version: 4	**See also:** Slide Show	

Burn to Disc is an option in the Slide Show Output dialog box that allows you to burn your slide show onto "a self-running disc that can be played on your computer or TV using a DVD player.

You can select from two different output options:

VCD (Video CD) which is lower in quality but takes up less space on the disc or

DVD (Digital Video Disk) which produce a presentation of higher quality.

Additional already saved slide shows can be added to the disc along with the one that you are currently working on.

Burn tool

Menu: -	
Shortcut: O	**OS:** Mac, Windows
Version: 1, 2, 3, 4	**See also:** Dodge tool

The Burn tool darkens specific areas of a photograph when the tool tip is clicked and dragged across the picture surface. The tool's attributes are based on the settings in the options bar and the current brush size. The strength of the darkening is governed by the exposure setting. Most professionals choose to keep this value low and build up the tool's effect with repeated strokes over the same area.

You can also adjust the precise grouping of tones, highlights, midtones or shadows that you are working on at any one time by setting the option in the Range menu.

Calibrate monitor

Menu: -	
Shortcut: -	**OS:** Mac, Windows
Version: 1, 2, 3, 4	**See also:** Color Settings

Photoshop Elements has a sophisticated color-management system that will help ensure that what you see on screen will be as close as possible to what you print and what others see on their screens.

For this reason, it is important that you set up your computer to use this system before starting to make changes to your images.

The critical part of the process is the calibration of your monitor. To achieve this, use the following steps:

To start the calibration process make sure that your monitor has been turned on for at least 30 minutes.

Check that your computer is displaying thousands (16-bit color) or millions (24- or 32-bit color) of colors.

Remove colorful or highly patterned backgrounds from your screen, as this can affect your color perception. (Continued over page.)

Start the Adobe Gamma utility. In Windows, this is located in the Control Panel. For Macintosh users, use Apple's own Display Calibrator Assistant, as Adobe Gamma is not used with the new system software.

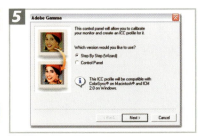

Use the step-by-step Wizard to guide you through the setup process. If a default profile was not supplied with your computer, contact your monitor manufacturer or check their website for details.

Save the profile, including the date in the file name. As your monitor will change with age, you should perform the Gamma setup every couple of months. Saving the setup date as part of the profile name will help remind you when last you used the utility.

© www.ablestock.com 2005

Canvas

Menu: -	
Shortcut: -	OS: Mac, Windows
Version: 1, 2, 3, 4	See also: Canvas Size

In creating documents in Photoshop Elements the program makes a distinction between the canvas (1), upon which pictures and other content is placed, and the image content (2) itself.

This is true even for photos with one layer only. For most newly imported photos the canvas and image size are exactly the same and so the canvas remains hidden from view.

Given this distinction, it is possible to resize, alter the format or change the color of the canvas without affecting the image at all.

Before

© www.ablestock.com 2005

After

Canvas Size

Menu: Editor: Image > Resize > Canvas Size	
Shortcut: -	OS: Mac, Windows
Version: 1, 2, 3, 4	See also: Image Size

Altering the settings in the Canvas Size dialog changes the dimensions of the background the image is sitting upon. Larger dimensions than the picture result in more space around the image. Smaller dimensions crop the image.

To change the canvas size, select Canvas Size from the Resize selection of the Image menu and alter the settings in the New Size section of the dialog. You can control the location of the new space in relation to the original image by clicking one of the sections in the Anchor diagram. Leaving the default setting here will mean that the canvas change will be spread evenly around the image.

Keep in mind that increasing the canvas size, or adding canvas (which is sometimes called 'adding out') will also increase the size that the picture can be printed.

Whereas adding extra layers to a picture (' adding up') does not increase the printed size.

Step-by-step instructions for changing canvas size are on the next page.

With the picture already open in the Standard Editor workspace select Image > Resize > Canvas Size.

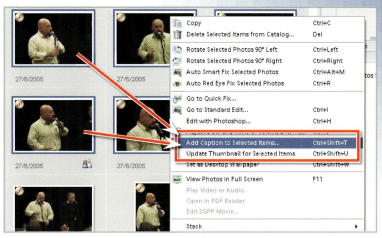

In the Canvas Size dialog add in the new values for the width and height of the canvas. When making the canvas larger click and drag the white square in the 3 × 3 grid to determine where the new canvas area will be added. Leaving the square in the middle will mean the new canvas area will be added evenly surrounding the current image area.

You can either select the color that will be used to fill the new canvas area by choosing a new background color before starting the Canvas Size feature, or by selecting a Canvas Extension Color option from the drop-down menu at the bottom of the dialog.

Caption, adding to multiple files

Menu: Photo Browser: Edit > Add Caption to Selected Items
Shortcut: Ctrl Shft T **OS:** Windows
Version: 4 **See also:** Captions

Captions are extra pieces of descriptive text that are stored with the photo and can be used by the Find command to help locate individual files. In addition, the captions you add to images can be utilized instead of file names as picture titles or descriptions in many Elements' Photo Creations projects.

In version 4.0 of the program it is possible to add the same caption to multiple photos in one easy step. Once the photos are multi selected in the Photo Browser workspace choose the Add Caption to Selected Items from the right-click menu.

Add the caption text in the dialog that is displayed. Click the OK button to apply the caption to the selected photos.

The Add Caption to Selected Items dialog also contains the option to Replace Existing Captions (1) with the newly added text. Leave this option unchecked if you wish to add the new caption to those that are already associated with individual photos.

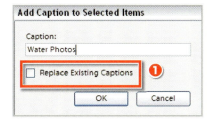

Multi-select images in the Photo Browser workspace and then choose the Add Caption to Selected Items option from the right-click menu.

Type the new caption into the dialog that pops up leaving the Replace Existing Captions option unchecked. Click OK.

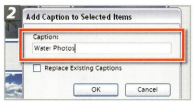

To view the newly added caption select Window > Properties to display the Properties pane.

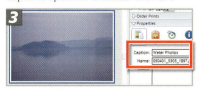

To add specific captions to individual photos simply select the thumbnail and then choose the Add Caption option from the right-click menu. The existing caption will be displayed in the dialog allowing you to replace or add to this description.

28

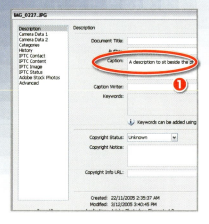

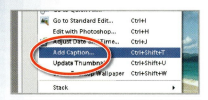

Caption, description field renamed

Menu:	Editor: File > File Info
	Photo Browser: Window > Properties
Shortcut: Photo Browser - Alt Enter	**OS:** Windows
Version: 4	**See also:** Captions

The Description field in the File Info dialog box in the version 3.0 Editor workspace has been renamed Caption in version 4.0 of the program.

Making this change means that the same terminology is now used in the Organizer and Editor workspaces for this type of metadata.

You can view the Caption data by selecting Editor: File > File Info (1) or Photo Browser: Window > Properties – General section (2).

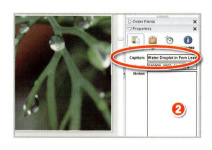

Captions

| **Menu:** Photo Browser: Edit > Add Caption |
| **Shortcut:** Ctrl Shft T | **OS:** Windows |
| **Version:** 3, 4 | **See also:** Tags, Keywords |

Captions are another way to 'title' your photos beyond the standard file name. In Photoshop Elements 4.0 and 3.0 for Windows they can be added and used in a range of different ways.

Adding a Caption – Captions can be added in the Single Photo View of the Photo Browser, the Properties Pane, via the Add Caption command or in the Caption field in the Date View.

Using a Caption – Captions can be used, printed or displayed, in photo creations, web photo galleries as well as on contact sheets.

> **Pro's Tip**
> Captions need to be added to photos before this text can be used as part of the layout in creations.

Card, greetings

| **Menu:** Photo Creation: Card |
Shortcut: -	**OS:** Windows
	Photo Creations,
Version: 3.0	**See also:** Photo Greetings Card,
	4-Fold Greeting Card

Creating greetings or birthday cards customized with your own pictures and heartfelt message is a good way to make the card-giving experience a little more personal.

The Photo Creations Card project in Elements 3.0 contains many different styles ranging from formal, season's greetings, valentine and baby cards. Most have decorative borders, appropriate color schemes and places for you to add your message. But the best part of this feature is the way that the front and inside faces of the project are automatically rotated and arranged so that when it is printed, the card is ready for folding. No more having to turn the paper around to print on the opposite side or having to guess which way to rotate the inside face to ensure it ends up the right way.

This project is called the 4-Fold Greeting Card in version 4.0.

Select the picture you want to feature on the card from the Photo Browser. Select the Card option from the Photo Creations and pick a card style from the template thumbnails on the right of the screen.

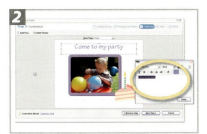

Swap any images that you want to remove from the card and then add a text message to the inside and a title to the outside of the card. Double-click on the writing in the text window to select it before changing the font, size or color to suit.

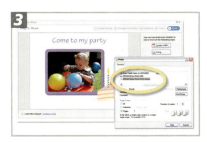

Save the card project, for editing again later if necessary, and then choose to print, e-mail your finished card or even create a PDF file of the project.
Unlike the standard Save As command, when you save (or resave) a photo creation project after making some changes, including changing the name, the action will overwrite the original.

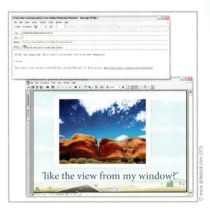

Card, postcard

Menu: Photo Creation: Postcard	
Shortcut: -	**OS:** Windows
Version: 3	**See also:** Photo Creations, Photo Greetings card

The Photo Creations Postcard project provides you with a quick and easy alternative to manually constructing a picture postcard for printing or e-mailing.

This approach also has the advantage of being able to select from a range of predesigned styles as well as the ability to output the final card to print, e-mail or PDF.

As with most Photo Creations projects, if you are unhappy with your choice of photos then you can substitute a different picture for the one that you have selected using the Add or Remove Photos buttons.

This project is called the Photo Greeting Card in Elements 4.0 and includes an online printing option. This is not a traditional postcard with space for printing on both sides of the card and the option for mailing without an envelope.

Cascade windows

Menu: Editor: Window > Images > Cascade	
Shortcut: -	**OS:** Mac, Windows
Version: 2, 3, 4	**See also:** Tile, Match Zoom, Match Location

Photoshop Elements provides a range of ways to view the pictures that are currently open in the Standard Editor workspace.

Cascade windows (Window > Images > Cascade) is one of these options. In this viewing mode pictures are stacked and overlapped from the top left to the bottom right of the screen.

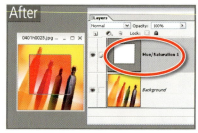

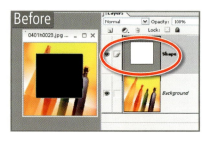

Before

After

Catalog

Menu: Photo Browser: File > Catalog	
Shortcut: Ctrl Shft C	**OS:** Windows
Version: 3	**See also:** Photo Browser

When you import pictures (and other media files) into the Photo Browser of Photoshop Elements 4.0 and 3.0 for Windows the program creates a database of the images and their details. As well as storing thumbnails of the original photographs (for displaying in the browser) the database also holds information such as where the photo is located, what format it is in, the date the picture was taken and what tags or keywords are attached to it.

The database that Elements creates is called a Catalog and is used by the program to track and help organize your files. A new catalog is automatically created when you first install Photoshop Elements. Any pictures added to the program from that time forward are organized in this default catalog.

New catalogs can be created from either the Photo Browser or Date View work-spaces by selecting File > Catalog, clicking the New option, choosing a location for the file and then adding a new catalog name.

This dialog also contains the option to repair or recover a damaged catalog. Select this feature when catalog information is lost or damaged due to power failure during a cataloging operation.

Chalk & Charcoal filter

Menu: Editor: Filter > Sketch > Chalk & Charcoal filter	
Shortcut: -	**OS:** Mac, Windows
Version: 1, 2, 3, 4	**See also:** Charcoal filter

The Chalk & Charcoal filter is one of several drawing-like filters that can be found in the Sketch section of the Filter menu in Photoshop Elements. The feature simulates the effect of making a drawing of the photograph with white chalk and black charcoal. The tones in the photograph that range from shadow to mid gray are replaced by the charcoal strokes and those lighter values (from mid gray to white) are 'drawn' in using the chalk color.

The filter dialog gives you control over the balance of the amount and placement of the charcoal and chalk areas as well as the pressure of the stroke used to draw the picture. Higher values for the Charcoal (1) and Chalk (2) area sliders will increase the number and variations of tones that are drawn with these colors. High settings for the Stroke Pressure slider (3) produce crisper transitions between tones and a more contrasty result.

Pro's Tip

To add a little more color to your Chalk and Charcoal 'drawings' select colors other than black and white for the foreground and background values. Click each swatch to open the color picker where you can select the new hue.

Change Layer Content

Menu: Editor: Layer > Change Layer Content	
Shortcut: -	**OS:** Mac, Windows
Version: 3, 4	**See also:** Layer Content Options

The type of adjustment, shape or fill layer can be changed at any time by selecting the Layer > Change Layer Content option and selecting a new layer type. Rather than adding a new layer to the stack this feature is used to change the nature of layers that already exist.

In the example, a Rectangular Shape layer has been changed to a Hue/Saturation adjustment layer. Notice that the rectangular shape remains, but rather than the rectangle being filled with a solid color it now outlines an area of Hue/Saturation adjustment.

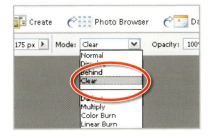

Charcoal filter

Menu: Editor: Filter > Sketch > Charcoal
Shortcut: - **OS:** Mac, Windows
Version: 1, 2, 3, 4 **See also:** Chalk & Charcoal filter

Giving similarly textured results to the Chalk & Charcoal filter, the straight Charcoal filter makes use of only one drawing tone to create the sketching effect.

Three sliders control the appearance of the final result. Charcoal Thickness (1) adjusts the density of the drawn areas whereas the Detail slider (2) adjusts the level of detail that is retained from the original picture. Care should be taken with the settings used for the Light/Dark Balance slider (3) to ensure that some shadow and highlight detail is retained.

Chrome filter

Menu: Editor: Filter > Sketch > Chrome
Shortcut: - **OS:** Mac, Windows
Version: 1, 2, 3, 4 **See also:** -

The Chrome filter is another Sketch filter designed to change the appearance of your picture so that it looks like it is created from another surface. In this case the filter converts the detail of the picture to simulate the look of polished chrome.

During the transformation you have control over both the detail (1) that is retained in the filter photo as well as the smoothness (2) of the chromed surface.

In some instances a further levels enhancement to increase the contrast of the final filtered picture will help produce brighter highlights on the silvered surface.

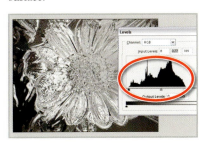

Clear blending mode

Menu: -
Shortcut: - **OS:** Mac, Windows
Version: 3, 4 **See also:** -

The Clear blend mode that is available for the painting and drawing tools in Photoshop Elements removes the image pixels from the layer, converting the area to transparent. For instance, when the Brush is set to Clear mode it acts in a similar way to the Eraser tool.

For the Clear mode to be available in the blend mode menu of the options bar, the layer's Transparency Lock must not be selected and the layer itself cannot be a background layer.

Before

After

Clear, memory

Menu: Editor: Edit > Clear	
Shortcut: -	**OS:** Mac, Windows
Version: 3, 4	**See also:** Purge, Scratch Disks, Memory & Image Cache

Starting life in previous versions of Elements as the Edit > Purge command, the Clear feature removes various stored images and data from the computer's short-term or RAM memory. Clearing the memory space taken up by the Undo History steps and anything currently stored in the Clipboard will provide more memory for Elements to use for processing.

With general editing and enhancement tasks on moderately sized pictures there is little need to regularly clear the computer's memory. But if you are applying complex changes to a large file, or if you don't have much RAM installed on your computer, then freeing up the memory will help make editing operations run faster.

The Edit > Clear menu contains the following options:

Undo History – This selection clears all the History steps currently stored in Memory.

Clipboard Contents – Choosing this option will clear any images stored in the Clipboard memory space.

All – The All option clears both the Undo History and Clipboard Contents.

Clipboard

Menu: -	
Shortcut: -	**OS:** Mac, Windows
Version: 1, 2, 3, 4	**See also:** Clear

The Clipboard is a part of the computer's memory that is allocated to storing information that is copied and pasted.

In Photoshop Elements the Clipboard memory space is used every time you select a picture part, copy it and paste it back down as a new layer. During this process the copied image is stored on the Clipboard and remains there until it is replaced by a new copied part or is deleted using the Clear command. Clear the Clipboard if you regularly copy large pictures, or find that you are always low on memory. Whenever possible drag and drop picture elements from one document to another instead of using Copy and Paste as dragging does not store anything on the clipboard.

Clone Stamp tool

Menu: -	
Shortcut: S	**OS:** Mac, Windows
Version: 1, 2, 3, 4	**See also:** Pattern Stamp Tool, Spot Healing Brush, Healing Brush Tool

Scanning your prints or negatives is a great way to convert existing pictures into digital, but sometimes during the process you pick up a few unwanted dust marks as well as the picture details.

Or maybe when you photographed your mother you did not realize that the electricity pole in the background would look like it is protruding from her head in your picture. Removing or changing these parts of an image is a basic skill needed by all digital photographers and Photoshop Elements contains just the tool to help eliminate these unwanted areas.

Called the Clone Stamp tool (or sometimes the Rubber Stamp tool), the feature selects and samples an area of your picture and then uses these pixels to paint over the offending marks. It takes a little getting used to but as your confidence grows so too will the quality of your repairs and changes.

Pro's Tip

1. Make sure that you select the layer that you want to clone from, before using Alt/Option + Click to select the sample point.

2. Alternatively, if you want to sample from all the image layers in the picture select the Use All Layers option in the tool's options bar.

3. Watch the cursor move over the sampled area as you clone. To avoid unexpected results be sure that the sample cursor doesn't move into unwanted parts of the picture.

The Clone Stamp tool works by sampling a selected area and pasting the characteristics of this area over the blemish, so the first step in the process is to identify the areas in your picture that need repair. Make sure that the image layer you want to copy is selected.

Next, locate areas in the photograph that are a similar tone, texture and color as the areas needing to be fixed. It is these areas that the Clone Stamp tool will copy and then use to paint over fence wires.

Select the area to be sampled, or the 'Sample Point'. Do this by holding down the Alt key (Win) or the Option key (Mac) and clicking the left mouse button when the cursor (now changed to cross hairs) is over a part of the image that suits the area to be repaired.

32
c

With the sample point selected you can now move the cursor to the area to be fixed. Click on the blemish and a copy of the sample point area is pasted over the mark. Depending on how well you chose the sample area, the blemish will now be blended into the background seamlessly. Continue to click and drag to repair more areas.

Pro tip: If the area to be fixed is lighter than the sample point (as in this example), you can also use the Darken blending mode. If vice versa, use Lighten blending mode.

You may need to reselect your sample point if you find that the color, texture or tone doesn't match the surrounds of the blemish. You can also change the brush size and hardness to alter the characteristics of both the sample and stamp areas. A softer edge helps blend the edge areas of the newly painted parts of the picture with the original image.

Switching between aligned and non-aligned (when the Aligned option is not selected) can really help when you are rebuilding missing parts of your restoration project. 'Aligned' sets the sample point so that it remains the same distance from the stamped area no matter where on the picture you start to click, and 'Non-aligned' repositions the sample point back to the original sample spot each time the mouse is moved and then clicked.

Close, Close All

Menu:	Editor: File > Close
	Editor: File > Close All
Shortcut:	Ctrl W **OS:** Mac, Windows
	Shft Ctrl W
Version:	1, 2, 3, 4 **See also:** -

To close a single open file from the Editor workspace select File > Close. To close multiple open picture windows, select File > Close All. The Close All command is not supported in Quick Fix editing workspace.

Clouds filter

Menu:	Editor: Filter > Render > Clouds
Shortcut:	- **OS:** Mac, Windows
Version:	1, 2, 3, 4 **See also:** -

The Clouds filter is one of the options in the Render group of filters. The feature creates a random cloud-like pattern based on the currently selected foreground and background colors. Apart from altering these colors there are no other options for adjusting the effect created by this filter.

Collections

Menu:	Photo Browser: Right-Click > Add to Collection
Shortcut:	- **OS:** Windows
Version:	3, 4 **See also:** Collection Group,
	Collections pane

A collection is another way that you can order and sort your photos. After creating a collection you drag selected images from the Photo Browser to the Collection Pane, or vice versa, where they can be used to make a new Photo Creation project or displayed using the Photo Review feature. Photos from the organizer workspace can be added directly to any collection by right-clicking and selecting Add to Collection from the pop-up menu.

Unlike when working with Tags, pictures grouped in a collection are numbered and can be sequenced. You can reorder photos in a collection by Dragging & Dropping. The same photo can be a part of several different collections.

When adding your photos to a collection you are not duplicating these photos but rather adding the pictures to a visual list of the group's contents. In this way, only one copy of the original photo is stored on the computer, but it can be viewed and used in many ways.

Pro's Tip

1. To quickly add photos to a collection, drag the collection onto the photos.

2. To quickly view all the pictures contained in a collection click the check box next to the collection.

Collection Group

Menu: -	
Shortcut: -	**OS:** Windows
Version: 3, 4	**See also:** Collections

Different collections (and the photos they contain) can be organized into groups that have a common interest or theme. For instance, collections that contain pictures of the kids, family vacations, birthday parties and mother and father's days events can all be collated under a single 'Family' collection group heading.

• • • • • • • • • • • • • • • • • • • •

Collections, order

Menu: -	
Shortcut: -	**OS:** Mac, Windows
Version: 3, 4	**See also:** Collections

Unlike Tagged photos the pictures in a collection have a specific order. Images can be click-dragged around the collection to alter their position in the sequence and the number in the top left of the thumbnail represents the position of the photo in this sequence.

When the images in a collection are used in a Photo Creation the picture order is used to sequence the images in the project.

To make a new collection click on the New button in the Collections pane and select the New Collection menu item.

In the Create Collection dialog choose the group that the new collection will belong to, add the name and include any explanation details for the group. Click OK.

Select the photos to be included in the collection in the Photo Browser and drag them to the collection heading in the Collections pane.

To view all the pictures contained in a collection double-click on the Collection heading in the Collections pane.

Single photos or even groups of pictures can be added to more than one collection at a time by multi-selecting the collection names first before dragging the images to the pane.

• • • • • • • • • • • • • • • • • • • •

Collections pane

Menu: -	
Shortcut: -	**OS:** Mac, Windows
Version: 3, 4	**See also:** Collections

The Collections pane is the pivot point for all your collection activities. Here you can view, create, rename and delete collections. If the pane is not displayed in the Photo Browser workspace then click the Organize Bin at the bottom right of the browser and then choose the Collections tab.

34

Most black and white photographs will need to be changed to RGB mode for this technique (Image > Mode > RGB Color). Now click on the foreground swatch in the toolbox and select a color appropriate for your picture. Here I chose a dark green for the leaves.

Color, Quick Fix Editor

Menu: Photo Browser: Edit > Go to Quick Fix	
Shortcut: -	**OS:** Mac, Windows
Version: 3, 4	**See also:** Quick Fix Editor, Hue/Saturation

The Quick Fix Editor provides a series of one-click or semi-automatic fixes for common problems with lighting, contrast, color and sharpness. All the controls are contained in the one screen for speed and ease of use.

One set of controls is designed specifically for Color adjustment. Apart from the Auto button which provides a single step color balance operation similar to Enhance > Auto Color Correction, the dialog also contains two sets of sliders, one for Hue/Saturation adjustment (1) and one used for white balance control (2).

Use the uppermost sliders for changes that are similar to those obtained with the Hue/Saturation feature. The Temperature and Tint controls provide fine-tuning for the white balance or for removing the color cast from digital photographs.

Color blending mode

Menu: -	
Shortcut: -	**OS:** Mac, Windows
Version: 1, 2, 3, 4	**See also:** Blending Modes

The Color option is one of the many blend modes that can be set for both layers and painting/drawing tools in Photoshop Elements.

This mode is particularly useful when creating traditional hand coloring effects (adding color to a black and white picture). Unlike when working with the normal mode, where the color applied by the brush paints over (and replaces) the original color and detail of the photo beneath, the Color mode maintains the detail and replaces the color only.

1. Zoom in close and then change your brush's size and edge softness to get into those small and tricky areas of your picture.

2. If you accidentally paint into an area with the wrong color, don't panic. Either use the Edit > Undo command or reselect the surrounding color using the Eyedropper tool and then paint over the mistake.

Select the Brush tool from the toolbox and adjust its size and edge softness using the settings in the options bar. Change the blend mode to Color by clicking on the Mode drop-down menu in the options bar and selecting the Color option from towards the bottom of the list.

Now apply the color and notice that the brush is substituting the color for the gray tones in the picture and it is doing so proportionately: dark gray = dark green, light gray = light green. Once the leaves and stems have been colored, select new colors for the flowers and finally the bucket.

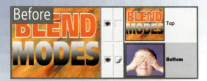

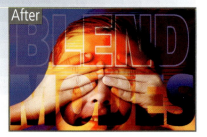

© www.abestock.com 2005

In Photoshop Elements 4.0 and 3.0 you can open, convert from RAW, edit and enhance 16-bit or high-bit files. The feature set that can be used with this high quality file type is limited but wherever possible you should make image changes in this mode before converting to 8-bit mode for final enhancements.

Color Burn blending mode

Menu:	-	
Shortcut:	-	OS: Mac, Windows
Version:	1, 2, 3, 4	See also: Blend modes

The Color Burn blending mode is one of the group of modes that darken the picture.

Here, when the upper layer is changed to the Color Burn mode, its content is used to darken the bottom layer and in the process mirror the color of the upper layer. Blending with a white upper layer produces no change.

Color Cast, removal

Menu:	Editor: Enhance > Adjust Color > Remove Color Cast	
Shortcut:	-	OS: Mac, Windows
Version:	2, 3, 4	See also: Color Variations

Photographing under a range of mixed lighting conditions can cause your pictures to have a strange color cast. Removing this tint is the job of the Remove Color Cast feature, designed to be used with images that have areas that are meant to be white, gray or black.

After selecting the feature you then use the Eyedropper tool (1) to click onto the neutral area and all the colors of the image will be changed by the amount needed to make the area free from color casts. All the other colors in the picture follow suit, creating a cast-free photograph.

This command works particularly well if you happen to have a white, gray or black in your scene. Some image makers include a gray card in the corner of scenes that they know are going to produce casts in anticipation of using Color Cast to neutralize the hues later.

Color depth

Menu:	-	
Shortcut:	-	OS: Mac, Windows
Version:	1, 2, 3, 4	See also: Mode, Convert to 8 Bits

Each digital file you create (photograph or scan) is capable of representing a specific number of colors. This capability, usually referred to as the 'mode' or 'color depth' of the picture, is expressed in terms of the number of 'bits'.

Most images these days are created in 24-bit mode. This means that each of the three color channels (red, green and blue) is capable of displaying 256 levels of color (or 8-bits) each. When the channels are combined, a 24-bit image can contain a staggering 16.7 million discrete tones/hues.

This is a vast amount of colors and would be seemingly more than we could ever need, see, or print, but many modern cameras and scanners are now capable of capturing up to 16-bits per channel or 'high-bit' capture. This means that each of the three colors can have up to 65,536 different levels and the image itself a whopping 281,474,976 million colors (last time I counted!).

Versions 1.0 and 2.0 of Photoshop Elements were only capable of supporting 8-bit files, but in versions 4.0 and 3.0 of the program you can now open and edit (in a limited way) 16-bit files. Editing pictures in 16-bit or high-bit mode provides far better results (smoother and with more detail) than manipulation in 8-bit. Where possible perform all editing in 16-bit mode.

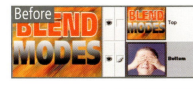

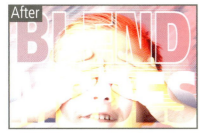

Color Dodge blending mode

Menu: -	
Shortcut: -	**OS:** Mac, Windows
Version: 1, 2, 3, 4	**See also:** Blend modes

The Color Dodge blending mode is one of the group of modes that lighten the picture.

When the top layer is changed to the Color Dodge mode, its content is used to lighten the bottom layer in a dodging fashion. In the process, the bottom layer's color mirrors that of the upper layer.

Blending with a black upper layer produces no change.

Color Halftone filter

Menu: Editor: Filter > Pixelate > Color Halftone	
Shortcut: -	**OS:** Mac, Windows
Version: 1, 2, 3, 4	**See also:** -

The Color Halftone filter replicates the look of the CMYK (Cyan, Magenta, Yellow and Black) printing process. The photograph is broken into the four colors and the tone for each of the colors represented by a series of dots. Where the color is strongest the dots are bigger and can even join up. In the lighter tones the dots are small and are surrounded by large areas of white paper.

The controls in the filter dialog are separated into two sections – the size of the dot that makes up the screen (1) and the angle that each of the color screens will be applied (2). In practice the best results are obtained when the dot size is altered and the screen angle left alone.

Color Halftone is one of the Pixelate group of filters.

Color modes

Menu: Editor: Image > Mode	
Shortcut: -	**OS:** Mac, Windows
Version: 1, 2, 3, 4	**See also:** Color depth, Bitmap

Photoshop Elements can create, edit and convert images to and from several different color modes. The mode of a picture document determines the maximum number of colors that can be stored in the file and this in turn affects the size of the file. Generally speaking more colors means a larger file size.

The mode options available in Photoshop Elements are listed under the Image > Mode menu. They are:

Bitmap – Can only contain black and white colors.

Grayscale – Supports up to 256 levels of gray including black and white. The Grayscale mode can support 16-bit color depth.

Indexed Color – Can contain up to 256 different colors and is the default color mode for the GIF file format.

RGB Color – This is the default mode for all photos in Elements. It is an 8-bit color mode which means that it can support 256 levels of color in Red, Green and Blue channels, giving a combined maximum total number of hues possible as over 16 million. Colors in this mode are described by three numbers representing the red, green and blue value of the individual pixel. The RGB color modes can support 16-bit color depth.

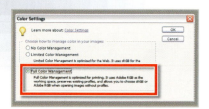

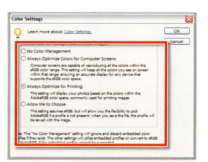

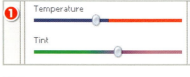

Color Settings, 2.0/3.0

Menu: Editor: Edit > Color Settings
Shortcut: Shft Ctrl K **OS:** Mac, Windows
Version: 2.0, 3.0 **See also:** –

Good color management is the foundation of consistent color from the time of capture (photographing or scanning) through editing and enhancement tasks and finally to printing. Establishing a workflow that understands the capabilities and limitations of each of the devices in this production process is key to setting up a color-managed system. For this reason professionals use an ICC (International Color Consortium) profile-based system to manage the color in their pictures.

Photoshop Elements offers three options for color management – No Color Management, Limited Color Management and Full Color Management. Users can nominate the option that they wish to use for an editing session by clicking on a radio button in the Color Settings dialog (Edit > Color Settings).

To use a fully managed workflow which understands the characteristics of cameras, scanners and printers you should pick the 'Full Color Management' option as this is the only choice that makes use of a complete ICC profile workflow throughout.

To ensure that you get the benefits of color management at home, be sure to turn on color management features for your camera, scanner, monitor, software and printer.
Always tag your files as you capture them and then use this profile to help keep color consistency as you edit, output and share your work.

Color Settings, 4.0

Menu: Editor: Edit > Color Settings
Shortcut: Shft Ctrl K **OS:** Windows
Version: 4 **See also:** AdobeRGB, sRGB, Assign Profile, Convert to Profile

In Elements 4.0 Adobe has completely revamped the color-management system to make it easier to understand and more logical to use. You now have four options to choose from in the Color Settings dialog.

No Color Management – This option leaves your image untagged, deletes attached profiles when opening images and doesn't add a profile when saving.

Always Optimize Colors For Computer Screens – Attaches sRGB to photos without a profile and uses sRGB as the working space, but maintains any attached profiles when opening images.

Always Optimize For Printing – Attaches AdobeRGB to photos without a profile and uses AdobeRGB as the working space, but maintains any attached profiles when opening images.

Allow Me To Choose – Maintains all attached profiles, but allows the user to choose between sRGB and AdobeRGB when opening untagged files (Editor workspace only).

In addition to these settings changes version 4.0 also includes the ability to change the profile attached to your photo or even remove it totally.

To ensure that Elements is operating with a color-managed workflow think about how you would normally view your work and then choose between Screen Optimized and Print Optimized options. If alternatively you need image-by-image control then select the 'Allow Me To Choose' setting.

Color temperature

Menu: -
Shortcut: - **OS:** -
Version: - **See also:** Remove Color Cast, Color Variations, Quick Fix Editor, RAW Editor

Color temperature refers to the color of the lighting used to illuminate your photos. Most digital cameras have a range of Color Temperature or White Balance settings designed to accommodate changing lighting conditions.

Matching your camera's setting to the light source in the picture will help ensure that the photograph is recorded without a color cast. Alternatively, some cameras have an auto white balance option that attempts to match the light source and the way that the sensor records to obtain neutral cast-free pictures.

Photoshop Elements also has Color Temperature sliders in both the Color section of the Quick Fix Editor (1) and the White Balance part of the RAW Editor (2). Both these features are designed to correct imbalances between light source and sensor settings at the time of capture.

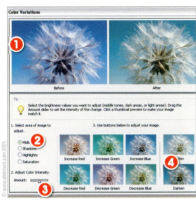

Color Variations

Menu: Enhance > Adjust Color > Color Variations	
Shortcut: -	**OS:** Mac, Windows
Version: 2, 3, 4	**See also:** Remove Color Cast

An alternative to using the Remove Color Cast feature for neutralizing tints in your pictures is the Color Variations command.

The feature is divided into four parts.

The top of the dialog contains two thumbnails (1) that represent how the image looked before changes and its appearance after.

The radio buttons (2) allow the user to select the parts of the image they wish to alter. In this way, highlights, midtones and shadows can all be adjusted independently.

The Amount slider (3) controls the strength of the color changes. The final part (4) is taken up with six color and two brightness preview images. These represent how your picture will look with specific colors added or when the picture is brightened or darkened.

Clicking on any of the thumbnails will change the 'after' picture by adding the color chosen. To add a color to your image, click on a suitably colored thumbnail. To remove a color, click on its opposite.

As well as providing a method for neutralizing unwanted color casts the Color Variations option can also be used to add tints to monochromes. In a technique that is reminiscent of traditional print toning you can use the feature to split tone shadow and highlights with different colors. See the step by step for details.

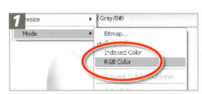

Most black and white photographs will need to be changed to RGB mode for this technique (Image > Mode > RGB Color). If you are starting with a colored photo convert it to a monochrome using the Enhance > Adjust Color > Remove Color command.

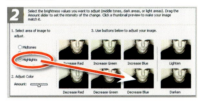

Next select the Color Variations option from the Enhance > Adjust Color menu. Check the Highlights option in the dialog and then click on the thumbnail for the color to apply to these tones. In the example the highlights have been colored yellow (Decrease Blue).

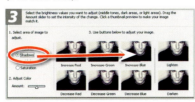

Without closing the Color Variations dialog now check the Shadows option and add a different color to these image tones. In the example the shadows were colored blue by clicking the Increase Blue thumbnail repeatedly. Click OK to apply the split toning changes.

Colored Pencil filter

Menu: Editor: Filter > Artistic > Colored Pencil	
Shortcut: -	**OS:** Mac, Windows
Version: 1, 2, 3, 4	**See also:** -

The Colored Pencil filter is one of the options in the Artistic group of filters. The feature creates a drawn version of the photograph simulating the effect of colored pencils. The detail in the image is retained and different tones are created using crosshatching.

Three slider controls can be found in the filter dialog. The Pencil Width (1) controls the bands of drawn color that replicate the picture's detail; the Stroke Pressure (2) adjusts the amount of color laid down on the paper surface; and the Paper Brightness (3) determines the tone of the paper the pencil is drawn on (from black to white).

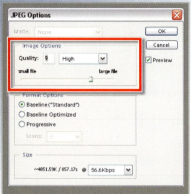

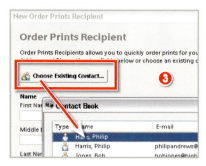

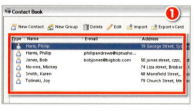

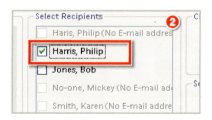

The Options dialog box for the lossy JPEG file format provides a slider control that moves between the two extremes of small file with least image quality and large file with best image quality.

Compression

Menu: -	
Shortcut: -	OS: Mac, Windows
Version: 1, 2, 3, 4	See also: JPEG format, JPEG2000, TIFF

The files that hold our digital pictures store information about the color, brightness and position of the pixels that make up the image. As the resolution and color depth of pictures increase so too does the file itself. Some of the more recently released cameras are capable of capturing pictures with file sizes beyond 20Mb each.

Large files like these take up a lot of storage room and are impossible to e-mail. For this reason a lot of photographers shrink their files by applying a form of compression to their pictures. Compression is a system that reorders and rationalizes the way in which the information is stored. The result is a file that is optimized and therefore reduced in size.

There are two different types of compression possible:

Lossy – This compression type is capable of shrinking files to very small sizes (file size can be reduced to as little as 1% of the original) but loses picture detail in the process. The JPEG file format uses this type of compression.

Lossless – The lossless approach maintains all the detail of the original but optimizes the file and can reduce file sizes by up to 40%. The TIFF file format is an example of a file format that uses this compression.

The JPEG 2000 format supports both Lossless and Lossy compression.

Good compression comes from lossy storage of the image, but images which retain all their original quality are only possible via lossless systems.

Connect to Camera or Scanner

Menu: Welcome Screen: Connect to Camera or Scanner (Mac)	
Shortcut: –	OS: Mac
Version: 3	See also: –

The Connect to Camera or Scanner option is located on the Welcome Screen for the Macintosh version of Elements 3.0 (1).

When selected, the option displays the Select Import Source dialog (2). Using the drop-down Import menu you can choose any cameras or scanners that are connected and installed on your computer. This will open the driver or download software for the device which can be used to download pictures from the camera or scan originals using a scanner.

Constrain Proportions

Menu: Editor: Image > Resize > Image Size	
Shortcut: -	OS: Mac, Windows
Version: 1, 2, 3	See also: Aspect ratio

When the Constrain Proportions option in the Image Size dialog is selected any changes will maintain the proportions of the photo's sides. Keeping the sides of a picture in proportion when changing size is also called Maintaining the Aspect Ratio of the picture.

This option should always be selected unless you intentionally wish to squash or stretch the photo.

Contact Book

Menu: Photo Browser: Edit > Contact Book	
Shortcut: -	OS: Windows
Version: 4	See also: Contact Book auto populate

The Elements' Contact Book first introduced in version 4.0 is a key component of the e-mail and sharing features in the program. Like similar features in other e-mail programs the Contact Book is a place to store names, postal addresses, phone numbers and e-mail addresses for all your friends and relatives.

Contacts are added, grouped, edited, imported and exported via the Contact Book dialog (1) which is displayed after selecting Edit > Contact Book from inside the Photo Browser workspace.

Contacts can be added manually by inputting all the details or imported automatically from existing sources of details such as Microsoft Outlook.

Contacts listed in the Contact book can be used as E-mail (2) or Order Prints (3) recipients. Simply select the correct recipient from the list in the feature's dialog or click the Choose Existing Contact button.

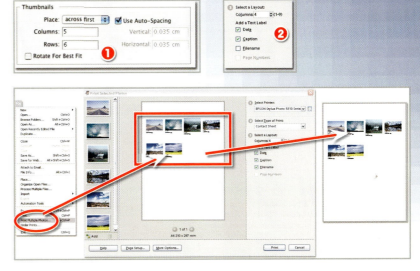

Contact Book, auto populate

Menu: Photo Browser: Edit > Contact Book	
Shortcut: -	**OS:** Windows
Version: 4	**See also:** Contact Book

To save the hassle of having to reinput all of your contacts into the Elements Contact Book, Adobe provides an Import option that is available inside the Contact Book dialog. The next step after clicking the Import button is to select the source of the contacts. Elements will list all sources that support the vCard format and are currently installed on your computer in a single dialog ready for you to choose. After clicking the correct Contact Source select the OK button to add the contacts to your Elements' book.

This process is also called Auto Populating the book.

Contact Book, export

Menu: Photo Browser: Edit > Contact Book	
Shortcut: -	**OS:** Windows
Version: 4	**See also:** Contact Book

The Export vCard option (1) in the Elements Contact Book allows you to save contact details in the cross-application vCard format (2).

Contact Sheet

Menu: Editor: File > Print Multiple Photos	
	Editor: File > Contact Sheet II (Mac)
	Photo Browser: File > Print
Shortcut: -	**OS:** Mac, Windows
Version: 1, 2, 3, 4	**See also:** Print, Print Multiple Photos

The Contact Sheet option creates a series of small thumbnail versions of all the images in a catalog or those that were multi-selected before opening the tool.

These small pictures are arranged on pages and can be labeled with file name, captions and dates. Once created it is an easy task to print a series of these contact sheets that can be kept as a permanent record of a folder's images. The job of selecting the best pictures to manipulate and print can then be made with hard copies of your photos without having to spend the time and money outputing every image to be considered.

The feature can be accessed via the Print options in the Organizer or Editor workspaces.

The options contained within the Contact Sheet dialog allow the user to select the number of columns of image thumbnails and the content of the text labels that are added. The page size and orientation can be chosen via the Page Setup button. Slightly different options are available in the Mac 3.0 (1) and Windows (2) versions of the feature.

Contact Book, import

See: Contact Book, auto populate

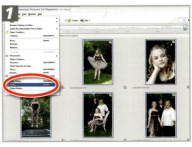

Multi-select the pictures from inside the Photo Browser. Select File > Print and then choose Contact Sheet. Use the Add and Remove Photos buttons to adjust the list of pictures to be included in the contact sheet.

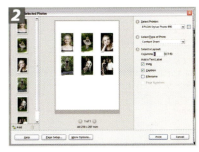

Select the printer from the drop-down list in section one of the dialog. In section two of the dialog select Contact Sheet from the drop-down list of print types. In the final section choose the number of columns to use (and therefore the total number of thumbnails to place on a single sheet) and select the content of the label text to be included. Click Print to output the sheet.

41

C

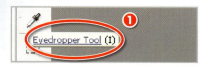

Conté Crayon filter

Menu: Editor: Filter > Sketch > Conté Crayon	
Shortcut: -	**OS:** Mac, Windows
Version: 1, 2, 3, 4	**See also:** -

The Conté Crayon filter is one of the options in the Sketch group of filters. The feature replicates the effect of a traditional conté crayon drawing created with dark and light crayons on a textured paper background. The detail in the image is retained and different tones and colors are created using shaded areas of background and foreground color.

The controls for the filter are divided into two sections – one that controls the interaction of the dark and light tones or picture details (1) and a second that houses sliders and drop-down menus for adjusting the surface texture (2).

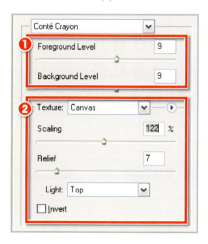

Context help

Menu: -	
Shortcut: -	**OS:** Mac, Windows
Version: 3, 4	**See also:** Context menu

Photoshop Elements versions 3.0 and 4.0 have a sophisticated help system that provides the information you need at the time you need it via a range of context-based help features.

Tool tips – A pop-up that displays the tool's shortcut key, name and link to help page (1).

Feature links – Links placed in the feature's dialog that link directly to help pages (2).

Feature tips – Short descriptive tips placed in the feature's dialog to aid with making decisions (3).

. .

Context menus

Menu: -	
Shortcut: -	**OS:** Mac, Windows
Version: 1, 2, 3, 4	**See also:** Context help

Photoshop Elements contains a context menu system which provides a pop-up menu of options when you right-click (Ctrl-click – Mac) over an image, tool, selection or palette. Context menus are not available for all items in the workspace.

Contiguous option

Menu: -	
Shortcut: -	**OS:** Mac, Windows
Version: 1, 2, 3, 4	**See also:** Magic Wand, Paint Bucket

The Contiguous option is available in tools that base their changes or selection on locating pixels of a specific color in a photo. The option can be found in the option bars of the Magic Wand, the Background Eraser and Paint Bucket tools and controls how the pixels are selected throughout the image.

Choosing Contiguous will restrict the selection to those pixels of the same color that are adjacent to where the tool was first clicked on the image surface (1).

Turn the setting off and the tools will locate similar colored pixels throughout the whole photo irrespective of if they are connected to the pixel first selected (2).

42

Continuous tone

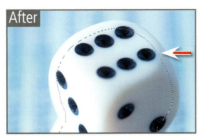
Before

Low contrast

Posterized tone

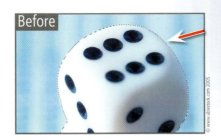
After

High contrast

Continuous tone image

Menu: -	
Shortcut: -	OS: Mac, Windows
Version: 1, 2, 3, 4	See also: Bitmap, Halftone filter

The term Continuous Tone refers to pictures that have a range of tones and colors that move seamlessly from one to another. Traditionally this term was used to describe photographs (black and white or color) and to distinguish them from those images printed in magazines, whose tones are created with a series of dots.

Digital photographs, whether displayed on screen or output in printed form, give the appearance of a continuous tone picture even though the photograph is entirely created of very small blocks called Pixels.

It is important to maintain the appearance of continuous tone in our photographs throughout the editing and enhancement process. Sometimes the extreme correction needed for poorly exposed pictures causes the colors and tones of the photograph to lose the continuous appearance and become posterized.

Contract, selection

Menu: Editor: Select > Modify > Contract	
Shortcut: -	OS: Mac, Windows
Version: 1, 2, 3, 4	See also: Expand

An active selection can be altered and adjusted using the options listed under the Select > Modify menu. One option is the Contract command which reduces the size of the selection by the number of pixels entered into the feature's dialog. If the selection incorporates part of the document edge this part of the marquee will not be changed by the command.

Contrast, image

Menu: -	
Shortcut: -	OS: Mac, Windows
Version: 1, 2, 3, 4	See also: Brightness/Contrast, Levels, Shadows/Highlights, Auto Levels, Auto Contrast

The contrast of a picture refers to how the tones are distributed between black and white points.

A low contrast photograph can appear dull and generally contains no pure black or white points anywhere in the image. A high contrast picture does contain the black and white tones, but in extreme examples, where too much contrast exists, subtle shadow and highlight details disappear as they are represented as either black or white.

Picture contrast can be adjusted in Photoshop Elements by using features such as Auto Levels, Auto Contrast, Brightness/Contrast, Levels and Shadows/Highlights.

Some enhancement techniques make use of certain layer blending modes (e.g., Color Burn, Vivid Light, etc.) to increase contrast of the image.

Convert to Profile

Menu:	Editor: Image > Convert Color Profile	
Shortcut: -	**OS:** Windows	
Version: 4	**See also:**	AdobeRGB, sRGB, Assign Profile, Remove Profile

Selecting one of the options in the Image > Convert Color Profile menu will convert the picture's color to the selected color space.

Elements 4.0 provides the option to convert between two different profiles – sRGB, which is generally used for screen presentations and web work, and AdobeRGB which is the basis of most print work.

The conversion process changes the image's colors as it modifies the picture to fit within the new color space. However, if you press Ctrl when selecting a new profile, it will apply the profile without converting.

This gives the image the appearance that it has been converted but maintains the underlying colors of the original. This option is the same as Photoshop's Assign Profile command.

The Convert Color Profile menu also contains a Remove Profile option which discards the ICC profile currently associated with the open photo.

Convert to 8 Bits/Channel

Menu: Editor: Image > Mode > Convert to 8 Bits/Channel	
Shortcut: -	**OS:** Mac, Windows
Version: 3, 4	**See also:** Eight-bit

Elements 4.0/3.0 contains some features that now work with 16-bit files, but there are other tools and options that can only be applied to an 8-bit file. To use these features you will need to convert your file to 8 bits per channel before accessing the tool.

Open an image to crop and select the Cookie Cutter tool from the toolbox. Click the Shape button in the options bar to reveal the pop-up menu of cookie shapes. Select the shape to use. To soften the edge of the cookie cutter crop, add a Feather value in the options bar.

Cookie Cutter tool

Menu:	-	
Shortcut: Q	**OS:** Mac, Windows	
Version: 3, 4	**See also:** Custom Shape tool	

The new Cookie Cutter tool functions much like a fancy cropping feature, allowing users to remove the edges of their pictures in a range of graphic hard-edged shapes.

The feature works in a very similar way to the Custom Shape tool as it too allows users to select and draw a range of predesigned shapes in the workspace. It is after the drawing step that the two tools differ. The shape drawn with the Cookie Cutter is used to define the edges of the current image. In this way the feature functions as a fancy Crop tool, providing a range of graphic designs that can be used to stamp out the edges of your pictures.

Adding a Feather value via the options bar softens the edge of the crop, producing smoother transitions between the filled shape and the background.

Click and drag the tool over the surface of the picture. Let the mouse button go and click and drag the edge handles to adjust the size of the cookie shape to suit the picture. Double-click inside the cookie shape or click the 'tick' icon in the options bar to apply the crop.

Copy command

Menu: Editor: Edit > Copy
Shortcut: Ctrl C **OS:** Mac, Windows
Version: 1, 2, 3, 4 **See also:** Copy Merged, Paste

Just like other computer software (word processing and spreadsheet software) Photoshop Elements contains the standard Copy and Paste commands. Located under the Edit menu, the Copy option duplicates the contents of the picture content in the current selection and stores it in the Clipboard memory of the computer.

Copying is usually the first step in the process; the next action is usually to paste the picture part into the same or a new document. This step is handled by the Edit > Paste command.

Copy Merged command

Menu: Editor: Edit > Copy Merged
Shortcut: Shft Ctrl C **OS:** Mac, Windows
Version: 2, 3, 4 **See also:** Copy, Paste

Just like the Copy command, the Copy Merged option copies the contents of a selection, but the difference is that this command also copies and merges the content of all the layers within the selected area. This feature is particularly helpful for creating a single layer copy of a multi-layered composition but without merging or flattening the original.

To make a single layer copy of the content of a multi-layered Elements document, without flattening or merging, start by selecting the whole canvas area using Select > All.

Now copy the merged layers using Edit > Copy Merged and then create a new document the size of the copied layers with File > New > Blank File and paste down the merged copy using Edit > Paste.

Craquelure filter

Menu: Filter > Texture > Craquelure
Shortcut: - **OS:** Mac, Windows
Version: 1, 2, 3, 4 **See also:** -

The Craquelure filter is one of the options in the Texture group of filters. The feature creates an effect that looks as if the picture has been created on a surface of cracked mud.

Three slider controls can be found in the Filter dialog. The Crack Spacing (1) controls the distance between crack edges, the Crack Depth (2) adjusts the width of the crack line and its shadow, and the Crack Brightness (3) determines how dominant or strong the crack lines will appear in the final result.

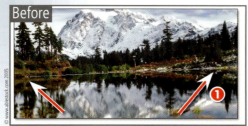

Before

After

Crooked photos, fixing

Menu: -
Shortcut: P **OS:** Windows
Version: 4 **See also:** Straighten and Crop Image

In Elements 4.0 a new tool has been added to the program to help you straighten the horizon lines in your photos. Called the Straighten tool, you can automatically rotate your pictures so that any line is aligned horizontally.

Start by selecting the tool from the toolbar and then click-drag the cursor to draw a line parallel to the picture part that should be horizontal (1).

Once you release the mouse button Elements automatically rotates the photo to ensure that the drawn line (and the associated picture part) is horizontal in the photo.

But don't stop there. This new tool also has the ability to straighten vertically as well. Hold down the Ctrl key while you drag the Straighten tool along a vertical line and then release the mouse button.

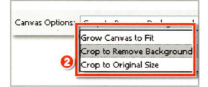

When rotating the image, Elements can handle the resulting crooked edges of the photo in three different ways. The three approaches are listed in the drop-down menu in the options bar (2). They are:

Grow Canvas to Fit – The canvas size is increased to accommodate the rotated picture. With this option you will need to manually remove the crooked edges of the photo with the Crop tool.

Crop to Remove Background – After rotating Elements automatically removes the picture's crooked edges. This results in a photo with smaller dimensions than the original.

Crop to Original Size – The photo is rotated within a canvas that is the size of the original picture. This option creates a photo which contains some edges that are cropped and others that are filled with the canvas color.

Crop command

Menu: Editor: Image > Crop
Shortcut: - **OS:** Mac, Windows
Version: 1, 2, 3, 4 **See also:** Crop tool

An on-the-fly cropping technique that is an alternative to using the Crop tool starts with drawing a regular rectangular selection or marquee to define the size and shape of the crop (1).

Once the area has been selected then the Crop option is chosen from the Image menu (2).

The picture parts outside the selection marquee are removed or cropped.

New in Photoshop Elements 4.0 is the fact that the crop command works even if there is not selection active. Choosing Crop without a selection will place a default crop rectangle centered in the image (3). From there, you can change the Aspect Ratio settings from the menu, input height and width values, and/or rotate the crop.

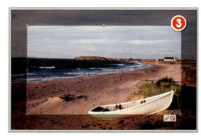

46

Crop confirmation

Menu: -	
Shortcut: -	**OS:** Windows
Version: 4	**See also:** Crop tool, Crop command

Elements 4.0 has a new way to accept the crop you make with the Crop tool. After dragging out the marquee, crop the image by clicking the new green tick button at the bottom right of the marquee.

These new Commit and Cancel buttons replace similar features that sat on the options bar in previous versions of the program.

Crop marks, printing

Menu: Editor: File > Print	
Shortcut: Ctrl P	**OS:** Mac, Windows
Version: 1, 2, 3, 4	**See also:** Print, Borders

One of the many print options available in the Elements' Print Preview dialog is the ability to add crop marks to a print. These vertical and horizontal lines provide a visual indication where the edge of the picture is on the paper.

The crop marks are generally used to aid with trimming the excess paper from the surrounds of the print.

To add crop marks to your print check the Print Crop Marks option in the Print Preview dialog.

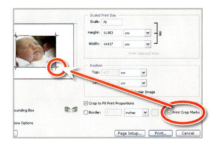

Crop presets

Menu: -	
Shortcut: C	**OS:** Windows
Version: 4	**See also:** Crop tool

The Crop tool options bar in version 4.0 of Elements contains a new setting called Aspect Ratio. The Aspect Ratio drop-down menu contains three different crop types.

No Restriction – This option is the default setting allowing the user to draw crop marquees across the photo surface without constraint.

Use Photo Ratio – With this option the crop format is constrained to the format of the document currently open.

Set Sizes (i.e. 2.5 x 2 inch) – These are a group of preset crop sizes that suit popular print and photograph sizes and formats.

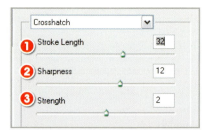

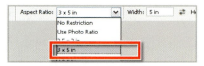

Before

After

To start a new crop select the Crop tool and click-drag a marquee over the parts of the picture you want to keep. You don't have to be exact with this first rectangle as you can adjust the size and shape of the marquee by click-dragging the corner and side handles.

By dragging the cursor whilst it is outside the marquee it can be rotated to crop and straighten at the same time.

Crop tool

Menu: -	
Shortcut: C	**OS:** Windows
Version: 4	**See also:** Crop command

The Crop tool was revamped in Elements 4.0. The Clear option and Front Image button have been removed and the Shield Color and Opacity options are now found in Preferences > Display & Cursors. In version 4.0 with a crop marquee active – either by dragging the tool or choosing the Crop command – you can change the options live to get the results you want. Simply select a new Aspect Ratio setting from the drop-down list. If you choose a preset size (e.g., 5 x 7inches), the tool detects the height and width and places the crop according to the longest side.

Crop tool

Menu: -	
Shortcut: C	**OS:** Mac, Windows
Version: 1, 2, 3, 4	**See also:** Crop command

The act of cropping or removing parts of a picture that are unwanted is a skill that most digital photographers use regularly.

Elements has a specially designed cropping feature called the Crop tool. Cropping is a simple matter of drawing a rectangle around the parts of the picture that you wish to keep, leaving the sections that will be removed outside of the marquee. The areas outside the cropping marquee are shaded a specific color (usually semi-transparent black) to allow the viewer to preview the results of the crop.

To help with fine adjustments the edges and corners of the cropping marquee contain small squares called Handles. The marquee can be resized or reshaped at any time by click-dragging one of the handles. When you are satisfied with your crop you can execute the command by double-clicking your cursor inside the cropping marquee, pushing the Enter key or clicking on the 'tick' in the options bar.

Pro's Tip

1. The settings entered into the width, height and resolution sections of the Crop tool option bar remain until you click the Clear button.

2. If you want the dimensions and resolution of an image to become the settings used to crop a second picture then select the original and click the Front Image button. The picture's characteristics are input into the settings area of the tool ready for the next crop.

To help you preview how your cropped picture will appear, Elements shades the area of the picture that is to be removed. You can alter the color and opacity of this shading (called the Shield) using the settings in the Display & Cursors section of the Preferences. The crop is executed by clicking the 'tick' at the bottom right of the crop marquee.

Extension technique

You can make a crop of a specific size and resolution by adding these values to the options bar before drawing the cropping marquee. Using this feature you can crop and resize in one step.

With the dimensions and resolution values set when you click-drag the Crop tool it will only draw rectangles the size and shape of the values you have entered.

When you execute the crop, Photoshop Elements will automatically crop and resize the picture.

Here we have prepared the image to be printed on a sheet of 10 x 8 inch paper at a resolution of 200 pixels per inch.

Crosshatch filter

Menu: Editor: Filter > Brush strokes > Crosshatch	
Shortcut: -	**OS:** Mac, Windows
Version: 1, 2, 3, 4	**See also:** -

The Crosshatch filter is one of the options in the Brush strokes group of filters. The feature recreates the color and different tones in the picture using crosshatching or a series of overlapping strokes.

Three slider controls can be found in the Filter dialog. The Stroke Length (1) controls the length of the crosshatching stroke; the Sharpness (2) adjusts how crisp the edge of the stroke appears; and the Strength (3) determines how obvious the effect is to the viewer.

Painting cursor – Normal Brush Tip (originally Brush size)

Painting cursor – Full Brush Tip

Painting cursor – Precise

Painting cursor – Standard

Painting cursor – Crosshair in Brush Tip

Other tools – Precise

Other tools – Standard

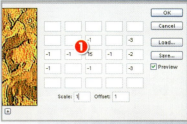

Cursors, tool pointer

Menu: Editor: Edit > Preferences > Display & Cursors	
Shortcut: -	**OS:** Mac, Windows
Version: 1, 2, 3, 4	**See also:** Preferences

The tool pointer or cursor that is displayed when working with Elements tools can be changed to a range of options. Setting up the default pointer style is controlled via the options in the Edit > Preferences > Displays & Cursors dialog. Here you can select from the following cursor options:

Standard – The pointer is displayed as the Tool icon.

Precise – The pointer is displayed as a set of crosshairs.

Brush Size – The pointer is displayed in the size and shape of the current brush tip.

The Caps Lock key switches the cursor between Brush Size and its original setting.

Cursor tips

Menu: Editor: Edit > Preferences > Display & Cursors	
Shortcut: –	**OS:** Windows
Version: 4	**See also:** Preferences

For Elements 4.0 there were changes made to the Cursor settings and two new options added. Brush Size is now called **Normal Brush Tip**. It displays a line at the point where the opacity of a soft brush reaches 50%.

Full Brush Tip displays a line at the point where the opacity of a soft brush extends to 0%. This means for soft brushes you'll see a larger outline.

Finally, there is a checkbox to '**Show Crosshair in Brush Tip**'. This adds a crosshair centered inside either of the brush tip cursors.

Custom filter

Menu: Editor: Filter > Other > Custom	
Shortcut: -	**OS:** Mac, Windows
Version: 1, 2, 3, 4	**See also:** -

The Custom filter is one of the options in the Other group of filters. The feature allows the user to create, save, load and share their own customized filter effects.

The Filter dialog contains a grid of text boxes into which you can enter numbers that will alter the brightness of the pixels that the filter is applied to. Values from −999 to +999 can be entered into any of the boxes. Values don't have to be entered into all boxes.

The central box (1) represents the pixels being evaluated with the values placed in those around the center being adjustments made to the surrounding pixels.

Before

After

c

Custom Shape tool

Menu: -	
Shortcut: U	**OS:** Mac, Windows
Version: 1, 2, 3, 4	**See also:** Shapes

The Custom Shape tool is one of the group of shape tools that includes rectangle, ellipse, rounded rectangle, polygon and line. All these drawing options create hard-edged, or vector-based, graphics.

The Custom Shape tool allows you to draw a variety of pre-made shapes. After selecting the tool and picking the fill color, you can draw the shape by clicking and dragging the mouse. Different shapes can be selected from the drop-down thumbnail list (1) under the Shape preview in the options bar. A new layer is created automatically for each new shape. This layer contains a shape thumbnail and the layer's name.

The tool's options (2) include:

Unconstrained – Set width and height by dragging the mouse.

Defined Proportions – Only allows shape drawings of a specific proportion.

Defined Size – Draws the shape at the size that the shape was initially created.

Fixed Size – The shape is drawn according to the size settings you input.

From Center – Draws the shape from the center outwards rather than from a corner.

Elements comes supplied with a vast range of shapes. New shape sets can be added to those already visible as thumbnails by clicking the side arrow button in the Custom Shape Picker palette.

Cut command

Menu: Editor: Edit > Cut	
Shortcut: Ctrl X	**OS:** Mac, Windows
Version: 1, 2, 3, 4	**See also:** Copy, Paste

As part of the standard editing control group, which also includes the Paste and Copy commands, the Cut option removes image parts to the Clipboard. A selection must be made first before using the command. After cutting the selection, the contents of the selection area are filled with the background color (1) or in the case of cutting a background layer the selection area is filled with transparency.

The picture parts cut to the Clipboard can then be pasted down as a new layer in the same file or used as a basis for the creation of a new document.

With a selection still active, pressing the Delete key will perform the same function as the Edit > Cut command except that using the Cut command will put the image on the Clipboard, whereas pressing the Delete key will not.

Cutout filter

Menu: Editor: Filter > Artistic > Cutout filter	
Shortcut: -	**OS:** Mac, Windows
Version: 1, 2, 3, 4	**See also:** -

The Cutout filter is one of the options in the Artistic group of filters. The feature recreates the tone and shape of the original photo using a series of flat areas of color similar to pieces of 'cutout' paper.

Three slider controls can be found in the Filter dialog. The Number of Levels (1) controls the number of colors in the final result; the Edge Simplicity (2) adjusts how much detail will be in the edge of the flat color areas; and the Edge Fidelity (3) determines how flat, or textured, the edge detail will be.

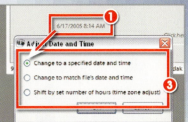

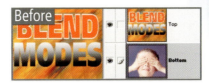

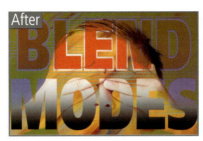

Before

After

Darken blending mode

Menu: -	
Shortcut: -	OS: Mac, Windows
Version: 1, 2, 3, 4	See also: Blend modes

The Darken blending mode is one of the group of modes that darken the picture.

When the top layer is changed to the Darken mode both layers are examined at each part of the picture. When the darkest color is located – it can be from either layer – it is selected as the final color. Next the pixels in the top layer are compared to the final color; if they are lighter then they are replaced, if darker they are left unchanged.

Date, changing

Menu: -	
Shortcut: -	OS: Windows
Version: 4	See also: Date View

In version 3.0 users could change the date associated with the photo by simply clicking on the Date entry that sat beneath the thumbnail in the Photo Browser workspace.

Some photographers found that the convenience of this one-click date change workflow meant that they were inadvertently changing photo dates even when they didn't mean to. So in version 4.0 of the program Adobe changed the process by which you change photo dates.

Now, by default, clicking on the date entry that sits beneath thumbnail (1) won't display a Date Change dialog. This option has to be turned on in the Photo Browser preferences. Navigate to Edit > Preferences > General and select the Adjust Date and Time by Clicking on Thumbnail Dates option (2).

After changing this setting, clicking on the date entry will display the Adjust Date and Time dialog (3). Here you can select how to change the time and date from three different options. To alter the time and date to a particular setting choose the Change to a Specified Date and Time option and click OK. This action displays the Set Date and Time dialog (4) which contains several input dialogs to adjust date and time.

Open the source picture containing the image part that you want to use as a base for the new brush tip. Using one of the selection tools outline the image part. Here I selected a single holly leaf.

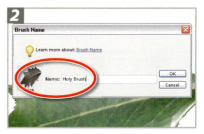

With the selection still active pick Edit > Define Brush and enter a new name for the Holly Brush. Click OK to add the brush to the current set of brush tips.

52

D

Date View

Menu: –	
Shortcut: –	**OS:** Windows
Version: 3, 4	**See also:** Organizer, Photo Browser

Your photos can be viewed in a range of different ways in the Organizer or Photo Browser workspace. The standard view (Photo Browser view) displays the pictures as a series of thumbnails in a rows and columns format. You can sort the sequence of the photos according to date taken, associated tags and collections.

Another option is to view the photos in Date View mode. Here the images are also grouped and displayed based on the date they were taken, but they are shown in a calendar format. You can choose a year, month or day based calendar with each view containing a slide show feature that will automatically flick through all the photos taken on a specific date.

Pictures displayed in Date View can be edited, printed, shared and included in Photo Creation projects by clicking one of the shortcut buttons at the top of the screen.

Define Brush

Menu: Editor: Edit > Define Brush from Selection	
Shortcut: –	**OS:** Mac, Windows
Version: 1, 2, 3, 4	**See also:** Brush

Photoshop Elements includes a sophisticated Brush engine that, when combined with the program's ability to make a brush tip from almost any image ,allows the user unlimited drawing options to play with.

At the center of brush customization is the Define Brush from Selection feature. After using any of the selection tools to outline a part of a picture that will be the new brush tip, select Define Brush from Selection under the Edit menu. Name the new brush and click OK. The new tip will now be available at the bottom of the list of brushes in the tool's options bar.

In the example a customized Holly Brush tip is created to be used to help decorate a Christmas card.

Select the new brush tip from the bottom of the brush list thumbnails. Set the foreground color to black, and click and drag to draw with the brush.

To further refine the look and characteristics of the new brush click on the More Options button in the options bar. Apply new settings for the Spacing, Fade, Hue Jitter and Scatter options and also change the fore- and background colors. Click and drag to test the new brush tip.

When completed select the Save Brush option from the pop-out menu in the Brush List Thumbnails palette.

Define pattern

Before

De-Interlace

Using the new pattern as fill

After

After De-interlacing

Define Pattern

Menu: Editor: Edit > Define Pattern from Selection	
Shortcut: -	**OS:** Mac, Windows
Version: 1, 2, 3, 4	**See also:** Define Brush from Selection

Working in a similar way to the Define Brush from Selection feature, this option creates and saves a pattern tile for use with tools such as the Pattern Stamp and the Fill command.

To create a new pattern pick Rectangular Marquee tool from the selection tools in the tool bar. Make sure that the Feather option is turned off. Select the picture part that will become the new pattern. Choose the Edit > Define Pattern from the Selection option and add a new pattern name in the pop-up dialog.

The pattern you create is saved to the bottom of the Pattern Picker (1) menu and becomes available for use immediately after its creation.

Defringe

Menu: Editor: Enhance > Adjust Color > Defringe Layer	
Shortcut: -	**OS:** Windows
Version: 4	**See also:** -

No matter how hard you try, when cutting round a subject you usually leave a few pixels from the old background. When you paste the cutout to the new background the unwanted pixels may stick out like a sore thumb. This orange flower, for example, cut out from a typical green foliage background has a few dark green pixels around the edge that show up when it's pasted to its new blue background.

The Defringe command, which is new for Elements 4.0, changes these green pixels to orange to produce a cleaner effect. Like most commands, you can enter a pixel value, in this case a width of between 1 and 200 pixels, depending on the nature of your original selection.

De-interlace filter

Menu: Editor: Filter > Video > De-interlace	
Shortcut: -	**OS:** Mac, Windows
Version: 1, 2, 3, 4	**See also:** Frame from Video

Photoshop Elements contains the ability to capture still frames from digital video footage. The Frame from Video (1) feature found under the File > Import menu displays the footage and allows the user to grab individual frames.

The process used to record digital video means that photos captured in this way may contain some missing pixels (every second video line). The De-interlace filter is designed to replace this missing picture detail by either interpolating the pixels or duplicating the ones surrounding the area (2). Interpolation provides the smoothest results and Duplication the sharpest.

Also included in the Filter dialog is the option to select which video field to keep and which to eliminate (3). If you are unsure which option to select apply the filter to the image with different options set creating two example photographs and then compare the results.

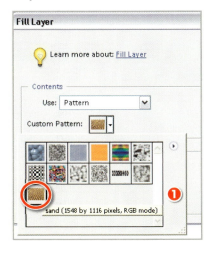

The picture above left is the straight cutout and above right is after the Defringe feature was applied to the pasted image.

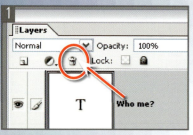

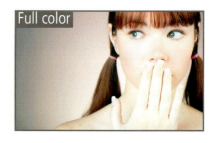

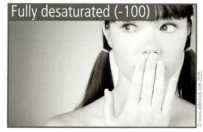

Before

After

Full color

Fully desaturated (-100)

D

Delete, layers

Menu: Editor: Layer > Delete Layer
Shortcut: - **OS:** Mac, Windows
Version: 1, 2, 3, 4 **See also:** Layers, Layers palette

There are four ways to delete a single layer from the layer stack in Photoshop Elements.

1. Select the layer in the Layers palette and then drag it to the Dustbin icon (Delete Layer button) at the top of the palette.

2. Select the layer in the palette, click on the Dustbin icon and then select Yes in the Confirmation dialog box. To avoid this dialog box hold down the Alt/Option when clicking the dustbin.

3. After selecting the layer to be discarded, choose Layer > Delete Layer.

4. Make sure that the layer to remove is selected in the palette then choose Delete Layer from the pop-up menu displayed via the More button (top right of the palette).

Delete selection

Menu: -
Shortcut: Delete **OS:** Mac, Windows
Version: 1, 2, 3, 4 **See also:** Cut, Copy

The contents of active selections can be deleted by pressing the Delete key. This action results in the pixels contained within the selection being converted to the current background color.

The results are the same as selecting Edit > Cut with an active selection, with the exception that deleting does not store a copy of the selected area on the clipboard.

In the example, a rectangular selection was made on the surface of the picture before hitting the Delete key. To soften the edges the selection was feathered (1) first before deleting.

Desaturate

Menu: Editor: Enhance > Adjust Color > Hue/Saturation
Shortcut: Ctrl/Cmd U **OS:** Mac, Windows
Version: 1, 2, 3, 4 **See also:** Grayscale, Remove Color

The term Saturation refers to the vividness of the color in the picture. Desaturating the color reduces the color's strength in the photograph. Desaturating the image totally removes all color from the picture leaving a grayscale image.

The Hue/Saturation feature (1) in Photoshop Elements is the key control for adjusting the saturation of colors. Moving the middle slider (Saturation) in the dialog to the left allows gradual desaturation of the colors in the picture. Moving the control completely to the left produces a photograph with no color present.

The same Saturation slider is available in the Quick Fix editor.

The Enhance > Adjust Color > Remove Color option is a quick way to fully desaturate a photo.

Partially desaturated (-50)

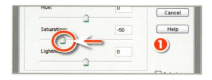

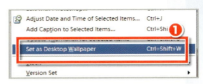

Before

After

Deselect

Menu: Editor: Select > Deselect	
Shortcut: Ctrl/Cmd D	**OS:** Mac, Windows
Version: 1, 2, 3, 4	**See also:** Selection

To remove an active selection from the canvas choose Select > Deselect from the menu bar or use the key combination Ctrl/Cmd + D.

Alternatively, you can click anywhere on the canvas outside of the current selection area. This may cause a new selection to be created if you are in the middle of using a selection tool such as the Magic Wand or Magic Selection Brush.

New for version 4.0 is the ability to press the ESC button to deselect, as well as the options listed above.

Desktop Wallpaper, set as

Menu: Photo Browser: Edit > Set as Desktop Wallpaper	
Shortcut: Ctrl Shft W	**OS:** Windows
Version: 4	**See also:** -

Though not a totally new feature, Elements 3.0 allowed the use of a single photo as the Windows desktop image, the option in version 4.0 provides the opportunity to create the wallpaper from several photos (2).

Simply multi-select (or select a single thumbnail) the photos to be included from those displayed in the Photo Browser workspace. Next, select Edit > Set as Desktop Wallpaper (1) and Elements does the rest.

To reset the desktop, or choose another Wallpaper option, choose from the list in the Background section (3) of the Desktop tab in the Window's Display Properties dialog.

Despeckle filter

Menu: Editor: Filter > Noise > Despeckle	
Shortcut: -	**OS:** Mac, Windows
Version: 1, 2, 3, 4	**See also:** Reduce Noise filter

The Despeckle filter is one of the options in the Noise group of filters. The feature smooths the speckled appearance of photos taken with high ISO settings whilst trying to retain as much detail in the original as possible.

The filter isolates the edges and areas of high contrast in the picture before applying its smoothing changes.

As no controls, or preview, are provided with the filter, using the feature is a matter of 'try it and see'. If the results are unsatisfactory then you can undo the filter changes by selecting Edit > Undo Despeckle.

Generally, better results are obtained using the more sophisticated and controllable Reduce Noise filter.

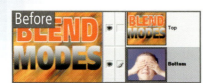

Diamond gradient

Menu:	-	
Shortcut: G (Gradient tool)		**OS:** Mac, Windows
Version: 1, 2, 3, 4		**See also:** Gradients

Photoshop Elements has five different gradient options. All the gradient types gradually change color and tone from one point in the picture to another.

The Diamond gradient (1) changes color from a center point outwards in a diamond shape.

Difference blend mode

Menu:	-	
Shortcut: -		**OS:** Mac, Windows
Version: 1, 2, 3, 4		**See also:** Blend modes

The Difference blending mode is one of the group of modes that compare and highlight the differences between the top and bottom layers.

By changing to the Difference mode both layers are compared and the color values in the layer (top or bottom) where pixels are brightest are subtracted from the other layer's colors. In this way, colors in the top layer can be subtracted from the bottom, or values in the bottom layer can be taken away from the top based on layer brightness.

Blending with a black upper layer produces no change. Blending with a white upper layer inverts the bottom layer's colors.

Difference Clouds filter

Menu:	Editor: Filter > Render > Difference Clouds	
Shortcut: -		**OS:** Mac, Windows
Version: 1, 2, 3, 4		**See also:** Filters

The Difference Clouds filter is one of the options in the Render group of filters. The feature fills the document with randomly drawn clouds based on variations in hues ranging from the foreground to background colors.

Applying the filter once creates a basic cloud pattern (1) with colors fluctuating between the foreground and background hues. Applying the filter several times creates a more random effect with new colors and textures entering the picture (2).

Diffuse filter

Menu:	Editor: Filter > Stylize > Diffuse	
Shortcut: -		**OS:** Mac, Windows
Version: 1, 2, 3, 4		**See also:** Filters

The Diffuse filter is one of the options in the Stylize group of filters. The feature softens and diffuses the look of the picture by moving the image pixels around. The effect can be quite subtle and generally more control over the application of diffusion can be obtained using the Diffuse Glow filter.

Four different settings (1) and a Preview window are available in the Filter dialog.

Normal – Applies the effect randomly throughout all the pixels in the picture.

Darken Only – Replaces light pixels in the photograph with darker ones.

Lighten Only – Replaces darker pixels with lighter ones.

Anisotropic – Applies the soften to all pixels in the picture.

Original

Before

Directional lighting

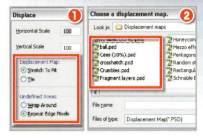

Diffuse Glow filter

Menu: Editor: Filter > Distort > Diffuse Glow
Shortcut: - **OS:** Mac, Windows
Version: 1, 2, 3, 4 **See also:** Filters

The Diffuse Glow filter is one of the options in the Distort group of filters. The feature adds a strong softening and diffusion effect to the photograph. As a result large areas of tone appear to glow and the whole photograph takes a lighter, more high-key look.

Three slider controls can be found in the Filter dialog. The Graininess slider (1) controls the amount of grain-like texture in the resultant photo; the Glow Amount (2) adjusts the degree that bright colors bleed into the surrounding areas; and the Clear Amount (3) determines the strength of the diffusion effect.

Directional option, Lighting Effects filter

Menu: Editor: Filter > Render > Lighting Effects
Shortcut: - **OS:** Mac, Windows
Version: 2, 3, 4 **See also:** Omni, Spotlight, Lighting Effects

The Lighting Effects filter provides a vast array of options to adjust the way that light is distributed in, or projected on, your photos. One of the options is the lighting type. The choices are:

Omni – Shines light in all directions like a naked light bulb.

Spotlight – Shines light in a beam shaped like an ellipse.

Directional – Shines light as if the light source is far away from the picture.

You can adjust a directional light type in the following ways:

1. Drag the center circle to move the light.

2. To change the direction of the light drag the square end and move it to a separate angle or position in the photograph.

3. To adjust the strength of the light, click and drag the end circle to make the line longer. The shorter the line the brighter the light source.

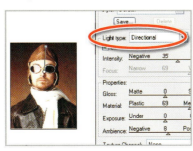

Displace filter

Menu: Editor: Filter > Distort > Displace
Shortcut: - **OS:** Mac, Windows
Version: 1, 2, 3, 4 **See also:** Displacement maps

The Displace filter changes the look of a photo by shifting the position of pixels in the original image. The position and amount of the shift are determined by a displacement map picture which is combined with the original photo as part of the filtering process.

To displace a picture, start by selecting the filter from the Distort menu. Next, set the values in the Filter dialog (1). In this example I used 100% for both scales, Stretch To Fit and Repeat Edge Pixels settings. Click OK and then choose a displacement map from those saved in the Elements 4.0/Plug-ins/Displacment Map folder (2).

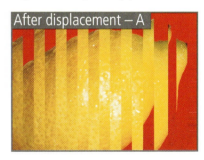
After displacement – A

Displacement map – A

After DIY displacement

1

Start creating a displacement map by resetting the fore- and background colors to default (black and white). Then create some artwork. Here I filled a new document with a linear gradient.

Before BLEND MODES

After BLEND MODES

Displacement maps

Menu: -	
Shortcut: -	**OS:** Mac, Windows
Version: 1, 2, 3, 4	**See also:** Displace filter

Displacement maps are Photoshop Elements files (PSD) that have been designed for use with the Displace filter. The program ships with several examples but you can also make your own.

The amount of displacement in the final picture is based on the tonal value of the map. Dark areas or those pixels with values approaching 0 give the maximum negative shift. Light areas or those with values near 255 produce the maximum positive shift. Middle values (around a value of 128) produce no displacement.

Use the filters and painting tools in Elements to create your own maps.

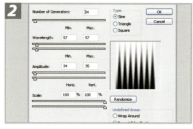

2

Next, to add a bit more of a graphic edge to the map I used the Distort > Wave filter to convert the gradient to tall black and white spikes.

3

The finished map was then saved as a Photoshop Elements (PSD) file to the Elements 4/plug-ins/displacement maps folder.

Dissolve blending mode

Menu: -	
Shortcut: -	**OS:** Mac, Windows
Version: 1, 2, 3, 4	**See also:** Blend modes

The Dissolve blending mode is one of the group of modes that lighten the picture.

Using the mode blends top and bottom layers using a pattern of pixels. As the opacity of the top layer drops, more of the bottom layer can be seen. The effect is similar to the dissolve transition or editing cut found on many video editing or slide show creation software packages.

Blending when the top layer's opacity is set to 100% produces no effect. Reduce the top layer's opacity setting to see the change. The example uses an 80% opacity for the top layer.

After displacement – B

Displacement map – B

4

Now the example image was opened and the Distort > Displace filter selected. Both scales were set to 100% and the Stretch To Fit and Repeat Edge Pixel options were selected. After clicking OK I browsed for and located my newly created 'spike' map which was then used as a basis for the picture's distortion.

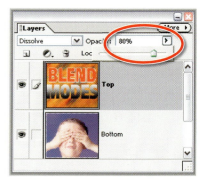

Before

After

Distorting a layer

Menu: Editor: Image > Transform > Distort
Shortcut: - **OS:** Mac, Windows
Version: 1, 2, 3, 4 **See also:** Free Transform, Skew, Perspective

The Image > Transform menu contains four options that allow you to change the shape of your pictures from their standard rectangle format. The Distort feature is one of these options and is used to stretch and squeeze your photos.

After selecting Image > Transform > Distort (1) you may be prompted to change the background to a standard layer ready for transformation (2). Click Yes in this dialog. Next change the shape of your picture by click-dragging the corner handles to new positions in the document. When completed either double-click on the transformed layer or press the Enter key to 'commit' the changes.

To cancel the changes at any time during the distortion process press the Esc key.

Pro's Tip Holding down the Alt/Opt key whilst distorting mirrors the changes around the center point of the photo.

Divide Scanned Photos

Menu: Editor: Image > Divide Scanned Photos
Shortcut: - **OS:** Mac, Windows
Version: 3, 4 **See also:** -

For those readers with many pictures to scan the Divide Scanned Photos feature (introduced in version 3.0) will prove a godsend. Now you can scan several prints at once on a flatbed scanner and then allow Elements to separate each of the individual pictures and place them in a new document.

To ensure accurate division of photos place a colored backing sheet on top of the prints to be scanned. This helps the program distinguish where one picture starts and the other ends.

Document size

Menu: Editor: Window > Info
Shortcut: - **OS:** Mac, Windows
Version: 1, 2, 3, 4 **See also:** Info palette

The Info palette contains a variety of details regarding the document that is currently open in the workspace as well as the position of any selected tool. Added to the bottom of the palette for version 3.0 of Photoshop Elements is another information panel that displays a range of document and program data (1).

To change what is shown in the palette you must choose Palette Options from the More menu, then check which status options checkboxes you want to display. If selected, you can display all seven options at once at the bottom of the Info palette.

Document size is one of the options that can be selected. The figure on the left represents an estimate of the file's size when flattened and saved in the Photoshop Elements format (PSD). The number on the right is the approximate size of the current open file including all layers.

In all versions of the program (except 3.0 for Windows) this detail could be found on the left-hand side of the status bar at the bottom of the screen (2). To display the bar select Window > Status Bar.

Before

After

© www.ablestock.com 2005
© www.ablestock.com 2005

① ②

Dodge tool

Menu: -	
Shortcut: O	**OS:** Mac, Windows
Version: 1, 2, 3, 4	**See also:** Burn tool, Sponge tool

The Dodge tool lightens specific areas of a photograph when the tool tip is clicked and dragged across the picture surface. The tool's attributes are based on the settings in the options bar and the current brush size.

The strength of the lightening is governed by the exposure setting. Most professionals choose to keep this value low and build up the tool's effect with repeated strokes over the same area.

You can also adjust the precise grouping of tones, highlights, midtones or shadows that you are working on at any one time by setting the option in the Range menu.

DPI (dots per inch)

Menu: -	
Shortcut: -	**OS:** Mac, Windows
Version: 1, 2, 3, 4	**See also:** Resolution, Color Halftone filter

The term 'dots per inch' started as a measurement of the screen size used by offset printers when converting continuous tone pictures to a series of colored ink dots. It literally refers to the number of dots that would be used in a single inch of a printed picture. The higher the DPI value, the finer the screen and, therefore, the smaller the dot size. Typically newspapers use a DPI value of around 85 and good quality magazines 150.

More recently the term has been used to represent the digital resolution of a photo as well as a measure for scanning resolution. Even though most readers will understand what others mean when they say 'What is the DPI of that photo?' or 'What DPI do you have your scanner set to?', this is an incorrect use of the term.

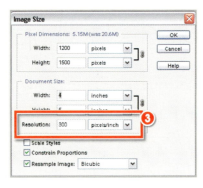

③

PPI – For digital photos the correct unit of measure is PPI or pixels per inch as this describes the resolution of the picture in terms of its primary component – pixels. The picture will only be converted to dots per inch when printed.

SPI – The unit that should be used when discussing scanner settings is SPI or samples per inch. This describes how often the scanning head will sample the information in the photo original per inch.

DPI – As dots per inch started life as a printing term it still has a place in this part of the digital photography process. In fact, in inkjet technology the number of dots laid down by the printer head is often called DPI.

Pro's Tip A picture with the same pixel dimensions can be printed to two different sizes by altering the number of pixels per inch that are used in the output process. In this way the same file can be used to output a 5 × 4 inch print (2), or a 10 × 8 inch photo (1), by altering the picture's resolution (pixels per inch) within the Image Size dialog (3).

60

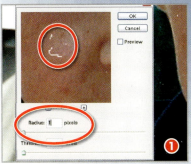

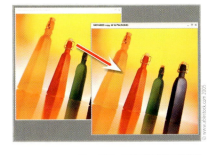

Duplicate image

Menu: Editor: File > Duplicate
Shortcut: - **OS:** Mac, Windows
Version: 1, 2, 3, 4 **See also:** -

The File > Duplicate command makes an exact copy of the current open document in the Editor (1) and Organizer workspaces. As well as the picture itself being copied and opened in a new window the feature also duplicates any tags, captions and notes associated with the photo.

The picture can also be duplicated whilst being stored in the Photo Bin by right-clicking on the thumbnail and selecting the duplicate option (2).

All duplicated files are added to the current catalog and are automatically given a file name ending with '-copy'.

Duplicate Layer

Menu: Editor: Layer > Duplicate Layer
Shortcut: - **OS:** Mac, Windows
Version: 1, 2, 3, 4 **See also:** Layers

Any layer can be copied and inserted into the current document with the Layer > Duplicate Layer command. Simply select the layer to be copied, choose Duplicate Layer from the Layer menu(1), insert a new name (2) and choose the destination of the new layer (3) in the Duplicate Layer dialog.

An alternative method to copy a layer is to click-drag the layer from its position in the stack onto the New Layer button in the Layers palette (4). This approach bypasses the Duplicate Layer dialog and simply adds 'copy' to the name of the original layer.

A final method for copying a selected layer is to choose the Duplicate Layer (5) option from the Ctrl-click menu (Cmd click –Macintosh).

Dust & Scratches filter

Menu: Editor: Filter > Noise > Dust & Scratches
Shortcut: - **OS:** Mac, Windows
Version: 1, 2, 3, 4 **See also:** Spot Healing Brush

The Dust & Scratches filter in Elements helps to eliminate annoying spots and marks by blending or blurring the surrounding pixels to cover the defect. The settings you choose for this filter are critical if you are to maintain image sharpness whilst removing small marks. Too much filtering and your image will appear blurred, too little and the marks will remain.

To find settings that provide a good balance, first try adjusting the Threshold setting to zero. Next, use the Preview box in the Filter dialog to highlight a mark that you want to remove. Use the zoom controls to enlarge the view of the defect (1).

Now drag the Radius slider to the right. Find, and set, the lowest Radius value where the mark is removed (2).

Next, increase the Threshold value gradually until the texture of the image is restored and the defect is still removed (3).

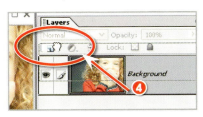

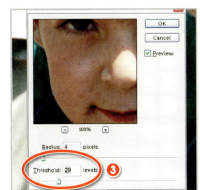

DVD menu templates, editing

Menu: Photo Browser: Edit > Set as Desktop Wallpaper
Shortcut: Ctrl Shft W **OS:** Windows
Version: 4 **See also:** -

Photoshop Elements 4.0 can create new, or edit existing, DVD menu templates which are used in Premier Elements 2.0. In this editing process the background, buttons and text can all be adjusted or replaced.

The DVD menus used in Premier Elements contain a set of two templates – the main menu and the scene menu. When editing or creating templates the user can alter buttons, backgrounds and text in either or both of these menus.

To make use of this menu editing feature you need to have Premier Elements installed as well as Photoshop Elements.

To create a new a template select File > New > DVD Template from inside the Standard Editor workspace of Photoshop Elements.

In the DVD Template Editor dialog choose the video format that suits your country and the aspect ratio (wide – 16:9 or standard – 4:3) that matches the television set that the DVD will be viewed on. Then select the Start from scratch option.

In the next screen choose a background from the list on the right of the dialog.

Add buttons to the background by clicking on the Add button first and then clicking on the button style from the list on the right.

The next screen is for editing button text or adding in extra text to the template. Click the Add Text button to place new headings and the Delete Text to remove existing titles. To edit existing text click on the type and then add the new text into the Change Selected Text box.

Now for creating the Scene menu. Start by selecting a background and then add in Scene Marker buttons.

Use the text options in the next screen to alter the labels that sit beneath the Scene Marker buttons. It is at this point that you can also add in extra heading or description text to the menu.

Now save off the template design providing a name for the newly created or edited set of menus.

The new template is saved to the Custom folder in the DVD themes in Premier Elements. When creating a new DVD menu open the Templates dialog by selecting the Change Template button in the DVD workspace and navigate to the Custom collection of templates. Your newly created template will be listed here ready to use.

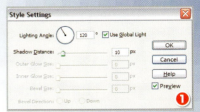

Edit in Progress

Menu:	-	
Shortcut:	-	OS: Windows
Version:	3, 4	See also:

Pictures displayed in the Photo Browser workspace can be selected and transferred to the Quick Fix or Standard editing workspaces by selecting the thumbnail and then choosing the 'Go to...' option from the right-click pop-up menu.

Once the photo is opened in either editing space an Edit in Progress warning is displayed on the thumbnail in the Photo Browser. This not only serves to remind the user that the file is currently open in the editing space but also locks the file so that no changes can be made in the Browser space. The image can still be used in a Photo Creation even when it is being edited.

When the photo is closed and no longer displayed in either editing space the warning is removed from the thumbnail.

Effects

Menu:	Editor: Window > Styles and Effects	
Shortcut:	-	OS: Mac, Windows
Version:	3, 4	See also: Scale Effects, Layer Styles, Hide All Effects, Clear Effects

Early on in the digital imaging revolution, users started to place visual effects like drop shadows or glowing edges on parts of their pictures.

With the release of packages like Elements, these types of effects have become far more sophisticated and built-in features of the program. Now, it is possible to apply an effect like a 'drop shadow', or a bold outline, to the contents of a layer with the click of a single button. Some effects changes are applied to the layer contents, others create a new layer to store the effect.

In version 3.0 and 4.0 Adobe has grouped all these layer effects under a single palette called Styles and Effects. As with many features in the program, a thumbnail version of each effect provides a quick reference to the results of applying the changes. To add the effect to a selected layer, simply double-click on the thumbnail or drag the thumbnail onto the image.

With some options multiple effects can be applied to the one layer, selection or picture and the settings used to create the effects can be edited by double-clicking the 'f' icon on the selected layer in the palette (1).

Remove a layer style by selecting Layer > Layer Style > Clear Layer Style whilst selecting the layer with the style applied.

Effects, Hide All

Menu: Editor: Layer > Layer Style > Hide All Effects	
Shortcut: -	**OS:** Mac, Windows
Version: 1, 2, 3, 4	**See also:** Scale Effects, Layer Styles

Effects and Layer styles that have been applied to a layer can be temporarily hidden from view by selecting the Hide All Effects command (2).

A small 'f' icon is displayed on the left end of any layers that currently have style and effects applied (1).

The effects and styles can be redisplayed using the Layer > Layer Style > Show All Effects command (3).

Hiding the effects of a picture differs from clearing them (Layer > Layer Style > Clear Layer Style), as this option deletes any effects or styles currently applied to the layer, rather than just removing them from view.

Effects, Scale

Menu: Editor: Layer > Layer Style > Scale Effects	
Shortcut: -	**OS:** Mac, Windows
Version: 2, 3, 4	**See also:** Hide All Effects, Layer Styles

The Scale Effects command (Layer > Layer Style > Scale Effects) allows you to alter the look of the styles and effects applied to layers and text by altering their size and strength. The Scale slider adjusts the setting characteristics such as drop shadow, bevel edges and outline strokes from 1% of the original size up to 1000%. You can also scale effects with the new Scale Styles option in the Image Size dialog box (1). These commands are particularly useful for adjusting the scale of styles and effects after reducing or increasing the original image size.

Effects palette

Menu: Editor: Window > Styles and Effects	
Shortcut: -	**OS:** Mac, Windows
Version: 3, 4	**See also:** Clear Effects, Hide All Effects

The Styles and Effects palette, new in version 3.0 and 4.0 of Photoshop Elements, provides thumbnail representations of Effects, Styles and Filter changes (1).

By double-clicking on a thumbnail the effect, style or filter is applied to your picture, layer or selection.

It is possible to apply multiple changes to a single picture using combinations of items from the Effects, Styles and Filter options. Effects can be cleared or hidden using these options in the Layer > Layer Style menu.

Eight-bit

Menu: -		
Shortcut: -	**OS:** Mac, Windows	
Version: 1, 2, 3, 4	**See also:** Color depth, Convert to 8 Bits/Channel	

Standard digital photos contain three color channels – red, green and blue (RGB). The vast number of colors we see in most pictures are created by mixing various tones of these three primary colors together.

The number of different tones possible in each channel is called the Color Depth of the file. Most photos have an 8-bit color depth, which means that each channel is capable of supporting 256 levels of tone. When you mix this number of tones of all three channels, it is possible to create over 16 million different colors in an 8-bit system.

Some digital cameras can capture pictures with higher bit modes, providing the possibility of even more tones per channel and therefore a greater number of colors overall.

By default Photoshop Elements creates, enhances and edits 8-bit files, but with version 3.0 of the program, Adobe included the ability to make basic adjustments to 16-bit files also.

Moving the tool tip over the picture surface whilst the Info palette is displayed shows the RGB values for each of the color channels (1).

The color depth of open documents is also displayed in the title bar in a bracketed section after the document name (2).

Elliptical Marquee tool

Menu: -		
Shortcut: M	**OS:** Mac, Windows	
Version: 1, 2, 3, 4	**See also:** Rectangular Marquee tool	

By clicking and dragging the Elliptical Marquee tool on the picture surface, it is possible to draw oval-shaped selections.

Holding down the Shift key whilst using this tool restricts the selection to circle shapes, whilst using the Alt (Windows) or Options (Mac) keys will draw the selections from their centers.

E-mail contacts

Menu: Photo Browser: Edit > Contact Book		
Shortcut: Ctrl Shft W	**OS:** Windows	
Version: 4	**See also:** Contact Book, Order Prints Pane	

The Contact Book in Photoshop Elements 4.0 is the place where the program's e-mail and online print ordering system (Order Prints Pane) sources e-mail address and delivery details.

Recipient's contact details, including their e-mail addresses, are added to the book by firstly displaying the dialog (1) by selecting the feature from the Edit menu in the Photo Browser workspace (Edit > Contact Book) and then clicking onto the New Contact button (2). The contact details are then added to the new contact form (3) before clicking OK to save the information and add the new contact to the list in the book.

The details that can be added for each contact include name, address, phone numbers and e-mail address.

Existing contact details stored in such programs as Outlook and Outlook Express can be automatically added to the Photoshop Elements Contact Book via the Import button (4).

eE

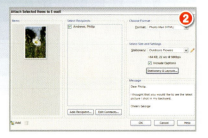

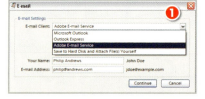

E-mailing pictures

Menu: Editor: File > Attach to E-mail
Photo Browser: File > Attach to E-mail
Shortcut: - **OS:** Mac, Windows
Version: 3, 4 **See also:** Attach to E-mail, JPEG

E-mail is a great form of communication; attaching pictures to e-mails means that you can add visuals to your text messages. But before you can start inserting your pictures into e-mails the photos need to be optimized to ensure they are sufficiently small enough to transmit quickly.

Optimization involves three steps:

1. Reduction in pixel dimensions of the original picture to suit the dimensions of a typical screen. Typical suitable sizes range from 600 × 480 to 800 × 600 pixels.

2. Change of image resolution to suit screen display. Most e-mail photos are converted to a resolution of 72 dpi to match screen display.

3. Compressing the reduced-sized picture using a file format that is designed for web work. JPEG is the best format for shrinking the file size of the photos small enough to suit e-mail transmission.

These steps can be performed manually in Elements using a combination of the Image Size and Save As features or even with the Save for Web option. Alternatively, both the Macintosh (1) and Windows (2) versions of version 3.0 have specialized Attach to E-mail features.

These options use a wizard approach to perform the optimization process and are by far the easiest way to prepare and send pictures attached to e-mails.

E-mail to Mobile Phone

Menu: -
Shortcut: Share button **OS:** Windows
(shortcuts bar)
Version: 3, 4 **See also:** Attach to E-mail

Photoshop Elements 3.0 and 4.0 provide an option for e-mailing photos directly to a mobile phone. The E-mail to Mobile Phone feature optimizes the selected photo to the size and format suitable for mobile phone use and then e-mails the picture and a short message to your phone.

To use the feature, push the Share button on the shortcuts bar in the Photo Browser or Date View workspace and then select the E-mail to Mobile Phone item from the menu. Input your E-mail client program, name and address, then click Continue (1).

In the E-mail to Mobile Phone dialog, add or delete the pictures to include (2), select the recipient for the e-mail (3), choose the image size to suit the receiving phone (4) and then add your message (5) before clicking OK.

Embed color profile

Menu: Editor: File > Save for Web, Editor: File > Save As
Shortcut: Alt Shft Ctrl/Cmd S, **OS:** Mac, Windows
Shft Ctrl/Cmd S
 See also: Color Settings,
Version: 1, 2, 3, 4 Missing Profile,
ICC Profile

A core part of a color-managed editing system is the ability to save pictures so that they are tagged or have a color or ICC profile attached. The profile describes the color space that the picture was created in and allows the accurate representation of the colors and tones in the photo on screen and when printed.

Photoshop Elements allows the saving or embedding of color profiles (in file formats that support the option) in both the Save As (1) and Save for Web (2) dialogs. An embedding or profile check box is contained in each of these dialogs.

To maintain the completeness of the color-management system and the accurate representation of photos on your, and other, systems ensure that this checkbox is always ticked.

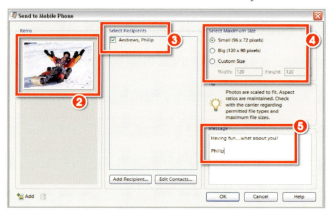

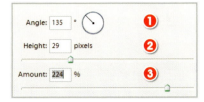

Emboss filter

Menu: Editor: Filter > Stylize > Emboss	
Shortcut: -	**OS:** Mac, Windows
Version: 1, 2, 3, 4	**See also:** -

The Emboss filter, as one of the group of Stylize filters, uses the photo to recreate the look of embossed or beaten metal.

The edges in the picture are used as the basis for the effect with the three controls in the dialog providing adjustment over the strength and quality of the effect.

The Angle dial (1) alters the direction of the light used to provide highlight and shadow lines for the embossing. The Height slider (2) alters apparent depth of the embossing by increasing the size of the shadow and highlight detail, and the Amount control (3) varies the contrast and prominence of the effect.

Eraser tool

Menu: -	
Shortcut: E	**OS:** Mac, Windows
Version: 1, 2, 3, 4	**See also:** Magic Eraser

The Eraser tool changes image pixels as it is dragged over them. If you are working on a background layer then the pixels are erased or changed to the background color. In contrast, erasing a normal layer will convert the pixels to transparent, which will let the image show through from beneath.

As with the other painting tools, the size and style of the eraser is based on the selected brush tip – (1) erasure with a hard-edged brush tip and (2) erasure with a soft-edged brush tip. But unlike the others the eraser can take the form of a paint brush, pencil or block (Mode in the options bar). Setting the opacity will govern the strength of the erasing action.

Apart from the straight Eraser tool, two other versions of this tool are available – the Background Eraser and the Magic Eraser. These extra options are found hidden under the Eraser icon in the toolbox.

The **Background Eraser** is used to delete pixels around the edge of an object. This tool is very useful for extracting objects from their backgrounds. The tool pointer is made of two parts – a circle and a cross hair.

The **Magic Eraser** uses the selection features of the Magic Wand to select similarly colored pixels to erase. This tool works well if the area of the image you want to erase is all the same color and contrasts in tone or color with the rest of the image.

Background Eraser

To use the Background Eraser tool, the crosshair is positioned and dragged across the area to be erased, whilst at the same time the circle's edge overlaps the edge of the object to be kept. The success of this tool is largely based on the contrast between the edge of the object and the background. The greater the contrast, the more effective the tool. Again, a Tolerance slider is used to control how different pixels need to be in order to be erased.

Magic Eraser

The Magic Eraser selects and erases pixels of a similar color from a picture. The selection part of the tool works in a similar way to the Paint Bucket or Lasso tools in that pixels are selected based on their color and tone.

The Contiguous setting forces the feature to select similar pixels that are adjacent to each other and the Tolerance value determines how alike the colors need to be before they are erased.

Remember

Both the Background Eraser and Magic Eraser tools erase to transparency so using them on a background layer automatically converts it to a standard image layer as part of the erasing process.

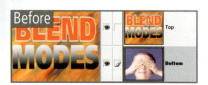

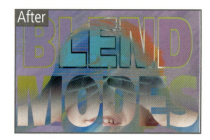

Event, add Date View

Menu:	-		
Shortcut:	-	OS:	Windows
Version:	3, 4	See also:	Date View

The Date View mode of the Photo Browser provides a calendar-based view of the pictures in your catalog. As well as this thumbnail presentation, the view provides other calendar options such as allowing you to add events and notes on any day in the calendar.

To add an event either right-click on the day (2) or click the Event icon (1) and then insert the details in the pop-up.

The notes are visible in the month and day views and are indicated in the year view as a change in color of the date from gray to light blue. Adobe includes some pre-installed events on the calendar such as Christmas Day and New Year's Day.

Exclusion blending mode

Menu:	-		
Shortcut:	-	OS:	Mac, Windows
Version:	1, 2, 3, 4	See also:	Blend modes

The Exclusion blending mode is one of the group of modes that base their effects on the differences between two pictures.

This option is similar to the Difference mode but produces less dramatic and less contrasty results. When the upper layer is changed to the Exclusion mode the result displays the tonal difference between the two layers.

The difference is calculated by locating the lighter and darker pixels and then subtracting these from either of the two layers producing the resultant color.

Blending with a black top layer produces no change. Blending with a white top layer inverses the value of the bottom layer.

EXIF data

Menu:	Editor: File > Browse Folders		
Shortcut:	Shft Ctrl/Cmd O	OS:	Mac, Windows
Version:	3, 4	See also:	Metadata

EXIF, or the Exchangeable Information Format, is a data format that is used for recording digital camera capture details and then displaying them inside software applications such as Photoshop Elements.

The information recorded by the camera and saved in this format can include shutter speed, aperture, camera model, date and time the photo was taken, and exposure mode that the camera was set to.

There are two places where you can view the available EXIF data for a picture:

A. In the Photo Browser right-click a selected photo and choose the Show Properties option from the pop-up menu. Next press the Info or Metadata button ('i') in the top right of the dialog and the Complete option at the bottom to display the info available for the picture (1).

B. When working in the Editor workspace of Elements 3.0 select the File > Browse Folders feature and then adjust the Metadata panel, bottom left, so that the EXIF information is displayed (2).

EXIF data is one part of a set of metadata information that can be viewed and, to some extent, edited and even created in Elements. Other metadata options include File Properties, IPTC or copyright information, edit history and any GPS details.

Exit command

Menu:	Photo Browser or Editor: File > Exit, Editor: File > Quit (Mac)
Shortcut: Ctrl/Cmd Q	**OS:** Mac, Windows
Version: 1, 2, 3, 4	**See also:** -

To exit or close Photoshop Elements select File > Exit or File > Quit for Macintosh users. If any files are open at the time of selecting the Exit command, a Confirmation dialog will be shown asking the user if they want to save the file before quitting or cancel the action (1).

Expand selection

Menu:	Editor: Select > Modify > Expand
Shortcut: -	**OS:** Mac, Windows
Version: 1, 2, 3, 4	**See also:** Contract selection

An active selection can be altered and adjusted using the options listed under the Select > Modify menu. One option is the Expand command which increases the size of the selection by the number of pixels entered into the feature's dialog. If the selection incorporates part of the document edge this part of the marquee will not be changed by the command.

Export

Menu:	Photo Browser: File > Export
Shortcut: Ctrl E	**OS:** Windows
Version: 3, 4	**See also:** -

The Export feature in the Photo Browser (Organizer) is designed to provide a quick, easy, automated way to create and save copies of multi-selected pictures from inside the workspace.

The feature's dialog contains thumbnail representations of the pictures to be exported on the left-hand side of the dialog (1). Extra photos can be added or excess pictures deleted using the buttons at the bottom of this thumbnail area.

The following controls are also included in the dialog:

File Type – Determines the file format that the exported pictures will be saved in (2). Unlike when saving from the Editor workspace, only five file formats are available here. For a more robust list of fie formats, save files from the Editor workspace.

Photo Size – Pick the size of the exported photos. The image dimensions can be reduced in size but not enlarged (3).

Quality – This setting adjusts the compression setting used for photos exported in JPEG format (4).

Location – The folder or directory where the copies will be saved (5).

File Names – Sets the name of exported files. Options include keeping the original names or adding a base name plus a sequential number (6).

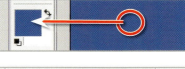

Export Collection

Menu: Photo Browser: Window > Collections	
Shortcut: Ctrl Alt L	**OS:** Windows
Version: 3, 4	**See also:** Collections

Collections (and collection groups) are one way that Photoshop Elements organizes and manages the many pictures you have in your catalog. It can take a considerable amount of time to establish and build a complex collection structure, but once created the structure can be shared with other Elements users.

When you export a collection, the structure of the collection, not the images themselves, is saved and made available for others to use.

To export a collection start by making sure that the Collections pane is visible (Window > Collections) and then select the New > Save Collections to File option (1). In the dialog that appears, select the Export All Collections option (2) to save a copy of the whole structure, or the Export Specified Collection Group item for only part of the structure.

To import the collection structure on another machine select the New > From File item in the Collections pane (3) and then choose the exported file. The original photos don't need to be available to import an exported catalog.

Extrude filter

Menu: Editor: Filter > Stylize > Extrude	
Shortcut: -	**OS:** Mac, Windows
Version: 1, 2, 3, 4	**See also:** -

The Extrude filter, as one of the group of Stylize filters, projects the photo onto a series of extruded shapes that seem to explode from the middle of the document. By altering the settings in the Filter's dialog you can choose the shape of the extrusions – blocks or pyramids (1). The size (2) and depth (3) of the extruded shapes can be set in pixels. Partly completed blocks can be masked or shown as part of the final image (4).

Eyedropper tool

Menu: -	
Shortcut: I	**OS:** Mac, Windows
Version: 1, 2, 3, 4	**See also:** Info

The Eyedropper tool is used to sample colors in a picture. After selecting the tool click on the color in the picture to set a new foreground color and Alt-click (Option-click for Macintosh) for a background color. The size of the area sampled can be adjusted using the options in the Sample Size menu in the options bar. Large pixel samples average the color and tone of the areas they select.

As the eyedropper tool is automatically activated when selecting any of the Enhance menu commands (e.g., Levels, Hue/Satuation) you can sample colors from the image whilst working in the dialog.

Pro's Tip With a painting tool selected, press the Alt/Option key to quickly invoke the Eyedropper tool.

①

②

Facet filter

Menu: Editor: Filter > Pixelate > Facet	
Shortcut: -	**OS:** Mac, Windows
Version: 1, 2, 3, 4	**See also:** Filters

The Facet filter, as one of the group of Pixelate filters, simulates the look of a hand-worked painting by recreating the photo with blocks of color.

The filter contains no controls to alter the strength or appearance of the effect. Some changes in end results are possible by altering the image size before applying the filter. The filtering process produces more dramatic results when applied to low resolution files than when used with pictures with large pixel dimensions.

As the filter doesn't have an Image Preview option it may be necessary to filter the picture several times with different resolution settings before deciding on the best values to use. Use Edit > Undo to reverse the last filter change.

Faux fonts

Menu: -	
Shortcut: -	**OS:** Mac, Windows
Version: 1, 2, 3, 4	**See also:** Font

Some font families include several different versions of the typeface that you can use in conjunction with the Type tool. Typically, the Typeface options or styles include Bold, Italic and Bold Italic as well as the standard Regular faces (1). Each of the font faces shares the same basic letter design but a different alphabet is installed for each Face option (i.e. a different set of letters for Bold, Italic and Bold Italic options).

For fonts that don't have these Face or Style options Photoshop Elements has several 'faux' font choices (2) available that can be used as a substitute. Faux fonts simulate the look of different font faces and include Bold (3), Italic (4), Underline (5) and Strikethrough (6).

Without feather ❶

Before

With feather ❷

© www.ablestock.com 2005

1

To create a vignetting effect start by making an oval selection of the focal point of the picture using the Elliptical Marquee tool. Next, invert the selection (Select > Inverse) so that everything else except this part is now included in the selection.

Feather command

Menu: Editor: Select > Feather
Shortcut: Alt/Opt Ctrl/Cmd D **OS:** Mac, Windows
Version: 1, 2, 3, 4 **See also:** Selection

By default most selections are created with a sharp edge that marks the parts of the picture that are included within the selection and those areas that are outside. When changes are made to a photograph via these sharp-edged selections the distinction between edited and non-edited sections of the image are very obvious. The Feather command softens the transition between selected and non-selected areas.

The example shows a vignetting or edge darkening effect created with a sharp selection (1) and then the same effect repeated with a feathered selection (2).

You can feather a selection in two ways:

Before making a selection: Add a feather amount in the options bar of the Selection tool before drawing the selection (4).

After a selection is created: To feather an existing selection, draw the selection and then choose the Select > Feather (3) command and add a feather amount in the dialog that appears (5).

The greater the value used for the Feather Radius the smoother the transition will be. Just like blurring, the higher the file's resolution, the greater the amount of feathering required to produce the same results.

2

Feather Selection

Learn more about: Feather Selection

Feather Radius: 50 pixels

With the selection still active choose the Feather command (Select > Feather) and input a Feather Radius value into the dialog. Click OK to continue.

3

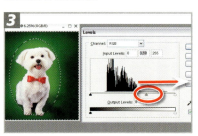

Now pick the Levels feature (Enhance > Adjust Lighting > Levels) and drag the middle slider to the right to darken the selection area (drag the slider to the left to lighten these parts). Click OK to apply the changes.

Feather: 40 px ☑ Anti-aliased ④

Feather Selection

Learn more about: Feather Selection

Feather Radius: 50 pixels ⑤

File Browser

Menu: Editor: File > Browse Folders
Shortcut: Shft Ctrl/Cmd O **OS:** Mac, Windows
Version: 1, 2, 3, **See also:** Photo Browser, File Info

This option is available for both Macintosh and Windows users (except version 4.0) and takes you directly to the Elements File Browser, which displays both a preview (2) and thumbnail versions of images (3) that you have created at another time and have saved to disk.

Users can navigate between image directories using the folder tree in the top left-hand corner of the dialog (1). Camera, or scanner, settings and image information can be viewed in the bottom left (3) in the scrollable metadata text box. Users can add their own caption, copyright, author and title information for individual images through the File Info dialog box (File > File Info).

Images can be renamed and folders added or deleted directly in the dialog using the extra options found in the File menu (5) at the top of the box.

Groups of selected images can be 'Batch Renamed' or moved to new folders. Double-clicking a thumbnail in the browser will open the selected image directly into the program.

File Type	Compression	Layers	Metadata	Uses
Photoshop (.PSD)	✗	✓	✓	Desktop publishing (DTP), Internet, publishing, photographic work
GIF (.GIF)	✓	✗	✗	Internet
JPEG (.JPG)	✓	✗	✓	DTP, Internet, publishing, photographic work
TIFF (.TIF)	✓	✓	✓	DTP, Internet, publishing, photographic work
PNG (.PNG)	✓	✗	✗	Internet

filename.ext
❶ ❷

File association

Menu: Editor: Edit > File Association	
Shortcut: -	**OS:** Windows
Version: 3, 4	**See also:** File Format, File Extensions

The File Association Manager controls the linking of specific file types with the Windows version of the Photoshop Elements program.

When double-clicking on the file types selected in this dialog the picture will automatically open in Elements.

You can select the individual files to associate manually by clicking on each file type in turn, or choose to Select All, or Deselect All, file types by choosing these buttons. The Default option selects a set of file types suggested by Adobe. You will also see a similar screen with the same association options when first installing Photoshop Elements. The changes you make becomes the new default settings.

File extensions

Menu: -	
Shortcut: -	**OS:** Windows
Version: 1, 2, 3, 4	**See also:** File format

A file extension is the three letter abbreviation (2) of the file format that is added after the file's name (1). Windows programs use the extension as a way of recognizing the content of the file as well as the way that it is structured. For example, if you save a file named 'Image 1' in the TIFF format then the full file name would be 'Image 1 .tif' and a JPEG version of the same file would be 'Image 1 .jpg'. Most programs automatically add an extension to the file as it is being saved. This occurs even if the extensions are hidden from view when viewing file names in the browser. In Windows XP the extension is hidden by default. To view the extension in any folder, choose Tools > Folder Options > View, and deselect 'Hide extensions for known file types'.

File format

Menu: -	
Shortcut: -	**OS:** Mac, Windows
Version: 1, 2, 3, 4	**See also:** File extensions, File association, Save As

Photoshop Elements can open and save files in a multitude of different file formats. The format you use will be determined by the end use of the photo. If the picture is destined for the Internet then the JPEG format is the best option. In contrast, photos used in publishing are often saved in the TIFF format. For most editing and enhancement work the Photoshop, or PSD, format should be used. It provides the best combination of features and image quality. Pictures in the PSD format can be duplicated in other formats for specific uses by resaving the file via the File > Save As option. Not all formats supported in the Editor workspace are supported by the Organizer (e.g., EPS, PICT and RAW).

73

JPEG

(Joint Photographic Experts Group) – This format is the industry standard for compressing photos destined for the World Wide Web (www) or for storage when space is limited. JPEG compression uses a 'lossy compression' (image data and quality are sacrificed for smaller file sizes when the image files are closed).

The user is able to control the amount of compression. A high level of compression leads to a lower quality image and a smaller file size. A low level of compression results in a higher quality image but a larger file size.

It is recommended that you only save to the JPEG file format for web work and only after you have completed all your image editing.

TIFF

(Tagged Image File Format) – This file type is the industry standard for images destined for publishing (magazines and books).

TIFF uses a 'lossless' compression (no loss of image data or quality) called 'LZW compression'.

Although preserving the quality of the image, LZW compression is only capable of compressing images a small amount.

PSD

(Photoshop Document) – PSD is the default format used by both Photoshop and Photoshop Elements. An image that is composed of 'layers' may be saved as a Photoshop document.

It is good practice to keep a PSD document as the master file from which all other files are produced depending on the requirements of the output device.

GIF

(Graphics Interchange Format) – This format is used for logos and images with a small number of colors and is very popular with web professionals. It is capable of storing up to 256 colors, animation and areas of transparency. Not generally used for photographic images.

PNG

(Portable Network Graphics) – A comparatively new web graphics format that has a lot of great features.

Like TIFF and GIF the format uses a lossless compression algorithm that ensures what you put in is what you get out. It also supports partial transparency (unlike GIF's transparency off/on system) and color depths up to 64-bit.

EPS

(Encapsulated PostScript) – Originally designed for complex desktop publishing work, it is still the format of choice for page layout professionals. Not generally used for storing of photographic images but worth knowing about.

JPEG2000

Dubbed JPEG2000, this format is designed as an upgrade to the aging JPEG format. It provides 20% better compression, less image degradation than JPEG, full color management profile, transparency and 16-bit support, can store saved selections and has the ability to save the file with no compression at all.

PDF

Portable Document Format is an Adobe multi-use file format that can be read equally as well by Windows-, Macintosh- and Linux-based machines. The format correctly displays images, text and formatting on the different systems and is fast becoming a standard for press- and web-based document delivery.

File Formats:

Before

After

© www.ablestock.com 2005

File Info command

Menu: Editor: File > File Info	
Shortcut: Alt/Opt Ctrl/Cmd I	**OS:** Mac, Windows
Version: 1, 2, 3, 4	**See also:** EXIF, Metadata

The File Info command displays the meta-data associated with the currently open picture. This includes data recorded from the camera (EXIF) at the time the picture was created as well as any copyright information, description and authorship details (1). The dialog also lets you add customized information to the picture (2) such as adding a document title, description (caption) and copyright notice, but no changes can be made to the Keywords, Camera Data 1 or Camera Data 2 sections. Keywords can be added in the Windows version of the program using the Tags feature in the Photo Browser (3) and added in the Mac version in the Keywords pane of the File Browser.

The details displayed in the File Info dialog can also be seen in the Metadata section of the Properties panel of the Photo Browser (4).

Fill command

Menu: Editor: Edit > Fill Layer	
Shortcut: -	**OS:** Mac, Windows
Version: 1, 2, 3, 4	**See also:** Paint Bucket, Solid Color

When there is no active selection in the open picture the Fill command over-paints the contents of the whole layer with a selected color or pattern. When a selection is active the Fill command paints the color in the area of the selection only.

The content of the fill is selected from the drop-down Use menu (1) where the choices include Foreground, Background Colors, Black, White, 50% Gray or a Pattern. You can also select a specific color by choosing the Color option and then selecting the hue from the Color Picker dialog that is displayed.

Other options in the dialog include the ability to apply the color via a range of blend modes (2) and an adjustment for the opacity (3) of the fill paint that is applied to the layer.

The Solid Color adjustment layer works in a similar way to the Fill command but applies the color in a separate editable layer (4). This option has the advantage of not destroying the contents of the original layer when the fill is applied.

Fill Flash

Menu: Enhance > Adjust Lighting > Fill Flash	
Shortcut: -	**OS:** Mac, Windows
Version: 1, 2	**See also:** Shadows/Highlights

The Fill Flash feature (Enhance > Adjust Lighting > Fill Flash) is designed to lighten shadow areas in a photograph.

In version 1 of the program the feature contained a single Lighter slider, but with the release of Elements 2.0 Adobe added a Saturation control as well. The tool does not feature in version 3.0 or 4.0 of Elements as its functions are covered more effectively with the new Shadows/Highlights feature.

Start by moving the Lighter slider to lighten the image tones. Next adjust the Saturation control to restore the color strength (1).

This tool needs careful application as the effect is easily overdone and when this happens the tonal enhancement becomes coarse and obvious.

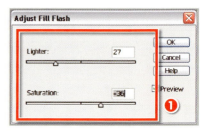

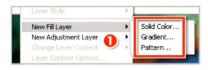

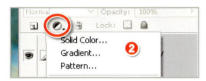

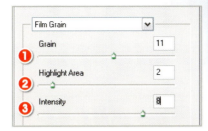

Fill layers

Menu: Editor: Layer > New Fill Layer	
Shortcut: -	**OS:** Mac, Windows
Version: 1, 2, 3, 4	**See also:** Fill, Gradient, Pattern

Photoshop Elements contains the options to create three different types of fill layers:

Solid Color – Creates a new layer filled with a color selected from the pop-up color picker (3).

Gradient – Creates a new layer filled with a gradient that gradually changes from one color to another or to transparency. Pick from preset gradient types or create your own (4).

Pattern – Creates a layer filled with a pattern that you choose from the palette (5).

A fill layer is created by selecting the specific fill type from the list available under the Layer > New Fill Layer menu (1), or by clicking the New Fill or Adjustment Layer button (2) in the Layers palette. The new fill layer is always created above the current active layer in the layer stack.

Film Grain filter

Menu: Editor: Filter > Artistic > Film Grain	
Shortcut: –	**OS:** Mac, Windows
Version: 1, 2, 3, 4	**See also:** Filters

The Film Grain filter, as one of the group of Artistic filters, simulates the texture that was typical of 'grainy', high-speed films of old.

The three settings in the dialog provide control over the grain strength and how it is applied.

The Grain slider (1) alters the strength and size of the grain that is added to the picture. A higher value produces a more pronounced result with less of the detail in the photo being retained. The Highlight Area control (2) alters the amount of highlight tones, with higher values producing a lighter and more posterized result. The Intensity slider (3) works like a contrast slide, creating more defined results as the control is moved to the right.

Filter Gallery

Menu: Editor: Filter > Filter Gallery	
Shortcut: -	**OS:** Mac, Windows
Version: 3, 4	**See also:** Filters, Styles and Effects

The Filter Gallery is designed to allow the user to apply several different filters to a single image. It can also be used to apply the same filter multiple times to the same photo.

The dialog consists of a preview area (1), a collection of filters that can be used with the feature (2), a settings area with sliders to control the filter effect (3) and a list of filters that are currently being applied to the picture (4).

Multiple filters are applied to a picture by selecting the filter, adjusting the settings to suit the image and then clicking the New Effect Layer button at the bottom of the dialog. Filters are arranged in the sequence they are applied.

Applied filters can be moved to a different spot in the sequence by click-dragging them up or down the stack. Click the Eye icon to hide the effect of the selected filter from preview. Filters can be deleted from the list by selecting them first and then clicking the Dustbin icon at the bottom of the dialog.

Most of the filters that can't be used with the Filter Gallery feature are either applied to the picture with no user settings, or make use of a dedicated Filter dialog that contains a preview area and several slider controls.

Filters can also be accessed via the Filter section for the Styles and Effects palette.

F

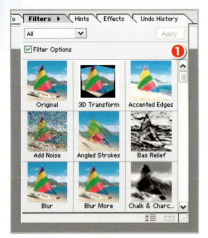

Filters

Menu: Editor: Filter
Shortcut: Ctrl/Cmd F (last filter) **OS:** Mac, Windows
Version: 1, 2, 3, 4 **See also:** Filter Gallery,
Styles and Effects

Digital filters are based on the traditional photographic versions, which are placed in front of the lens of the camera or enlarger to change the way the image is captured or printed. Now, with the click of a button it is possible to make extremely complex changes to our images almost instantaneously – changes that a few years ago we couldn't even imagine.

The filters in Adobe Photoshop Elements can be found grouped under a series of subheadings based on their main effect or feature in the Filter menu.

Selecting a filter will apply the effect to the current layer or selection. Some filters display a dialog that allows the user to change specific settings and preview the filtered image before applying the effect to the whole of the picture. This can be a great time saver, as filtering a large file can take several minutes.

Other filters are incorporated into a Filter Gallery (Filter > Filter Gallery) feature that provides both preview and controls in a single dialog.

Filters can also be accessed via the Filter section for the Styles and Effects palette.

Filters palette

Menu: Editor: Window > Styles and Effects
Editor: Window > Filters (pre-version 3.0)
Shortcut: - **OS:** Mac, Windows
Version: 1,, 2 **See also:** Filter Gallery,
Styles and Effects

The number and type of filters available can make selecting which to use a difficult process. To help with this decision, Elements also contains a Filter Browser type feature that displays thumbnail versions of different filter effects.

Before version 3.0 of the program the browser was a separate palette (1) and could be displayed by selecting Window > Filters or clicking on it's tab in the Palette Dock.

With the release of version 3.0 the browser became part of the thumbnail previews located in the new Styles and Effects palette (2).

Double-clicking the filter preview thumbnail will open the Filter Gallery and apply the filter changes to your picture.

The selection of filters previewed at any one time can be changed by altering the selection in the pop-up menu at the top of the palette.

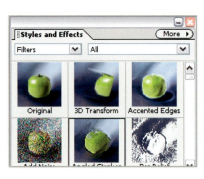

Find

Menu: Photo Browser: Find
Shortcut: - **OS:** Windows
Find All Version Sets,
Version: 3, 4 **See also:** Find by Details,
Find by Visual Similarity

One of the great benefits of organizing your pictures in the Photo Browser workspace is the huge range of search options that then become available to you.

In fact there are so many search options that Adobe created a new menu heading 'Find' specifically to hold all the choices. Here you will be able to search for your photos based on a selected date range, filename, caption, media type (video, photo, audio or creation), history (when an item was e-mailed, printed, received, imported, used in a creation project or even shared online) and even by the predominant color in the photo.

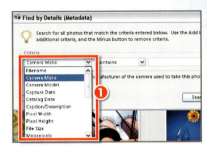

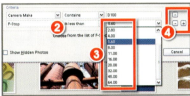

Find All Version Sets

Menu: Photo Browser: Find > All Version Sets	
Shortcut: Ctrl Alt V	**OS:** Windows
Version: 4	**See also:** Find, Version Set

The Find > All Version Sets feature (1) is one of two new Find options introduced in Elements 4.0 (the other being Find > By Details (Metadata)).

Using this option it is now possible to isolate just those photos that have been collated in version sets. The sets located as a result of the search are displayed in a new browser window (2).

Pro's Tip If you want to display all the items contained in a set then right-click on the thumbnail and choose Version Set > Reveal Items in Version Set from the pop-up menu.

Find by Details (Metadata)

Menu: Photo Browser: Find > By Details (Metadata)	
Shortcut: -	**OS:** Windows
Version: 4	**See also:** Find

In a new and very powerful search option in Elements 4.0 the wealth of information that is stored with your photo as metadata can be used as a basis for locating specific pictures.

The Find > By Details (Metadata) option displays a sophisticated search dialog that allows you to nominate specific criteria (1) to use when looking within the metadata portion of the picture file. The dialog also provides sections to choose how to match (2) the search text (Starts with, Ends with, Contains, etc.) and a place to insert the search text (3) or value (Filename, Camera Make, Camera Model, Capture Date, etc.).

Beyond simple camera-based metadata you can also use this dialog to search for any Captions, Notes, Tags or Collections that you have applied to your pictures.

Pro's Tip For more sophisticated search options you can add extra criteria by clicking on the '+' button on the right of the dialog. Alternatively criteria can be removed by clicking the '−' button (4).

Find by Visual Similarity

Menu: Photo Browser: Find > By Visual Similarity with Selected Photos	
Shortcut: -	**OS:** Windows
Version: 4	**See also:** Find

The Find > By Visual Similarity (1) with Selected Photos feature is a new search option in version 4.0 and replaces the Find > By Color Similarity that appeared in version 3.0.

Both Find options use the color and tones of the currently selected photos (or photo) in the Browser workspace as the basis of the search. Photos that most match the search criteria are displayed in a new browser window. The degree of matching is listed as a percentage value in the bottom left of each thumbnail (2).

This style of search method is also known as 'Pixel-matching'.

The first step to using the Find Edges filter to confine sharpening to just the edges of a picture is to make a copy of the background layer (Layer > Duplicate Layer) and desaturate the color (Enhance > Adjust Color > Remove Color).

Find Edges filter

Menu: Editor: Filter > Stylize > Find Edges
Shortcut: - **OS:** Mac, Windows
Version: 1, 2, 3, 4 **See also:** Filters

The Find Edges filter, as one of the group of Stylize filters, searches for and highlights the edges in a picture. The feature classifies edges as being picture parts where there is a major change in tone, color and/or contrast.

The feature outlines the edges it locates with dark lines against a lighter colored background. There are no extra controls of slider adjustments available for this filter.

The edge-finding ability of this filter is used in the following step-by-step technique to isolate the sharpening effects of the Unsharp Mask filter to the edges of a picture.

Next apply the Find Edges filter (Filter > Stylize > Find Edges) to the grayscale layer and then invert the results (Filter > Adjustments > Invert).

Now select all of the filtered layer (Select > All) and copy the selection to memory (Edit > Copy). Create a new Levels Adjustment layer (Layer > New Adjustment Layer > Levels) but make no adjustments and click OK. Select the thumbnail of the adjustment layer (Alt/Opt-Click) and then paste (Ctrl/Cmd V) the copied selection into the layer to create a layer mask.

Find Faces for Tagging

Menu: Photo Browser: Find > Find Faces for Tagging
Shortcut: - **OS:** Windows
Version: 4 **See also:** Tags, Find

The ability to add tags (keywords) to photos in Elements is one of the program's key strengths, providing a great way to sort the thousands of images that reside on our hard drives.

Many photographers use the tagging feature to sort their pictures of people, adding different tags for each family member or friend featured in the photo. Doing this makes the often time-consuming process of finding photos of a particular person a lot easier as the tags can be used as the basis for the search.

In version 4.0 the Adobe engineers have added a new auto feature that speeds up the location of people photos as well as the process of adding tags. Called Find Faces for Tagging (1), the feature searches through your thumbnails isolating the faces of people in the photos and then displays these faces in a new special Face Tagging window (2). Adding tags is then a simple matter of dragging then from the Tags Pane (3) onto the faces.

Create a new selection using the layer mask by Ctrl/Cmd clicking the thumbnail. With the selection still active, hide the marching ants (Ctrl/Cmd H) as well as the levels and filtered layers (click on the Eye icon). Now choose the picture layer from the layer stack and apply the Unsharp Mask Filter. The filter will be applied through the selection and as the selection is of the edges of the picture only then the sharpening effect will be restricted to these areas.

Before edge sharpening

After edge sharpening

© www.ablestock.com 2005

Before

After Flip Horizontal

Fixed Size option

Menu: -		
Shortcut: –	**OS:** Mac, Windows	
	See also: Marquee tool,	
Version: 1, 2, 3	Crop tool	

The Fixed Size option is available in the options bar of both the marquee (1) and Crop tools (2). This feature allows you to set the size of the selection or cropping area before drawing the shape on the picture's surface.

The size can be nominated in pixels (px), inches (in), centimeters (cm). or millimeters (mm).

Fixed Size is no longer an Options bar menu item for the Crop tool in Elements 4.0.

Flatten Image

Menu: Editor: Layer > Flatten Image		
Shortcut: -	**OS:** Mac, Windows	
Version: 1, 2, 3, 4	**See also:** Merge Layers, Merge Linked	

The Flatten Image command combines the detail of all visible layers into a single layer. In the process transparent areas are filled with white and hidden layers are discarded.

After flattening, text, shape and adjustment layers are no longer present nor are their contents editable. The file size of the flattened picture will be much smaller than the layered version. To flatten your image select the option from the Layer menu (1) or from the menu that pops out from the More button in the Layers palette (2).

As a general rule you should not flatten the layers in Elements documents unless you are absolutely sure that you do not want to edit the picture further. If you are unsure, make a copy of the layered file and flatten the copy, keeping the original safe for editing later. Also, if you have vector layers such as text or shapes and want to print them at the highest quality possible then do not flatten the image.

Flip Horizontal

Menu: Editor: Image > Rotate > Flip Horizontal		
Shortcut: -	**OS:** Mac, Windows	
Version: 1, 2, 3, 4	**See also:** Flip Layer Horizontal	

The Flip Horizontal command rotates the picture (and all its layers) from left to right and creates a result similar to a reflection of the photo in a mirror.

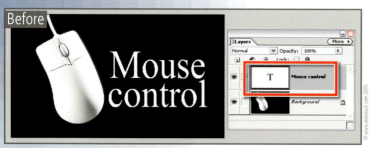

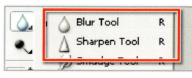

Flip Layer Horizontal

Menu: Editor: Image > Rotate > Flip Layer Horizontal	
Shortcut: -	**OS:** Mac, Windows
Version: 1, 2, 3, 4	**See also:** Flip Horizontal

The Flip Layer Horizontal command rotates the selected layer from left to right and creates a result similar to a view of the reflection of the layer contents in a mirror.

Flip Layer Vertical

Menu: Editor: Image > Rotate > Flip Layer Vertical	
Shortcut: -	**OS:** Mac, Windows
Version: 1, 2, 3, 4	**See also:** Flip Vertical

The Flip Layer Vertical command rotates the layer from top to bottom and produces a result similar to the view of the layer and its contents when it was flipped upside down.

Focus tools

Menu: -	
Shortcut: R	**OS:** Mac, Windows
Version: 1, 2, 3, 4	**See also:** Blur tool, Sharpen tool

The Focus tool group contains the Blur and Sharpen tools. The tools are used like a paintbrush but instead of laying down color on the canvas the image is blurred (1) or sharpened (2).

The Size (brush tip), Mode (blend mode) and Strength settings for the tool are all controlled in the options bar.

When using these tools most professionals apply repeated low strength strokes to build up the effect rather than a single application using a high strength setting.

Flip Vertical

Menu: Editor: Image > Rotate > Flip Vertical	
Shortcut: -	**OS:** Mac, Windows
Version: 1, 2, 3, 4	**See also:** Flip Layer Vertical

The Flip Vertical command rotates the picture (and all its layers) from top to bottom and produces a result similar to the view of the picture if it was flipped upside down.

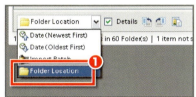

Folder View

Menu:	-	
Shortcut:	-	**OS:** Windows
Version:	4	**See also:** Date view, Import Batch view

Along with both the Date and Import Batch views, the thumbnails in the Photo Browser can be displayed in Folder view. This option shows a folder tree representation of your computer on the left side of the browser workspace. Change to this viewing mode by selecting the Folder Location entry from the drop-down menu at the bottom left of the workspace (1). Whilst in this mode clicking on a thumbnail will automatically reveal the folder where the photo is stored (2).

Font size

Menu:	-	
Shortcut:	-	**OS:** Mac, Windows
Version:	1, 2, 3, 4	**See also:** Fonts, selecting

The size of the text you place in your image files is measured as pixels, millimeters or points.

I find the pixel setting most useful when working with digital files, as it indicates to me the precise size of my text in relationship to the whole image. Millimeter and points values, on the other hand, vary depending on the resolution of the picture and the resolution of the output device.

Some of you might be aware that 72 points approximately equals 1 inch, but this is only true if the picture's resolution is 72 dpi. At higher resolutions the pixels are packed more closely together and therefore the same 72 point type is smaller in size.

To change the units of measurement used for type, go to the Units & Rulers option in the Preferences menu and then select the Type measure unit you want from the drop-down type menu (1).

To set the size of your font before adding the text to the picture input the value in the Font Size section of the options bar.

To change font size of existing type select the type and then alter the font size value.

Font styles and families

Menu:	-	
Shortcut:	-	**OS:** Mac, Windows
Version:	1, 2, 3, 4	**See also:** Faux fonts

The Font Family is a term used to describe the way that the letter shapes look. Most readers would be familiar with the difference in appearance between Arial and Times Roman. These are two different families each containing different characteristics that determine the way that the letter shapes appear (1).

The font style refers to the different versions of the same font family. Most fonts are available in regular, italic, bold and bold italic styles (2).

Both font characteristics, family and style, can be altered via the items on the Type options bar.

You can download new fonts from specialist websites to add to your system. After downloading, the fonts should be installed into the fonts section of your system directory. Windows and Macintosh users will need to consult their operating system manuals to find the preferred method for installing new fonts on their computer.

Fonts, selecting

Menu:	-	
Shortcut:	-	**OS:** Mac, Windows
Version:	1, 2, 3, 4	**See also:** Font size, Font styles and families

You can select the typeface or font family in one of two ways: by choosing the family along with other type characteristics in the options bar, before adding the text to the picture; alternatively you can select the existing text and then choose a different typeface (1).

Fonts WYSIWYG

Menu: -	
Shortcut: -	**OS:** Windows
Version: 4	**See also:** -

New for version 4.0 is the WYSIWYG (What You See Is What You Get) preview that is displayed on the Text tool font menu. Now you can see an example of how the letter shapes for each font family appear right in the menu itself. You can change the size of the font preview in the Type Preferences (Preferences > Type > Font Preview Size). The default is Medium.

Foreground color

Menu: -	
Shortcut: -	**OS:** Mac, Windows
Version: 1, 2, 3, 4	**See also:** Background color

Photoshop Elements bases many of its drawing, painting and filter effects on two colors – the foreground and background colors. The currently selected foreground and background colors are shown at the bottom of the toolbox as two colored swatches. The topmost swatch (1) represents the foreground color, the one beneath (2) the hue for the background.

The default for these colors is black and white but it is possible to customize the selections at any time. Double-click the swatch and then select a new color from the color picker window (5).

To switch foreground and background colors click the double-headed curved arrow at the top right (3) and to restore the default (black and white) click the mini swatches bottom left (4).

Fragment filter

Menu: Editor: Filter > Pixelate > Fragment	
Shortcut: -	**OS:** Mac, Windows
Version: 1, 2, 3, 4	**See also:** Filters

The Fragment filter, as one of the group of Pixelate filters, breaks the picture into smaller sections and slightly offsets these parts. The change is often very subtle and only obvious at high magnification or when applied to a low resolution file. There are no extra controls for altering the look or strength of the effect.

Frame, select a

Menu: Editor: File > Print Multiple Photos	
Shortcut: Alt Ctrl P	**OS:** Windows
Version: 3, 4	**See also:** Print

One of the features of the Print Multiple Photos option introduced in Elements 3.0 is the ability to add a frame to your picture before printing. Elements ships with a range of pre-made frames that can be added, automatically sized and rotated directly from the Print Photos dialog.

Simply select the picture to print and then choose the Print Multiple Photos (even if it is only one image) to open the dialog. After setting the print options select the frame from the list provided before pressing Print. Frames are only available for the Picture Package and Label options.

Frame From Video command

Menu: Editor: File > Import > Frame From Video	
Shortcut: -	**OS:** Mac, Windows
Version: 2, 3, 4	**See also:** -

With more and more still digital cameras providing movie options it is no wonder that Adobe included a feature that enables you to grab frames of your favorite video. Called the Frame From Video feature, the option allows you to review your footage and select specific still frames to send to Elements.

To make photos from your own video start by selecting the feature from the File > Import menu or from the Camera or Scanner button in the Mac Welcome screen.

When the Frame From Video dialog appears click the Browse option to search for and locate your movie files. If the videos are stored in the AVI, MPEG or WMV formats you should be able to display the first frame of the movie as a thumbnail. This will make the task of selection easier. Click on the file and select the Open button.

Using the VCR buttons (play, forward, reverse, stop and pause) at the bottom of the dialog play the video to locate the sections that contain the images you want.

Click the Grab Frame button to capture the video frame as a still image (1) and then pass it to the Elements workspace. Alternatively you can use the slider control to move through the video sequence, stopping to Grab as you go. Once you are happy with your selection(s) click Done.

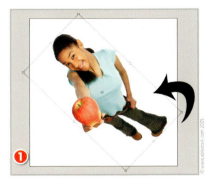

Free Rotate Layer

Menu:	Editor: Image > Rotate > Free Rotate Layer
Shortcut: -	OS: Mac, Windows
Version: 1, 2, 3, 4	See also: Rotate

The Free Rotate Layer option allows you to spin the contents of a layer around a pivot point. After selecting the command a bounding box surrounds the layer and the mouse pointer changes to a curved arrow to indicate that it is in Rotate mode. When you click-drag the mouse the layer rotates (1).

By default the pivot point is in the center of the layer, but you can select a new position for this point by clicking onto one of the corner or side boxes in the reference point diagram (2) in the options bar.

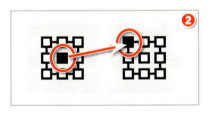

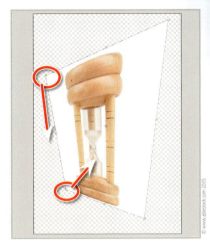

Free Transform command

Menu:	Editor: Image > Transform > Free Transform
Shortcut: Ctrl/Cmd T	OS: Mac, Windows
Version: 1, 2, 3, 4	See also: Distort, Perspective, Skew

The Image > Transform menu contains four options that allow you to change the shape of your pictures from their standard rectangle format. The Free Transform feature is one of these options but unlike the others, which tend to only allow one style of change, Free Transform can be used to scale, rotate, distort, skew or even apply a perspective change to your picture. After selecting the feature you may be prompted to change the background to a standard layer ready for transformation. Click Yes in this dialog.

Use the following key stroke combinations to change the shape of your layer:

Scale – Click-drag any of the bounding box handles. To scale proportionately hold the Shift key down whilst dragging.

Rotate – Move the mouse pointer outside the bounding box and click-drag to rotate.

Distort – Ctrl/Cmd-click-drag a bounding box handle to distort.

Skew – Shft-Ctrl/Cmd-click-drag a bounding box handle to skew.

Perspective – Ctrl/Cmd-Alt/Opt-Shft-click-drag to apply perspective changes.

When completed either double-click on the transformed layer or press the Enter key to 'commit' the changes. To cancel press the Esc key.

You cannot apply Distort or Perspective to Type layers.

Freehand selection

Menu: -	
Shortcut: L	OS: Mac, Windows
Version: 1, 2, 3, 4	See also: Lasso

Freehand selection is another term for the style of selection created with the Lasso tool, as the effectiveness and accuracy of the selection is largely dependent on the drawing (mouse-moving) abilities of the user.

It was for this reason that Adobe developed the Magnetic Lasso, which is designed to stick to the edges of picture parts as you draw.

Professionals whose work regularly requires them to make freehand selections often use a Stylus and Graphics tablet as they find the approach more natural and more akin to drawing with a pencil.

Full Screen view

Menu:	Photo Browser: View > View Photos in Full Screen
Shortcut: F11	OS: Windows
Version: 4	See also: -

Starting life as the Photo Review feature in version 3.0, the View Photos in Full Screen option provides an instant slide show of the files that you have currently displayed in the Photo Browser. With the provided controls you can play, pause or advance to next or last photos, enlarge or reduce the size of the picture, automatically enhance, add and remove tags, mark the files for printing and add the file to a chosen collection. Specific picture properties such as tag, history and metadata are available by hitting the Alt + Enter keys to display the Properties window.

Gaussian Blur filter

Menu: Editor: Filter > Blur > Gaussian Blur	
Shortcut: -	**OS:** Mac, Windows
Version: 1, 2, 3, 4	**See also:** Blur

The Gaussian Blur filter, as one of the group of Blur filters, softens the look of photos, producing a blur effect that is similar to out of focus pictures.

This filter is often used to blur the background of photographs, producing an artificial shallow Depth of Field effect. To reproduce these results select the area to be blurred first and then apply the filter.

Unlike the Blur and Blur More options, the Gaussian Blur filter provides a slider control that governs the strength of the effect (1).

Get Photos

Menu: Photo Browser: File > Get Photos	
Shortcut: Shft Ctrl G	**OS:** Windows
Version: 3, 4	**See also:** Open

The Organizer, in Photo Browser view, creates the thumbnails that it displays during the process of adding your photographs to a collection. Adding your photos to a collection starts with the Get Photos command and includes a range of options for the source of these pictures.

To start your first collection simply select the View and Organize option from the Welcome screen and then proceed to the File > Get Photos menu option. Select one of the listed sources of pictures provided and follow the steps and prompts in the dialogs that follow.

Get Photo sources:

Camera or Card Reader

This will probably be the most frequently used route for your images to enter the Elements program.

Here you can make use of the Adobe Photo Downloader dialog to transfer and catalog picture files from your camera or memory card (in a reader) to your computer.

Scanner

The Get Photos > From Scanner option enables users to obtain images directly from the scanners they have connected to their computers.

Files and Folders

Acting much like the File > Open option common to most programs this selection provides a familiar window that allows you to search for and catalog photos that are already on your computer or on CDs, data DVDs, or external Hard Drives.

Mobile Phone

It is no surprise given the availability of phone-cameras that Adobe has seen fit to include a new 'Get Photos > From Mobile Phone' option in Elements 3.0.

The option does not link your computer directly to your mobile phone, you will need the software that came with the unit for that, but rather watches the default folder where your phone pictures are downloaded and automatically catalogs pictures stored here.

Online Sharing Service

After a simple, and free, sign-up procedure users can upload web-friendly copies of pictures directly to a sharing and print service hosted by www.ofoto.com. Once stored online the files can be shared with friends and relatives. This 'Get Photos' option provides access to these online sharing files .

Searching

The Get Photos > By Searching option provides a speedy way to locate all the folders connected to your computer that contain pictures that you may want to add to your Photo Browser catalogs.

PhotoDeluxe and ActiveShare Albums

Users of both PhotoDeluxe and ActiveShare products can incorporate the contents of the Albums created with these programs into their Elements Photo Browser.

After selecting the appropriate option from the Get Photos menu, Elements will locate and list the albums found in the folder you are searching.

Once selected the images are then imported into the Photo Browser and organized automatically according to date.

General Fixes (Quick Fix)

Menu: -	
Shortcut: -	**OS:** Mac, Windows
Version: 3, 4	**See also:** Standard Editor, Lighting,

The Quick Fix Editor is home for many of the automatic or 'quick and easy' enhancement tools. You can access and apply the features via the menu system or take advantage of the controls displayed in the Palette Bin (1).

The controls include:

General fixes – Smart Fix and Red Eye fix.

Lighting – Levels, Contrast, Shadows/Highlights/Midtone Contrast.

Color – Saturation, Hue, Temperature, Tint.

Sharpen – Sharpen amount.

For most controls you can let the program apply the changes for you by pressing the Auto button, or you can take control of the changes you apply by using the slider control.

Also included in the Quick Fix dialog are several tools grouped in a toolbar (2) to the left. These are the Zoom, Move and Crop tools as well as the Red Eye, Magic Selection and Selection Brushes.

GIF format

Menu: -	
Shortcut: -	**OS:** Mac, Windows
Version: 1, 2, 3, 4	**See also:** JPEG, Save for Web

The GIF format is used to optimize logos and graphics for use on web pages. The format supports up to 256 colors (8-bit), transparency (2), LZW compression and simple animation.

When converting a full color picture to GIF the number of colors is reduced and mixed using one of four options – Selective, Perceptual, Adaptive and Restrictive, or Web (1). The Dither option (4) helps simulate continuous tone by mixing patterns of dots. The total number of colors (3) used in the final file can also be set in the dialog. Save images in the GIF format by selecting the GIF option in the Save for Web feature (1) or via the Compuserve GIF format option in the Save As option.

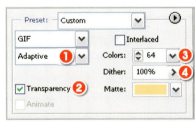

Glass filter

Menu: Editor: Filter > Distort > Glass	
Shortcut: -	**OS:** Mac, Windows
Version: 1, 2, 3, 4	**See also:** Filters

The Glass filter, as one of the group of Distort filters, simulates the texture of a picture when it is viewed through rippled glass.

The look and style of the ripple is determined by the various controls in the Filter's dialog. The Distortion slider (1) alters the amount of the image that is affected by the glass ripple. The Smoothness control (2) adjusts the sharpness of the ripple detail and the Texture menu (3) contains a series of options for the style of glass used in the filter. The Scaling slider (4) controls the size of the glass elements used to distort the picture and the Invert setting (5) switches the way that the effect is applied.

GIF – Selective

GIF – Adaptive

GIF – Perceptual

GIF – Restrictive (Web)

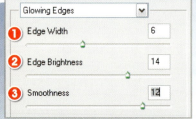

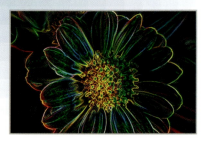

Before

After

Glowing Edges filter

Menu: Editor: Filter > Stylize > Glowing Edges	
Shortcut: -	**OS:** Mac, Windows
Version: 1, 2, 3, 4	**See also:** -

The Glowing Edges filter, as one of the group of Stylize filters, searches for and draws neon-like colored lines around the edges of picture elements.

The edges in the picture are used as the basis for the effect, with the three settings in the dialog providing control over how these are located and the style of the drawn neon line.

The Edge Width slider (1) alters the size and dominance of the lines drawn around the edges. The Edge Brightness control (2) alters the brightness of the lines and the balance of light and dark in the picture, and the Smoothness slider (3) adjusts the amount of fine detail in the end result.

Gradient Editor

Menu: -	
Shortcut: G	**OS:** Mac, Windows
Version: 1, 2, 3, 4	**See also:** Gradients

The Gradient Editor dialog is used to adjust the existing gradient options found in the Gradient Picker palette or create and save completely new choices to the feature.

To create a new gradient start by displaying the dialog by clicking the Edit button in the Gradient options bar. Select a preset option (1) to base the new gradient upon. Change colors by double-clicking the color stop (5) and choosing a new color from the Color Picker dialog. Alter the new color's position in the gradient by click-dragging the stop.

Adjust the position of the opacity by click-dragging the opacity stops (2, 3) along the gradient. Change the midpoint of color or opacity changes by click-dragging the midpoint control (4).

To add new color or opacity stops click on the upper or lower side of the gradient. To delete existing stops drag them into the middle of the gradient.

Save the finished gradient by entering a name and pressing the New button. The gradient will be displayed as a new option in the Gradient Picker palette.

Gradient Map adjustment layer

Menu: Editor: Layer > New Adjustment Layer > Gradient Map	
Shortcut: -	**OS:** Mac, Windows
Version: 1, 2, 3, 4	**See also:** Gradient Map filter, Gradients

The Gradient Map adjustment layer works in a similar way to the Gradient Map filter in that it swaps the tone of the picture with the colors of the selected gradient.

Applying the changes via an adjustment layer means that the results are always editable later and the original photograph remains untouched. By double-clicking the layer thumbnail (left side) the Gradient Map dialog opens and displays the original settings that were used in the adjustment layer. These settings can be altered and the adjustment layer reapplied.

The Gradient Map feature in either the filter or adjustment layer form is often used to create a custom conversion of a color image to grayscale. By selecting a simple black to white gradient (1) in the feature the tones in the original image are mapped evenly to the grayscale gradient.

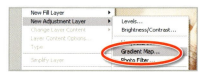

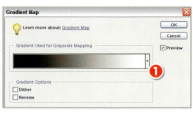

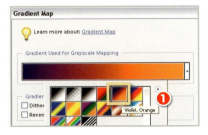

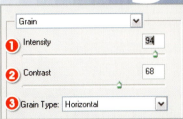

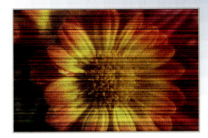

Gradient Map filter

Menu: Editor: Filter > Adjustment > Gradient Map	
Shortcut: -	**OS:** Mac, Windows
Version: 1, 2, 3, 4	**See also:** Gradients, Gradient Map adjustment layer

The Gradient Map filter, as one of the group of Adjustment filters, converts the underlying tones (grayscale information) of the photo to the colors and tones of the selected gradient. The dialog contains options for selecting the gradient to use as the basis of the mapping (1) as well as two checkbox controls.

Dither – For applying a Dither to the gradient to help smooth out changes in color and tone.

Reverse – Switches the mapping process so that dark tones are converted to light tones and light tones to dark.

Linear

Gradients

Menu: -	
Shortcut: G	**OS:** Mac, Windows
Version: 1, 2, 3, 4	**See also:** Gradient Editor

Photoshop Elements has five different gradient types. All the options gradually change color and tone from one point in the picture to another. The choices are:

Linear (1) – Changes color from starting to end point in a straight line.

Radial (2) – Radiates the gradient from the center outwards in a circular form.

Angle gradient (3) – Changes the color in a counter-clockwise direction around the starting point.

Reflection (4) – Mirrors a linear gradient on either side of the drawn line.

Diamond (5) – Changes color from the center outwards in a diamond shape.

To create a gradient start by selecting the tool and then adjusting the controls in the Options palette. Choose the colors from the Gradient Picker drop-down menu (6) and the style from the five buttons to the right (1–5). Click and drag the mouse pointer on the canvas surface to stretch out a line that marks the start and end points of the gradient. Release the button to fill the layer with the selected gradient.

Pro's Tip For a longer transition of tones, drag a longer line – it can extend beyond the canvas; for a more abrupt transition, drag a shorter line.

Grain filter

Menu: Editor: Filter > Texture > Grain	
Shortcut: -	**OS:** Mac, Windows
Version: 1, 2, 3, 4	**See also:** Filters, Film Grain

The Grain filter, as one of the group of Texture filters, simulates the look of the grain of high-speed film.

The look of the effect is adjusted by three settings in the dialog. The Intensity slider (1) alters the density of the grain effect and the Contrast control (2) adjusts the underlying contrast of the whole picture. The Grain Type menu provides a variety of texture options that can be used for filtering. Film grain or Regular is one of the entries but the look of the end result differs greatly with different selections.

With some grain types the current foreground and background colors are used for the grain and background hues. Changing these colors often results in dramatically different results.

Diamond

Reflected

Radial

Angle

Grayscale

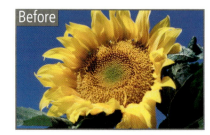

Before

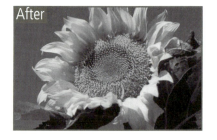

Monochrome

After

© www.ablestock.com 2005

Graphic Pen filter

Menu: Editor: Filter > Sketch > Graphic Pen	
Shortcut: -	**OS:** Mac, Windows
Version: 1, 2, 3, 4	**See also:** Filters

The Graphic Pen filter is one of the group of Sketch filters. The feature simulates the effect of making a drawing of the photograph with a thin graphic arts pen. Close, overlapping strokes are used for the shadow areas, midtones are represented by balancing strokes and with the paper color showing through, and highlight details are drawn with a few sparse strokes. The filter uses the current foreground color to draw the lines. The dialog gives you control over the balance of light and dark – paper and stroke (2) and the length of the pen stroke (1) used to draw the picture. There is also a drop-down menu for selecting the direction of the pen strokes (3).

Grayscale images

Menu: -	
Shortcut: -	**OS:** Mac, Windows
Version: 1, 2, 3, 4	**See also:** -

Grayscale images, in computer terms, are those photos that contain no color. These pictures contain a series of gray tones from pure black through to white. The more tones that exist between the black and white points the smoother any graduations in the picture will be. The photographic equivalent of a grayscale picture is a black and white photograph.

Sometimes the term Monochrome is used to describe grayscale photos because they only contain a single (mono) color (chrome) – black on a white background. However, monochrome can also refer to photos that use a color other than black for the tones.

Grayscale mode

Menu: Editor: Image > Mode > Grayscale	
Shortcut: -	**OS:** Mac, Windows
Version: 1, 2, 3, 4	**See also:** Color modes

It is possible to change the color mode of your picture by selecting a different mode from the Image > Mode menu (1).

A picture that is in Grayscale mode contains no color at all and supports a total of 256 levels of gray, with a value of 0 being black and 256 being white.

When converting a color photograph to Grayscale mode in Elements 3.0 you may need to confirm that you wish to lose all the color in the photo. Clicking OK to this request will lose the picture's three color channels (RGB) and retain tone and detail in a single gray channel (2).

Graphics Tablet

Menu: -	
Shortcut: -	**OS:** Mac, Windows
Version: 1, 2, 3, 4	**See also:** -

Many professionals prefer to work with a stylus and tablet when creating complex masks. The extra options provided by the pressure sensitivity of the stylus along with the familiar 'pencil and paper' feeling makes using this approach more intuitive and often faster than using a mouse.

Most drawing and painting tools as well as the Magnetic Lasso in Photoshop Elements have a Tablet Options (1) section on their options bar which contains a range of settings that can be activated to function with the stylus or pen pressure.

Grid

Menu: Editor: View > Grid
Shortcut: - **OS:** Mac, Windows
Version: 1, 2, 3, 4 **See also:** Rulers

The Grid is available in both the Quick Fix and Standard editing spaces. With the grid displayed and the Snap to Grid option (View > Snap to Grid) selected objects will automatically align with grid lines and intersections when being moved or sized.

The grid is often used in conjunction with the Rulers (View > Rulers) feature to help align and size objects and picture parts.

The color, style and spacing of the grid can be adjusted via the Grid section of the Edit > Preferences dialog (Windows) or the Photoshop Elements > Preferences dialog (Mac).

Group with Previous command

Menu: Editor: Layer > Group with Previous
Shortcut: Ctrl/Cmd G **OS:** Mac, Windows
Version: 1, 2, 3, 4 **See also:** Layers

The Group with Previous command combines the contents of two layers using a clipping group. The feature is often used to insert the contents of one layer into the non-transparent areas of another. The example shows the winter image, top layer, being clipped by the letter shapes (non-transparent areas) of the bottom layer.

This occurs because all the layers in the clipping group have the opacity attributes and blend mode of the bottom-most layer.

You can create a clipping group in three different ways:

1. Select the top layer and then choose Layer > Group with Previous.

2. Link the layers using the Chain icon in the Layers palette and then select Layer > Group Linked (version 1.0, 2.0, 3.0).

3. Hold down the Alt/Opt key whilst you click on the boundaries between the two layers that you wish to group.

Grow, selection

Menu: Editor: Select > Grow
Shortcut: - **OS:** Mac, Windows
Version: 1, 2, 3, 4 **See also:** Expand, Contract

As well as the options listed under the Select > Modify menu, an active selection can also be altered and adjusted using the Grow and Similar commands.

The Select > Grow feature increases the size of an existing selection by incorporating pixels of similar color and tone to those already in the selection. For a pixel to be included in the 'grown' selection it must be adjacent to the existing selection and fall within the current tolerance settings located in the options bar (1).

Halftone Pattern filter

Menu: Editor: Filter > Sketch > Halftone Pattern	
Shortcut: -	**OS:** Mac, Windows
Version: 1, 2, 3, 4	**See also:** Filters, Color Halftone

The Halftone Pattern filter, as one of the group of Sketch filters, simulates the look of a picture that has been printed using a halftone or screened pattern. The filter provides similar looking results to the Color Halftone feature except here the pattern is created in monochrome and is based on the current foreground and background colors. Another difference is that the filter contains a Preview window and the ability to change the pattern type (3).

The size of the pattern element (1), dot or line, and the overall contrast of the effect (2) is controlled by the sliders in the dialog. The pattern type can be switched between dot (4), line (5) or circle (6) options.

Hand tool

Menu: -	
Shortcut: H	**OS:** Mac, Windows
Version: 1, 2, 3, 4	**See also:** Move

The Hand tool helps users navigate their way around images.

This is especially helpful when the image has been 'zoomed' beyond the confines of the screen. When a picture is enlarged to this extent it is not possible to view the whole image at one time; using the Hand tool the user can drag the photograph around within the window frame.

You can invoke the Hand tool at any time by pressing the Spacebar (except when using the Type tool).

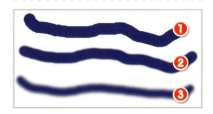

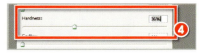

Hardness option

Menu: -	
Shortcut: B	**OS:** Mac, Windows
Version: 1, 2, 3, 4	**See also:** Brush

Hardness (4) is one of the options from the Additional Brush Options palette which is displayed when the More Options button is pressed. The slider control adjusts the softness of the edge of the brush tip. A setting of 100% (1) produces a sharp-edge brush stroke, 50% moderately soft (2) and 1% a very soft brush stroke (3).

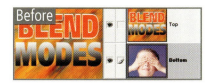

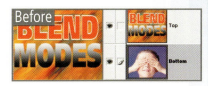

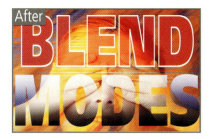

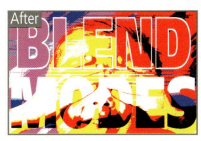

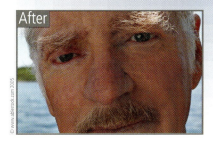

Hard Light blending mode

Menu: –		
Shortcut: –		**OS:** Mac, Windows
Version: 1, 2, 3, 4		**See also:** Blend modes

The Hard Light blending mode is one of the group of Overlay modes that base their effects on combining the two layers depending on the tonal value of their contents.

This option is similar to the Overlay mode but produces a more dramatic and sometimes more contrasty result. The content of the top layer is either Screened or Multiplied depending on its color and tonal value. If the tone in the top layer is lighter than 50% then this section of the bottom layer is screened (lightened); if the tone is darker, then it is multiplied (darkened).

Blending with 50% gray produces no change. When combined with the High Pass filter this blend mode is used to create editable sharpening effects that don't use any of the sharpening filters.

Hard Mix blending mode

Menu: –		
Shortcut: –		**OS:** Mac, Windows
Version: 1, 2, 3, 4		**See also:** Blend modes

The Hard Mix blending mode is one of the group of Overlay modes that base their effects on combining the two layers depending on the tonal value of their contents. This option is similar to the Overlay mode but produces a more dramatic, contrasty and posterized result. The luminosity of the top layer is combined with the color of the bottom to produce a picture with large flat areas of dramatic color (maximum colors 8). Lowering the opacity of the top layer (Hard Mix layer) reduces the posterization effects. Blending with 50% gray produces no change.

The Hard Mix option can be used to add a high contrast sharpening effect to a picture. Blur a duplicate layer of the original and then change to Hard Mix and adjust the layer's opacity to control the degree of contrast and sharpening.

Healing Brush

Menu: -		
Shortcut: J		**OS:** Mac, Windows
Version: 3, 4		**See also:** Spot Healing Brush

The Healing Brush is designed to work in a similar way to the Clone tool; the user selects the area (Alt/Option-click) to be sampled before painting and then proceeds to drag the brush tip over the area to be repaired.

The tool achieves such great results by merging background and source area details as you paint. Just as with the Clone Stamp tool, the size and edge hardness of the current brush determine the characteristics of the Healing Brush tool tip (1).

One of the best ways to demonstrate the sheer power of the Healing Brush is to remove the wrinkles from an aged face. In the example, the deep crevices of the fisherman's face have been easily removed with the tool. The texture, color and tone of the face remain even after the 'healing' work is completed because the tool merges the new areas with the detail of the picture beneath.

Help

Menu:	Editor: Help > Photoshop Elements Help	
	Photo Browser: Help > Photoshop Elements Help	
Shortcut: F1		**OS:** Mac, Windows
Version: 3, 4		**See also:** Hints, Context Help

The completely revised Photoshop Elements Help system provides a variety of ways to present you with the knowledge you need.

The Help window contains Contents, Index and Glossary tabs, buttons for navigating backwards and forwards through help topics, and for displaying the help's home page and printing help topics, and a place to search for all entries on a specific topic.

The window lists the help topics on the left and the contents of the selected entry on the right.

You can access the new Help Center by selecting Photoshop Elements' Help option from the Help menu, entering a search item in the space on the Shortcuts bar or pressing the Help button also located here, clicking the links in tooltips or clicking Help buttons in dialog boxes, and via context menus and palette menus.

Shown

Text layer shown

Radius: 22.2 pixels
①

Hidden ①

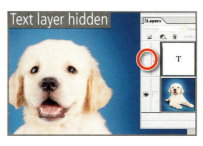
Text layer hidden

Hiding palettes

Menu: -
Shortcut: Tab
OS: Mac, Windows
Version: 1, 2, 3, 4
See also: Palette Bin

Open palettes can be hidden and re-displayed by pressing the Tab key (1).

To close the palette altogether click the red 'X' in the top right corner of the Palette window. Alternatively palettes open in the workspace can be dragged to the Palette Bin, which can be shown or hidden by clicking or dragging on the bin's boundary (resize bar).

Hiding/Showing layers

Menu: Editor: Window > Layers
Shortcut: -
OS: Mac, Windows
Version: 1, 2, 3, 4
See also: Layers

The Photoshop Elements Layers palette displays all the layers in your picture and their settings in the one dialog box. Layers can be turned off by clicking the eye symbol on the far left of the layer so that it is no longer displayed. This action removes the layer from view but not from the stack. You can turn the layer back on again by clicking the eye space. You can Alt/Option-click on an Eyeball icon to show all layers or just that layer.

High Pass filter

Menu: Editor: Filter > Other > High Pass
Shortcut: –
OS: Mac, Windows
Version: 1, 2, 3, 4
See also: Filters

The High Pass filter, as one of the group of Other filters, isolates the edges in a picture and then converts the rest of the picture to mid gray. The filter locates the edge areas by searching for areas of high contrast or color change.

The filter contains a single slider, Radius (1), that controls the filtering effect. When the Radius value is set to low only the most prominent edge detail is retained and the remainder of the picture converted to gray. Higher values produce a result with less of the picture converted to gray.

The combination filter effects of edge finding and changing picture parts to gray makes this feature a tool that is often used for advanced sharpening techniques like the one detailed here.

Before High Pass Sharpening

After High Pass Sharpening

1

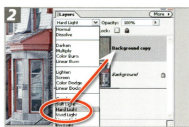
2

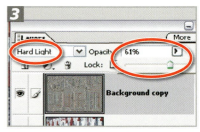
3

Make a copy (Layer > Duplicate Layer) of the picture layer that you want to sharpen. Filter the copied layer with the High Pass filter (Filter > Other > High Pass) and press OK.

With the filtered layer still selected switch the blend mode to Hard Light. This mode blends both the dark and light parts of the filtered layer with the picture layer, causing an increase in contrast.

Adjust the opacity of this layer to govern the level of sharpening. Sharpening using this technique means that you can remove or adjust the strength of the effect later by manipulating the filtered layer.

Magic Wand

Selects part of an image based on the similarity in color of adjacent pixels (the Tolerance setting in the options bar controls the range of colors selected). The magic wand is useful for selecting odd-shaped areas without having to trace a complex outline using a selection tools.

Related topics

Using the magic wand tool

Moving or inverting a selection border

Hints

Menu: Window > Hints (ver.2.0)	
Shortcut: -	**OS:** Mac, Windows
Version: 1, 2, 3, 4	**See also:** How To, Recipes

The Hints feature provides instant descriptions and help for the tool or feature that you are currently using.

In versions 1.0 and 2.0 of the program the Hint details were displayed in a special Hints palette. The palette was located in the Palette Well or under the Window menu.

In version 3.0 of the program the same information can be found by clicking the help or hyperlink associated with the feature or tool.

Hints palette

Menu: Window > Hints	
Shortcut: -	**OS:** Mac, Windows
Version: 1, 2	**See also:** Hints

In developing Elements Adobe has designed a range of learning aids that can help you increase your skills and understanding of the program.

One such feature is the Hints palette, which is located in the Palette Well or under the Window menu. When open this window shows information about the tool or menu currently selected.

The Hints function is an extension to the Help system and offers the user a more detailed explanation of the item, and tutorials related to the tool or menu selected by clicking the More button.

In version 3.0 of Elements hints are more contextual and can be found hyperlinked with the associated tool or feature.

Histogram

Menu: Editor > Window > Histogram	
Shortcut: -	**OS:** Mac, Windows
Version: 1, 2, 3, 4	**See also:** Levels

The first step in taking charge of your pixels is to become aware of where they are situated in your image and how they are distributed between black and white points.

The Histogram palette displays a graph of all the pixels in your image. The left-hand side represents the black values (1), the right the white end of the spectrum (3) and the center section the midtone values (2). In a 24-bit image (8 bits per channel) there are a total of 256 levels of tone possible from black to white – each of these values is represented on the graph.

The number of pixels in the image with a particular brightness or tone value is displayed on the graph by height. The higher the spike at any point the more pixels of this value are present in the picture.

History states

Menu: Editor: Window > Undo History
Shortcut: - **OS:** Mac, Windows
Version: 1, 2, 3, 4 **See also:** Undo History Palette

Each editing or enhancement step that is performed on a picture in Elements is stored as a history state in the Undo History palette. The total number of states that can be stored is determined by the History States setting in the general area Preferences dialog. Once this number has been reached the oldest state is deleted to make way for the latest image change. Clicking on an earlier state will restore the picture to the way it was when the state was first added to the palette.

Horizontal Type tool

Menu: -
Shortcut: T **OS:** Mac, Windows
Version: 1, 2, 3, 4 **See also:** Type

The Elements Type tool provides the option to apply text horizontally across the page, or vertically down the page.

To place text onto your picture, select the Horizontal Type tool from the toolbox. Next, click onto the canvas in the area where you want the text to appear.

Do not be too concerned if the letters are not positioned exactly, as the layer and text can be moved later.

Once you have finished entering text you need to commit the type to a layer. Until this is done you will be unable to access most other Elements functions.

To exit the Text Editor, either click the 'tick' button (1) in the options bar or press the Control + Enter keys in Windows (2) or Command + Return for a Macintosh system.

How To palette

Menu: Editor: Window > How To
Shortcut: - **OS:** Mac, Windows
Version: 1, 2, 3, 4 **See also:** Hints

The How To palette, also known as the Recipes palette in version 1.0 of Elements, is an inbuilt tutorial system designed to take you step by step through a range of common enhancement and editing activities.

Rather than just simple text-by-text instruction, the Recipes are interactive. If you are unable or unsure how to perform a specific step, then you can ask the program to 'Do this step for me'.

To make best use of the feature, keep the palette open whilst performing each step on your own image.

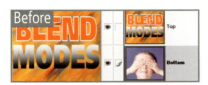

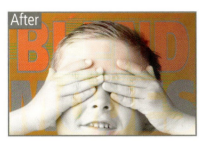

Hue blend mode

Menu: –	
Shortcut: –	**OS:** Mac, Windows
Version: 1, 2, 3, 4	**See also:** Blend Modes

The Hue blend mode is one of the group of modes that base their effects on combining the hue (color), saturation (color strength) and luminance (tones and details) of the two layers in different ways.

This option combines the Hue of the top layer with the Saturation and Luminance of the bottom.

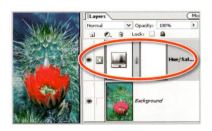

Hue/Saturation adjustment layer

Menu: Editor: Layer > New Adjustment Layer > Hue/Saturation	
Shortcut: -	**OS:** Mac, Windows
Version: 1, 2, 3, 4	**See also:** Hue/Saturation

The Hue/Saturation adjustment layer provides the same functionality as the Adjust Hue/Saturation feature. Manipulating the picture with an adjustment layer rather than directly means that the original picture is always kept intact and you can always change the settings of the adjustment later by double-clicking on the left-hand layer thumbnail.

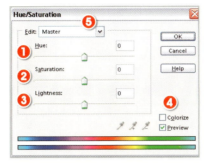

Hue/Saturation, adjust

Menu: Editor: Enhance > Adjust Color > Adjust Hue/Saturation	
Shortcut: Ctrl/Cmd U	**OS:** Mac, Windows
Version: 1, 2, 3, 4	**See also:** Color Variations

To understand how this feature works you will need to think of the colors in your image in a slightly different way. Rather than using the three-color model (Red, Green, Blue) that we are familiar with, the Hue/Saturation control breaks the image into different components – Hue or color, Saturation or color strength, and Lightness (HSL).

The dialog itself displays slider controls for each component, allowing the user to change each factor independently of the others. Moving the Hue control (1) along the slider changes the dominant color of the image. From left to right, the hue's changes are represented in much the same way as colors in a rainbow. Alterations here will provide a variety of dramatic results, most of which are not realistic and should be used carefully. Moving the Saturation slider (2) to the left gradually decreases the strength of the color until the image is converted to a grayscale. In contrast, adjusting the control to the right increases the purity of the hue and produces images that are vibrant and dramatic. The Lightness slider (3) changes the density of the image and works the same way as the Brightness slider in the Brightness/Contrast feature. The Colorize option (4) converts a colored image to a monochrome made up of a single dominant color and black and white.

If Master (5) is selected in the Edit menu, changes will affect the entire image. You can also select different color ranges from the menu and changes will affect only the selected color range.

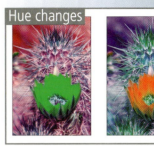
Before

95

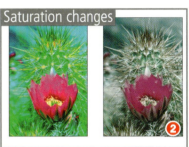
Hue changes

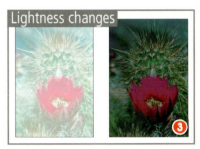
Saturation changes

Lightness changes

Colorize changes

Changes to Greens only

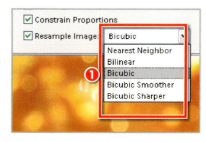

ICC profiles

Menu: -	
Shortcut: -	OS: Mac, Windows
Version: 1, 2, 3, 4	See also: Color Settings

Essentially color management is concerned with describing the characteristics of each device in the editing chain. This includes cameras, scanners, screens, editing software and printers.

This description, often called an ICC profile, is then used to translate image detail and color from one device to another.

Pictures are tagged, when they are first created (via camera or scanner), with a profile and when downloaded to a computer, which has a profiled screen attached, the image is translated to suit the characteristics of the monitor.

With the corrections complete the tagged file is then sent to the printer, where the picture is translated again to suit the printer's profile.

Through the use of a color-managed, ICC profile-based system we can maintain predictable color throughout the editing process and from machine to machine.

Image Interpolation

Menu: -	
Shortcut: -	OS: Mac, Windows
Version: 1, 2, 3, 4	See also: Image Size, Bicubic

A file with the same pixel dimensions can have several different document sizes based on altering the spread of the pixels when the picture is printed (or displayed on screen). In this way you can adjust a high-resolution file to print the size of a postage stamp, postcard or a poster by only changing the dpi or resolution. This type of resizing has no detrimental quality effects on your pictures as the original pixel dimensions remain unchanged.

This said, in some circumstances it is necessary to increase or decrease the number of pixels in an image. Both these actions will produce results that have less quality than if the pictures were scanned or photographed at precisely the desired size at the time of capture.

As this isn't always possible, Elements can increase or decrease the image's pixel dimensions using tools such as the Image Size or the Scale features. Each of these steps requires the program to interpolate, or 'make up', the pixels that form the resized image.

Interpolation is a process by which the computer program reduces or increases the number of pixels in the picture. To achieve this, the color and brightness levels of the existing pixels are averaged and used as a basis for creating new pixels according to a specific algorithm. When resizing pictures in Elements you can select from several different interpolation algorithms (1). These options are available in the Image Size feature.

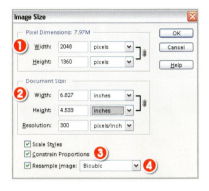

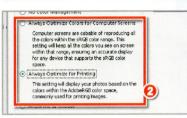

Image Size command

Menu: Editor: Image > Resize > Image Size
Shortcut: - **OS:** Mac, Windows
Version: 1, 2, 3, 4 **See also:** Canvas Size

The Image Size dialog provides several options for manipulating the number of pixels in your photograph and how big it prints.

At first glance the settings displayed here may seem a little confusing, but if you can make the distinction between the Pixel Dimensions of the image (1) and the Document Size (2), it will be easier to understand.

Keep in mind:

Pixel Dimensions represent the true digital size of the file.

Document Size is the physical dimensions of the file represented in inches (or centimeters) based on using a specific number of pixels per inch (resolution or dpi).

To keep the ratio of width and height of the new image the same as the original, tick the Constrain Proportions checkbox (3).

To change resolution, open the Image Size dialog and uncheck the Resample Image option (4). Next, change either the resolution, width or height settings to suit your output.

To increase the pixels or upsize the image, tick the Resample Image checkbox (4) and then increase the value of any of the dimension settings in the dialog. To decrease the pixels or downsize the image, decrease the value of the dimension settings.

Image Space, color management

Menu: -
Shortcut: - **OS:** Mac, Windows
Version: 1, 2, 3, 4 **See also:** Print

The Image, or Source, Space refers to the ICC profile that a picture has been tagged with. The profile might have been attached at the time of capture or added later but it is this image space profile that allows the image to be correctly displayed and printed.

So when shooting make sure that any color-management or ICC profile settings in the camera are always turned on (1). This will ensure that the pictures captured will be tagged with a profile. Those readers shooting film and converting to digital with scanners should search through the preference menus of their scanners to locate, and activate, any inbuilt color-management systems here as well. This way scanned pictures will be tagged as well.

Next, to ensure that Elements is correctly using the image space, make sure that the Full Color Management option (version 2.0 and 3.0) or either the Print or Screen Optimization (2) options is selected in the Color Settings dialog of the program. This ensures that tagged pictures coming into the work space are correctly interpreted and displayed ready for editing and enhancement.

It also guarantees that when it comes time to print, Elements can correctly translate your on-screen masterpieces into a format that your printer can understand (3).

Import command

Menu: Editor: File > Import
Shortcut: - **OS:** Mac, Windows
Version: 1, 2, 3, 4 **See also:** Open

The Import menu located under the File heading lists a range of sources for importing images into Elements. Acting much like the Import TWAIN feature found in older software, the feature links installed cameras and scanners with Elements and allows the user to control the driver software from inside the editing package.

The import sources listed under the menu normally include the following:

Installed scanners/cameras – Use the scanner driver or camera download software to import pictures from either of these device types.

Frame From Video – Import still frame from video footage.

WIA Support – Most cameras that are designed to connect to Windows computers are supplied with a WIA or Windows Image Acquisition driver that is used for downloading pictures from these devices.

PDF Image (version 3.0) – Imports the pictures that are stored as part of a PDF file.

The Import list for version 4.0 (1) does not contain the PDF option that was available in version 3.0 (2). Instead users can select the PDF file format from within the File > Open window.

Note: The exact contents of the import menu list are determined by the scanners or cameras that you have installed on your computer.

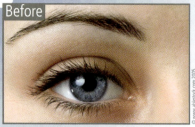

Before

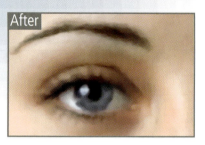

After

© www.ablestock.com 2005

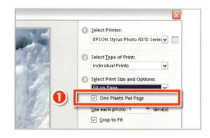

① Select Printer:
EPSON Stylus Photo R310 Serie

② Select Type of Print:
Individual Prints

③ Select Print Size and Options:
Fit on Page

❶ One Photo Per Page
Use each photo 1 time(s)
Crop to Fit

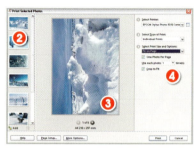

Indexed Color

Palette: Local (Perceptual) ❶

OK
Cancel

Colors: 256

Forced: None

☑ Transparency

☑ Preview

Options

Matte: None

Dither: Diffusion

Amount: 75 %

☐ Preserve Exact Colors

❷

Print Selected Photos

① Select Printer:
EPSON Stylus Photo R310 Serie

② Select Type of Print:
Individual Prints

③ Select Print Size and Options:
Fit on Page

One Photo Per Page
Use each photo: 1 time(s)
Crop to Fit

❷ ❹

❸

1 of 5
A4 210 x 297 mm

Help Page Setup... More Options... Print Cancel

Impressionist Brush tool

Menu: -
Shortcut: B **OS:** Mac, Windows
Version: 1, 2, 3, 4 **See also:** Brush

In addition to the standard painting options such as Brush, Paint Bucket, Pencil and Airbrush, Elements has a specialist Impressionist Brush tool that allows you to repaint existing images with a series of stylized strokes.

By adjusting the Special Paint Style, Area, Size and Tolerance options, you can create a variety of painterly effects on your images.

To use the Impressionist Brush select it from the toolbox (hidden under the Brush tool in Versions 4.0 and 3.0). Select Brush size, Mode and Opacity from the options bar (1). Set the Style, Area and Tolerance values from the More Options palette (2). Then, drag the brush over the image surface to paint.

Create Photo Browser Date Vie

Size: 20 px Mode: Normal Opacity: 47% ❶

More Options: ❷

Style: Tight Short

Area: 50 px

Tolerance: 0%

Indexed Color mode

Menu: Editor: Image > Mode > Indexed Color
Shortcut: - **OS:** Mac, Windows
Version: 1, 2, 3, 4 **See also:** Color Mode

The Indexed Color mode can support up to 256 different colors and is the default color mode for the GIF file format.

When a full color picture is converted to the Index mode the colors used are drawn from a special palette (1). The options for this change are are:

Exact – For pictures with 256 colors or less where the exact colors are used in the converted file.

System (Mac OS) and **System (Windows OS)** – Use the System palette.

Web – Uses a special set of 216 colors that can be displayed by all computer systems.

Uniform – Uses a palette of colors that have been evenly sampled from the RGB color space.

Perceptual – Uses a color set that gives priority to colors that the human eye is more sensitive to.

Selective – Similar to perceptual but also favors the web color set.

Adaptive – Builds a set of colors from those most present in the original picture.

Custom – Create your own palette of colors using the Color Table dialog box.

Previous – Uses the previous custom palette.

The dialog also has options to allow you to: select the total number of colors to present in the final conversion, force specific colors to be included; add transparency, select a matte color; and choose a dither type (2).

Individual Prints

Menu: Editor: File > Print Multiple Photos
Shortcut: Alt/Opt Ctrl P **OS:** Windows
Version: 3, 4 **See also:** Print Preview

First introduced in Elements 3.0 for Windows is the ability to set up and print several individual photographs at one time. Until the release of this edition of the program the traditional Print Preview dialog (Editor: File > Print) was the only way you could print one photo on a page.

This approach is fine if all you want to do is print a single photo, but what if you have 10 pictures that you want to print quickly and easily? Well this is where the Individual Prints option (1) in the Print Multiple Photos feature comes into play. This option allows the user to 'batch' (2) a variety of one-image-to-one page photos at the same time.

Though you don't have as many options when outputting your picture with this feature you can still choose the size of the photo on the page (3) and whether it will be cropped in order to fill the paper size fully (4). And for those times when you need a couple of prints of a group of pictures simply change the number of times the pictures will be used in the print batch.

Before

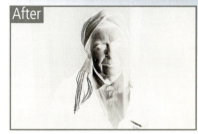

After

Info palette

Menu: Editor: Window > Info
Shortcut: – **OS:** Mac, Windows
Version: 1, 2, 3, 4 **See also:** -

The Info palette provides a variety of information about the open document. With the palette displayed, moving a tool pointer over the canvas surface will show details of the pixels beneath the tool tip.

The details are displayed in five sections of the palette:

(1, 2) First and second color readouts displayed in Grayscale, RGB, WEB or HSB color.

(3) Mouse coordinates displayed in pixels, millimeters, centimeters, inches, points, picas or percent.

(4) Width and height of marquee displayed in pixels, millimeters, centimeters, inches, points, picas or percent.

(5) File information such as document size, profile or dimensions and scratch sizes, efficiency, timing and current tool. In version 4.0 you can choose which info to show by selecting the checkboxes of the Status Info options you want displayed in the Info palette.

The units used for each display section are set via the pop-out menu displayed when the More button (top right) is pressed.

Ink Outlines filter

Menu: Editor: Filter > Brush Strokes > Ink Outlines
Shortcut: - **OS:** Mac, Windows
Version: 1, 2, 3, 4 **See also:** Filters

The Ink Outlines filter, as one of the group of Brush Strokes filters, draws fine black ink lines over the edge details of the original picture.

Three controls in the filter's dialog allow adjustment of the filtering process and results.

The length of the stroke used in the outlining process can be varied with the Stroke Length slider (1).

The Dark Intensity (2) and Light Intensity (3) sliders provide control over the brightness and contrast of the final result. When low values are used for both sliders a low contrast picture results. Conversely, higher settings produce a more contrasty result overall.

Invert adjustment layer

Menu: Editor: Layer > New Adjustment Layer > Invert
Shortcut: - **OS:** Mac, Windows
Version: 1, 2, 3, 4 **See also:** Layers, Invert

The Invert adjustment layer produces a negative version of your image. The feature literally swaps the values of each of the image tones.

When used on a grayscale image the results are similar to a black and white negative. However, this is not true for a color picture as the inverted picture will not contain the typical orange 'mask' found in color negatives.

Manipulating the picture with an adjustment layer rather than directly means that the original picture is always kept intact and you can always change the settings of the adjustment later by double-clicking on the left-hand layer thumbnail.

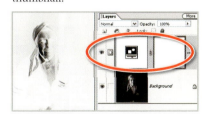

Invert filter

Menu: Editor: Filter > Adjustment > Invert
Shortcut: Ctrl/Cmd I **OS:** Mac, Windows
Version: 1, 2, 3, 4 **See also:** Filters

The Invert filter, as one of the group of Adjustment filters, reverses all the tones and colors in the picture, creating a negative effect.

No controls are available for the user to adjust the strength or style of the effect. The filter changes are applied immediately after the filter is selected from the menu.

JPEG format

Menu: Editor: File > Save As,
Editor: File Save for Web
Shortcut: Shft Ctrl/Cmd S **OS:** Mac, Windows
Alt/Opt Shft Ctrl/Cmd S
Version: 1, 2, 3, 4 **See also:** Save for Web

JPEG is a file format designed by the Joint Photographic Experts Group to use with pictures destined for the web or e-mail.

This format provides high levels of compression for photographic images. For instance, a 20Mb digital file can be compressed in the JPEG format so that it can be e-mailed quickly and easily to anywhere in the world.

To achieve this level of compression the format uses a lossy compression system, which means that some of the image information is lost during the compression process.

In Elements, photos can be saved in the JPEG format via dialogs in the Save As or Save for Web commands. The amount of compression is governed by a slider control (1) in the dialog box. The lower the number or the smaller the file, the higher the compression and more of the image will be lost in the process. You can also choose to save the image as a standard 'baseline', optimized or progressive image (2). This selection determines how the image will be drawn to screen when it is requested as part of a web page. The baseline image will draw one pixel line at a time, from top to bottom. The progressive image will show a fuzzy image to start with and then progressively improve as more information about the image comes down the line.

JPEG2000

Menu: Editor: File > Save As
Shortcut: Shft Ctrl/Cmd S **OS:** Mac, Windows
Version: 1, 2, 3, 4 **See also:** JPEG

The original JPEG format is more than a decade old and despite its popularity it is beginning to show its age. So in 2000 the specification for a new version of JPEG was released.

The revision, called JPEG2000, uses wavelet technology to produce smaller (by up to 20%), sharper files with less artifacts than traditional JPEG. The standard also includes options to use different compression settings and color depths on selections within images, as well as making it possible to save images in lossless form.

Photoshop Elements enables you to save in the JPEG2000 format via the Save As command. The feature's dialog contains a settings section (1), setting for the download preview (2) and a preview image (3).

The format also supports layer transparency, saved selections, ICC profiles, metadata, and 16-bit/channel images.

Labels, print

Menu: Editor: File > Print Multiple Photos	
Photo Browser: File > Print	
Shortcut: Alt Ctrl P	**OS:** Windows
Version: 3, 4	**See also:** Print

This feature was first introduced in Elements 3.0 for Windows. It is a multi-photo printing option that lays out and sizes images to suit the design of commercially available sheets of adhesive labels (1). Located in the Print Multiple Photos feature, the Labels option is an item on the drop-down menu in section 2 (Select Type of Print) of the dialog (2).

The Layout box contains a variety of label sheet designs and, just as with the Picture Package feature, you can add frames to your label photos.

To help with precise aligning of the print to the label sheet Adobe has also included an Offset print settings box. Here you can make slight adjustments of where the pictures print on the paper surface.

If the print is misaligned to the left then add a positive number to the settings; if the error is to the right then you will need to add a negative number to the dialog.

Lasso tools

Menu: -	
Shortcut: L	**OS:** Mac, Windows
Version: 1, 2, 3, 4	**See also:** Polygonal Lasso, Magnetic Lasso

As the name suggests, the Lasso tools are designed to capture picture parts by surrounding them with a drawn selection area (1).

The standard Lasso tool (2) works like a pencil, allowing the user to draw freehand shapes for selections. In contrast, the Polygonal Lasso tool draws straight-edge lines between mouse-click points. Either of these features can be used to outline and select irregular-shaped image parts.

A third version of the tool, the Magnetic Lasso, helps with the drawing process by aligning the outline with the edge of objects automatically.

For most tasks, the Magnetic Lasso is a quick way to obtain accurate selections, so it is good practice to try this tool first when you want to isolate specific image parts.

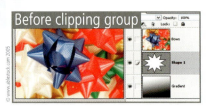

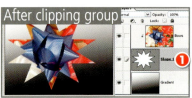

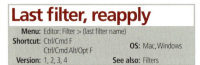

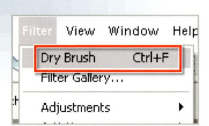

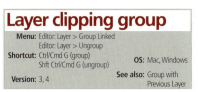

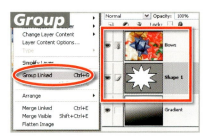

Last filter, reapply

Menu: Editor: Filter > (last filter name)
Shortcut: Ctrl/Cmd F
Ctrl/Cmd Alt/Opt F **OS:** Mac, Windows
Version: 1, 2, 3, 4 **See also:** Filters

Once a filter has been used to change the appearance of a picture, it can be reapplied using the same settings by selecting the filter's name from the top of the Filter menu. As a shortcut alternative the Ctrl and F keys can be pressed (Command F for Macintosh).

To reapply the last filter but allow for the settings to be changed via the filter's dialog use the Ctrl Alt F keystroke combination (Command Option F for Macintosh).

Layer clipping group

Menu: Editor: Layer > Group Linked
Editor: Layer > Ungroup
Shortcut: Ctrl/Cmd G (group)
Shft Ctrl/Cmd G (ungroup) **OS:** Mac, Windows
Version: 3, 4 **See also:** Group with
Previous Layer

A layer clipping group is a set of layers that are displayed through a mask. The bottom-most layer is used as the mask with solid areas (picture parts) displaying the contents of the grouped layers above and the transparent areas letting the layers beneath show through.

In this way the feature is often used to insert the contents of one layer into the non-transparent areas of another. The example shows the bow image (top layer) being clipped by the star shape layer (non-transparent areas) of the middle layer with the bottom gradient layer showing through.

Only the bow and the shape layers are part of the clipping group. The effect occurs because all the layers in the clipping group have the opacity attributes and blend mode of the bottom-most layer in the group (1).

You can create a clipping group in three different ways:

1. Select the top layer and then choose Layer > Group with Previous.

2. Link the layers using the Chain icon in the Layers palette and then select Layer > Group Linked.

3. Hold down the Alt/Opt key whilst you click on the boundaries between the two layers that you wish to group.

To ungroup a set of layers, select the bottom layer in the group (name underlined) and then choose Layer > Ungroup.

To make a clipping group, first link the layers to include in the group, ensuring that the bottom-most layer is the one to be used as the mask. Next select Layer > Group Linked.

To ungroup the layers in a clipping group, select the base layer for the group (the one underlined) and then choose Layer > Ungroup.

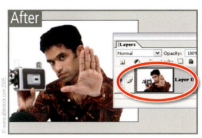

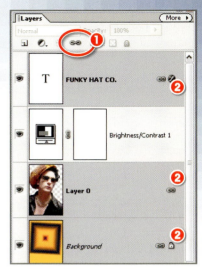

Layer Content Options

Menu: Editor: Layer > Layer Content Options	
Shortcut: -	**OS:** Mac, Windows
Version: 3, 4	**See also:** Change Layer Content

The settings used for an existing adjustment, shape or fill layer can be changed at any time by selecting the Layer > Layer Content option (1) and altering the values in the dialog that is displayed.

Double-clicking on the layer thumbnail of the adjustment layer is an alternative way to display the same dialog (2).

The settings used when first creating the layer are shown in the dialog, allowing the user to fine-tune, or change altogether, the enhancement effects.

Layer From Background

Menu: Editor: Layer > Layer From Background	
Shortcut: -	**OS:** Mac, Windows
Version: 1, 2, 3, 4	**See also:** Background layer

The bottom-most layer of any layer stack is called the background layer. By default this layer is locked, which means that you cannot change its position in the layer stack, its opacity or the blend mode.

In order to make changes to the content of the background layer it must be first converted to a standard image layer.

This can be achieved by making the background layer active (click on the layer) and then choosing the Layer From Background option from the Layer menu (1). Alternatively, double-clicking the background layer in the Layers palette will perform the same function.

 Holding down the Alt key while you double-click the background layer skips the new layer dialog.

Layer linking

Menu: -	
Shortcut: -	**OS:** Windows
Version: 4	**See also:** Layers

Version 4.0 introduces a new way to select and link layers in the Layers palette.

Layers can be linked by simply selecting and then clicking the Link layers button (button) in the top of the palette (1). This action places the Chain icon next to each of the layers that are linked together (2).

This new method of linking layers can now be multi-selected directly in the palette. Holding the Shift button down whilst selecting will choose all the layers in a sequence (consecutive layers in the stack). Using the Ctrl key whilst selecting chooses individual layers only.

Layers can also be linked, unlinked or already linked layers selected via the Linked layer options in the pop-up menu accessed via the More button (3) at the top right of the Layers palette.

Before

After

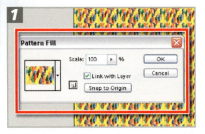
1

Change how adjustment layers merge with the image layer beneath by editing the layer mask. Start by creating a fill layer such as Pattern to the image. Then check to see that the default colors (white and black) are selected for the Elements foreground and background colors.

If the mask is selected in the Layers palette, the default colors will change to black and white by themselves.

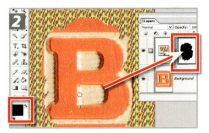
2

Select the Brush tool with black as the foreground color, click onto the layer mask thumbnail and paint onto the patterned surface. The pattern is removed, the picture beneath shows through and a black mark now appears in the layer thumbnail corresponding to your painting actions.

3

Painting with white as your foreground color restores the mask and paints back the pattern. You can experiment with transparent effects by painting on the mask with gray. The lighter the gray the more the pattern will dominate, the darker the gray the less the pattern will be seen.

100% opacity

50% opacity

0% opacity

Layer mask

Menu: -	
Shortcut: -	**OS:** Mac, Windows
Version: 1, 2, 3, 4	**See also:** Adjustment Layer, Brush

Each time you add a fill or adjustment layer to an image two thumbnails are created in the Layers palette. The one on the left controls the settings for the adjustment layer (1). The thumbnail on the right represents the layer's mask that controls how the adjustment is applied to the picture (2).

The mask is a grayscale image. When it's colored white no part of the layer's effects are masked or held back from the picture below. Conversely, if the mask thumbnail is totally black then none of the layer's effects are applied to the picture. Shades of gray equate to various levels of transparency. In this way the adjustment or fill layer can be selectively merged with the picture beneath by painting (in black and white and gray) directly on the layer mask thumbnail.

Pro's Tip

You can use the X key to switch between black and white as the foreground color.

Pressing Shift + Alt whilst clicking the mask thumbnail will show the ruby lith.

Layer opacity

Menu: -	
Shortcut: -	**OS:** Mac, Windows
Version: 1, 2, 3, 4	**See also:** Layers

The opacity or transparency of each layer in Elements can be changed independently. Depending on the level of opacity the parts of the layer beneath will become visible.

Change the opacity of each layer by moving the slider (1) in the Layers palette. A value of 100% means the layer is completely opaque, 50% translates to half transparent and 0% means that it is fully transparent.

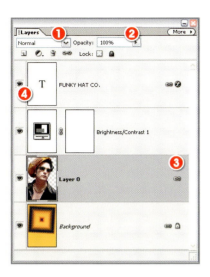

Layer Smart Object

Menu: -		
Shortcut: -	**OS:** Windows	
Version: 4	**See also:** Layers	

Elements 4.0 supports the display of the Smart Objects introduced into Photoshop CS2. The objects are embedded in a special layer and can be moved within the layer stack but can't be created or edited in Photoshop Elements.

Layers palette

Menu: Editor: Window > Layers		
Shortcut: -	**OS:** Mac, Windows	
Version: 1, 2, 3, 4	**See also:** Layers	

The Layers palette displays all your layers and their settings in the one place. Display the palette by selecting Window > Layers.

Individual layers are displayed, one on top of the other, in a 'layer stack'. The composite image you see in the workspace is viewed from the top down through the layers. Each layer is represented by a thumbnail on the left and a name on the right.

You can edit or enhance only one layer at a time. To select the layer that you want to change you need to click on the layer. At this point the layer will change to a different color from the rest in the stack and is now called the active layer (3).

Layers can be hidden from display in the workspace by clicking the eye symbol (4) on the far left of the layer so that it is no longer showing. This action removes the layer from view but not from the stack. You can redisplay the layer by clicking the eye space again.

The blend mode (1) and opacity (2) of individual layers can be altered using the controls at the top of the palette. New layers (5) as well as new adjustment layers (6) can be created by clicking the buttons just below the blend and opacity controls. The Dustbin button (7) is used to delete unwanted layers, the Chain icon to link layers (8) and the Lock Transparency and Lock All (9) buttons are used to restrict layer changes.

Layer Styles

Menu: Editor: Window > Styles and Effects		
Shortcut: -	**OS:** Mac, Windows	
Version: 1, 2, 3, 4	**See also:** Styles and Effects	

Layer styles are a set of preset effects that can be applied to the contents of a layer by simply clicking a thumbnail in the Layer Styles section of the Styles and Effects palette.

When a style is applied to the contents of a layer a small 'f' appears to the right end of the layer in the palette. The style effects are now linked with the layer and will move and change as the content is edited.

Multiple styles can be applied to a single layer and their effects can be cleared or hidden using the options in the Layer > Layer Styles menu.

The settings used for the style can be adjusted using the Layer > Layer Styles> Style Settings dialog.

Layer via Copy

Menu: Editor: Layer > New > Layer via Copy		
Shortcut: Ctrl/Cmd J	**OS:** Mac, Windows	
Version: 1, 2, 3, 4	**See also:** Layers, Layer via Cut	

The Layer via Copy command creates a new layer and copies the contents of the current selection onto it.

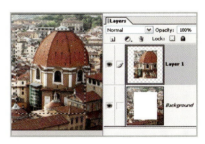

Layer via Cut

Menu: Editor: Layer > New > Layer via Cut		
Shortcut: Shft Ctrl/Cmd J	**OS:** Mac, Windows	
Version: 1, 2, 3, 4	**See also:** Layers, Layer via Copy	

The Layer via Cut command cuts the contents of a selection, creates a new layer and pastes it into the layer.

If the detail is cut from a background layer then the empty space is filled with the background color. When the detail is cut from a layer the space is left transparent.

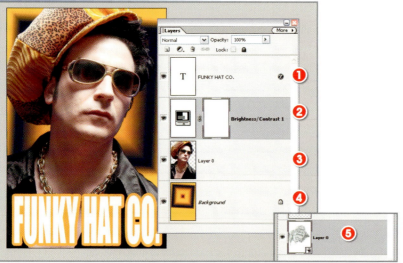

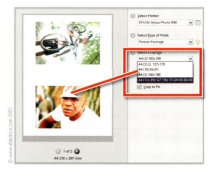

Layers

Menu: Editor: Window > Layers
Shortcut: - **OS:** Mac, Windows
Version: 1, 2, 3, 4 **See also:** Background layer

Digital photographs are flat files with all the picture parts contained in a single document. Unless you are undertaking complex editing and enhancement tasks many pictures remain this way until they are printed, but Elements also contains the ability to use layers with your pictures.

This feature releases your images from having to keep all their information in a flat file. Different image parts, added text and certain enhancement tasks can all be kept on separate layers. The layers are kept in a stack and the image you see on screen in the work area is a composite of all the layers.

Sound confusing? Well try imagining, for example, that each of the image parts of a simple portrait photograph are stored on separate plastic sheets. These are your layers. The background sits at the bottom. The portrait is laid on top of the background and the text is placed on top. When viewed from above the solid part of each layer obscures the picture beneath. Whilst the picture parts are based on separate layers they can be moved, edited or enhanced independently of each other.

When layered files are saved in the PSD file format all the layers will be preserved and present the next time the file is opened.

Elements supports the following layer types:

Image layers – This is the most basic and common layer type and contains any picture parts or image details. Background is a special type of image layer (3).

Text layers – Designed solely for text, these layers allow the user to edit and enhance the text after the layer has been made (1). They are vector-based layers and must be simplified (rasterized) to apply a filter or paint on.

Adjustment layers – These layers alter the layers that are arranged below them in the stack. They act as a filter through which the lower layers are viewed (2). You can use adjustment layers to perform many of the enhancement tasks that you would normally apply directly to an image layer without changing the image itself.

Fill layers – Users can also apply a Solid Color, Gradient or Pattern to an image as a separate layer. These three selections are available as a separate item (Layer > New Fill Layer) under the Layer menu or grouped with the Adjustment Layer options via the Quick button at the bottom of the Layers palette.

Shape layers – Drawing with any of the shape tools creates a new vector-based shape layer. The layer contains a thumbnail for the shape as well as the color of the layer.

Background layers – An image can only have one background layer. It is the bottom-most layer in the stack. No other layers can be moved beneath this layer and you cannot adjust this layer's opacity or its blending mode (4).

Smart Object Layer (version 4.0 only) - A special layer that contains a Photoshop CS2 Smart Object. Elements cannot create or edit smart objects (5).

By default Elements classifies a newly downloaded picture as a background layer. You can add extra 'empty' layers to your picture by clicking the New layer button at the bottom of the Layers palette. The new layer is positioned above your currently selected layer. Actions, such as adding text with the Type tool, automatically create a new layer for the content. When selecting, copying and pasting image parts, Elements also creates a new layer for the copied portion of the picture.

Layout, select a

Menu: Editor: File > Print Multiple Photos
Photo Browser: File > Print
Editor: File > Picture Package (Macintosh)
File Browser: Automate > Picture Package (Macintosh)
Shortcut: Alt/Opt Ctrl/Cmd P (Editor) **OS:** Mac, Windows
Ctrl/Cmd P (Browser)
Version: 1, 2, 3, 4 **See also:** Print

When printing several images using the Print Multiple Photos and Picture Package features it is possible to select from a variety of different layout options.

After selecting the printer and choosing Picture Package for the type of print, a list of layouts will be available as a drop-down menu in the Select a Layout section of the dialog.

The images selected in the Photo Browser or currently open in the Editor will be automatically inserted into the layout. New pictures can be added by clicking the Add photos button (bottom left) and then dragging the photo onto the layout. Add multiple copies of the same picture by dragging the photo from the thumbnail list onto the layout several times.

The range of layout options available is based on the paper size and format selected in the printer settings.

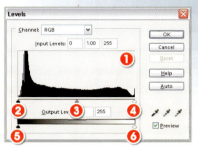

Leading, type

Menu: -	
Shortcut: -	**OS:** Mac, Windows
Version: 3, 4	**See also:** Type

Originally referring to the small pieces of lead that were placed in-between lines of metal type used in old printing processes, nowadays it is easier to think of the term referring to the space between lines of text. Smaller values reduce the space between lines (1) and larger numbers increase this space (2). Elements 3.0 includes the ability to alter the leading of the type input in your documents. The leading control can be found in the Type options bar (3). Start with a value equal to the font size you are using and increase or decrease from here according to your requirements.

Lens Flare filter

Menu: Editor: Filter > Render > Lens Flare	
Shortcut: -	**OS:** Mac, Windows
Version: 1, 2, 3, 4	**See also:** Filters

The Lens Flare filter, as one of the group of Render filters, adds a bright white spot to the surface of photos in a way that resembles the flare from light falling on a camera lens.

This filter is often used when light sources such as the sun, a street lamp or car headlights are part of the picture.

The Filter dialog contains a preview thumbnail on which you can position the center of the flare by click-dragging the crosshairs (1). Also in the dialog is a brightness or strength slider (2) and a selection of lens types to choose from (3).

Levels command

Menu: Editor: Enhance > Adjust Lighting > Levels	
Shortcut: Ctrl/Cmd L	**OS:** Mac, Windows
Version: 1, 2, 3, 4	**See also:** Shadow/Highlights

Looking very similar to the Histogram, this feature allows you to interact directly with the pixels in your image.

As well as a graph (1), the dialog contains two slider bars. The one directly beneath the graph has three triangle controls for black (2), midtones (3) and white (4), and represents the input values of the picture.

The slider at the bottom of the box shows output settings, and contains black (5) and white (6) controls only.

To distribute the picture tones across the whole of the spectrum, drag the input shadow (left end) and highlight (right end) controls until they meet the first set of pixels at either end of the graph. When you click OK, the pixels in the original image are redistributed using the new white and black points.

Altering the midtone control will change the brightness of the middle values of the image, and moving the output black and white points will flatten, or decrease, the contrast.

Clicking the Auto button is like selecting Enhance > Auto Levels from the menu bar.

Use the following guide to help you make tonal adjustments for your images using the Levels feature.

L

107

IL

www.ElementsA-Z.com

Five down lights

Contrast increase

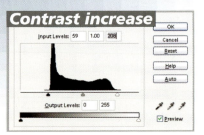

To increase contrast – Move the input black and white controls to meet the first group of pixels.

Contrast decrease

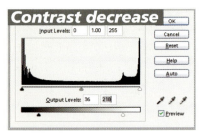

To decrease contrast – Move the output black and white points towards the center of the slider.

Darken midtones

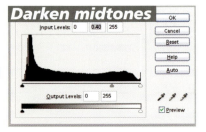

To make middle values darker – Move the input midtone control to the right.

Lighten midtones

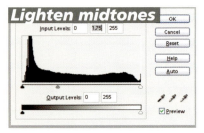

To make middle values lighter – Move the input midtone control to the left.

Before

Lighten blending mode

Menu: -	
Shortcut: -	OS: Mac, Windows
Version: 1, 2, 3, 4	See also: Blend modes

The Lighten blending mode is one of the group of Lighten modes that base their effects on combining the light tones of the two layers.

Both top and bottom layers are examined and the lightest tones of either layer are kept whilst the darker values are replaced. This mode always produces a lighter result.

Spotlight

Lighting Effects filter

Menu: Editor: Filter > Render > Lighting Effects	
Shortcut: -	OS: Mac, Windows
Version: 1, 2, 3, 4	See also: Filters

The Lighting Effects filter, as one of the group of Render filters, simulates the look of various light sources shining onto the picture surface. Single or multiple light sources can be added to the photo.

The Filter dialog contains a preview thumbnail that is used to adjust the position, shape and size of the projected light (1). The rest of the dialog is broken into four different control sections:

Style (2) – Provides a drop-down menu of predesigned light styles along with any customized styles you have created and saved.

Light Type (3) – Alters the color, intensity and focus of the selected light.

Properties (4) – Contains controls for how the subject reacts to the light.

Texture Channel (5) – Has options for creating texture with the light shining onto the photo.

This feature is often used for creating, or enhancing existing, lighting type effects on the main subject in a picture.

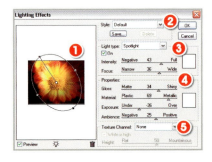

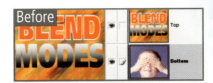

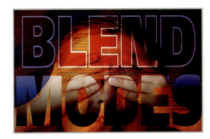

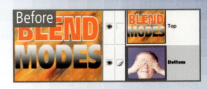

Lighting, Quick Fix Editor

Menu: Photo Browser: Edit > Go to Quick Fix
Shortcut: - **OS:** Windows
Version: 3, 4 **See also:** Shadow/Highlights

The Quick Fix Editor provides a single place to access many of the adjustment tools needed to regularly enhance your pictures.

The Lighting section (4) contains Auto Levels (1) and Contrast (2) buttons which work in the same way as their namesakes found in the Enhance menu of the Standard Editor. Clicking these buttons provides automatic adjustment and distribution of picture tones with the Levels control additionally providing some color cast correction as well.

Also included are the three sliders that together make up the Shadows/Highlights feature. Manual adjustment of these controls provides incremental enhancement of shadows, highlights and midtone contrast (3).

Linear Burn blending mode

Menu: -
Shortcut: - **OS:** Mac, Windows
Version: 1, 2, 3, 4 **See also:** Blend modes

The Linear Burn blending mode is one of the group of Darken modes that base their effects on darkening the picture by adjusting the brightness of the blended image.

This option analyzes the brightness of the details in top and bottom layers and darkens the bottom layer to reflect the tone of the top layer.

The filter always produces a darker effect and blending with a white top layer produces no change.

Linear Dodge blending mode

Menu: -
Shortcut: - **OS:** Mac, Windows
Version: 1, 2, 3, 4 **See also:** Blend modes

The Linear Dodge blending mode is one of the group of Lighten modes that base their effects on lightening the picture by adjusting the brightness of the blended image.

This option analyzes the brightness of the details in top and bottom layers and brightens the bottom layer to reflect the tone of the top layer.

The filter always produces a lighter effect and blending with a black top layer produces no change.

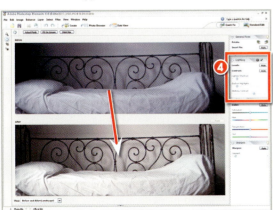

Linear Gradient

		U
	Rectangle Tool	U
	Rounded Rectangle Tool	U
	Ellipse Tool	U
	Polygon Tool	U
	Line Tool	U
	Shape Selection Tool	U

Linear Gradient tool

Menu: -
Shortcut: G **OS:** Mac, Windows
Version: 1, 2, 3, 4 **See also:** Gradients

Photoshop Elements has five different gradient types. All the options gradually change color and tone from one point in the picture to another.

The linear gradient (1) changes color from starting to end point in a straight line.

To create a gradient, start by selecting the tool and the linear gradient type (2). Then adjust the controls in the Options palette.

Choose the colors from the Gradient Picker drop-down menu and the style from the five buttons to the right.

Click and drag the mouse pointer on the canvas surface to stretch out a line that marks the start and end points of the gradient. Release the button to fill the layer with the selected gradient.

Linear Light blending mode

Menu: -
Shortcut: - **OS:** Mac, Windows
Version: 1, 2, 3, 4 **See also:** Blend modes

The Linear Light blending mode is one of the group of Overlay modes that base their effects on combining the two layers depending on the tonal value of their contents.

This option combines both burning and dodging of the picture in the one mode.

If the tone in the top layer is lighter than 50% then this section of the bottom layer is lightened; if the tone is darker, then it is darkened.

Blending with 50% gray produces no change.

Lines

Menu: -
Shortcut: U **OS:** Mac, Windows
Version: 1, 2, 3, 4 **See also:** Arrowheads, Shape tool

The Line tool is one of the vector-based shape tools. Unlike the Brush or Pencil tools, which draw with pixels, the lines created with this tool are always sharp-edged and high quality.

To create a line with the tool click and drag on the canvas surface. Holding down Shift when drawing restricts the tool to drawing straight lines at intervals of 45°.

The options bar for the tool contains the following settings:

Arrowhead start and end – Determines which end of the line an arrowhead will be added. Leaving the boxes unchecked creates a line with no arrowheads.

Arrowhead width and length – Sets the width of the arrowhead at the base and the overall length of the head based on a percentage of the line weight.

Concavity – Determines the degree to which the arrowhead is concaved as a percentage of the total length of the head.

Weight – Controls the thickness of the line in pixels.

Color – Sets the line color.

Style – Determines if a layer style is automatically added to the line as it is drawn.

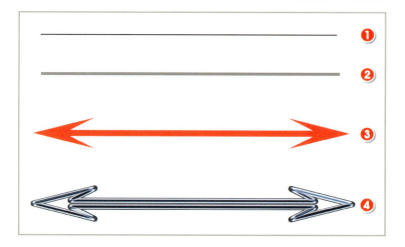

(1) 3 pixels weight, black.
(2) 10 pixels weight, gray.
(3) 20 pixels weight, red, arrowheads start and end.
(4) 20 pixels weight, chrome style, arrowheads start and end.

Liquify filter

Menu: Editor: Filter > Distort > Liquify	
Shortcut: -	**OS:** Mac, Windows
Version: 1, 2, 3, 4	**See also:** Filters

The Liquify filter, as one of the Distort group of filters, allows the user to push, pull, rotate, reflect, pucker and bloat the whole or a selected part of a picture.

The filter uses a sophisticated dialog containing an interactive preview of your picture that you can directly distort using the tools and Tool options. The effects obtained with this feature can be subtle or extreme depending on how the changes are applied. Stylus and tablet users have extra options and control based on pen pressure.

Loading Brushes

Menu: Editor: Edit > Preset Manager	
Shortcut: -	**OS:** Mac, Windows
Version: 1, 2, 3, 4	**See also:** Brush, Define Brush

New brushes can be added into the Brush Preset palette (Brush tool options bar) by pressing the sideways button at the top of the dialog and then selecting the Load Brushes item from the pop-up menu.

The feature opens a file browser dialog so that you can search for ABR or Adobe Brush files to load. Elements includes a range of predefined brush sets, or ABR files, that can be loaded from the Elements/Presets/Brushes folder.

Alternatively you can create and save your own brush sets using the Edit > Define Brush from Selection feature and the settings in the Tool's option bar.

Loading Gradients

Menu: Editor: Edit > Preset Manager	
Shortcut: -	**OS:** Mac, Windows
Version: 1, 2, 3, 4	**See also:** Gradients, Gradient Editor

Elements is shipped with a variety of gradient styles which are displayed in the Gradient preset palette (Gradient tool options bar). New gradients can be added into the Preset palette by pressing the Sideways button at the top of the dialog and then selecting the Load Gradients item from the pop-up menu.

The feature opens a File Browser dialog so that you can search for GRD or Adobe Gradient files to load. Those GRD files included in Elements can be loaded from the Elements/Presets/Gradients folder.

Alternatively you can create and save your own gradients using the Gradient Editor.

Select the Liquify filter. The dialog opens with a preview in the center, tools to the left and tool options to the right (use the Size, Pressure and Jitter options to control the effects of the tools). Broaden the subject's smile by selecting the Warp tool and dragging the edge of the lips sideways and upwards. Make the brush smaller if too much of the surrounding detail is being altered as well.

Now let's exaggerate the perspective in the existing picture. Select the Pucker tool and increase the size of the Brush to cover the entire bottom of the figure. Click to squeeze in the subject's feet and legs.
Now select the Bloat tool and place it over the upper portion of the subject; click to expand this area. If you are unhappy with any changes you can use the keyboard shortcuts for Edit > Undo (Ctrl/Cmd + Z) to remove the last changes. If you want you can bloat the eyes as well.

To finish the caricature switch back to the Warp tool and drag some hair out and away from the subject's head. You can also use this tool to drag down the chin and lift the cheekbones. The picture can be selectively restored at any point by choosing the Reconstruct tool and painting over the changed area.
Click OK to apply the changes that you have previewed to the fuller image. Depending on the size of the original this can take some time.

Loading Patterns

Menu: -	
Shortcut: S	**OS:** Mac, Windows
Version: 1, 2, 3, 4	**See also:** Patterns, Pattern Stamp tool, Define Pattern

A variety of patterns are pre-loaded in the Elements program when it is shipped. New options can be added into the Pattern Preset palette (Pattern Stamp tool options bar) by pressing the sideways button at the top of the dialog and then selecting the Load Patterns item from the pop-up menu.

The feature opens a File Browser dialog so that you can search for PAT or Adobe Pattern files to load. Those PAT files included in Elements can be loaded from the Elements/Presets/Patterns folder.

Alternatively you can create and save your own patterns using the Edit > Define Pattern from Selection feature.

Patterns can be used with the Paint Bucket and Pattern Stamp tools and are also located as an option in the Fill Layer dialog box.

Load Selection

Menu: Editor: Select > Load Selection	
Shortcut: -	**OS:** Mac, Windows
Version: 1, 2, 3, 4	**See also:** Save Selection

Photoshop Elements thankfully gives you the option to save complex selections so that they can be used again later.

With your selection active choose the Save Selection option from the Select menu. Your selection will now be saved as part of the file.

When you close your file and then open it again later you can retrieve the selection by choosing Load Selection (1) from the same menu.

This feature is particularly useful when making sophisticated multi-step selections, as you can make sequential saves, marking your progress and ensuring that you never lose your work.

The Load Selection dialog also provides you with another way to modify your selections. Here you will find the option to load saved selections in any of the four listed selection modes (2). This provides you with an alternative method for building complex selections which is based on making a selection and then saving it as an addition. In this way you can create a sophisticated selection one step at a time.

Load Swatches

Menu: Editor: Window > Color Swatches	
Shortcut: -	**OS:** Mac, Windows
Version: 1, 2, 3, 4	**See also:** Swatches

A variety of color swatch palettes are supplied with Photoshop Elements. Some are pre-loaded in the Color Swatch palette and can be selected from the drop-down menu at the top left of the palette (1).

Other swatch options – custom colors you have created or downloaded from the Web – can be loaded into the palette by pressing the sideways More button at the top of the dialog and then selecting the Load Color Swatches item from the pop-up menu (2).

The feature opens a File Browser dialog so that you can search for ACO (Swatch) or ACT (Color Table) files to load. Swatch files are generally stored in the Elements/Presets/Color Swatches folder.

Lock all

Menu: -	
Shortcut: -	OS: Mac, Windows
Version: 2, 3, 4	See also: Layers palette, Lock Transparency

Photoshop Elements provides the option to lock layers so that their transparency, pixels or position cannot be changed.

This option is great for fixing the current editing state of a layer so that neither its content nor its position are changed by subsequent enhancement steps.

The Lock All button located at the top of the Layers palette locks and unlocks selected layers (1). A Locked Padlock icon is displayed on the right-hand end of all locked layers (2). A dark-shaded padlock indicates that the layer has been locked with the Lock All button.

To lock a layer, select the layer and click on the Lock All button at the top of the Layers palette. The shaded padlock will be displayed.

To unlock a locked layer, select the layer and then press the Lock All button. The shaded padlock will be removed from the right end of the selected layer.

Lock Transparency

Menu: -	
Shortcut: -	OS: Mac, Windows
Version: 2, 3, 4	See also: Lock All, Layers palette

As well as the option to lock all the attributes of a layer, Elements also provides an option to lock just the transparency of a layer.

Use this locking option to ensure that editing changes do not alter, or impinge upon, the transparent part of the layer.

The Lock Transparent Pixels button located at the top of the Layers palette locks and unlocks selected layers (1). A Locked Padlock icon is displayed on the right-hand end of all locked layers (2). Unlike the shaded Lock All padlock, the Lock Transparency icon is lightly shaded.

To lock the transparency of a layer, select the layer and click on the Lock Transparent Pixels button at the top of the Layers palette. The lightly-shaded padlock will be displayed.

To unlock a layer with its transparency locked, select the layer and then press the Lock Transparent Pixels button. The lightly-shaded padlock will be removed from the right end of the selected layer.

Lossless compression

Menu: -	
Shortcut: -	OS: Mac, Windows
Version: 1, 2, 3, 4	See also: Lossy compression, TIFF

Lossless compression is an approach to reducing the size of picture files that does not lose any image details or quality in the process. The same details are present in pictures after compressing and decompressing as there were in the original file.

At best the lossless approach produces compressed files that are half their original size. Some file formats such as JPEG2000 have options for both lossless and lossy compression (1).

A lossless file format should always be used to save original photos and artwork.

Common file formats that use lossless compression are:

- **TIFF** (available in uncompressed and compressed lossless forms)
- **PNG**
- **GIF** (only supports 256 colors)
- **JPEG2000** (has lossy and lossless options).
- **DNG** (the save to DNG option in the Camera Raw dialog also offers lossless compression of Raw files).

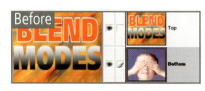

Original file – 2.6Mb

© www.ablestock.com 2005

Before BLEND MODES

BLEND MODES Top

Bottom

JPEG Options

Matte: None

Image Options

Quality: 10 Maximum

small file large file

①

Format Options

Baseline ("Standard")

TIFF compressed – 1.6Mb

Lossy compression

Menu: -	
Shortcut: -	**OS:** Mac, Windows
Version: 1, 2, 3, 4	**See also:** Lossless compression, JPEG, JPEG2000, Save for Web

Lossy compression is an approach to reducing the size of picture files that discards image details and reduces photo quality in the process of creating smaller files.

The Save dialogs for file formats that use this method of compression generally contain a slider control that adjusts picture quality and file compression (1).

In general terms the better the picture quality the larger the files (less compression) and conversely the smaller the file size (most compression) the worse the resultant image quality.

The Elements Save for Web feature contains a visual before and after preview of the results of differing levels of lossy JPEG compression. This provides the opportunity to preview the visual results of the compression to ensure that the degree of quality loss is acceptable.

Picture files can be dramatically reduced in size using lossy compression algorithms, which makes this approach most suitable for shrinking files for Internet work or file transmission. Lossy file formats should not be used as primary archival format.

Common file formats that use lossy compression are:

- **JPEG**
- **JPEG2000** (has lossy and lossless options)
- **Photoshop PDF** (JPEG option)
- **Photoshop TIFF** (JPEG option).

GIF comp. 256 col. – 0.3Mb

JPEG2000 lossless

JPEG2000 max.comp. – 0.02Mb

JPEG max.comp. – 0.02Mb

Luminosity blending mode

Menu: -	
Shortcut: -	**OS:** Mac, Windows
Version: 1, 2, 3, 4	**See also:** Blend modes

The Luminosity blending mode is one of the group of Hue modes that base their effects on combining the hue, saturation and luminosity of the two layers.

This option creates the result by combining the hue and saturation of the bottom layer with the luminosity of the top layer.

The final image is the inverse of the results obtained when the Color mode is selected.

· · · · · · · · · · · · · · · · · · · ·

TIFF Options

Image Compression

○ NONE
◉ LZW **①**
○ ZIP
○ JPEG

OK

Cancel

LZW compression

Menu: -	
Shortcut: -	**OS:** Mac, Windows
Version: 1, 2, 3, 4	**See also:** Lossy, Lossless, JPEG

LZW or Lempel-Ziv-Welch compression is a lossless compression algorithm used to shrink the size of picture files by recognizing repeating patterns in the picture and only storing these once.

The algorithm is commonly used in the GIF format and is an option when saving TIFF files (1). Though LZW doesn't reduce file sizes as small as JPEG it does have the advantage of not losing any of the original data in the compression process.

114

Before

After

1

Select the tool from the tool box. Click the side arrow to reveal hidden tools if the standard eraser is showing. Set the Tolerance, Contiguous and Use All Layers settings.

Magic Eraser tool

Menu: -	
Shortcut: E	**OS:** Mac, Windows
Version: 1, 2, 3, 4,	**See also:** Eraser, Background Eraser, Magic Extractor

The Magic Eraser selects and then erases pixels of similar tone and color. The tool is great for removing unwanted backgrounds when making composite or montage pictures.

The Tolerance setting determines how alike the pixels need to be before they are erased. High settings will include more pixels of varying shades and colors.

Select the Contiguous option to force the tool to select pixels that are adjacent to each other and choose Use All Layers if you want to sample the color to be erased from a mixture of all visible layers.

The Magic Extractor feature, first introduced in Photoshop Elements 4.0, also performs and admirable job of removing backgrounds from photos.

2

Select the Opacity value: 100% removes all pixels; lower values make the erased area semi-transparent. Click on the layer part you wish to erase.

Before

Before

Tolerance - 30

After

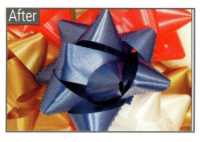

After

Tolerance - 10

© www.ablestock.com 2005

Magic Extractor

Menu:	-		
Shortcut:	-	**OS:**	Windows
Version:	4	**See also:**	Magic Selection Brush, Magic Eraser

The Magic Extractor feature quickly removes the background of a picture whilst retaining the subject in the foreground.

This new addition is an extension of the technology that makes the Magic Selection Brush possible. Just as is the case with the new brush, the Magic Extractor works by marking, with a scribbled line or a series of dots, the foreground (to be kept) and the background (to be removed) parts of the picture. Elements then automatically finds all the background parts in the picture and removes them from the document, filling the space with your choice of black, gray, white or transparency.

The Magic Extractor works within its own window (1), which includes a zoomable preview area (2), a set of tools for marking the fore- and background parts of a photo (3), touch-up options to refine extraction results (4), as well as settings to select what will fill the background area once it is removed (5).

Magic Selection Brush

Menu:	-		
Shortcut:	F	**OS:**	Windows
Version:	4	**See also:**	Magic Extractor, Magic Wand, Selection Brush

The new Magic Selection Brush provides a quicker, easier and, in most cases, more accurate way to make selections by combining both the drawing and color selection approaches of the other tools we have covered. To make a selection choose the tool from the toolbar. If it is hidden from view click the small arrow at the bottom right of the Selection Brush button to reveal the tool.

Now use the tool to scribble or place a dot on the picture parts that you want to select. Once you finish drawing release the mouse button; Elements will then create a selection based on the parts you have painted.

You don't have to be too careful with your initial painting as the program registers the color, tone and texture of the picture parts and then intelligently searches for other similar pixels to include in the selection.

Magic Wand tool

Menu:	-		
Shortcut:	W	**OS:**	Mac, Windows
Version:	1, 2, 3, 4,	**See also:**	Lasso, Marqee, Magic Selection Brush

The Magic Wand makes selections based on color and tone. When the user clicks on an image with the Magic Wand tool Elements searches the picture for pixels that have a similar color and tone.

How identical a pixel has to be to the original hue selected is determined by the Tolerance value in the options bar. The higher the value, the less alike the two pixels need to be, whereas a lower setting will require a more exact match before a pixel is added to the selection.

Turning on the Contiguous option will only include the pixels that are similar and are adjacent to the original pixel in the selection.

Before

After

| | Rectangular Marquee Tool | M |
| | Elliptical Marquee Tool | M |

117

Magnetic Lasso tool

Menu: -		
Shortcut: L	**OS:** Mac, Windows	
Version: 1, 2, 3, 4	**See also:** Lasso	

The Magnetic Lasso is one of three Lasso tools available in Photoshop Elements. Lasso tools make selections by drawing a marquee around the picture part to be selected. The Magnetic Lasso helps with the drawing process by aligning the selection outline with the edge of objects automatically.

The tool uses contrast of color and tone as a basis for determining the edge of an object. The accuracy of the 'magnetic' features of this tool is determined by three settings in the Tool's options bar.

Edge Contrast is the value that a pixel has to differ from its neighbor to be considered an edge.

Width is the number of pixels either side of the pointer that are sampled in the edge determination process.

Frequency is the distance between fastening points in the outline.

For most tasks, the Magnetic Lasso is a quick way to obtain accurate selections, so it is good practice to try this tool first when you want to isolate specific image parts.

Magnifying pictures

Menu: —		
Shortcut: —	**OS:** Mac, Windows	
Version: 1, 2, 3, 4	**See also:** Zoom tool, Zoom In/Out	

To magnify a specific area of a picture select the Zoom tool and click and drag over the area to be magnified. When you release the mouse button the picture zooms into the area you selected.

Marquee tools

Menu: -		
Shortcut: M	**OS:** Mac, Windows	
Version: 1, 2, 3, 4	**See also:** Lasso, Magic Wand, Selection	

Photoshop Elements has two different marquee tools – Rectangular (1) and Elliptical (2). Both tools are designed to draw regular shapes around the picture parts to be selected.

By clicking and dragging the Rectangular or Elliptical Marquees, it is possible to draw rectangular and oval-shaped selections.

Holding down the Shift key whilst using these tools will restrict the selection to square or circular shapes, whilst using the Alt (Windows) or Options (Mac) keys will draw the selections from their centers.

M

After selecting the Magnetic Lasso tool, click and release the mouse button to mark the first fastening point. Trace the outline of the object with the mouse pointer. Extra fastening points will be added to the edge of the object automatically.

If the tool doesn't snap to the edge automatically, click the mouse button to add a fastening point manually. Adjust settings in the options bar to vary the tool's magnetic function. To close the outline, either double-click or drag the pointer over the first fastening point.

mM

Before

After Match Zoom

118

Masks

Menu: -	
Shortcut: -	**OS:** Mac, Windows
Version: 1, 2, 3, 4	**See also:** Adjustment layers, Fill layers, Layer Masks

The layer masks in Photoshop Elements provide a way of protecting areas of a picture from enhancement or editing changes. Used in this way, masks are the opposite to selections, which are designed to restrict the changes to only the area selected.

Masks are standard grayscale images and because of this fact they can painted, edited, filtered and erased just like other pictures. Masks are displayed as a separate thumbnail to the right of the main layer thumbnail in the Layers palette (1). The black portion of the mask thumbnail is the protected area (2) and the white section shows the area where the image is not masked and therefore can be edited and enhanced. Elements uses masks as part of the application of adjustment and fill layers as well as with the Selection Brush when used in Mask mode. Elements will also open Photoshop files that already include layer masks.

Match Zoom

Menu: Editor: Window > Images > Match Zoom	
Shortcut: -	**OS:** Mac, Windows
Version: 1, 2, 3, 4	**See also:** Zoom tool, Magnify Images, Match Location

Photoshop Elements 4.0 and 3.0 provide a range of ways to view several images when they are all open in the standard Editor workspace at the same time. Added to the viewing modes that were available in version 2 of the program are the Automatic Tile Windows option, which adjusts all open pictures to fit the workspace and then resizes these windows if pictures are opened or closed, and the Match Zoom and Location options.

The Match Zoom feature displays all open pictures at the same magnification. The zoom setting that is matched is based on the setting of the currently selected document (1).

> **Shift + Zoom tool** switches to the Match Zoom mode.
>
> **Shift + Hand tool** or Shift Spacebar Hand tool switches to the Match Location mode.

Pro's Tip

Maximize mode

Menu: Editor: Window > Images > Maximize Mode	
Shortcut: -	**OS:** Mac, Windows
Version: 1, 2, 3, 4	**See also:** Tile Windows, Cascade

The Maximize mode (2) is one of the many ways that open pictures can be viewed in Photoshop Elements. Selecting this option from the Window > Images menu, or clicking the button in the top right of the document window, switches the view from Auto Tiled mode to a single image surrounded by the gray work area background.

Other options for displaying open documents include:

Minimize (1) – Reduces open window to just a title bar but keeps document in the workspace.

Close (3) – Closes the document.

Automatically tile windows (4) – Automatically resizes open windows to fit the workspace. Resizes the document windows to suit when new documents are opened or other documents closed.

Multi-window mode (5) – Displays the document in its own smaller, movable window in the workspace.

Match Location

Menu: Editor: Window > Images > Match Location	
Shortcut: -	**OS:** Mac, Windows
Version: 1.0, 2.0, 3.0	**See also:** Zoom tool, Magnify Images, Match Location

The Match Location feature adjusts all open pictures so that the same view (middle, upper right, lower left, etc.) of each photo is displayed for all photos. The location setting that is matched is based on the setting of the currently selected document.

Before

After Match Location

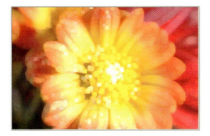

Maximum filter

Menu: Editor: Filter > Other > Maximum	
Shortcut: -	**OS:** Mac, Windows
Version: 1, 2, 3, 4	**See also:** Curves, Shadow/Highlights

The Maximum filter, as one of the Other group of filters, grows or bleeds the lighter areas of the picture whilst at the same time reducing the size of the darker toned parts. In making these changes, the filter analyzes the brightness of the pixels in a given area (radius) and increases the brightness to the level of the darkest pixel in the area.

The filter contains a single slider control that adjusts the radius (1) or size of the area used to determine the pixel brightness value.

Media types, Photo Browser

Menu:	
Shortcut: -	**OS:** Mac, Windows
Version: 1, 2, 3, 4	**See also:** Get Photos

The Photoshop Elements Photo Browser feature is designed to organize a range of media types. These include photos, video, audio, creations (Photo Creations) photos with audio captions and PDF documents (version 4.0 only).

The thumbnails for video, PDF, creation and audio caption files contain an icon in the top right to indicate their media type. All audio files are displayed with the same 'loud speaker' thumbnail picture.

The specific media types shown as thumbnails in the Photo Browser workspace are determined by the selections in the Items Shown dialog – View > Media Types (1). Deselect an item to hide it from view.

Groups of files of the same media type can be located and displayed via the Find > By Media Type option (2).

Median filter

Menu: Editor: Filter > Noise > Median	
Shortcut: -	**OS:** Mac, Windows
Version: 1, 2, 3, 4	**See also:** Filters

The Median filter, as one of the Noise group of filters, reduces the speckle type noise in a picture by finding the middle pixel brightness across the selected radius and removing pixels that deviate greatly from this brightness.

The filter contains a single slider control that adjusts the radius (1) or size of the area used to determine the median, or middle, pixel brightness value.

The filter has a blur effect as well as a reduction in local contrast.

Media – Photo

Media – Video

Media – Creation

Media – PDF

Media – Audio

Media – Caption

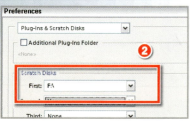

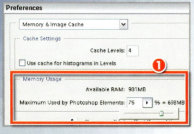

Memory

Menu: Editor: Edit > Preferences > Memory and Image Cache
Shortcut: - **OS:** Mac, Windows
Version: 1, 2, 3, 4 **See also:** Preferences, Scratch Disks

Photoshop Elements uses two types of memory that it uses in the process of editing and enhancing your pictures.

RAM (Random Access Memory) – Temporarily stores program information and the details of any pictures you have open. This type of memory is extremely fast and is the memory most preferred by the program. Typical figures for the RAM size are 256Mb, 512Mb and 1024Mb. You can allocate how much of your computer's RAM is used by Elements by adjusting the Memory and Image Cache settings in the Edit > Preferences dialog (1).

Hard drive memory – As the information is stored in RAM only whilst the computer is turned on, there is also a need for a permanent memory storage option as well. A hard drive is used for this type of long-term storage. Although much slower than RAM, it is the hard drive that we 'Save' our pictures to and 'Open' them from. Most computers these days have hard drives of between 80 and 200Gb (80,000 – 200,000 Mb) on which to store your pictures.

For those occasions when the Elements project you are working on requires more RAM than you have available you can allocate part of your hard drive as extra 'Virtual' RAM or in Photoshop Elements speak – a 'Scratch Disk'. Set the location of your scratch disk via the Plug-ins and Scratch disks option of the Edit > Preferences dialog (2).

Note: Memory settings changes only take effect after restarting Elements.

Menu bar

Menu: -
Shortcut: - **OS:** Mac, Windows
Version: 1, 2, 3, 4 **See also:** Options bar, Shortcuts bar

The Photoshop Elements menu bar contains five specialist menus of Image, Enhance, Layer, Select and Filter as well as the usual File, Edit, View, Window and Help headings common to most programs (1). Grouped under these special menu headings are the various editing and enhancement commands that are the real power of the program.

Selecting a menu item is as simple as moving your mouse over the menu heading, clicking to show the list of items or menu (2) and then moving the mouse pointer over the option you wish to use. With some selections a second menu (sub-menu) appears (3), from which you can make further selections.

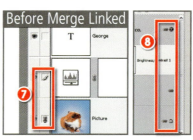

Before Merge Linked

After Merge Linked

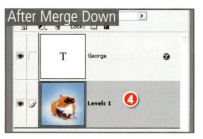

After Merge Down

Merge Down

Menu: Editor: Layers > Merge Down
Shortcut: Ctrl/Cmd E **OS:** Mac, Windows
Version: 1, 2, 3, 4 **See also:** Merge Linked, Merge Visible

The Merge Down command combines the contents of the selected layer with the one directly beneath it in the layer stack. In the example (4), the Levels adjustment layer (2) was selected and merged down into the picture layer (3). Merging options can be selected from the pop-out menu in the Layers palette (5) as well as the options in the Layers menu.

Multiple layers add to the overall file size and memory usage when editing. Merging layers reduces file size and hence memory usage. Merging layers also reduces the ability to edit the content of the individual layers later. For this reason, pros often make a copy of the layered file first before flattening the picture.

Merge Linked

Menu: Editor: Layer > Merge Linked
Shortcut: - **OS:** Mac, Windows
Version: 1, 2, 3, 4 **See also:** Merge Down, Merge Visible

The Merge Linked command combines the content of layers that have been linked within the document. To link several layers so that the contents of each layer can be blended together click the small box to the right of the Visibility icon ('eye') in all versions except 4.0 where you multi-select the layers to link and then click the Link button at the top of the Layers palette. This action displays a small Chain icon to indicate the layer is linked (7) (8). Linking layers and then applying the Merge Linked command is a good way to flatten a selected subset of all the layers that make up the document. The Merge Linked option is only available in the Layers menu when linked layers are present in the current document.

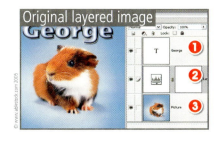

Original layered image

After Merge Visible

File Properties

Filename	: DSC_0004.NEF
Date Created	: 24/08/2004 09:53:47 AM
Date Modified	: 24/08/2004 09:53:47 AM
Image Format	: Camera Raw
Width	: 3008
Height	: 2000
Color Mode	: RGB
Resolution	: 240.0
File Size	: 9.60M
Bit Depth	: 16, 16, 16
Creator	: Nikon Transfer 6.1.0 W

Type Medium lines

Fine dots
Medium dots
Grainy dots
Coarse dots
Short lines
Medium lines
Long lines
Short strokes
Medium strokes
Long strokes

Metadata

File Properties
IPTC
Camera Data (Exif)
GPS
Camera Raw
Edit History

Search…
Increase Font Size
Decrease Font Size
Metadata Display Options…

Merge Visible

Menu: Editor: Layers > Merge Visible
Shortcut: Shft Ctrl/Cmd E **OS:** Mac, Windows
Version: 1, 2, 3, 4 **See also:** Merge Down, Merge Linked

The Merge Visible command combines the content of all visible layers within the document into a single image layer. Layers can be hidden from view (made not visible) by clicking the Eye icon on the left of the layer in the Layers palette. In the example the visible type (1), adjustment (2) and picture layers (3) were all merged (4).

To make a copy of the merged visible layers, create a new layer and then hold down the Alt (Option for Mac) key whilst selecting the Merge Visible option.

Merging any layer with the background yields the background; merging with another layer creates a single layer.

Metadata palette

Menu: Photo Browser: Windows > Properties
Shortcut: Alte Enter **OS:** Mac, Windows
Version: 1, 2, 3, 4 **See also:** EXIF, File Info

The Metadata palette in the Editor's File Browser in version 3.0 or the Metadata tab of the Windows > Properties palette shows a variety of information about your picture that is attached to the image file. Some of the detail is created at time of capture or creation and other parts are added as the file is edited.

The metadata that can be displayed (1) includes File Properties, IPTC (copyright and caption details), EXIF (Camera Data), GPS (navigational data from a global positioning system), Camera Raw and Edit History. To display the contents of each metadata category click on the side arrow to the left of the category heading (2).

Some of the data displayed in this palette, such as the copyright, description, author and caption information, can be edited via the File > File Info dialog.

The range of content types that is displayed in the palette is controlled by the selections in the Metadata Display Options (3).

Mezzotint filter

Menu: Editor: Filter > Pixelate > Mezzotint
Shortcut: - **OS:** Mac, Windows
Version: 1, 2, 3, 4 **See also:** Filters

The Mezzotint filter, as one of the Pixelate group of filters, recreates tone and color in a similar way to the way it is produced in etched printing plates. A series of strokes, dots or lines are used in a pattern to create detail and tone. Grayscale pictures are recreated in black and white strokes, and colored photos remade with a fully saturated pattern of colored texture.

The filter contains no single slider control to adjust the strength or positioning of the effect, rather a drop-down menu of texture types is provided (1). Each type (stroke, line, dot) creates a different pattern of texture and tone.

Minimum filter

Menu: Editor: Filter > Other > Minimum
Shortcut: - **OS:** Mac, Windows
Version: 1, 2, 3, 4 **See also:** Curves, Shadow/Highlights

The Minimum filter, as one of the Other group of filters, grows or bleeds the darker areas of the picture whilst at the same time reducing the size of the lighter toned parts. In making these changes, the filter analyzes the brightness of the pixels

in a given area (radius) and reduces the brightness to the level of the darkest pixel in the area.

The filter contains a single slider control that adjusts the radius (1) or size of the area used to determine the pixel brightness value.

Radius: 36 pixels

Minimize mode

Menu:	Editor: Window > Images > Minimize Mode	
Shortcut:	-	OS: Mac, Windows
Version:	1, 2, 3, 4	See also: Tile Windows, Cascade

The Minimize mode (1) is one of the many ways that open pictures can be viewed in Photoshop Elements. Selecting this option from the Window > Images menu, or clicking the button in the top right of the document window, will display the picture as a title bar at the bottom of the Editor workspace.

Other options for displaying open documents include:

Maximize (2) – Displays the picture the maximum size in the workspace.

Close (3) – Closes the document.

Automatically tile windows (4) – Automatically resizes open windows to fit the workspace, even when pictures are opened or closed.

Multi-window mode (5) – Displays the document in its own smaller, movable window in the workspace.

Missing Profile version 1.0, 2.0, 3.0

Menu:	-	
Shortcut:	-	OS: Mac, Windows
Version:	1, 2, 3	See also: Color Settings

After opting for a fully managed system in the Edit > Color Settings of Photoshop Elements, opening a picture that doesn't have an attached ICC profile will display a Missing Profile dialog. Here you have three choices about how to proceed, and more importantly, how Elements will deal with the colors in the file:

Leave as is – This option keeps the file free of a color profile. Not a preferred option.

Assign working space AdobeRGB – Attaches the profile recommended for pictures that are destined for printing.

Assign sRGB – Assigns a profile that is recommended for photos that are used on the web or viewed on screen.

Select the assign option that most suits your output needs and then click OK.

• •

Missing Profile ver. 4.0

Menu:	-	
Shortcut:	-	OS: Windows
Version:	4	See also: Color Settings

In version 4.0 opening a photo without an attached profiles displays a different dialog but still with three choices:

Leave as is – As before this option keeps the file free of a color profile.

Optimize... for screen display – This replaces the Assign sRGB option but performs the same change.

Optimize... for Print output – This option assigns the AdobeRGB profile which is recommended for printing.

Modify Magic Selections

Menu:	-	
Shortcut:	-	OS: Windows
Version:	4	See also: Magic Selection Brush tool

Just like the other selection tools there are tools to modify the selections that the Magic Selection Brush creates.

When creating a new selection the brush is in the default or New Selection mode (1).

To include other areas in the selection click the Indicate Foreground button (2) in the tool's options bar and paint or place a dot on a new picture part. This step will cause Elements to regenerate the selection to include your changes.

To remove an area from the selection, click on the Indicate Background button (3) and scribble or dot the part to eliminate. Again Elements will regenerate the selection to account for the changes.

The Shift and Alt keys can be used whilst drawing to change modes 'on the fly' and add to or subtract from the selection.

The Magic Selection Brush is available in both the Standard and Quick Fix Editor workspaces.

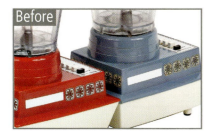

Before

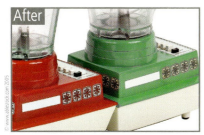

After

© www.ablestock.com 2005

Modify range of Hue sliders

Menu: Editor: Enhance > Adjust Color > Adjust Hue/Saturation
Shortcut: Ctrl/Cmd U **OS:** Mac, Windows
Version: 1, 2, 3, 4 **See also:** Hue/Saturation

The Hue/Saturation control adjusts the color and vibrancy of color in a picture. In the default mode, Edit Master, these changes are applied to all the colors in the picture. The drop-down Edit menu allows the user to select a different range of colors to apply the changes to (1). In the example, the hue of the blue colors in the picture was altered to green.

In addition to selecting a specific color to edit, the Hue/Saturation dialog also provides the ability to fine-tune the range of tones included in the selection.

Two color bars are displayed at the bottom of the dialog when a color range is selected in the Edit menu. The top bar shows the color currently selected; the bottom bar indicates the colors that the selected hues will be converted to. Between the two bars are four slider controls. The vertical white bars (2) define the edges of the color range and the triangles (3) are the edges of the fall-off from the color range. By click-dragging the white bars the size and scope of the selected range can be altered. This allows fine-tuning of the colors selected and substituted.

Modify selections

Menu: Editor: Select > Modify
Shortcut: - **OS:** Mac, Windows
Version: 1, 2, 3, 4 **See also:** Smooth, Expand, Contract

Existing selections can be modified in the following ways:

Border – Choosing the Border option from the Modify menu displays a dialog where you can enter the width of the border in pixels (between 1 and 200). Clicking OK creates a border selection that frames the original selection.

Smooth – This option cleans up stray pixels that are left unselected after using the Magic Wand tool. After choosing Modify enter a radius value to use for searching for stray pixels and then click OK.

Expand – After selecting Expand enter the number of pixels that you want to increase the selection by and click OK. The original selection is increased in size. You can enter a pixel value between 1 and 100.

Contract – Selecting this option will reduce the size of the selection by the number of pixels entered into the dialog. You can enter a pixel value between 1 and 100.

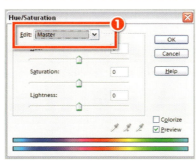

Mosaic filter

Menu: Editor: Filter > Pixelate > Mosaic
Shortcut: - **OS:** Mac, Windows
Version: 1, 2, 3, 4 **See also:** Filters

The Mosaic filter, as one of the Pixelate group of filters, simulates the look of a pixel-based picture that has been enlarged greatly. The photo is recreated in large single colored blocks. The filter contains a single slider control that adjusts the Cell Size (1) or 'pixel' block size. The higher the value entered here the larger the blocks used to recreate the photo.

123

M

mM

After selective Motion Blur

Motion Blur filter

Menu: Editor: Filter > Blur > Motion Blur
Shortcut: - **OS:** Mac, Windows
Version: 1, 2, 3, 4 **See also:** Filters

The Motion Blur filter is one of several blur options that can be found in the Blur section of the Filter menu. This feature is great for putting back a sense of movement into action pictures that have been frozen by being photographed with a fast shutter speed. Used by itself, the filter produces pictures that are very blurred and often lack any recognizable detail. For more realistic results apply this filter via a feathered selection to help retain sharpness in some picture parts whilst blurring others.

The Filter dialog contains a single slider, a preview window and a motion direction (angle) dial. The Angle dial (1) determines the direction of the blur and should be set to simulate the natural direction of the subject. The Distance slider (2) controls the amount of blur added to the picture.

To control the picture parts to be blurred we start by selecting the area to remain sharp. Use the Lasso tool to draw a freehand selection around the driver. Next, invert the selection (Select > Inverse) so that the entire image except the driver is now selected.

To soften the transition between the sharp and blurred sections apply a large feather (Select > Feather) to the selection. This replaces the normal sharp edge of the selection with a gradual change between selected and non-selected areas.

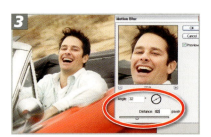

Next hide the selection using the shortcut keys of Ctrl/Cmd + H (the selection is still active, you just cannot see the marching ants) and open the Motion Blur dialog. Adjust the Angle and Distance settings to suit the picture and check the preview. Click OK to complete.

Move tool

Menu: -
Shortcut: V **OS:** Mac, Windows
Version: 1, 2, 3, 4 **See also:** -

The Move tool is used to change the position of layer content within the confines of the Image window. The Move tool has two extended features in the options bar that change the way that the tool works:

Auto Select Layer – Allows the tool to automatically select the uppermost layer when the mouse cursor clicks on it.

Show Bounding Box – Automatically shows the bounding box (1) of the layer content that is currently selected. In this mode the corner and side handles of the bounding box can be moved to scale the layer contents.

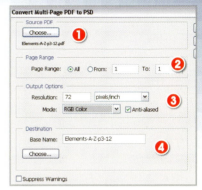

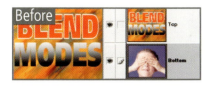

Multiply blending mode

Menu: -
Shortcut: - **OS:** Mac, Windows
Version: 1, 2, 3, 4 **See also:** Blend modes

The Multiply blending mode is one of the group of Darken modes that multiplies the color of the bottom layer with the top producing an overall darker result.

When the top layer is black the resultant blended layer is also black. There is no change when the bottom layer is blended with a white top layer. This blend mode is often used for creating fancy edge effects on photos (see below) and it's also very handy for 'washed out' or overexposed images. Simply duplicate the layer and set it to Multiply mode.

Create an edge picture with a black surround and a completely white interior. Layer this image on top of a picture and resize to suit the image.

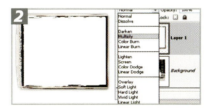

With the edge layer selected, change the blend mode to Multiply to allow the picture beneath to show through the white sections of the edge layer.

Multi-Page PDF to PSD

Menu: Editor: File > Automate > Multi-page PDF to PSD
Shortcut: - **OS:** Mac, Windows
Version: 1, 2, 3 **See also:** -

The Multi-Page PDF to PSD option located in the File > Automate menu converts the individual pages of a PDF document to separate Photoshop Elements PSD files.

In the feature's dialog you can input the name and location of the source PDF document (1), the destination directory for the converted files (4), page range (2), output resolution and color mode (3) as well as the base name (4) for the newly created documents.

For opening a single page of a PDF document as a new Elements document (rather than converting multiple pages) use the File > Open command. Using this approach to open a multi-page file will display the PDF Page Selector dialog (5) complete with thumbnails of each page.

This feature is not included in version 4.0 of Photoshop Elements.

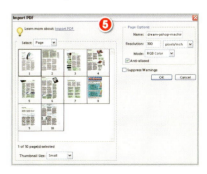

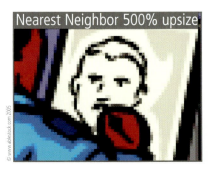

Nearest Neighbor 500% upsize

Original

Navigator

Menu: Editor: Window > Navigator	
Shortcut: -	**OS:** Mac, Windows
Version: 1, 2, 3, 4	**See also:** Zoom In/Out

The Navigator palette is a small scalable Preview palette that shows the entire image together with a highlighted rectangle (1) the size, scale and shape of the area currently displayed in the document window (2).

A new frame can be drawn (scaling the Image window with it) by holding the Command/Ctrl keys and making a new marquee. The frame can be dragged around the entire image with the Hand tool.

The Zoom tools (3) can be clicked, the slider can be dragged, or a figure can be entered as a percentage.

Nearest Neighbor interpolation

Menu:	
Shortcut: -	**OS:** Mac, Windows
Version: 1, 2, 3, 4	**See also:** Interpolation, Image Size, Bicubic interpolation

Nearest Neighbor is one of the interpolation methods that is available when resizing pictures using the Image Size feature (1).

This option provides the fastest and coarsest results and is only recommended for use with screen grabs or hard-edged illustrations. It is not a method that works well with photographs. Instead, one of the bicubic options should be used to resize these image types.

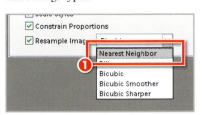

Neon Glow filter

Menu: Editor: Filter > Artistic > Neon Glow
Shortcut: - **OS:** Mac, Windows
Version: 1, 2, 3, 4 **See also:** Filters

The Neon Glow filter, as one of the Artistic group of filters, colors the image with foreground and background hues, adds a glow color and then softens the image.

The filter contains two sliders and a Color Selection box.

The Glow Size setting (1) adjusts the position of the glow in the tonal range of the picture. Low values place the glow in the shadow areas, higher settings move the glow to the highlights.

The Glow Brightness slider (2) oscillates the picture's tinting between foreground, background and glow colors.

The Glow Color (3) can be selected by double-clicking (single-click) the Color box and selecting a new hue from the Color Picker dialog.

Changing the foreground and background colors greatly alters the nature of the filtered results (4).

New command

Menu: Editor: File > New
 Photo Browser: File > New
Shortcut: Ctrl/Cmd N (Blank File) **OS:** Mac, Windows
Version: 1, 2, 3, 4 **See also:** -

The File > New option in both the Editor (1) and Photo Browser (2) workspaces provides the user with a starting point for a range of picture projects. The options are:

Blank File – This option creates an Elements picture from the settings selected in the New dialog box. The box has sections for the image's name, width, height, resolution, mode and background content. You can also choose an existing template from a range of document types from the drop-down Preset menu.

Image from Clipboard – Once a picture, or selection, has been copied to memory selecting this option automatically creates a new document of the correct size to accommodate the copied content and pastes the image in as a new layer.

Creation – This selection allows Windows users to jump from the editing program directly into the Photo Creation process. Selecting the option from the Editor workspace displays the Creation Setup window, whereas individual Photo Creation projects can be selected from the list provided in the Photo Browser: File > New menu.

Photomerge Panorama – This option takes you directly to the Photomerge Add Files dialog. Here you can use the Browse button to locate the pictures that you want to include in the stitched panorama. After clicking OK, the images are transferred to the Photomerge workspace, where the program arranges and blends the individual images to form a single wide-angle photograph.

New Layer button

Menu: -
Shortcut: - **OS:** Mac, Windows
Version: 1, 2, 3, 4 **See also:** Layers Palette

The New Layer button located at the top of the Layers palette (1) creates a new blank layer above the currently selected layer when pressed. The new layer is transparent by default. The results are the same as if the Layer > New > Layer menu item is selected.

In versions 1.0 and 2.0 of Photoshop Elements the New Layer button is located at the bottom of the Layers palette.

New Brush

Menu: -
Shortcut: B **OS:** Mac, Windows
Version: 1, 2, 3, 4 **See also:** Brush

To add a new brush to those listed in the Brush Preset palette display the pop-up palette from the options by pressing the downwards arrow (1). Select a brush from those listed and modify using the various settings in the options bar. Press the sideways arrow (2) in the top right of the Preset palette and select Save Brush from the menu. Enter the new brush name and click OK. The new brush will be added to the bottom of the list in the palette.

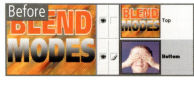

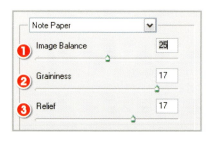

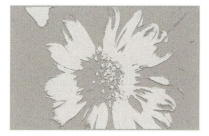

128

New Window

Menu: Editor: View > New Window for
Shortcut: - **OS:** Mac, Windows
Version: 1, 2, 3, 4 **See also:** -

The New Window command creates another image window for the current document. The two windows can be sized, zoomed and moved independent of each other.

This feature is most often used to help see the effects of fine detail editing. The view in one window is magnified (1) whilst the other is kept so that the whole picture is displayed (2). Enhancing or editing activities are performed in the zoomed-in window and the changes checked in the whole display view.

Normal blending mode

Menu: -
Shortcut: - **OS:** Mac, Windows
Version: 1, 2, 3, 4 **See also:** Blend modes

The Normal blending mode is the default mode of newly created layers and newly selected brush tools.

When the top layer's blend mode is set to Normal and set to 100% opacity, no part of the bottom layer is visible and no blending of the two layers takes place. The picture parts of the top layer are treated as opaque and therefore cover and obscure all image detail beneath.

Note Paper filter

Menu: Editor: Filter > Sketch > Note Paper
Shortcut: - **OS:** Mac, Windows
Version: 1, 2, 3, 4 **See also:** Filters

The Note Paper, as one of the Sketch group of filters, redraws the photo as textured light and dark tones based on the current selection of fore- and background colors.

The Filter dialog contains three sliders that control the look and strength of the effect.

The Image Balance setting (1) adjusts which areas are toned the foreground color and which are converted to the background hue. Low values favor the background color and high settings color more of the picture with the foreground color.

The Graininess slider (2) determines the amount of grain that is added to the picture.

The Relief slider (3) adjusts the strength of the simulated side lighting falling on the paper surface. With higher values the texture is more pronounced.

Changing the foreground and background colors away from their defaults greatly alters the nature of the filtered results (4).

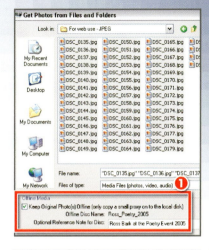

Ocean Ripple filter

Menu: Editor: Filter > Distort > Ocean Ripple	
Shortcut: -	**OS:** Mac, Windows
Version: 1, 2, 3, 4	**See also:** Filters

The Ocean Ripple filter, as one of the Distort group of filters, applies a rippled distortion to the whole of the picture surface. In this way it can create similar looking results to those obtained with the Glass or Ripple filters.

The filter contains two sliders controls.

The Ripple Size setting (1) adjusts the scale of the wave-like ripples that are added to the picture. Low values create smaller, less dramatic ripples.

The Ripple Magnitude slider (2) determines how far each ripple is distorted. High settings create a greater level of distortion in the final result.

Offline storage of files

Menu:	Photo Browser: File > Get Photos > From Files and Folders
Shortcut: -	**OS:** Mac, Windows
Version: 3, 4	**See also:** Get Photos

Most Elements users create their catalogs (the thumbnail collections that you see in the Photo Browser workspace) from folders of images stored on their hard drives or directly from their camera downloads, but did you know that the program can also generate catalogs from pictures that you have stored on CD or DVD disks?

When you File > Get Photos from your disk you have an option at the bottom of the dialogue (1) that allows you to keep the original pictures 'Offline' (on the CD or DVD) but load proxy versions of the photos into Elements to use for browsing, searching, tagging and organizing. If you try to make any changes to the photo itself Elements is clever enough to ask you to insert the original disk so that the program can apply edits to the full version of the file.

All offline files are indicated with a small CD Disk icon in the top left-hand corner of the thumbnail (2).

If you don't select the Offline option in the Get Photos dialogue Elements will copy the photos from your disk to the hard drive and then create a catalog from this collection of files.

Offset filter

Menu: Editor: Filter > Other > Offset	
Shortcut: -	**OS:** Mac, Windows
Version: 1, 2, 3, 4	**See also:** Filters

The Offset filter, as one of the Other group of filters, displaces the picture within the image window.

The filter contains two slider controls plus several options that determine how the offset areas are dealt with.

The Horizontal and Vertical sliders (1) adjusts how offset the picture is from its original position. The greater the values the larger the offset will be.

The Undefined Area options (2) determine how the space left in the Image window when the picture is repositioned will be treated.

Set to Background – This options fills the gap left in the image window with the current background color.

Repeat Edge Pixels – The pixels at the edge of the repositioned picture are repeated to the edge of the Image window.

Wrap Around – The picture is wrapped around the Image window so that the edges that are cropped due to the repositioning are added back into the picture on the opposite side.

Wrap Around

Omni Lighting Effects

Menu: Editor: Filter > Rerider > Lighting Effects	
Shortcut: -	**OS:** Mac, Windows
Version: 1, 2, 3, 4	**See also:** Lighting Effects

Omni is one of the lighting types featured in the Lighting Effects filter. The Omni style shines light in all directions, creating a bright center and then a sharp fall-off of light intensity.

This light type is great for highlighting a specific part of a scene whilst reducing the brightness of the rest of the picture.

Move the light by click-dragging the light's center. You can decrease or increase the size of the Omni light source by click-dragging one of the light handles.

Adjust the characteristics of the light source by changing its properties. The brightness of the light is determined by the Exposure and Intensity sliders.

. .

Set to Background

Repeat Edge Pixels

One Photo Per Page

Menu: Editor: File > Print Multiple Photos	
	Photo Browser: File > Print
Shortcut: Ctrl/Cmd P	**OS:** Mac, Windows
Version: 1, 2, 3, 4	**See also:** Print

The One Photo Per Page option (3) located in the Print Multiple Photos dialog forces the feature to create pages with only one photo included. If the layout selected has space for more than one photo then selecting the One Photo Per Page option will cause the feature to repeat the photo in each space in the template (1). Deselecting the option will allow Elements to position other photos in these spaces (2).

Online Help

Menu: Editor: Help > Photoshop Elements Online
Photo Browser: Help > Photoshop Help Online
Shortcut: - **OS:** Mac, Windows
Version: 1, 2, 3, 4 **See also:** Hints

As well as the extensive help and tutorial resources that are contained within the Photoshop Elements program itself, extra tutorials, hints, tips and tricks can be found online.

Select the Help > Photoshop Elements Online menu item (1) to take you to the Adobe web pages dedicated to your favorite photo editing program (2).

Opacity

Menu: -
Shortcut: - **OS:** Mac, Windows
Version: 1, 2, 3, 4 **See also:** Layer Opacity

The opacity setting can be adjusted for a range of tools and features in Photoshop Elements. It is a setting that controls the transparency of an object or layer. A value of 100% is completely opaque (not transparent at all), whereas a setting of 0% means that the layer or object is completely transparent. Brush opacity slider (1). Layer opacity control (2).

Open

Menu: Editor: File > Open
Shortcut: Ctrl/Cmd O **OS:** Mac, Windows
Version: 1, 2, 3, 4 **See also:** Open As, Open Recently Edited File

Working in much the same way as the Get Photos > From Files and Folders option, selecting File > Open presents you with the standard Windows (1) or Macintosh (2) File Browser.

From here you can navigate from drive to drive on your machine before locating and opening the folder that contains your pictures. You can refine the display options by selecting the specific file type (file ending) to be displayed (3) and as we have already noted you can also choose the way to view the files.

In the Windows example, the thumbnail view was selected so that it is possible to quickly flick through a folder full of pictures to locate the specific image you are after.

Open As

Menu: Editor: File > Open As
Shortcut: Alt Ctrl O **OS:** Windows
Version: 1, 2, 3, 4 **See also:** Open, Open Recently Edited file

On the odd occasion that a specific Windows file won't open, using the File > Open command you can try to open the file in a different format. Do this by selecting the File > Open As option and then choosing the file you want to open (1). The feature is used if a file has an incorrect file extension or no file extension at all.

After making this selection pick the desired format (2) from the Open As pop-up menu, and click the Open button. This action forces the program to ignore the file format it has assumed the picture is saved in and treat the image as if it is saved as the file type you have selected.

If the picture still refuses to open, then you may have selected a format that does not match the file's true format, or the file itself may have been damaged when being saved.

Open File for Editing

Menu: Welcome Screen: Open File for Editing
Shortcut: – **OS:** Mac
Version: 3.0 **See also:** Open

The Open File for Editing option located on the Welcome Screen in the Macintosh version of Elements 3.0 takes the user directly to the File Browser, from where individual images can be selected and opened. The option is the same as selecting File > Browse Folders from inside the Editor workspace.

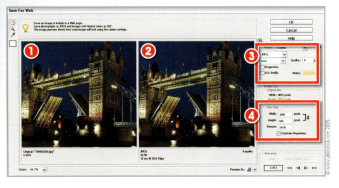

Open Recently Edited File

Menu: Editor: File > Open Recently Edited File
Shortcut: - **OS:** Mac, Windows
Version: 1, 2, 3, 4 **See also:** Open, Open As

As you browse, open and edit various pictures from your folders Elements keeps track of the last few files and lists them under the File > Open Recently Edited Files menu item (1).

This is a very handy feature as it means that you can return quickly to pictures that you are working on without having to navigate back to the specific folder where they are stored.

By default Photoshop Elements lists the last 10 files edited. You can change the number of files kept on this menu via the 'Recent file list' setting in the Edit > Preferences > Saving Files window (2). Don't be tempted to list too many files as each additional listing uses more memory.

Optimization, web

Menu: Editor: File > Save for Web
Shortcut: Alt Shft Ctrl/Cmd S **OS:** Mac, Windows
Version: 1, 2, 3, 4 **See also:** JPEG, GIF

The skill of making a highly visual site that downloads quickly is largely based on how well you optimize the pictures contained on the pages of the site.

The process of shrinking your pictures for web use involves two steps:

- Firstly, the pixel dimensions of the image need to be reduced so that the image can be viewed without scrolling on a standard screen. This usually means ensuring that the image will fit within a 600 × 480 pixel space.
- Secondly, the picture is compressed and saved in a web-ready file format. There are two main choices here, GIF and JPEG.

The best way to optimize your pictures for web use is via the Save for Web (Editor: File > Save for Web) option in Elements.

This feature provides before (1) and after (2) previews of the compression process as well as options for compression (3) and reducing the pixel dimensions of your pictures (4), all in the one dialog.

Using the feature you can select the file format, adjust compression settings (5), examine the predicted file size and preview the results live on screen.

In the process of optimizing your photos to suit web delivery the Save for Web feature strips any existing Metadata from files it produces.

Options bar

Menu: -
Shortcut: - **OS:** Mac, Windows
Version: 1, 2, 3, 4 **See also:** Menu bar, Shortcuts bar

Long bar beneath the shortcuts and menu bars, which displays the various settings and options available for the tool that is currently selected.

132

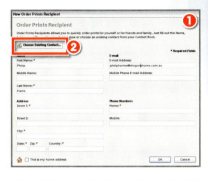

Order Prints pane

Menu:	Photo Browser: Window > Order Prints		
Shortcut:	-	**OS:**	Windows
Version:	4	**See also:**	Order Prints, Order Prints pane adding contacts

Version 4.0 of Elements introduces a new streamline method of ordering online prints to accompany the program's ability to select, upload, print and deliver photos online.

Individual or multi-selected thumbnails are dragged and dropped onto contact names in the Order Prints pane (1). The photos to print are associated with the contact name and once the order is confirmed they are uploaded, printed and sent to the contact using the delivery details first entered when creating the contact.

To order prints using the feature start by ensuring that the pane is displayed by selecting Organizer: Window > Order Prints. Next select or multi-select the images from the Photo Browser (Organizer) workspace to print. Drag the selected prints to the Contact name or Target (2) in the pane. When the target changes color let go of the mouse button to drop the pictures. And finally press the Confirm Order button (3) to process the order with the online print company.

Order Prints pane – adding contacts

Menu:	Photo Browser: Window > Order Prints		
Shortcut:	-	**OS:**	Windows
Version:	4	**See also:**	Order Prints, Order Prints pane

To add new contacts to the Order Prints pane open the feature and press the Add New Contact button. Insert the details in the dialog displayed (1).

Alternatively you can import existing contact details from the Contact Book by selecting the Choosing Existing Contact (2) button in the Add New Contacts dialog. This action displays the Elements' Contact Book (3) from which you can select the details to add.

Order Prints pane – reviewing an order

Menu:	Photo Browser: Window > Order Prints		
Shortcut:	-	**OS:**	Windows
Version:	4	**See also:**	Order Prints, Order Prints pane

To review and confirm a specific order open the Order Prints pane, select a contact name from those listed and then press the View Photos in Order button. Review the photos shown in the dialog and then press the Confirm Order button to place the online print order.

Order Prints

Menu:	Editor: File > Order Prints		
	Photo Browser: File > Order Prints		
Shortcut:	-	**OS:**	Mac, Windows
Version:	1, 2, 3	**See also:**	Print

Although many images you make, or enhance, with Elements will be printed right at your desktop, occasionally you might want the option to output some prints on high quality photographic paper. The Order Prints option (1), located in the File menu, provides just this ability.

Using the resources of kodakgallery.com in the USA, Europe and the UK, Elements users can upload copies of their favorite images to the company's site and have them photographically printed in a range of sizes (2). The finished prints are sent to you via the mail.

This service provides the convenience of printing from your desktop with the image and archival qualities of having your digital pictures output using a photographic rather than inkjet process.

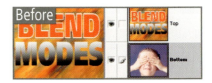

Organize Bin

Menu: -	
Shortcut: -	**OS:** Windows
Version: 3, 4	**See also:** Photo Browser

The Organize Bin (1) stores the Tags, Properties, Order Prints and Collections panes and sits to the right of the main thumbnail area in the Photo Browser workspace. Like all the Bin features in Elements, the Organize Bin can be opened when you need to access the panes it contains and closed when you need to maximize the available workspace.

There are three ways to open/close the Organize Bin:

1. Select Photo Browser: Window > Organize Bin.
2. Click the Organize Bin toggle button (2) at the bottom right of the Photo Browser screen.
3. Press the button on the bin's left edge (3).

Organize Open Files

Menu: Editor: File > Organize Open Files	
Shortcut: -	**OS:** Windows
Version: 3, 4	**See also:** Get Photos

If you have files that are open in the Editor workspace and are as yet unsaved, the Organize Open Files feature (1) will automatically open the Save As dialog with the Include in the Organizer setting (2) selected.

If a file has already been saved, it is added to the Organizer without the Save As dialog. When saved they are added to the thumbnail list in the Photo Browser.

Overlay blending mode

Menu: -	
Shortcut: -	**OS:** Mac, Windows
Version: 1, 2, 3, 4	**See also:** Blend modes

The Overlay blending mode is one of the group of Overlay modes which combines the effects of both the Multiply and Screen modes. Colors of the top layer overlay the bottom layer's pixels but the highlight and shadow tones of the bottom layer are preserved.

There is no change when the bottom layer is blended with a 50% gray top layer.

Output Levels

Menu: Editor: Enhance > Adjust Lighting > Levels	
Shortcut: Ctrl/Cmd L	**OS:** Mac, Windows
Version: 1, 2, 3, 4	**See also:** Levels

The Output Levels controls (1) in the Levels dialog sit at the very bottom of the feature. By moving these black and white point sliders inwards, you are compressing the full tonal range of the picture. The result is a less contrasty photo. Such a change may be necessary to suit the requirements of a particular printer, or just to reduce the contrast of a picture taken on a sunny day.

Organizer workspace

Menu: -	
Shortcut: -	**OS:** Windows
Version: 3, 4	**See also:** Editor

Along with the new Quick Fix Editor, Elements 3.0 for Windows has incorporated the sophisticated Organizer browser, first introduced in Photoshop Album, into its digital photography system.

Though the older File Browser feature (Editor: File > Browse Folders) is still available in Editor mode and will adequately provide a quick way to visually locate your images, it doesn't contain the range of search, tag and display options that the Organizer can boast.

Once the picture files have been imported (Organizer: File > Get Photos) into the browser they can be viewed by date taken, their associated tags and even their folder location.

Pairs of pictures can be viewed side by side with the View > Photo Compare feature to help choose the best shot from a series of images taken of the same subject.

Instant slide shows of whole collections, or just those pictures selected from the browser, can be created and displayed using the View > Photo Review feature.

Simple editing tasks, such as the automatic adjustment of levels, contrast and/or sharpness, along with simple orientation and crop changes can be performed directly from inside the browser with the Auto Fix feature.

Finding your favorite pictures has never been easier as you can search by date, caption, filename, history, media type, tag and color similarity (to already selected photos).

(1) Menu bar
(2) Shortcuts bar
(3) Timeline
(4) Date of images being shown
(5) Jump to Date View button
(6) Collections tab
(7) Tags tab
(8) Organize Bin hide/display toggle button
(9) Thumbnail size
(10) Thumbnails
(11) Photo Review feature
(12) Show/Hide image properties
(13) Photo Browser arrangement

Page Setup

Menu: Editor: File > Page Setup
Photo Browser: File > Page Setup
Shortcut: Shft Ctrl/Cmd P **OS:** Mac, Windows
Version: 1, 2, 3, 4 **See also:** Print

The Page Setup dialog, in conjunction with the Print and the Print Multiple Photos dialogs, controls all the printing options from Photoshop Elements.

Here you can change the orientation of the paper that you are printing on – Portrait is vertical and Landscape is horizontal (1).

Page Setup also provides options to input values for the paper Size (2) and paper Source (3), which are both determined by the printer that is currently selected.

If you wish to change printers, then clicking the Printer button (4) will take you to a second dialog, where you can select another printer that is installed and connected to your computer.

The Page Setup dialog can also be accessed via the button at the bottom of the Print Multiple or Print Selected Photos (5).

Paint Bucket tool

Menu: -
Shortcut: K **OS:** Mac, Windows
Version: 1, 2, 3, 4 **See also:** Magic Wand

The Paint Bucket tool is grouped with the painting and drawing tools in the Elements toolbar.

The feature combines the selecting prowess of the Magic Wand and the coloring abilities of the Fill command to create a tool that fills all pixels of a similar color (1) with the current foreground color (2).

If the Contiguous option is selected then the pixels that will be filled must be adjacent to one another. How similar in color and tone the pixels have to be before being filled is based on the Tolerance setting.

To ensure a realistic substitution of color try using the tool in the Color mode (3) as this will maintain the texture, shadow and details of the original picture.

Paint Daubs filter

Menu: Editor: Filter > Artistic > Paint Daubs			
Shortcut: -		**OS:** Mac, Windows	
Version: 1, 2, 3, 4		**See also:** Filters	

The Paint Daubs filter, as one of the Artistic group of filters, applies a painterly effect to the whole of the picture surface. In the process the fine detail of the photo is eclipsed by large areas of painted color.

The filter contains two slider controls and a Brush Type menu.

The Brush Size setting (1) adjusts the scale of the painted areas. Low values create smaller areas with finer detail.

The Sharpness slider (2) determines how much of the original detail is maintained in the painting process. High settings create a greater level of detail and low values create broad areas of smooth color.

The Brush Type menu (3) contains a list of different styles of brushes. Changing brush types can alter the final filter result greatly.

Painting tools

Menu: –			
Shortcut: B		**OS:** Mac, Windows	
Version: 1, 2, 3, 4		**See also:** Brush	

Palette Bin

Menu: Editor: Window > Palette Bin			
Shortcut: F7		**OS:** Mac, Windows	
Version: 1, 2, 3, 4		**See also:** Palettes, Organize Bin	

The Palette Bin (1) stores the Elements palettes and sits to the right of the main screen in the Editor workspace. Like all the Bin features in Elements, the Palette Bin can be opened when you need to access the palettes it contains and closed when you need to maximize the available workspace. The palettes can be dragged from the bin into the main workspace (and back again) by click-dragging the palette's title bar.

There are four ways to open/close the Palette Bin:

1. Select Editor: Window > Palette Bin.
2. Click the Palette Bin toggle button (2) at the bottom right of the Editor screen.
3. Press the button (3) on the bin's left edge.
4. You can also partially close or open the bin by dragging the resize bar (3).

Although many people will employ Elements to enhance images captured using a digital camera, some users make pictures from scratch using the program's painting and drawing tools. Illustrators, in particular, generate their images with the aid of tools such as the Paint Bucket, Airbrush and Pencil. This is not to say that it is not possible to use drawing or painting tools on digital photographs. In fact, the judicious use of tools like the Brush can enhance detail and provide a real sense of drama in your images. All the painting and drawing tools are grouped in the one section of the program's toolbar for easy access.

Palettes

Menu: Editor: Window >			
Shortcut: F7 (Palette Bin)		**OS:** Mac, Windows	
Version: 1, 2, 3, 4		**See also:** Palette Bin	

A palette is a window that contains details and information that are used for the alteration of image characteristics. Photoshop Elements contains the following palettes: Color Swatches, Histogram, How To, Info, Layers, Navigator, Styles and Effects, and Undo History.

The palettes are displayed and hidden by selecting them from the Window menu (1). They can be grouped together in the Palette Bin (2), or dragged into the main workspace (3).

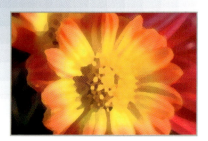

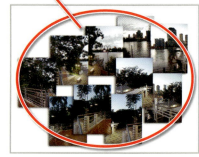

Palette Knife filter

Menu: Editor: Filter > Artistic > Palette Knife
Shortcut: - **OS:** Mac, Windows
Version: 1, 2, 3, 4 **See also:** Filters

The Palette Knife filter, as one of the Artistic group of filters, simulates the look of a picture created by applying thick broad areas of paint with a palette knife.

The filter contains three sliders controls.

The Stroke Size setting (1) adjusts the strength of the effect and the size of the broad areas of paint. Low values retain more of the detail of the original picture.

The Stroke Detail slider (2) determines how coarsely the color is applied. Low values create a more broken up result.

The Softness control (3) alters the sharpness of the stroke's edge. A high setting produces strokes with a softer edge.

Palette Well

Menu: -
Shortcut: - **OS:** Mac, Windows
Version: 1, 2 **See also:** Palette Bin

In versions 1.0 and 2.0 of Elements open palettes could be dragged to the Palette Well space in the option bar to save work-space area. This action reduces the palette to a tab in the well. To view the palette click onto the tab heading; to reinstate the palette to the workspace click and drag the tab out of the well.

The Palette Well feature has now been replaced by the Palette Bin.

Panoramas, creating

Menu: -
Shortcut: - **OS:** Mac, Windows
Version: 1, 2, 3, 4 **See also:** Photomerge

The process of creating a wide-angle picture, or panorama, using the Elements Photomerge feature is broken into three different stages:

1. **Capturing the source photos** Shoot a range of images whilst gradually rotating the camera so that each photograph overlaps the next.

2. **Stitching images using Photomerge** Import the pictures into Photomerge and use its automated process to position, match and stitch the edge details of the separate image files to create a new single panoramic picture.

3. **Producing the panorama** Make final editing and enhancement changes on the finished panoramic photo before printing the picture.

Capture source images

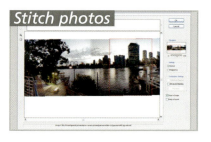
Stitch photos

Produce panorama

The paragraph text mode in Photoshop Elements 4.0 automatically wraps lines of text when they meet the edge of the text box.

Paragraph text

Menu:	-	
Shortcut: T		**OS:** Windows
Version: 4		**See also:** Type tool

In previous versions of Elements text was entered one line at a time. The user needed to press the Enter key at the end of each line in order to start a new line of text underneath. In version 4.0 this way of working is no longer necessary. Now text is entered in Paragraph mode which will automatically wrap when the cursor reaches the text box edge.

To create a paragraph, select the Type tool and then click and drag a text box on the surface of the picture. Automatically Elements positions a cursor inside the box and creates a new layer to hold the contents. Typing inside the box will add text that automatically wraps when it reaches the box edge. When you have completed entering text, either click the 'tick' button in the options bar, or press the Control + Enter keys.

You can resize or even change the shape of the box at any time by selecting a Type tool and then clicking onto the area where the paragraph text has been entered. This action will cause the original text box to display. The box can then be resized by moving the cursor over one of the handles (small boxes at the corners/edges) and click-dragging the text box marquee to a new position. The text inside the box will automatically rewrap to suit the new dimensions.

Paste command

Menu: Editor: Edit > Paste	
Shortcut: Ctrl/Cmd V	**OS:** Mac, Windows
Version: 1, 2, 3, 4	**See also:** Paste Into Selection

The Edit > Paste command pastes the current contents of the computer's clipboard as a new layer in the open Photoshop Elements document.

This menu option is grayed out (not available) if there is currently nothing copied to the clipboard.

Paste Into Selection

Menu: Editor: Edit > Paste Into Selection	
Shortcut: Shft Ctrl/Cmd V	**OS:** Mac, Windows
Version: 1, 2, 3, 4	**See also:** Paste

The Edit > Paste Into Selection command pastes the contents of the clipboard into the active selection of the current Photoshop Elements document.

The pasted picture part is inserted into the selected area and the boundaries of the inserted picture are highlighted by a selection marquee (marching ants). The selection can be moved and transformed within the boundaries of the insertion area whilst the selection remains active.

Once the selection is deselected, the inserted picture becomes part of the layer it was passed into and no editing of this type is available.

After sky change

To replace the sky in a picture start by making a selection of just the sky. Here the Magic Wand was used to select the predominantly blue sky region.

Now open a substitute sky picture and make a selection of the sky. Copy the selection (Edit > Copy) and then switch back to the original picture and choose Edit > Paste Into Selection.

PQ

Immediately after pasting, press the Ctrl/Cmd T keystrokes combination and use the Free Transform feature to resize and adjust the proportions of the new sky to fit the area of the old.

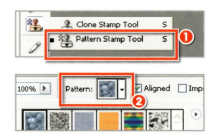

Patchwork filter

Menu: Editor: Filter > Texture > Patchwork
Shortcut: - **OS:** Mac, Windows
Version: 1, 2, 3, 4 **See also:** Filters

The Patchwork filter, as one of the Texture group of filters, simulates the look of the surface of a patchwork quilt. In the process the picture is broken up into a series of squares.

The filter contains two slider controls.

The Square Size setting (1) adjusts the size of each square. The Relief slider (2) determines the degree of shadow that is applied to the texture squares. Low values have less shadow and therefore the appearance of lower relief.

Pattern, Fill Layers

Menu: Editor: Edit > Fill Layer or Fill Selection
Shortcut: – **OS:** Mac, Windows
Version: 1, 2, 3, 4 **See also:** Fill, Define Pattern from Selection

The Edit > Fill Layer command is generally used for filling layers, or active selections, with solid colors, but the feature can also be used for applying patterns to layers or selections.

After selecting Edit > Fill, choose Pattern as the option from the Use menu (1) and then select a pattern from the Custom Pattern palette (2).

To fill a layer, select the layer first and then choose Edit > Fill Layer. To restrict the pattern fill to the extent of a selection, create the selection first and then choose Edit > Fill Selection.

Use the Define Pattern feature to produce custom patterns to use with the Fill command.

Pattern Stamp

Menu: -
Shortcut: S **OS:** Mac, Windows
Version: 1, 2, 3, 4 **See also:** Define Pattern from Selection

The Pattern Stamp tool (1) is nestled in the toolbar with the Clone Stamp tool. The feature works like the Brush tool except that, instead of laying down color, the stamp paints with a pattern. The specific pattern used is selected from the Tool's options bar. A range of preset patterns is included with Elements or you can create your own from a selection with the Edit > Define Pattern from Selection command.

PDF find

Menu: Photo Browser: Find > By Media Type > PDF
Shortcut: Alt 6 **OS:** Windows
Version: 4 **See also:** PDF Format

The PDF file type has been added to the Find > By Media Type menu in Elements 4.0. This new option enables you to locate any cataloged PDF (Acrobat) files in the Photo Browser workspace. The results of the search are displayed in a separate window.

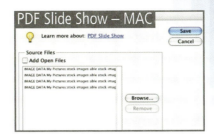

PDF format

Menu:	-	
Shortcut:	-	OS: Mac, Windows
Version:	1, 2, 3, 4	See also: Multi-page PDF to PSD

PDF or Portable Document Format is an Adobe multi-use file format that can be read equally as well by Windows-, Macintosh- and Linux-based machines. The format correctly displays images, text and formatting on the different systems and is fast becoming a standard for press- and web-based document delivery.

Photoshop Elements can read PDF files and also provides an option for output of image files in the format. When opened, multi-page PDF documents are displayed in the PDF Page Selector dialog, where individual pages are previewed and can be selected for opening (1).

PDF Open in PDF Reader

Menu:	-	
Shortcut:	-	OS: Windows
Version:	4	See also: PDF Format, PDF viewing

PDF files that are included in the Photo Browser can be opened directly into Adobe Acrobat Reader by selecting the Open in PDF Reader from the right-click pop-up menu.

Choosing this option displays the file in either the free Adobe Acrobat Reader (available from www.Adobe.com) or Adobe Acrobat, whichever is installed.

PDF Slide Show

Menu:	Photo Browser: File > New > Slide Show	
	Editor: File > New > Creation then Slide Show	
	Editor: File > Automation Tools > PDF Slide Show (Mac)	
	File Browser: Automate > PDF Slide Show (Mac)	
Shortcut:	–	OS: Mac, Windows
Version:	1, 2, 3, 4	See also: Custom Slide Show

When using the PDF Slide Show (Mac) or Simple Slide Show (Win) features a selection of images can be ordered, transitions and timing applied between individual slides, and the whole sequence saved as a self-running slide show.

The resultant PDF file can be saved to disk or CD or even uploaded to the web ready for online viewing.

The PDF file format can save text, graphics and photographs in high quality, and can be read by viewers with a wide range of computer systems using the free Adobe Acrobat Reader. By creating PDF-based slide shows, digital image makers can put together a showcase of their work, which can be shared with a range of viewers, irrespective of the computer system they use.

Windows users with version 3.0 and 4.0 of Elements have an extra choice of creating Custom Slide Shows using the Windows Media Video format. The presentations created with this option can contain music, narration and titles as well as the photo slides that the PDF version contains.

 In version 4.0 of Elements the Simple Slide Show option is not included so instead of using this option you can output shows created with the Slide Show Editor as PDF.

PDF tagging

Menu:	-	
Shortcut:	T	OS: Windows
Version:	4	See also: Tags, PDF Format, PDF viewing

Now that PDF files are recognized as valid media files in the Photo Browser workspace, they are able to be organized like any other files.

This means that PDF files can be tagged using either existing tags or ones created especially for sorting Acrobat files.

PDF viewing

Menu:	-	
Shortcut:	Ctrl I (Edit)	OS: Windows
Version:	4	See also: PDF Format

PDF files cataloged in the Photo Browser workspace can be viewed in two different ways:

1. They can be opened in the free Adobe Acrobat viewer by right-clicking on the thumbnail and then selecting the Open in PDF Reader option from the pop-up menu.

2. Alternatively the file can be sent to the main editing workspace where the page can be viewed and edited by choosing the Go to Standard Edit option from the right-click pop-up menu.

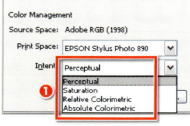

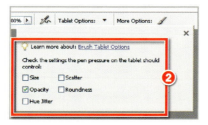

Pencil tool

Menu: -	
Shortcut: N	**OS:** Mac, Windows
Version: 1, 2, 3, 4	**See also:** Brush tool, Auto Erase

The Pencil tool is a pixel-based tool that uses the foreground color to paint with. It works in much the same way as the Brush tool, with the one difference that the pencil can only draw lines that have hard edges.

Freehand lines are drawn by click-dragging the mouse. Straight lines are drawn by holding down the Shift key whilst click-dragging.

The thickness or size (1), mode and opacity of the line can be altered via the tool's options bar. Also any brush that has a hard edge can be selected for use with the Pencil tool from the Brushes Preset palette section of the options bar (2).

Pen pressure

Menu: -	
Shortcut: -	**OS:** Mac, Windows
Version: 1, 2, 3, 4	**See also:** Brush, Graphic Tablet

The stylus, or pen, that is used in conjunction with a graphics tablet has the ability to alter the way that a tool functions according to the amount of pressure being applied to the stylus tip. The Brush tool in Elements is specially designed to take advantage of this function.

For example, the tool can be set to change the amount of color (opacity) laid down by the brush with the pressure applied to the pen. Light pressure produces lightly colored areas whereas heavy pressure paints with the full strength of the current foreground color.

Using a stylus and graphic tablet, along with Elements' pen pressure features and some skillful manipulation of the pen, will enable users to produce very subtle hand-drawn gradient (1) and shading effects.

The Brush tool's options bar contains a pop-up palette with a range of drawing features that can be linked with pen pressure (2).

Perceptual rendering intent

Menu: -	
Shortcut: -	**OS:** Mac, Windows
Version: 1, 2, 3, 4	**See also:** Color Management

At various points in the digital photography process it is necessary to change or alter the spread of colors in a picture so that they fit the characteristics of an output device, such as a screen or printer, more fully. Perceptual is one of the four different approaches that Photoshop Elements can use in this conversion process. The other choices are Saturation, Relative Colorimetric and Absolute Colorimetric.

Each approach produces different results and is based on a specific conversion or 'rendering intent'. The **Perceptual** setting puts conversion emphasis on ensuring that the adjusted picture, when viewed on the new output device, appears to the human eye to be very similar to the original photo. So this is a good choice for photo conversions.

The **Saturation** option tries to maintain the strength of colors during the conversion process (even if color accuracy is the cost). The **Relative Colorimetric** setting squashes or stretches the range of colors in the original so that they fit the range of possible colors that the new device can display. The **Absolute Colorimetric** option translates colors exactly from the original photo to the range of colors for the new device. Those colors that can't be displayed are clipped.

Specific Intents can be selected as part of the printing process via the color-management controls in the Show More Options section of the Print Preview dialog (1).

Before

After

Perspective, changing

Menu: Editor: Image > Transform > Perspective	
Shortcut: -	**OS:** Mac, Windows
Version: 1, 2, 3, 4	**See also:** Free Transform

The perspective of a picture can be changed by selecting the object, layer or picture part and then using the Image > Transform > Perspective command. Adjustments are made by dragging the corner handles of the selection.

This feature is particularly helpful when trying to correct the leaning or converging verticals that appear so often in travel photographs taken with a camera fitted with a wide-angle lens. Use the steps below to correct the perspective and height problems that occur when shooting in this way.

Photo Album pages

Menu: Photo Creations: Photo Books with Album Pages	
Shortcut: -	**OS:** Windows
Version: 3, 4	**See also:** Photo Creations

'Scrapbooking' is fast becoming one of the most popular ways to collate and share your photographs with friends and relatives, and the Photo Album Pages feature (Album Pages in version 4.0) in the Photo Creations workspace is a terrific way to produce the scrapbook pages (1).

Using the step-by-step wizard (2), your own images and one of the many template designs in the feature you can quickly and easily produce a series of pages (yes, including a title page) that look like they have been professionally laid out.

The finished pages can be printed on your own printer, output as a PDF file or sent as an e-mail attachment. Additionally, pages made with the Bound Photo Book in version 4.0 can be printed and bound online.

Photo Bin

Menu: Editor: Window > Photo Bin	
Shortcut: -	**OS:** Mac, Windows
Version: 3, 4	**See also:** Palette Bin

The Photo Bin (1) stores photos currently open in the Editor workspace. To increase screen real estate, you can minimize an image into the Photo Bin by choosing 'Minimize' from the Context menu when clicking on its thumbnail in the Photo Bin. You can redisplay it in the work area by choosing 'Restore' from the context menu. In Standard Edit mode, you can view multiple Image windows at once, but in Quick Fix mode, you can only view/edit one at a time. The Photo Bin allows you access to other images in Quick Fix mode. To view the next or previous image in the Photo Bin, click the Next/Previous Image button. The number of pictures stored in the bin is displayed in the Status Bin's bar (4).

The Photo Bin can be opened/closed by selecting Window > Photo Bin, clicking the Photo Bin toggle button (2) or pressing the button (3) on the Bin's top edge.

With the picture open in Elements make the grid visible (View > Grid) to help align your adjustments. Select the Perspective option from those listed in the Image > Transform menu. Click OK to the Warning window and then label the converted background layer.

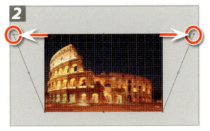

Click on the corner handles and drag these outwards until the edges are parallel with the grid lines. Double-click to OK the changes. Increase the canvas size vertically to allow for stretching the building upwards by selecting Image > Resize > Canvas Size and inputting 200% for the height value.

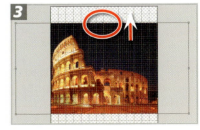

Select the Scale option from the Resize menu. Click and drag the middle top and bottom handles upwards (and downwards) to increase the height of the image. Use the Crop tool to trim unwanted areas of the corrected picture.

Photo Browser

Menu:	-		
Shortcut:	-	**OS:**	Windows
Version:	3, 4	**See also:**	Organizer workspace

The Photo Browser in Elements 3.0 and 4.0 for Windows has its origins in Photoshop Album and the older File Browser feature (Editor: File > Browse Folders) that was available in Editor mode in previous editions. Though it was the forerunner the File Browser didn't contain the range of search, tag and display options that the new Organizer or Photo Browser workspace provides.

Pictures can be imported into the Browser using the Get Photos command, viewed side by side with the Photo Compare command and seen as a slide show by selecting the Photo Review option.

Simple editing tasks, such as the automatic adjustment of levels, contrast and/or sharpness, along with simple orientation and crop changes, can be performed directly from inside the browser with the Auto Fix feature.

The Photo Browser is also referred to as the Organizer workspace.

Photo Compare

Menu:	Photo Browse: View > Compare Photos Side by Side
	Photo Browser: View > Photo Compare (version 3.0)
Shortcut: F12	**OS:** Windows
Version: 3, 4	**See also:** Photo Review, Organizer workspace

Closely linked to the Review feature is the Photo Compare option (retitled Compare Photos Side by Side in version 4.0), which allows Windows users to display two similar pictures side by side. This is a great way to choose between several images taken at the same time to ensure that the best one is used for printing or passed into the Editor work space for enhancement.

To select the images to display in the feature multi-select pictures in the Organizer workspace and then choose View > Photo Compare. The first of the selected pictures are shown side by side and the rest listed as thumbnails on the right of the screen. Click on these thumbnails to replace the images currently being compared.

All the adjustment and organizational controls found in the Photo Review feature are also available here, including the Zoom Control, which provides the ability to examine each candidate file more closely. You can also automatically enhance, add and remove tags, mark the file for printing and add the file to a chosen collection using the choices listed under the Action menu.

Photo Creations

Menu:	Editor: File > New > Creation		
Shortcut:	Alt Ctrl C	**OS:**	Windows
Version:	3, 4	**See also:**	-

The Photo Creations workspace is a common starting point for many different photo projects. Each of the imaging projects are set up in a wizard format, which enables users to quickly and easily produce professional looking end results.

With Photo Creations you can produce slide shows, greeting and postcards, calendars, web photo galleries, album pages and Video CD (VCD) presentations.

Whole catalogs, or even several individually selected files from the Photo Browser, can be used as a basis for these projects.

You can start the feature from the Photo Browser (Organizer), either of the two Image Editors (Quick Fix and Standard), using the 'Create' shortcut button or from the initial Welcome or start-up screen by selecting the 'Make Photo Creation' option.

The pictures to include in the project can be selected in the browser prior to opening the feature or added later using the 'Add Photos' command. The steps involved in creating the project are clear and precise with sophisticated results being available in minutes rather than hours, which would be the case if the same products were produced manually and unaided.

The following options are available as Photo Creations: Slide Show, VCD with Menu, Photo Books and Album Pages, Bound Photo Book, 4-Fold Greeting Card, Photo Greeting Card, Bound Wall Calendar, Wall Calendar and HTML Photo Gallery.

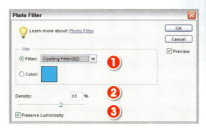

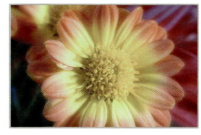

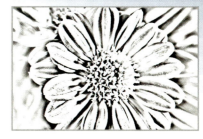

145

Photo E-mail

Menu:	Editor: File > Attach to E-mail
	Photo Browser: File > Attach to E-mail
Shortcut: -	**OS:** Windows
Version: 3, 4	**See also:** E-mailing pictures

Attaching your pictures to e-mails is not a new way to share your photos with friends the world over, but being able to embed them into the body of the e-mail on a fancy background is definitely a new twist on the process.

Adobe has included this new Photo Mail option together with the Adobe E-mail Service in the Elements 3.0 and 4.0. Now, selecting the File > Attach to E-mail option from either the Browser or Editor workspaces takes you to a specialized dialog, which provides options to add and delete the pictures included in the e-mail, select recipients for the mail, choose which stationery to use and even add your message. Clicking the OK button composes the e-mail and then places it into your e-mail program ready for you to send, or sends it directly using Adobe's mail service.

Photo Filter

Menu:	Editor: Filter > Adjustment > Photo Filter
Shortcut: -	**OS:** Mac, Windows
Version: 3, 4	**See also:** Filters

The Photo Filter, as one of the Adjustments group of filters, simulates the color changes that are made to a picture when it is photographed through a color correction filter.

The filter contains three controls.

In the Use section (1) you can select the type of filter from the drop-down list provided or create your own by double-clicking the color swatch and selecting a new hue.

The Density slider (2) determines the strength of the filters and the Preserve Luminosity (3) option adjusts the filtered photo to account for the density of the filter with the aim of maintaining the picture's original brightness.

The filter is also available as an adjustment layer.

Photocopy filter

Menu:	Editor: Filter > Sketch > Photocopy
Shortcut: –	**OS:** Mac, Windows
Version: 1, 2, 3, 4	**See also:** Filters

The Photocopy filter, as one of the Sketch group of filters, simulates the look of a picture that has been photocopied several times. The main highlight and shadow areas are represented as light and dark but there is very little middle tone retained in the filtered picture.

The filter contains two slider controls.

The Detail control (1) adjusts the level of original detail that is retained in the picture.

The Darkness slider (2) determines the overall brightness of the result.

The hues of the filtered picture are based on the current foreground and background colors.

With a photo open in the Editor workspace select File > Attach to E-mail to display the new dialog. Add or delete photos from the thumbnail list of those to include with the buttons at the bottom left of the dialog.

Choose an existing recipient (1) from the contacts list or add a new contact. Choose the Photo Mail (HTML) format (2) from the drop-down menu.

For the Photo Mail (HTML) option select the stationery (3) to use as a background for the e-mail. Add in your message and click OK. When your e-mail program displays the new message click Send to e-mail in the usual manner.

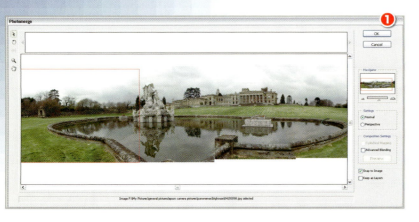

Photomerge

Menu: Editor: File > New > Photomerge Panorama
Photo Browser: File > New > Photomerge Panorama
File Browser: Automate > Photomerge (Mac)
Shortcut: - **OS:** Mac, Windows
Version: 1, 2, 3, 4 **See also:** Panorama

Photomerge (1) is included free within Elements and is Adobe's stitching technology that enables photographers to join overlapping photos to create wide-angle pictures.

Over the last versions of Elements Photomerge has been updated to include enhanced support for larger file sizes and better fine-tuning controls as well as the ability to produce the composition as separate source picture layers.

The source files are added to the feature by multi-selecting in the Photo Browser (File Browser for Mac) or simply being open in the Editor at the time of selecting File> New > Photomerge Panorama.

Photo Review

Menu: Photo Browser: View > View Photos in Full Screen
Photo Browser: View > Photo Review (version 3.0)
Shortcut: F11 **OS:** Windows
Version: 3, 4 **See also:** Photo Compare

The View Photos in Full Screen (previously Photo Review) feature provides an instant slide show of the pictures that you have currently displayed in the Photo Browser. Seeing the photos full size on your machine is a good way to edit the shots you want to keep from those that should be placed in the 'I will remember not to do that next time' bin.

Using the provided menu you can play, pause, or advance to next or last photos, using the VCR-like controls. You can enlarge or reduce the size that the picture appears on screen with the magnification slider (Zoom Level control). For quick magnification changes there are also 'Fit to Window' and 'Actual Pixels' buttons. But the real bonus of the feature is the list of actions that you can perform to pictures you review. You can automatically enhance, add and remove tags, mark the file for printing and add the file to a chosen collection using the choices listed under the Action menu. Specific picture properties such as the tag, history and metadata are available by hitting the Alt + Enter keys to display the Properties window.

Start the Photomerge feature. Click the Browse button in the Dialog box. Search for the pictures for your panorama. Click Open to add the files to the Source Files section of the dialog.

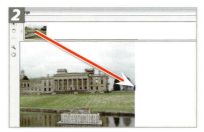

Select OK to open the Photomerge main workspace. The feature will automatically position the source files. If need be, click-drag photos to change position or add from the Light box (top of window).

As well as showing all the photos currently in the browser you can also multi-select the images to include in the review session before starting the feature, or even limit those pictures displayed to a particular collection.

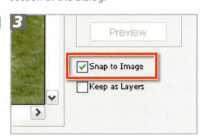

With the Snap to Image function turned on, Photomerge will match like details of different images when they are dragged over each other.

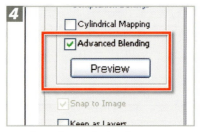

Use the Advanced Blending option to smooth out uneven exposure or tonal difference between stitched pictures. Click Preview to see the blending before clicking OK to produce the panorama.

The Photo Review preferences can be set when the feature is first opened or accessed via the last item on the Action menu.

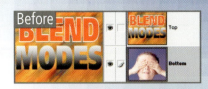

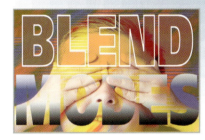

Photoshop format (PSD)

Menu: -

Shortcut: - **OS:** Mac, Windows

Version: 1, 2, 3, 4 **See also:** JPEG, GIF, TIFF

The Photoshop file format (PSD) is the native format of both Photoshop and Photoshop Elements programs. The format is capable of supporting layers, editable text, adjustment layers and millions of colors.

You should choose this format for all manipulation of your photographic images. The format contains no compression features but should still be used to archive complex images with multiple layers and sophisticated selections or paths as other format options remove the ability to edit these characteristics later.

Picture Package

Menu: Editor: File > Print Multiple Photos > Picture Package
Photo Browser: File > Print > Picture Package
Editor: File > Picture Package (Mac)
File Browser: Automate > Picture Package (Mac)

Shortcut: C-- **OS:** Mac, Windows

Version: 1, 2, 3, 4 **See also:** Print Multiple Photos

The feature allows you to select one of a series of predesigned, multi-print layouts that have been carefully created to fit many images neatly onto a single sheet of standard paper.

Macintosh users can access the feature via the File menu in the Editor or under the Automate menu in the File Browser.

There are designs that place multiples of the same size pictures together and those that surround one or two larger images with many smaller versions.

The Windows feature provides a preview of the pictures in the layout (1). You can also choose to repeat the same image throughout the design by selecting the One Photo Per Page option.

In Elements 4.0 and 3.0 for Windows there is no option to add labels in the Picture Package (as there was in version 2.0 of the feature), but you can select a frame (2) from one of the many listed to surround the photos you print. Elements 3.0 on the Mac does contain labels, as it is unchanged from the 2.0 version.

Version 4.0 does provide the option for Labels are available in the Organizer: File > Print dialog under Select a Layout selection.

Pin Light blend mode

Menu: -

Shortcut: - **OS:** Mac, Windows

Version: 1, 2, 3, 4 **See also:** Blend modes

The Pin Light blending mode is one of the group of Overlay modes which replaces colors based on the tone of the pixels in the top layer.

If the pixels in the top layer are lighter than 50% gray then all pixels in the bottom layer that are darker are replaced with the upper layer's colors. Pixels lighter than the upper layer are not changed.

If the pixels in the top layer are darker than 50% gray then all pixels in the bottom layer that are lighter are replaced and those darker are left unchanged.

147

PQ

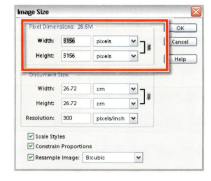

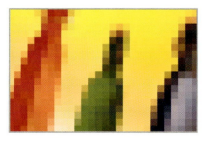

Pinch filter

Menu: Editor: Filter > Distort > Pinch	
Shortcut: -	**OS:** Mac, Windows
Version: 1, 2, 3, 4	**See also:** Filters

The Pinch filter, as one of the Distort group of filters, bloats or squeezes in a picture according to the setting selected.

The filter contains a single slider control, Amount (1), that varies both the strength of the effect and whether the filter bloats or squeezes the picture.

Also included in the dialog is a wire frame representation of the type and strength of the changes (2) and a Preview window.

Pixels

Menu: -	
Shortcut: -	**OS:** Mac, Windows
Version: 1, 2, 3, 4	**See also:** Pixel dimensions

Short for picture element, Pixels refers to the smallest image part of a digital photograph. From a distance, or with high resolution pictures, the pixel-based nature of digital photographs is not obvious, but when overly enlarged the blocky structure of the picture becomes noticeable.

Pixel dimensions

Menu: -	
Shortcut: -	**OS:** Mac, Windows
Version: 1, 2, 3, 4	**See also:** Pixels

Digital files have no real physical dimensions (inches or cm) until they are printed. The true dimensions of a digital file are based on the picture's width and height in pixels. It is only when the file is printed that a set number of pixels are used to create a square inch of the photograph that the file has physical dimensions. The pixel dimensions of a photo can be viewed via the Image > Resize Image Size dialog.

In versions 1.0 and 2.0 of Elements and the Macintosh edition of 3.0, you can also click on the Document Info Area of the Image window (Mac) or status bar (Windows) and get a quick glimpse of this info, plus channels and resolution.

For the Windows version of Photoshop Elements 3.0 this info was moved to the Info palette. In version 4.0 the feature returns, with details like the document size being available in the status bar as well as the info palette.

Pixel matching searches

Menu:	Photo Browser: Find > By Visual Similarity to Selected Photos		
Shortcut:	-	**OS:**	Windows
Version:	4	**See also:**	Find, Find By Visual Similarity

The Find > By Visual Similarity to Selected Photos feature is a new addition to the search options available in Photoshop Elements.

After selecting a photo or photos in the browser space choose the By Visual Similarity to Selected Photos option from the Find menu (1). Elements then searches through the database of pictures and locates the photos that best match according to color, tone and texture.

The results of the search are then displayed in a new window (2). The degree of matching of each of the images to the original selection is indicated by a percentage value located in the bottom left corner of the thumbnail.

This option is similar in nature to, and replaces, the Find > By Color feature that was present in Elements 3.0.

Place

Menu:	Editor: File > Place		
Shortcut:	-	**OS:**	Mac, Windows
Version:	1, 2, 3, 4	**See also:**	-

The File > Place command is used for importing and creating a new layer for documents created in vector file formats. In Photoshop Elements you can place PDF (Acrobat files), AI (Illustrator files) and EPS (Encapsulated Postscript files).

After choosing the option, select the picture to place from the File Browser dialog that appears and then size the graphic by click-dragging the corner handles of the bounding box. Complete the placement by double-clicking inside the bounding box, or clicking the tick mark in the options bar, or hitting Enter/Return keys.

During the placing process the vector information is converted to pixels (bitmap).

Plaster filter

Menu:	Editor: Filter > Sketch > Plaster		
Shortcut:	-	**OS:**	Mac, Windows
Version:	1, 2, 3, 4	**See also:**	Filters

The Plaster filter, as one of the Sketch group of filters, colors and shadows broad areas of the photo in textureless shapes. Some picture parts are raised and flattened, the rest is made to look hollow and low lying. The colors in the filtered picture are based on the current foreground and background colors.

The filter contains two slider controls and a drop-down menu for selecting the direction of the light (3) used for creating depth, shadow and highlight effects.

The Image Balance control (1) adjusts the amount of the image that is converted to raised flat surface and that which is changed to receding areas. The Smoothness slider (2) determines how much detail is retained in the raised areas.

PQ

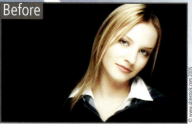
Before

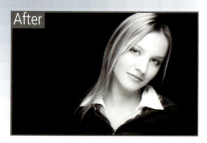
After

© www.allstock.com 2005

150

Plug-ins

Menu: -	
Shortcut: -	**OS:** Mac, Windows
Version: 1, 2, 3, 4	**See also:** Filters

Since the first version of Elements Adobe provided the opportunity for third-party developers to create small pieces of specialist software that could plug into the program. These extra features extend the capabilities of the program and some of them have become so popular that they find themselves added into the program proper in the next release of the software.

Most plug-ins register themselves as extra options in the Filter menu, where they can be accessed just like any other Elements feature.

The Delta100 filter (1) from www.silveroxide.com is a great example of plug-in technology. Designed to reproduce the look of particular types of black and white film stock, the installed filter can be selected from the Silver Oxide group (2) of products in the Filter menu.

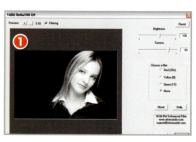
❶

❷

PQ

Plug-in options:

Flaming Pear – *Super Blade Pro*
Effect: This plug-in provides the most sophisticated control over surface and texture characteristics of text and objects available.
OS: Mac, Windows **Cost:** US$30.00
Website: www.flamingpear.com

Extensis – *Intellihance Pro 4*
Effect: Capable of comparing and applying up to 25 different enhancement options at one time, Intellihance Pro is the master of the quick fix.
OS: Mac, Windows **Cost:** US$199.00
Website: www.extensis.com

Alien Skin – *Eye Candy 4000*
Effect: Eye Candy 4000 is a collection of 23 different creative filters used for creating effects such as shadows, bevels, chrome, smoke, wood and even fur.
OS: Mac, Windows **Cost:** US$169.00
Website: www.alienskin.com

Digital Film – *Ozone 2*
Effect: Simulates the same tonal control available when using the film-based Zone System (created by Ansel Adams) with your digital photographs.
OS: Mac, Windows **Cost:** US$50.00
Website: www.digitalfilmtools.com

Harry's – *Filters 3.0*
Effect: A free collection of filters that can be used for creating up to 69 different imaging effects. Also contains the option to encrypt your photos.
OS: Mac, Windows **Cost:** FREE
Website: www.thepluginsite.com

Photowiz – *Color Washer*
Effect: The Color Washer plug-in is used for the correction and enhancement of colors in your pictures. Great for restoring faded colors in old photos.
OS: Windows **Cost:** US$49.95
Website: www.thepluginsite.com

PhotoTune – *20/20 Color MD*
Effect: Using a side-by-side comparison approach this PhotoTune plug-in takes the guesswork out of correcting the colors in your photos.
OS: Mac, Windows **Cost:** US$49.95
Website: www.phototune.com

AutoFX – *Photo/Graphic Edges*
Effect: Photo/Graphic Edges provides 14 photographic effects that are used to create an astonishing array of edges and borders for your images.
OS: Mac, Windows **Cost:** US$179.00
Website: www.autofx.com

PQ

Power Retouche – *Black & White Studio*

Effect: This plug-in replicates many of the effects of a traditonal darkroom including specific film looks.
OS: Mac, Windows **Cost:** US$75.00 £45.00
Website: www.powerretouche.com

VanDerLee – *Old Movie*

Effect: Create the look and feel of an old photo or movie frame with this plug-in. Includes controls for film type, scratches, camera, dust, fat and hair.
OS: Windows **Cost:** US$19.95
Website: www.v-d-l.com

Andromeda – *Shadow Filter*

Effect: Billed as the 'most advanced shadowing plug-in available' this filter really lives up to the hype. Master the controls and any shadows are possible.
OS: Mac, Windows **Cost:** US$109.00
Website: www.andromeda.com

Richard Roseman – *Vignette Corrector*

Effect: The plug-in removes or adds the darkened edges that are produced by low quality wide-angle lenses.
OS: Windows **Cost:** Free
Website: www.richardroseman.com

Lokas – *Artistic Effects*

Effect: The Artistic Effects collection is a series of customized filters that add surface effects to text and shapes. The options include gel, ice, metal, smoke and snow.
OS: Windows **Cost:** US$59.95
Website: www.artistic-effects.com

NIK – *Sharpener Pro Inkjet*

Effect: The range of NIK sharpening plug-ins is designed to sharpen your pictures to clarify output to a variety of print devices.
OS: Mac, Windows **Cost:** US$79.95
Website: www.nikmultimedia.com

AV Bros – *Puzzle Pro*

Effect: Although at first this seems like a simple jigsaw puzzle maker the ability to customize and add extra shapes really extends the options for this plug-in.
OS: Mac, Windows **Cost:** US$49.95
Website: www.avbros.com

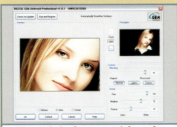

ASF – *Digital GEM Airbrush*

Effect: Provides glamor photo type results by automatically smoothing skin whilst retaining details in the areas like eyelashes and hair.
OS: Mac, Windows **Cost:** US$99.95
Website: www.asf.com

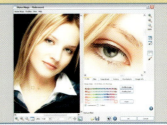

Digital Element – *Aurora*

Effect: The Aurora plug-in is an advanced world creator that produces highly sophisticated water, sky and lighting elements.
OS: Mac, Windows **Cost:** US$199.00
Website: www.digi-element.com

Andrew's Plugins – *V8*

Effect: There is plenty of creative choice here with nearly 20 different plug-in sets providing thousands of different effects and only costing $10.00 each.
OS: Mac, Windows **Cost:** US$10.00
Website: www.graphicxtras.com

The Imaging Factory – *Convert to B&W*

Effect: Powerful and customizable coversion plug-in designed for the dedicated monochrome enthusiast.
OS: Mac, Windows **Cost:** US$99.00
Website: www.theimagingfactory.com

PictureCode – *Noise Ninja*

Effect: Noise Ninja is a very sophisticated noise reduction plug-in that works extremely well with photographs taken using high ISO settings.
OS: Mac, Windows **Cost:** US$44.95
Website: www.picturecode.com

151

PQ

www.**ElementsA-Z**.com

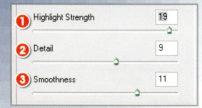

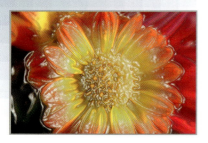

152

Plastic Wrap filter

Menu: Editor: Filter > Artistic > Plastic Wrap
Shortcut: - **OS:** Mac, Windows
Version: 1, 2, 3, 4 **See also:** Filters

The Plastic Wrap filter, as one of the Artistic group of filters, simulates the look of wrapping the photograph in a sheet of close-fitting plastic or cling film.

The filter contains three controls. The Highlight Strength (1) controls the size, amount and dominance of the highlight areas.

The Detail slider (2) determines how broad the highlight areas are and the Smoothness (3) option adjusts the sharpness of the edge of the highlight.

Pointers

Menu: -
Shortcut: - **OS:** Mac, Windows
Version: 1, 2, 3, 4 **See also:** Cursors

The terms Pointers and Mouse Cursors are often used interchangeably to represent the shape or icon that is displayed on screen at the mouse position. The default pointer styles for different tools can be selected from the Edit > Preferences > Displays & Cursors dialog (1).

Points, type size

Menu: -
Shortcut: - **OS:** Mac, Windows
Version: 1, 2, 3, 4 **See also:** Type

The size of the text you place in your image files can be measured as pixels, millimeters or points.

Most photographers find the pixel setting most useful when working with digital files, as it indicates the precise size of the text in relationship to the whole image.

Millimeter and points values, on the other hand, vary depending on the resolution of the picture and the resolution of the output device.

It is true that there are approximately 72 points to 1 inch, but this only remains true if the picture's resolution is 72 dpi. At higher resolutions the pixels are packed more closely together and therefore the same 72 point type is displayed smaller in size.

The default unit of measurement for type in Elements can be altered in the Edit > Preferences > Units & Rulers dialog (1).

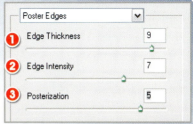

153

Polygonal Lasso tool

Menu: -
Shortcut: L
OS: Mac, Windows
Version: 1, 2, 3, 4
See also: Lasso, Magnetic Lasso

The Polygonal Lasso is one of three Lasso tools available in Photoshop Elements. Lasso tools make selections by drawing a marquee around the picture part to be selected. Unlike the other options the Polygonal Lasso draws in straight lines and is particularly good at selecting regular shaped objects.

To start a new selection choose the tool from the toolbar and click on the canvas at the picture part that will mark the beginning of the selection marquee. Now move the tool to a new position and notice that the marquee line stretches out from the first click position to follow the cursor. Move the cursor around until the stretched marquee aligns itself with the edge of the picture you are selecting and then click again. This marks another anchor point for the lasso line. Continue around the area to be selected, clicking the mouse at points where you wish to change direction until you reach your starting point, where you can double-click the tool to join up the two ends of the selection.

Pointillize filter

Menu: Editor: Filter > Pixelate > Pointillize
Shortcut: -
OS: Mac, Windows
Version: 1, 2, 3, 4
See also: Filters

The Pointillize filter, as one of the Pixelate group of filters, recreates the picture in a series of colored dots on a background the color of the current background color. The end result simulates the look of a pointillist painting.

The filter contains a single slider control, Cell Size (1), that varies the size of the dots used to create the effect.

Poster Edges filter

Menu: Editor: Filter > Artistic > Poster Edges
Shortcut: -
OS: Mac, Windows
Version: 1, 2, 3, 4
See also: Filters

The Poster Edges filter, as one of the Artistic group of filters, posterizes the colors in a picture whilst surrounding the edges with a dark border. The filter also adds some simple stippled shading to the picture.

The filter contains three controls. The Edge Thickness setting (1) adjusts the weight of the line and the heaviness of the shading.

The Edge Intensity slider (2) controls the darkness of the border and shading, and the Posterization setting (3) alters the number of colors used in the final result.

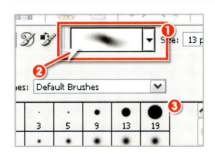

Pop-up palettes

Menu: -
Shortcut: -
OS: Mac, Windows
Version: 1, 2, 3, 4
See also: Options Bar

Pop-up palettes are located in the options bar of selected tools in the Editor workspace. The palette is displayed or 'popped-up' by clicking the down arrow (1) on the right of the preview thumbnail (2) of the current selected option. The example shows the Brush options bar with the pop-up palette displayed containing a library of preset brush shapes. Pop-up palettes are also available with the Gradient, Swatch, Patterns, Layer styles and Custom shapes tools.

Unlike normal palettes, they are not meant to persist and they disappear from view when you click off them or hit Enter/Return.

PQ

Posterize adjustment layer

Menu: Editor: Layer > New Adjustment Layer > Posterize
Shortcut: - **OS:** Mac, Windows
Version: 1, 2, 3, 4 **See also:** Posterize filter,
Adjustment layer

The Posterize adjustment layer produces the same effect as the Posterize filter but adds the benefits of maintaining the original picture and being able to edit the Posterize settings at a later date.

Posterize filter

Menu: Editor: Filter > Adjustments > Posterize
Shortcut: - **OS:** Mac, Windows
Version: 1, 2, 3, 4 **See also:** Filters,
Posterize Adjustment layer

The Posterize filter, as one of the Adjustments group of filters, reduces the total number of colors in an image by letting you set the number of brightness levels per channel. A setting of 3 will produce three levels of tone for each of the red, green and blue channels, giving a nine-color result.

Preferences, Editor

Menu: Editor: Edit > Preferences
Shortcut: Ctrl/Cmd K **OS:** Mac, Windows
Version: 1, 2, 3, 4 **See also:** Preferences Photo Browser

The Preferences dialog for the Editor workspace contains a range of settings that control the way that the program looks, displays pictures and processes your files. The settings are grouped in nine separate but housed together dialogs. When the Preferences option (1) is selected from the Edit menu the General dialog is displayed first with the other options accessed via the Next and Previous buttons (or by selecting the precise dialog from the Preferences menu).

Each Preferences dialog with standard settings selected is displayed below and on the facing page.

Grid – Settings for the spacing, style and color of the grid that is displayed via the View > Grid command. You have three choices of grid style – lines, dashed lines and dots.

Transparency – Options to alter the way that the transparent part of image layers is displayed. You can change the grid size and the colors used.

Type (version 4.0) – New for preferences is the Type section where options for Smart Quotes, the Font Preview Size, Font Names and Asian Text settings are located.

File Browser (version 3.0) – The settings here govern the way that the File Browser contained in the Editor workspace functions. Options include the maximum size of files included, the quality of the previews and the size of the thumbnails created.

Plug-Ins & Scratch Disks – Sets the location of the virtual memory or scratch disks that Elements uses when it runs out of RAM memory whilst processing your files. Make sure that the system drive is not selected as a scratch disk location as most operating systems run their own disk-based memory system on these drives. Also included here is the ability to identify an additional plug-ins folder. This plug-ins location is separate and extra to the default /Photoshop Elements 3.0/Plug-Ins/ directory.

Saving Files – Preferences for ensuring that an image preview is always stored with newly saved files and that all file extensions added are in the same case (upper or lower). Other options include the number of files in the File > Open Recently Edited list and ensuring compatibility of camera, TIFF and PSD file formats.

General – The General options here control the day-to-day functioning of Elements. The most important settings are the number of History States (high values really chew up memory resources), the Step Backward and Forward keystroke combinations, the style of Color Picker you favor, Save Palette Locations, Show Tool Tips and Relaxed Text Selection but the specifics of your setup will depend largely on the way that you prefer to work.

Units & Rulers – Use the settings in this dialog to alter the base units of measurement for rulers, type and print sizes that are displayed throughout the program. Though these preferences set the global units for all dialogs and tools in Elements, most features also contain drop-down menus that allow on-the-fly changes to units of measure. Default column sizes and gutters, along with resolution settings for new documents, are also stored in this location.

Memory & Image Cache – Use the Memory Usage setting here to ensure that as much RAM as possible is allocated exclusively to Elements. In this example, other programs will be run alongside of Elements so 55% of the total RAM is earmarked for the program, but more memory would mean faster processing.

Display & Cursors – Use this dialog to alter the default cursor or tool pointers used for painting, drawing and selection tools. Selecting the Use Pixel Doubling option speeds up the display of the results of editing changes by temporarily halving the resolution of the photo.

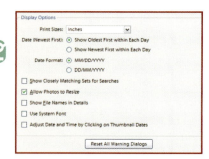

General... Ctrl+K

Files...

Folder Location View...

Editing...

Camera or Card Reader...

Scanner...

Calendar...

Tags and Collections...

Mobile Phone...

Sharing...

Services...

❶

2005 Editor Preferences...

Preferences, Photo Browser

Menu: Photo Browser: Edit > Preferences
Shortcut: Ctrl K **OS:** Windows
Version: 3, 4 **See also:** Preferences - Editor

The Preferences dialog for the Photo Browser or Organizer workspace contains a range of settings that control the way that this part of Elements works with your pictures.

The settings are grouped in nine separate but housed together dialogs. When the Preferences option (1) is selected from the Edit menu the General dialog is displayed first with the other options accessed by clicking on their heading in the listing to the left of the dialog (or by selecting the precise category from the Preferences menu).

Each Preferences dialog with standard settings selected is displayed below/ alongside.

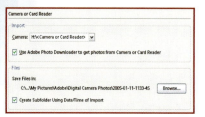

General – Settings that adjust the units of measure used for prints, the sequence that thumbnails are displayed, the exactness of successful search matches, photo resizing, the font used for labels and whether file names are shown with each thumbnail.

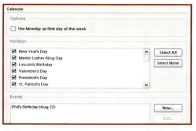

Camera or Card Reader – Allocate the location of your camera or card reader on your computer system and whether the Adobe Photo Downloader utility will be used for transferring files to the computer. Also nominate the folder where downloaded pictures are stored.

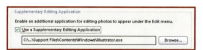

Tags and Collections – The default display settings for tags as well as options for how categories, groups, collections and tags are sorted.

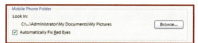

Editing – Choose an additional program used for editing or enhancing pictures.

Mobile Phone – Allocate the folder used for storing pictures downloaded from your mobile phone.

Scanner – Set up the default scanner, the file format used for scanned images and where these files are stored.

Display Options
Show Folders: ○ All Folders
 ⦿ Only Folders Containing Organized Files
Show Files: ⦿ All Files Grouped By Folder
 ○ Only Files in the Selected Folder

Folder Location View (version 4.0) – This new preferences section determines how folders are displayed in the revised Folder View mode of the Organizer.

Calendar – Set up options including choosing the holidays and special events that appear on any calendars in Elements as well as whether to use Monday (instead of Sunday) as the first day of the week.

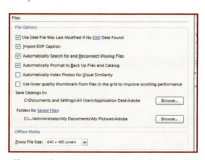

E-mail (version 3.0) – The settings used with the Elements features that have e-mail components.

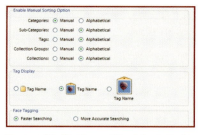

Files – File saving options including the location of catalogs and saved pictures and the size of the preview images created for offline photos.

Services – Options for the use of online services with Elements. Settings here determine Print and Share options available according to your location.

E-mail Settings
E-mail Client: Outlook Express
Sharing Settings
☐ Write E-mail captions to catalog

Sharing (version 4.0) – The E-mail preferences panel is replaced in version 4.0 with the Sharing panel. Here the default E-mail client is selected as well as the ability to write e-mail captions to the catalog.

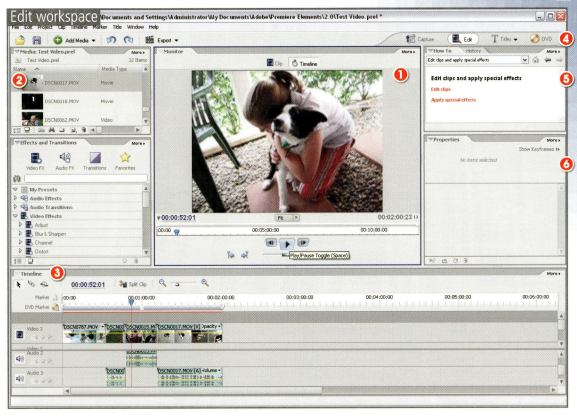

Edit workspace

Premiere Elements

Menu: –	
Shortcut: -	OS: Windows
Version: 2	See also: DVD menu template edit

To coincide with the release of Photoshop Elements 4.0 Adobe also created a new version of its popular digital video editing package – Premier Elements.

Premiere Elements is to digital video editing and production what Photoshop Elements is to still image editing and enhancement. The program provides a simple easy-to-use interface without sacrificing the depth of technology needed to produce Hollywood style productions complete with special effects, titles, credits and even Dolby® Digital sound.

The four individual workspaces that are included in Premiere Elements reflect the various phases of the digital video production process. Video is captured from an attached camera or imported into the program from existing files. Next the clips are positioned on the timeline, effects and titles added and finally the whole production is exported to DVD, video file or even back to tape.

A brief overview of Premiere Elements is included here because Adobe sees this package as a sister application to Photoshop Elements and has not only started to provide links between the two programs but also to bundle them together in a mini-suite.

One example of this crossover is the ability to create and edit Premiere Elements DVD menu templates from inside Photoshop Elements.

(1) Monitor panel.
(2) Media panel.
(3) Timeline.
(4) Task bar.
(5) How To panel.
(6) Properties panel.

Capture workspace

DVD workspace

Titles workspace

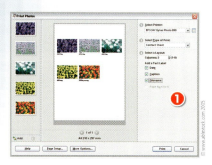

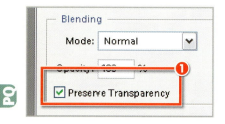

Preset Manager

Menu: Editor: Edit > Preset Manager	
Shortcut: -	**OS:** Mac, Windows
Version: 1, 2, 3, 4	**See also:** Brush, Gradient, Pattern, Swatches

The Edit > Preset Manager is a central location for the organization, saving and loading of Elements resources (or Preset Libraries) such as brushes, swatches, gradients and patterns (1) used in the Editor.

The More button displays a pop-up palette with view choices and extra resource libraries. The dialog also provides the ability to load, save, rename and delete individual resource items (e.g. brushes) or whole libraries (e.g. Faux Finish Brushes).

Preserve Transparency

Menu: -	
Shortcut: -	**OS:** Mac, Windows
Version: 1, 2, 3, 4	**See also:** Lock Transparency

The preserve transparency option in features like Fill Layer (1) shields the transparent area of a layer from any editing or enhancement changes. An alternative to selecting this option when using a tool is to lock the layer's transparency in the Layers palette.

Print Multiple Photos

Menu: Editor: File > Print Multiple Photos	
Shortcut: Alt Ctrl P	**OS:** Windows
Version: 3, 4	**See also:** Prints, individual

Elements 3.0 for Windows contains a brand new Print Multiple Photos feature (1) that provides users with a common place to start the print process. This feature largely replaces the Print Preview option found in earlier versions of the program.

To display the feature you can select the Print item from the File menu (Photo Browser) or select the Print Multiple Photos from the File menu in the Editor workspace.

Before accessing the feature it is possible to select the image or images that you want to print from the Photo Browser. Don't worry if you need to add more pictures when you are in the dialog as Adobe has kindly added an Add photos button at the bottom left of the screen.

Next, select the printer and then the style of prints (2) to produce. Options here include Individual Prints, Contact Sheet, Picture Package or Labels. Finally, adjust the options for the print type and press the Print button to produce your photo(s).

Print Space

Menu: -	
Shortcut: -	**OS:** Mac, Windows
Version: 1, 2, 3, 4	**See also:** Image Space

The Print Space refers to an ICC profile that has been specially created to characterize the way that your printer works.

Generally printer companies supply profiles with their hardware. The installation programs that provide drivers for the printers also install the Print Space profiles in the main system color folder. From here the profiles can be accessed by a range of programs including Elements.

When Elements is aware of the Print Space it can more easily translate the picture's tones and colors to suit the abilities of the printer.

To ensure that Elements uses your printer's profile select the Show More Options (1) section of the Print Preview dialog and then choose the profile from the Print Space drop-down menu (2). When printing from the Print Photos or Print Multiple Photos dialogs select the More Options at the bottom of the window and then choose the Print Space (3).

Individual Prints

Contact Sheet

Picture Package

Labels

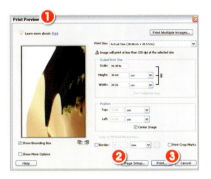

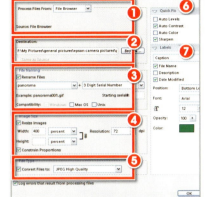

Printing, the basics

Menu: Editor: File > print
Shortcut: Ctrl/Cmd P **OS:** Mac, Windows
Version: 1, 2, 3, 4 **See also:** Page Setup

All of the print settings in Elements are contained in three separate but related dialog boxes – **Print Preview** (Editor: File > Print), **Page Setup** (Editor: File > Page Setup) and **Print Photos** (Editor: File > Print Multiple Photos – Windows only).

Similar output dialogs were included in previous versions of Elements but the upgraded features in the new release of the program have made the printing process much easier and more flexible.

The Print Preview dialog (1) is the first stop for most users. Here you can interactively scale your image to fit the page size currently selected for your printer. By deselecting the Center Image option and ticking the Show Bounding Box feature, it is possible to click and drag the image to a new position on the page surface.

Click the Page Setup button (2). In this dialog you can change the settings for the printer, such as paper type, size and orientation, printing resolution and color control, or enhancement. The extent to which you will be able to manually adjust these features will depend on the type of printer driver supplied by the manufacturer of your machine.

When complete, click OK to return to the Print Preview dialog. To complete the output process, press the Print button (3). This step displays a general Print dialog where the user has another opportunity to check the printer settings via the Properties button before sending the image on its way with a click of the OK button.

Process Multiple Files

Menu: Editor: File > Process Multiple Files
Shortcut: - **OS:** Mac, Windows
Version: 3, 4 **See also:** -

The Process Multiple Files feature is like a dedicated Batch Processing tool that can name, size, enhance, label and save in a specific file format a group of photos stored in a folder or selected via the File Browser.

The dialog's options include:

File source (1) – Files to be processed can be stored in a single folder; the files currently open in the workspace, pictures in the Photo Bin or images multi-selected in the File Browser.

File destination (2) – Sets the location where processed files will be saved.

File naming (3) – Options for naming or renaming of selected files including a range of preset naming styles.

Image sizing (4) – Specify size and resolution changes after choosing the unit of measure to work with from the drop-down menu. Proportions can be constrained.

File format type (5) – Select the file format that processed files will be saved or converted to.

Quick Fix enhancement (6) – Use the options here to apply automatic enhancement of the files being processed.

Add labels (7) – Add caption or filename labels to each of the processed files. Also contains an option for watermarking the pictures.

Progressive JPEG

Menu: Editor: File > Save As (JPEG)
Shortcut: Shft Ctrl/Cmd S **OS:** Mac, Windows
Version: 1, 2, 3, 4 **See also:** JPEG

Selecting the Progressive option (1) in the Save for Web dialog, or Save As JPEG feature creates a JPEG file that downloads in several separate passes rather than line by line. The initial pass displays a coarse blurry image which sharpens and becomes clearer with each successive pass.

PQ

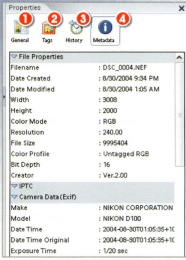

Prints, individual

Menu: Editor: File > Print Multiple Photos > Individual Prints
Photo Browser: File > Print > Individual Prints
Shortcut: Ctrl P **OS:** Windows
Version: 3, 4 **See also:** Print Multiple Photos

Elements 3.0 for Windows has the ability to set up and print several individual photographs at one time. The Individual Print option (1) in the Print Multiple Photos feature allows the user to 'batch' a variety of one-image-to-one page photos at the same time.

Purge

Menu: Edit > Purge
Shortcut: - **OS:** Mac, Windows
Version: 1, 2 **See also:** Clear

The Purge command frees up Elements' memory from storing temporary items such as copies of pictures stored in the clipboard, the record of changes made to the image kept for use by the Edit > Undo command and the History palette. The Purge command that featured in versions 1.0 and 2.0 of Elements has been replaced by the Edit > Clear option. Both commands perform the same function.

Properties pane

Menu: Photo Browser: Window > Properties
Shortcut: Alt Enter **OS:** Windows
Version: 3, 4 **See also:** Organize Bin, Metadata

The Properties pane is located in the Organize Bin in the Photo Browser workspace and contains four different categories of picture information. The contents of each category are displayed by clicking onto the tab heading.

General – The general category (1) stores the editable caption, name and notes details as well as the date, location, file size and audio attachment details.

Tags – Shows all the tags attached to the picture as well as any groups that the image belongs to (2).

History – Keeps a list of the changes made to the picture from the point of being imported into Elements until its current state (3).

Metadata – Displays a list of all the metadata associated with the picture (4). This includes camera or EXIF data, IPTC tags (International Press Telecommunications Council), file properties, camera RAW information, edit history and GPS data (Global Positioning System).

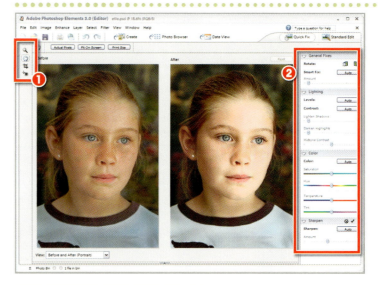

Quick Fix Editor

Menu: -
Shortcut: - **OS:** Mac, Windows
Version: 1, 2, 3, 4 **See also:** Editor

The Quick Fix Editor contains a reduced tool and feature set designed to facilitate the fast application of the most frequent of all enhancement activities undertaken by the digital photographer.

The Zoom, Hand, Crop and Red Eye Removal tools are located in a small toolbar (1) to the left of the screen and are available for standard image-editing changes, and the fixed Palette Bin (2), to the right, contains the necessary features to alter and correct the lighting, color, orientation (Rotate) and sharpness of your pictures.

One of the best aspects of the new version of this editing option is the fact that the user can choose to apply each image change automatically, via the Auto button, or manually using the supplied sliders. This approach provides both convenience and speed when needed with the option of a manual override for those difficult editing tasks.

The adjustment features are arranged in a fashion that provides a model enhancement workflow to follow – simply move from the top to the bottom of the tools starting with picture rotation, working through lighting and color alterations and, lastly, applying sharpening.

160

Radial Gradient

Radial Blur filter

Menu: Editor: Filter > Blur > Radial Blur	
Shortcut: -	**OS:** Mac, Windows
Version: 1, 2, 3, 4	**See also:** Filters

The Radial Blur filter, as one of the group of Blur filters, applies a directional blur to pictures to simulate either spinning or zooming the camera whilst the picture is being taken.

The dialog contains four controls. The Amount slider (1) determines the strength of the effect or the level of blur in the final result. The Blur Method options (2) allow the user to select between Spin (5) or Zoom (6) type blurs. The Quality options (3) determine the length of time taken to apply the effect and the level of quality in the final result. The Draft setting produces rough results quickly whereas the Best option creates a higher quality end product but takes more time. The Blur Center preview (4) not only provides a wire frame preview of the settings, but allows the user to reposition the center of the blur.

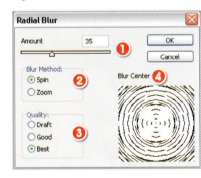

Radial Gradient tool

Menu: -	
Shortcut: G	**OS:** Mac, Windows
Version: 1, 2, 3, 4	**See also:** Gradients

Photoshop Elements has five different gradient types. All the options gradually change color and tone from one point in the picture to another.

The Radial Gradient (1) changes color from the center of a circle outwards and is drawn from the center point.

To create a gradient start by selecting the tool and the Radial Gradient type (2). Then adjust the controls in the Options palette.

Choose the colors from the Gradient Picker and then click and drag the mouse pointer on the canvas surface to stretch out a line that marks the start and end points of the gradient. Release the button to fill the layer with the selected gradient.

Rasterizing

Menu: -	
Shortcut: -	**OS:** Mac, Windows
Version: 1, 2, 3, 4	**See also:** Simplify

Rasterizing is the process by which vector-based graphics, such as shapes, text, solid color layers, patterns and gradients are converted to pixel-based pictures.

Photoshop Elements calls this process 'Simplifying the layer' and it is a necessary step if any of the filters are to be applied to the layer's content or if you want to edit the layer using the painting tools.

The vector contents in Illustrator (.AI, .EPS) or Acrobat (.PDF) files are also rasterized when opened in Photoshop Elements.

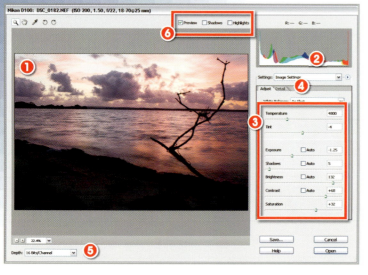

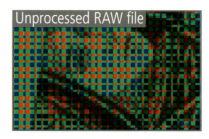
Unprocessed RAW file

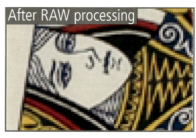
After RAW processing

RAW file editor

Menu: -	
Shortcut: -	OS: Mac, Windows
Version: 3, 4	See also: RAW files

Photoshop Elements 3.0 was the first version of the program to have a full featured RAW editor built into the program. Designed specifically to allow you to take the unprocessed RAW data directly from your camera's sensor and convert it into a usable image file format, the Elements RAW editor also provides access to several image characteristics that would otherwise be locked into the file format.

Variables such as color depth, white balance mode, image sharpness and tonal compensation (contrast and brightness) can all be accessed, edited and enhanced as a part of the conversion process (3). Performing this type of editing on the full high-bit, RAW data provides a better and higher quality result than attempting these changes after the file has been processed and saved in a non-RAW format such as TIFF or JPEG.

When you open a RAW camera file in Elements 3.0 you are presented with a RAW editing dialog containing a full color, interpolated preview (1) of the data captured by the sensor. Using a variety of menu options, dialogs and image tools you will be able to interactively adjust image data factors such as tonal distribution and color saturation.

Many of these changes can be made with familiar slider-controlled editing tools normally found in features like Levels and the Shadows/Highlights control. The results of your editing can be reviewed immediately via the live preview image and associated histogram graphs (2).

After these general image-editing steps have taken place you can apply some enhancement changes such as filtering for sharpness, removing color noise and applying smoothing via the settings under the Detail tab (4).

The final phase of the process involves selecting the color depth (5) and image orientation. Clicking the OK button sets the program into action, applying your changes to the RAW file, whilst at the same time interpolating the picture (Bayer) data to create a full color image and then opening the processed file into the full Editor workspace.

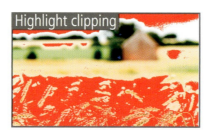
Highlight clipping

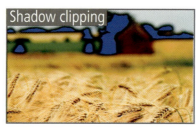
Shadow clipping

The integrated Highlight and Shadow clipping warnings (6) in the RAW editor provide visual cues when dark pixel details are being converted to pure black (blue) or delicate highlights are being clipped to pure white (red). Make sure that these settings are on before starting to edit.

RAW files

Menu: -	
Shortcut: -	OS: Mac, Windows
Version: 3, 4	See also: RAW file editor

More and more medium- to high-end cameras are being released with the added feature of being able to capture and save your pictures in RAW format. Selecting the RAW format stops the camera from processing the color separated (primary) data from the sensor and reducing the image's bit depth, and saves the picture in this unprocessed file type. This means that the full description of what the camera 'saw' is saved in the picture file and is available to you for use in the production of quality pictures. Many photographers call this type of file a 'digital negative' as it has a broader dynamic range, extra colors and the ability to correct slightly inaccurate exposures.

Read Watermark

Menu: Editor: Filter > Digimarc > Read Watermark	
Shortcut:	OS: Mac, Windows
Version: 1, 2, 3, 4	See also: Watermark

To check to see if a picture you are editing is watermarked, select Filter > Digimarc > Read Watermark (1).

Marked pictures will then display a pop-up dialog with author's details and a linked website where further details of use can be obtained.

Recipes

Menu: Window > Show Recipes	
Shortcut: -	**OS:** Mac, Windows
Version: 1.0	**See also:** How To

Recipes are a style of interactive tutorials that first appeared in version 1.0 of Photoshop Elements. In versions 2.0, 3.0 and 4.0 of the program Recipes became How To tutorials.

As well as written instructions the tutorials contain special hyperlinked sections that instruct Elements to perform the step for you.

You can display the How To palette by selecting this option from the Window menu.

Reconnect

Menu: Photo Browser: File > Reconnect	
Shortcut: -	**OS:** Windows
Version: 3, 4	**See also:** Photo Browser

When Photoshop Elements catalogs newly downloaded (or imported) pictures the program creates a preview thumbnail of the photos that it then displays in the Photo Browser. Unlike other browser utilities (including the File Browser in the Editor workspace) the images you see on screen are small copies of the original files which are stored elsewhere on your computer. Any edits you make (either in the Organizer or the Editor) are made to a copy of the original file. The edited file is named '<filename>_edited-1.jpg'. The changes are then reflected back in the thumbnail located in the Photo Browser.

This link between browser thumbnail and original photo file is an important one and Elements generally does a great job of maintaining all the connections, but occasionally the Photo Browser has trouble locating the original or source file. When this occurs, a small red Broken Picture icon appears on the thumbnail (1) in the browser and the next time you try to edit the photo a Reconnect Missing Files dialog is displayed (2). Here you search for, and reconnect, the original file with the catalog thumbnail.

Elements also contains an auto-reconnect feature that searches for (3) and relinks broken connections automatically. The feature can be turned off and on via the Automatic Search For and Reconnect Missing Files option located in the Edit > Preferences > Files dialog. When the auto function fails to relink thumbnails and original pictures then the Reconnect Missing Files dialog is displayed to allow the link to be re-established manually.

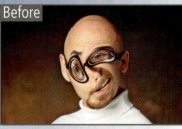

Before

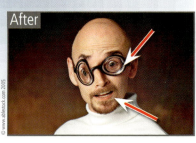

After

© www.abletock.com 2005

Reconstruct tool, Liquify filter

Menu: Editor: Filter > Distort > Liquify	
Shortcut: -	**OS:** Mac, Windows
Version: 1, 2, 3, 4	**See also:** Liquify filter, Filters

Whilst working inside the Liquify filter dialog it is possible to selectively reverse any changes made to the photo by applying the Reconstruct tool.

When applied to the surface of the image the distorted picture parts are gradually altered back to their original state.

Like the other Tool options in the filter, the size of the area affected by the tool is based on the Brush Size setting and the strength of the change is determined by the Brush Pressure value.

Rectangular Marquee

Menu: -	
Shortcut: M	**OS:** Mac, Windows
Version: 1, 2, 3, 4	**See also:** Elliptical Marquee

By clicking and dragging the Rectangular Marquee tool on the picture surface, it is possible to draw rectangle or box selections (1).

Holding down the Shift key whilst using this tool restricts the selection to square shapes (2), whilst using the Alt (Windows) or Options (Mac) keys will draw the selections from their centers.

Redo

Menu: Editor: Edit > Redo	
Shortcut: Ctrl/Cmd Y	**OS:** Mac, Windows
Version: 1, 2, 3, 4	**See also:** Undo, Undo History

The Redo command performs the action that was last reversed by the Undo command. Located under the Edit menu, the actual Redo entry changes depending on the nature of the last action that was undone. If the Undo command hasn't been used then the Redo option is unavailable (grayed out).

Red Eye Brush

Menu: -	
Shortcut: Y	**OS:** Mac, Windows
Version: 1, 2	**See also:** Red Eye Removal Brush

The Red Eye Brush changes the crimson color in the center of the eye for a more natural looking black.

To start removing red eye in your own pictures pick the tool from the toolbox, select the brush size and type, push the default colors button on the options bar and then click on the red section of the eyes.

Though designed specifically for this purpose, the tool can also be used for changing other colors. To achieve this click on the 'current' color swatch and use the eyedropper to sample the color you wish to change. Next click on the 'Replacement' swatch to pick the hue that will be used as a substitute. Now when the brush is dragged over a 'current' color it will be changed to the 'replacement' hue.

The Tolerance slider controls how similar to the current color a pixel must be before it is replaced. Low values restrict the effect to precisely the current color; higher values replace a broader range of dissimilar hues.

The Red Eye Brush tool has been replaced with the Red Eye Removal Brush in version 3.0 of the program.

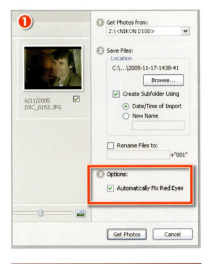

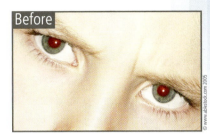

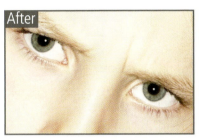

Before

After

© www.abstock.com 2005

Red Eye Removal – automatic

Menu: Editor: Enhance > Auto Red Eye Fix	
Shortcut: -	**OS:** Windows
Version: 4	**See also:** Red Eye Removal Brush

The red removal options in Elements have been revamped and extended for version 4.0 of the program. In this release it is possible to search for and correct red eye automatically.

The option is available in the dialog of both the Get Photos > From Camera or Card Reader (1) and the Get Photos > From Files and Folders (2) features. When selected, Elements locates the images that have been taken with a flash from those being imported into the Photo Browser. It does this by searching through the metadata of the photos checking for the 'flash fired' entry in the camera EXIF data. Elements then corrects the red eye in these pictures.

Red Eye Removal Brush

Menu: -	
Shortcut: Y	**OS:** Mac, Windows
Version: 3, 4	**See also:** Red Eye Brush tool

The dreaded Red Eye syndrome plagues a lot of portrait photos taken with flash at night. In creating the new version of the Red Eye Removal tool for Elements 3.0 Adobe recognized that this is a common problem that needs a quick, easy and reliable correction solution. The Red Eye Removal tool replaces the Red Eye Brush of previous releases. Its forte is changing the crimson color in the center of the eye for a more natural looking black.

To correct Red Eye with this tool is a simple process that involves selecting the tool and then clicking on the red section of the eye. Elements locates the red color and quickly converts it to a more natural dark gray. The tool's options bar provides settings to adjust the pupil's size and the amount that it is darkened. Try the default settings first and if the results are not quite perfect, undo the changes and adjust the option's settings before reapplying the tool.

The Red Eye Removal tool is available in both the Quick Fix and Standard editing workspaces.

Red Eye Removal – via selection

Menu: –	
Shortcut: Y	**OS:** Windows
Version: 4	**See also:** Red Eye Removal Brush

The newly revamped Red Eye Removal Brush is generally used to correct the crimson part of the eye in flash photos by clicking on this section of the eye.

Red eye can also be corrected by using the tool to click-drag a marquee around the eye section of the face. Use this approach when the one-click option doesn't produce the required results.

166

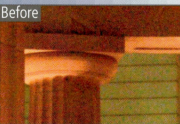

Before

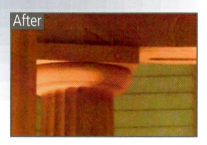

After

Before

After

❶

Mode: Nor

❷ Reflected Gradient

Reduce Noise filter

Menu: Editor: Filter > Noise > Reduce Noise	
Shortcut: -	**OS:** Mac, Windows
Version: 3, 4	**See also:** Dust & Scratches filter

To help combat the noisy (spotty) photos produced when using the high ISO setting on many cameras the Adobe engineers included a Noise Reduction filter in Elements 3.0. Revamped to include a Remove JPEG Artifact option (4) in version 4.0 the feature includes a Preview window, a Strength slider (1), a Preserve Details control (2) and a Reduce Color Noise slider (3). As is the case with the Dust & Scratches filter, you need to be careful when using this filter to ensure that you balance removing noise whilst also retaining detail.

The best way to guarantee this is to set your Strength setting first, ensuring that you check the results in highlights, midtone and shadow areas. Next, gradually increase the Preserve Details value until you reach the point where the level of noise that is being reintroduced into the picture is noticeable and then back off the control slightly (make the setting a lower number). For photographs with a high level of color noise (random speckles of color in an area that should be a smooth flat tone) you will need to adjust this slider at the same time as you are playing with the Strength control.

Reduce JPEG Artifacts

Menu: Editor: Filter > Noise > Reduce Noise	
Shortcut: -	**OS:** Windows
Version: 4	**See also:** DVD menu template edit

One of the side effects of saving space by compressing files using the JPEG format is the creation of box-like patterns in your pictures. These patterns or artifacts are particularly noticeable in images that have been saved with maximum compression settings.

With the Remove JPEG Artifact option selected in the Reduce Noise dialog, Photoshop Elements smooths out the box-like pattern created by the over-compression.

Reflected Gradient tool

Menu: -	
Shortcut: G	**OS:** Mac, Windows
Version: 1, 2, ,3, 4	**See also:** Gradients

Photoshop Elements has five different gradient types. All the options gradually change color and tone from one point in the picture to another.

The Reflected Gradient (1) changes color along a drawn line from the start to finish point and then reflects the same linear gradient on the opposite side of the starting point.

To create a gradient start by selecting the tool and the Reflected Gradient type (2). Then adjust the controls in the Options palette. Choose the colors from the Gradient Picker and then click and drag the mouse pointer on the canvas surface to stretch out a line that marks the start and end points of the gradient. Release the button to fill the layer with the selected gradient.

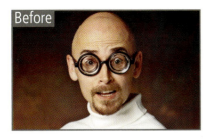

Before

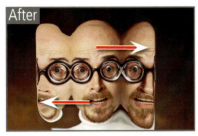

After

Before

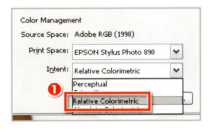

After

Reflection tool, Liquify filter

Menu: Editor: Filter > Distort > Liquify
Shortcut: - **OS:** Mac, Windows
Version: 1, 2, ,3, 4 **See also:** Liquify filter

The Reflection tool paints mirrored pixels as it is dragged across the surface of the photo. The direction in which the tool is applied determines which pixels are mirrored.

When the brush head is moved downwards the pixels on the left are mirrored into the painted area. Moving the brush upwards mirrors the pixels on the right. Painting from right to left mirrors the top pixels and from left to right the bottom ones.

Like the other Liquify tools, the size of the area affected by the tool is based on the Brush Size setting and the strength of the change is determined by the Brush Pressure value.

Relative Colorimetric rendering intent

Menu: –
Shortcut: – **OS:** Mac, Windows
Version: 1, 2, ,3, 4 **See also:** Saturation rendering intent

At various points in the digital photography process it is necessary to change or alter the spread of colors in a picture so that they fit the characteristics of an output device, such as a screen or printer, more fully. Relative Colorimetric is one of the four different approaches that Photoshop Elements can use in this conversion process. The other choices are Perceptual, Saturation and Absolute Colorimetric.

Each approach produces different results and is based on a specific conversion or 'rendering intent'. The **Relative Colorimetric** setting squashes or stretches the range of colors in the original so that they fit the range of possible colors that the new device can display or print.

The **Saturation** option tries to maintain the strength of colors during the conversion process (even if color accuracy is the cost). The **Perceptual** setting puts conversion emphasis on ensuring that the adjusted picture, when viewed on the new output device, appears to the human eye to be very similar to the original photo. The **Absolute Colorimetric** option translates colors exactly from the original photo to the range of colors for the new device. Those colors that can't be displayed are clipped.

Specific Intents can be selected as part of the printing process via the color-management controls in the Show More Options section of the Print Preview dialog (1).

Remove Color

Menu: Editor: Enhance > Adjust Color > Remove Color
Shortcut: Shft Ctrl/Cmd U **OS:** Mac, Windows
Version: 3, 4 **See also:** Hue/Saturation

The Remove Color feature erases all traces of color from the picture, just leaving the detail and tone.

The final result is a grayscale image which is still stored in an RGB Color mode. This is handy as it allows you to hand color or tone the picture whereas color pictures that are converted to the grayscale mode need re-converting back to RGB Color before this type of enhancement can occur.

The feature produces the same result as dragging the Saturation slider in the Hue/Saturation control all the way to the left (1). For this reason sometimes this type of change is called 'de-saturating' the picture.

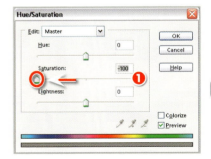

Remove Profile

Menu:	Editor: Image > Convert Color Profile > Remove Profile
Shortcut: -	**OS:** Windows
Version: 4	**See also:** Color Settings, ICC Profile

One of the new color-management options that is available in Photoshop Elements 4.0 is the ability to strip an ICC profile from a photo. The feature effectively changes the photo to an untagged state and although this is generally not recommended, the new option is part of a new fuller set of color profile controls that also includes Apply sRGB Profile and Apply Adobe RGB profile.

Rename a layer

Menu: -	
Shortcut: -	**OS:** Mac, Windows
Version: 2, 3, 4	**See also:** Layers

The title, or name, of a layer can be changed from the default assigned by the Elements program by double-clicking the layer's name in the Layers palette (1). The new layer name is typed directly into the Layers palette (2).

As your Elements compositions become more and more complex, careful naming of layers when they are created will make for easier navigation and editing of the many picture parts.

Background layers cannot be renamed unless they are converted to a standard image layer first.

New blank layers created via the Layer > New > Layer route can be named in the New Layer dialog as part of the creation process (3).

Rename Multiple Files

Menu:	Photo Browser: File > Rename Photo Browser: File > Rename Multiple Files (ver. 3.0)
Shortcut: Shft Ctrl N	**OS:** Mac, Windows
Version: 3, 4	**See also:** Process Multiple Files

The Rename (version 4.0) and Rename Multiple Files (version 3.0) feature, located in both the Photo Browser and the Process Multiple Files dialog, allows the user to rename a selected group of files or a complete folder in a single action.

When used from within the Photo Browser the files to be renamed need to be multi-selected first before choosing File > Rename. Input the new name that will be added to existing titles of the selected files in the Rename dialog (1) and then click OK.

In version 3.0 you multiselect the files and then choose Rename Multiple Files from the File menu (2). Next, the Batch Rename dialog is displayed where the destination folder (3), file naming (4) and format compatibility options (5) are set. Then to start the renaming process press the OK button.

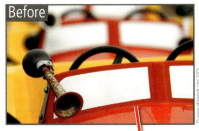

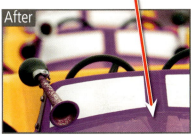

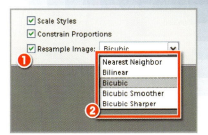

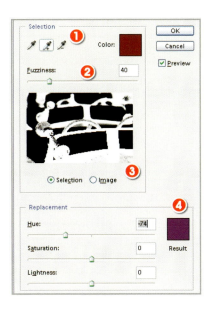

Replace Color

Menu: Editor: Enhance > Adjust Color > Replace Color
Shortcut: - **OS:** Mac, Windows
Version: 3, 4 **See also:** Paint Bucket tool

The Replace Color feature is designed to carefully select a specific color in a photo and replace it with another hue.

To select the color to be replaced choose the standard eyedropper (1) from the feature's dialog. Refine the selection by adding extra colors to the selection range with the 'plus eyedropper' or removing colors with the 'minus eyedropper'. The precision of the color selection is based on the Fuzziness control (2). Higher values encompass a more varied range of hues.

You can review the areas that are being included in the selection using the Preview window (with the Selection option active). The preview image (3) works in a similar way to the layer mask with the light areas fully selected, the gray areas partially selected and the dark areas not chosen at all.

The Replacement section (4) of the dialog is used for choosing the color that will be used as the selected color.

With all the options now selected, proceed to replace the selected color by pressing the OK button.

Resample Image

Menu: Editor: Image > Resize > Image Size
Shortcut: - **OS:** Mac, Windows
Version: 1, 2, 3, 4 **See also:** Interpolation

When the Resample Image option (1), located in the Image Size feature, is selected Photoshop Elements interpolates the original picture information to create either more or less pixels. This means that the program adds extra pixels to make the photo larger or combines pixels to make the image smaller. Elements uses one of five different interpolation algorithms to create the new picture (2).

Deselecting the Resample option stops the program from altering the number of pixels in the picture. In this event, picture sizes are altered by changes in resolution (the spread of pixels over a printed inch).

 In Elements version 4.0, the Resample option is unchecked (not selected) as the default.

Reselect

Menu: Editor: Select > Reselect
Shortcut: Shft Ctrl/Cmd D **OS:** Mac, Windows
Version: 1, 2, 3, 4 **See also:** Save Selection, Load Selection

The Reselect command re-establishes the latest selection made on the image.

After using a selection for making an editing change, most users will remove the selection by choosing Select > Deselect. If at a later time in the editing session you need to reselect the same areas simply choose Select > Reselect.

Keep in mind when using this feature that:

– it only restores the last selection created;

– changes to image or canvas size lose the selection; and

– once a file has been closed and reopened the feature will not restore the original selection.

To permanently store a selection use the Select > Save Selection option.

Reset All Tools

Menu: -
Shortcut: - **OS:** Mac, Windows
Version: 1, 2, 3, 4 **See also:** Reset Tool

The Reset All Tools feature returns all tools to their default settings. The option is located by clicking on the Tool's icon in the Tool's option bar.

• •

Reset Tool

Menu: -
Shortcut: - **OS:** Mac, Windows
Version: 1, 2, 3, 4 **See also:** Reset All Tools

The Reset Tool feature returns only the selected tool to its default settings. The option is located by clicking on the Tool's icon in the Tool's option bar.

Reset All Warning Dialogs

Menu: Editor: Edit > Preferences > General
Photo Browser: Edit > Preferences > General
Shortcut: Ctrl/Cmd K **OS:** Mac, Windows
Version: 1, 2, 3, 4 **See also:** Preferences

The Reset All Warning Dialogs button located in the Preferences > General section of the Editor and Photo Browser workspaces restores all pop-up warning dialogs to their original shipped state. This action overrides the previous selection of the 'Don't Show Again' option in Message dialogs throughout the program.

The option is positioned at the bottom of both the Editor (1) and Photo Browser (3) General preference dialogs. After pressing the Reset All Warning Dialogs button a Confirmation dialog will be displayed (2).

How the image will be used	Resolution
Screen or web use only	72 pixels per inch
Draft quality inkjet prints	150 ppi
Large posters (that will be viewed from a distance)	150 ppi
Photographic quality inkjet printing	200–300 ppi
Magazine printing	300 ppi

Resolution

Menu:	-	
Shortcut:	-	**OS:** Mac, Windows
Version:	1, 2, 3, 4	**See also:** DPI, Pixel Dimensions, Resolution option, Image Size

The resolution of a digital image is the measure of the number of pixels that are used to represent an inch of the picture. The units used to express this measure are pixels per inch or PPI.

Generally speaking, high PPI values mean that fine details in the photo are represented more clearly and the image appears to have continuous tone. When using low PPI settings the overall quality of the picture is less and, in extreme cases, individual pixels may be seen as colored blocks.

Different resolution settings are used for different outcomes and suggestions for these are tabled above. Changing the PPI means that a single image (with a fixed set of pixel dimensions) can be printed or displayed at a variety of different sizes.

The PPI value for a picture is altered via the Resolution setting in the Image Size dialog.

Resolution option

Menu:	Editor: Image > Resize > Image Size	
Shortcut:	-	**OS:** Mac, Windows
Version:	1, 2, 3, 4	**See also:** Resolution, Image Size, Pixel Dimensions

By altering the resolution of a file, an image with the same pixel dimensions can have several different document sizes based on the change of the spread of the pixels when the picture is printed (or displayed on screen).

In this way, you can adjust a high-resolution file to print the size of a postage stamp, postcard or a poster by only changing the PPI or resolution. This type of resizing has no detrimental quality effects on your pictures as the original pixel dimensions remain unchanged – no extra pixels have been added or taken away from the photo in the process.

To change resolution, open the Image Size dialog, select the Constrain Proportions item and uncheck the Resample Image option (1). Next, change either the resolution, width or height settings to suit your output. Changing any of these amounts will automatically adjust the other values to suit.

The default resolution used when creating new documents can be altered in the Units & Rulers preferences dialog (2).

Restore Preferences

Menu:	-	
Shortcut:	-	**OS:** Mac, Windows
Version:	1, 2, 3, 4	**See also:** Preferences

If Photoshop Elements starts to exhibit unusual behavior the cause may be a damaged preferences file. The file stores all the preference settings allocated either by default or as a result of changes made by the user to the settings via the Edit > Preferences menu.

Use the following keystroke combination immediately after Photoshop Elements begins to launch the Editor workspace to restore the program's preferences back to their default settings:

- Windows: Alt Ctrl Shft
- Macintosh: Opt Cmd Shft

Click Yes (1) when asked, to delete the current settings.

Before

After

Reticulation filter

Menu: Editor: Filter > Sketch > Reticulation
Shortcut: - **OS:** Mac, Windows
Version: 1, 2, 3, 4 **See also:** Filters

The Reticulation filter, as one of the group of Sketch filters, simulates the look of film that has been reticulated. This traditional effect is created by immersing film in hot and then cold baths during processing. As a result of the massive change in temperature the surface of the film breaks into the small textured clumps that are recreated digitally with this filter.

The dialog contains three controls. The Density slider (1) determines the overall darkness of the effect. The Foreground Level control (2) is used to adjust how the texture is applied to shadow areas and the Background Level slider (3) performs the same task but for the lighter tones in the picture.

As the filter uses the current foreground and background colors in the creation of the effect, altering these hues can change the end results radically (4).

Reveal All

Menu: Editor: Image > Resize > Reveal All
Shortcut: - **OS:** Mac, Windows
Version: 1, 2, 3, 4 **See also:** -

Often when combining or resizing several different picture layers in the one document it is not possible to see the full extent of the layer contents.

Rather than having to adjust the canvas size manually to provide a view of the content of all layers you can simply select the Reveal All command (1). This feature automatically resizes the canvas so that it fits the content of all layers.

In the process the extra space created in each layer is made transparent, except in the case of the background layer where it is filled with the current background color (2).

Reveal in Explorer

Menu: -
Shortcut: Alt Enter **OS:** Windows
Version: 3, 4 **See also:** Properties

Reveal in Explorer is one of the options in the Properties pane of the Photo Browser workspace. Pressing the Folder button (1) located at the bottom of the pane automatically opens Windows Explorer and displays the folder (and all its contents) where the original photo is located.

Using this feature is a quick and easy way to locate the precise storage location of images that have been cataloged in the Photo Browser.

The feature is also included in the File Browser of the Mac version of Elements 3.0. To use the feature select a file in the File Browser and then choose View > Reveal Location in Finder.

Before

After

Combined

Red

Green

Blue

Before

Rotate 90° Left

173

Revert to Saved

Menu:	Editor: Edit > Revert to Saved		
	Quick Fix: Edit > Revert to Saved		
Shortcut:	–	**OS:**	Mac, Windows
Version:	1, 2, 3, 4	**See also:**	Undo, Redo

The Revert to Saved feature restores the photo to the way that it looked the last time it was saved.

In the example, the photo was colored using the Hue/Saturation control and then filtered with the Posterize filter (1) to produce the Before result. Next the Edit > Revert to Saved option was selected and the picture was restored to the way it was before the changes – the After image.

The opening snapshot does not always represent the last saved version.

For example, let's look at the following editing sequence:

1. Open image
2. Apply edits
3. Save
4. Apply more edits
5. Revert to Saved

In this instance, the image will look like step 3 after Reverting, but the snapshot in Undo History looks like step 1.

RGB (Red, Green, Blue)

Menu:	-		
Shortcut:	-	**OS:**	Mac, Windows
Version:	1, 2, 3, 4	**See also:**	Color modes

In all digital photos several primary colors are mixed to form the many millions of distinct colors we see on screen or in print. These primary colors are often referred to as color channels.

Most images that are created by digital cameras are made up of Red, Green and Blue colors or channels and so are said to be RGB pictures.

In a standard 24-bit picture (8 bits per channel) each of the colors can have a brightness value between 1 and 256. So to represent a specific color you will have three values that describe the mix of red, green and blue used to create the hue.

You can see these values for any pixel in your pictures by displaying the Info palette (Window > Info) and then moving the cursor over your photo. The RGB values at any point are reflected in the Info palette (1).

In contrast, those pictures that are destined for professional printing are created with Cyan, Magenta, Yellow and Black channels (CMYK) to match the printing inks.

Sometimes the channels in an image are also referred to as the picture's Color mode.

Rotate

Menu:	Editor: Image > Rotate		
	Quick Fix: Image > Rotate		
Shortcut:	–	**OS:**	Mac, Windows
Version:	1, 2, 3, 4	**See also:**	Free Transform tool

The Image > Rotate menu contains a list of options that can be used to rotate your pictures. The options are divided into three sections.

Rotating the whole picture – The first section (1) is used for rotating the whole picture. Sometimes referred to as 'rotating the canvas', these features pivot the background as well as all other layers in the image. The Rotate buttons in Quick Fix act on the entire image.

Rotating a layer only – The next group of options (2) is designed for rotating the current selected layer. No other layers will be changed when selecting any of these options. The pivot action is restricted to the selected layers only. If there is an active marquee selection then the Rotate layer group changes to Rotate Selection.

Straightening – The last section includes two automatic options for straightening slightly crooked pictures (3). These actions are applied to the whole picture.

R

174

© www.ablestock.com 2005

Rough Pastels filter

Menu: Editor: Filter > Artistic > Rough Pastels	
Shortcut: -	**OS:** Mac, Windows
Version: 1, 2, 3, 4	**See also:** Filters

The Rough Pastels filter, as one of the group of Artistic filters, recreates the photo so that it looks like it has been drawn with colored pastels on a roughly textured paper.

The Filter dialog contains several controls that adjust the look and feel of the effect.

The settings used for the Stroke sliders (1) determine how strong the pastel stroke effect will be. High values create a coarse result where the pastel stroke is dominant. Low settings retain more of the original detail. The controls in the Texture section (2) vary the strength and type of texture that is added to the picture. Increasing the values used for both Scaling and Relief sliders will create a more textured result.

The Light option (3) controls the direction of the light that is used to create the highlight and shadow areas in the texture.

Roundness

Menu: -	
Shortcut: -	**OS:** Mac, Windows
Version: 1, 2, 3, 4	**See also:** Brush tool

The Roundness option is one of the Brush tool controls that is located in the More Options dialog on the Tool's options bar.

When set at 100% the brush tip is in the shape of a circle; as the value is decreased the shape becomes an oval that becomes more and more squashed. In the example the brush tip is shown at values of 100% (1), 50% (2), 25% (3) and 5% (4).

A preview of the altered brush tip shape is displayed in the thumbnail when adjusting the Roundness value in the More Options dialog (5).

Rulers

Menu: Editor: View > Rulers	
Shortcut: Shft Ctrl/Cmd R	**OS:** Mac, Windows
Version: 1, 2, 3, 4	**See also:** Grid

The Rulers option displays both horizontal and vertical rulers around the edge of the image window.

Clicking and dragging from the top left-hand corner (where the rulers intersect) allows you to reposition the '0' points of each ruler. This is helpful when using the feature to measure various picture parts.

Double-clicking anywhere on a ruler displays the Units & Rulers preferences dialog, where a new unit of measure can be selected from the choices in the drop-down menu (1).

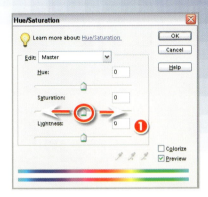

Sample Size, Eyedropper tool

Menu: –	
Shortcut: –	OS: Mac, Windows
Version: 1, 2, 3, 4	See also: Info palette

The Eyedropper tool samples the color of an area in an open image or on the desktop. When the mouse button is clicked the color of the area under the pointer is stored as the new foreground color.

The size of the sample area can be set in the Tool's options bar (1). The Point Sample copies the precise color of the pixel beneath the cursor whereas the 3 by 3 or 5 by 5 options store a color that is the average of the pixels contained in these sample areas.

Saturation

Menu: –	
Shortcut: –	OS: Mac, Windows
Version: 1, 2, 3, 4	See also: Hue/Saturation, Remove Color

The saturation of a color photo is usually described as the color's strength or vibrancy. Decreasing the saturation in a picture gradually removes the color from the image, creating more subtle or pastel shades. Continuing to lessen the saturation will eventually reach a point where no color remains and the photo is effectively a grayscale image. Increasing the saturation makes the colors more vibrant. You have to be careful when adjusting the picture in this way though as overly saturated pictures often print as flat areas of color with no detail. Saturation changes are made by moving the Saturation slider in the Hue/Saturation feature (1) or in the Quick Fix palette bin.

Saturation +50

Saturation +100

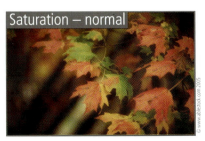
Saturation – normal

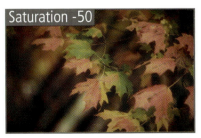
Saturation -50

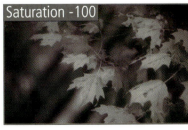
Saturation -100

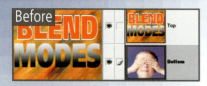

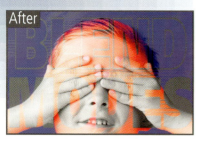

Saturation blending mode

Menu: –	
Shortcut: –	**OS:** Mac, Windows
Version: 1, 2, 3, 4	**See also:** Blend modes

The Saturation blending mode is one of the group of Hue modes that base their effects on combining the hue, saturation and luminosity of the two layers.

This option creates the result by combining the hue and luminance of the bottom layer with the saturation of the top layer.

There is no change if the top layer has no saturation (i.e. is filled with neutral grays).

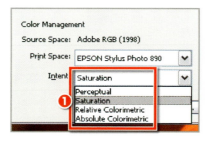

Saturation rendering intent

Menu: –	
Shortcut: –	**OS:** Mac, Windows
Version: 1, 2, 3, 4	**See also:** Perceptual rendering intent

At various points in the digital photography process it is necessary to change or alter the spread of colors in a picture so that they fit the characteristics of an output device, such as a screen or printer, more fully. Saturation is one of the four different approaches that Photoshop Elements can use in this conversion process. The other choices are Perceptual, Relative Colorimetric and Absolute Colorimetric.

Each approach produces different results and is based on a specific conversion or 'rendering intent'. The **Saturation** option tries to maintain the strength of colors during the conversion process. This occurs even at the expense of color accuracy.

The **Relative Colorimetric** setting squashes or stretches the range of colors in the original so that they fit the range of possible colors that the new device can display or print. The **Perceptual** setting puts conversion emphasis on ensuring that the adjusted picture, when viewed on the new output device, appears to the human eye to be very similar to the original photo. The **Absolute Colorimetric** option translates colors exactly from the original photo to the range of colors for the new device. Those colors that can't be displayed are clipped.

Specific Intents can be selected as part of the printing process via the color-management controls in the Show More Options section of the Print Preview dialog (1).

Save

Menu:	Editor: File > Save
	Quick Fix: File > Save
Shortcut:	**OS:** Mac, Windows
Version: 1, 2, 3, 4	**See also:** Save for Web, Version Set

Saving images edited in either the Quick Fix or Standard Editor workspaces is a three-step process that starts by choosing File > Save from the menu bar.

With the Save dialog open, navigate through your hard drive to find the directory or folder you wish to save your images in. Next, type in the name for the file and select the file format you wish to use. To include the edited file in a Version Set with the original, check the Save in Version Set with Original box at the bottom of the dialog.

The Save feature is grayed out, or unavailable, if no changes have been made to the picture since the last Save action.

Save As

Menu:	Editor: File > Save As
	Quick Fix: File > Save As
Shortcut: Shft Ctrl/Cmd S	**OS:** Mac, Windows
Version: 1, 2, 3, 4	**See also:** Save for Web, Version Set

For most images you should use the Photoshop or PSD format. This option gives you a file that maintains all of the specialized features available in Elements. However, if you want to share your images with others, either via the web or over a network, then you can choose to save your files in other formats, like JPEG or TIFF. To save a file in a format other than the PSD file type, select the File > Save As option, selecting a different option from the drop-down Format menu. The options in the Save As dialog box allow you to change the name of the file, the location you are saving to, or the format you are saving in.

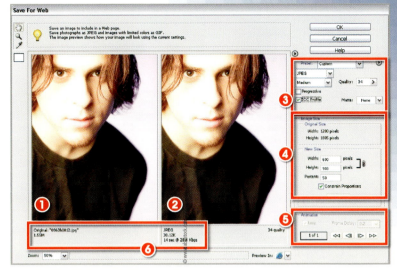

(1) Original picture. (2) Compressed preview. (3) Compression settings. (4) Size settings. (5) Animation settings (GIF only). (6) File size information.

Save As prompt

Menu: –	
Shortcut: -	OS: Windows
Version: 4	See also: Save, Save As

In the previous versions of Photoshop Elements you were always presented with a Save As dialog box when saving an edited file for the first time. In version 4.0 of the program it is possible to customize what happens when you save a newly edited file.

Three options are available:

Always Ask – The Save As dialog is always displayed when an original file is edited and then saved. All subsequent saves overwrite the original file.

Ask If Original – Is the default option and automatically displays the Save As dialog when you edit an original file and then try to save the changes. The first save, as well as all other subsequent saves, overwrites the original file.

Save Over Current File – This option doesn't open the Save As dialog but rather automatically saves the edited version over the top of the original file.

To alter the action that is taken when you save the changes to an edited file choose a new On First Save option from the File Saving section of the preferences (Edit > Preferences) in the Editor workspace.

Save for Web

Menu:	Editor: File > Save for Web
	Quick Fix: File > Save for Web
Shortcut: Shft Alt/Opt Ctrl/Cmd S	OS: Mac, Windows
Version: 1, 2, 3, 4	See also: Save As

When preparing photos for use on the Internet it is difficult to balance the good compression with acceptable image quality. So how much compression is too much? Well, Elements helps with this dilemma by including a special 'Save for Web' feature that previews how the image will appear before and after the compression has been applied.

Start the feature by selecting the Save for Web option from the File menu of either the Standard or Quick Fix Editor workspaces. You are presented with a dialog that shows side-by-side 'before' and 'after' versions of your picture. The settings used

to compress the image can be changed in the top right-hand corner of the screen. Each time a value is altered, the image is recompressed using the new settings and the results redisplayed.

JPEG, GIF and PNG can all be selected and previewed in the Save for Web feature. By carefully checking the preview of the compressed image (at 100% magnification) and the file size readout at the bottom of the screen, it is possible to find a point where both the file size and image quality are acceptable. By clicking OK it is then possible to save a copy of the compressed file to your hard drive ready for attachment to an e-mail or use in a web page.

Save Selection

Menu:	Editor: Select > Save Selection
Shortcut: –	OS: Mac, Windows
Version: 3, 4	See also: Load Selection

The Save Selection option allows the user to store complex, multi-step selections with the file that they were created for.

To save a selection choose the option after creating a selection and whilst it is still active. The selection is saved as part of the Elements file (PSD) and can be restored, using the Load Selection feature, next time the picture is opened. The Reselect option provides a similar function but only restores the last selection made during the current editing session.

TIFF, PDF and JPEG2000 file formats also support saved selections.

Before

After

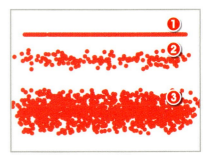

Save Swatches

Menu: –	
Shortcut: –	**OS:** Mac, Windows
Version: 1, 2, 3, 4	**See also:** Swatches

The Save Swatches feature allows you to store new, or edited, color swatches, or swatch libraries in a file that can be loaded again later.

To save swatches press the sideways More button at the top of the palette and then select the Save Swatches item from the pop-up menu.

The feature opens a File Browser dialog so that you can save the new swatch file (ACO) to a selected folder. Swatch files are generally stored in the Elements/Presets/ Color Swatches folder.

Scale

Menu: Editor: Image > Resize > Scale	
Shortcut: –	**OS:** Mac, Windows
Version: 1, 2, 3, 4	**See also:** Image Size, Canvas Size

The Scale feature allows the resizing of the content of individual layers. After selecting Image > Resize > Scale, click and drag one of the corner handles of the Bounding box that appears to resize the layer.

Holding down the Shift key whilst resizing constrains the proportions of the change to picture so that they are the same as the original. Double-click inside the Bounding box to confirm the scale change or click the Commit button in the options bar. When using the feature with a background image the layer will be converted to a normal image layer first. The overall dimensions of the image do not change.

Scatter option, Brush tool

Menu: –	
Shortcut: –	**OS:** Mac, Windows
Version: 1, 2, 3, 4	**See also:** Roundness option

The Scatter option is one of the Brush tool controls that is located in the More Options dialog on the Tool's options bar.

Dragging a brush when the tool is set at 0% creates a single line of brush strokes. Selecting higher values causes the brush strokes to deviate randomly from the drawn path. In the example a brush has been dragged across the canvas with scatter values of 0% (1), 50% (2) and 100% (3).

The Scatter option is adjusted by moving the slider in the More Options dialog (4).

Scratch disks

Menu: Editor: Edit > Preferences > Plug-Ins & Scratch Disks	
Shortcut: –	**OS:** Mac, Windows
Version: 1, 2, 3, 4	**See also:** Preferences

A scratch disk is really pseudo RAM or pretend memory. When Photoshop Elements runs out of the RAM needed to perform an enhancement change, it can use part of your hard drive as a fake extension to the system's memory.

The section of hard drive nominated as the RAM extension is called a Scratch Disk and correctly allocating such a disk will improve the performance of Elements on even the most humble machines.

Scratch disks are allocated in the Plug-Ins & Scratch Disks Preference dialog (1), with the new settings taking effect after the program has been rebooted. As up to four different disks can be used by the feature your fastest and least used drive should be allocated first, with other drives with a little extra space being nominated next.

The Preferences settings for Elements are located under the Edit > Preferences menu. Here you will find a series of settings that allow you to adjust the default workings of the program. To change or allocate scratch disks select the Plug-Ins & Scratch Disks option from the menu.

The Plug-Ins & Scratch Disks dialog has settings to allocate up to four different locations for use as extra RAM. It is best not to use the same location for Windows virtual memory. It is also worth selecting your fastest drive first as the extra speed will also help increase performance.

With the scratch disks now allocated click OK to close the window and then quit Elements as the changes will not take effect until you restart the program. Next time you use Elements you will be able to work with bigger files and perform more complex operations faster than ever before.

Screen blending mode

Menu: –	
Shortcut: –	**OS:** Mac, Windows
Version: 1, 2, 3, 4	**See also:** Blend modes

The Screen blending mode is one of the group of Lighten modes and as such always produces a result that is brighter than the original.

This mode produces its effect by multiplying the inverse of the colors from the top and bottom layers.

Blending with black produces no change. Blending with white produces a white result.

S

Mask Mode

Selection Mode

© www.ablestock.com 2005

© www.ablestock.com 2005

180

Selection Brush

Menu: –		
Shortcut: A	OS:	Mac, Windows
Version: 2,, 3, 4	See also:	Selection, Lasso, Magic Selection Brush

Responding to photographers' demands for even more options for making selections, Adobe included the Selection Brush for the first time in version 2.0 of Elements.

The tool lets you paint a selection onto your image. The size, shape and edge softness of the selection are based on the brush properties you currently have set. These can be altered in the Brush Presets pop-up palette located in the options bar.

The tool can be used in two modes – Selection and Mask.

The **Selection** mode is used to paint over the area you wish to select. The Mask mode works by reverse painting in the areas you want to 'mask from the selection'.

The **Mask** mode is particularly well suited for showing the soft or feathered edge selections made when painting with a soft-edged brush.

Holding down the Alt (Windows) or Option (Mac) keys whilst dragging the brush switches the tool from adding to the selection to taking away from the area.

The Magic Selection Brush introduced in version 4.0 is an automatic version of the Selection Brush. Sophisticated selections of complex objects can be created using both brushes one after the other.

S

Selections

Menu: –		
Shortcut: –	OS:	Mac, Windows
	See also:	Elliptical Marquee, Rectangular Marquee, Magnetic Lasso, Lasso, Polygonal Lasso, Magic Wand, Selection Brush
Version: 1, 2, 3, 4		

When first starting most users apply editing and enhancement changes to the whole photograph, but before too long it becomes obvious that sometimes it would be a benefit to restrict the alterations to a specific part of a picture. For this reason image-editing packages contain features that allow the user to isolate small sections of a photo, which can then be altered independently of the rest of the picture. The process of isolating a picture part is called 'making a selection'. When a selection is created in Photoshop Elements, the edges of the isolated area are indicated by a flashing dotted line, which is sometimes referred to as the 'marching ants'. A selection restricts any changes made to the image to just the area isolated by the marching ants.

(1) Non-selected area.
(2) Area selected with the rectangular marquee tool.
(3) Marching ants signifying the boundaries of an active selection.

To remove the selection and resume full Image-editing mode, the area has to be Deselected (Select > Deselect).

The selection tools in Elements can be divided into two groups:

Drawing selection tools, or those that are based on selecting pixels by drawing a line around the part of the image to be isolated. These include the Rectangular and Elliptical Marquee and Lasso tools, as well as the Selection Brush.

Color selection tools, or those features that distinguish between image parts based on the color or tone of the pixels. An example of this type of tool is the Magic Wand.

The marching ants of a feathered selection are located at the point where 50% or more of the image is selected.

Before

After Send Backward

Send Backward

Menu: Editor: Layer > Arrange > Send Backward	
Shortcut: Ctrl/Cmd [**OS:** Mac, Windows
Version: 1, 2, 3, 4	**See also:** Send to Back

The Send Backward option moves the selected layer one layer lower in the stack. In the example, the 'writer' layer was sent backwards, which means that its new position is below the 'Type' layer, causing it to become partially obscured.

• •

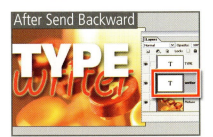

After Send to Back

Send to Back

Menu: Editor: Layer > Arrange > Send to Back	
Shortcut: Shft Ctrl/Cmd [**OS:** Mac, Windows
Version: 1, 2, 3, 4	**See also:** Send Backward

The Layer > Arrange menu contains a list of options that can be used for moving the active layer up and down the layer stack. Moving the position of image layers that contain sections that are transparent or semi-transparent will alter the look of the combined picture.

The Send to Back option transports the selected layer to the very bottom of the stack (but not below the background layer). In the example, the 'writer' type layer was sent back from its uppermost position to below the 'Picture' layer so that it is now hidden from view.

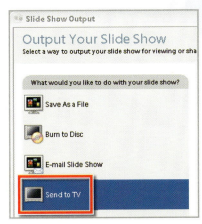

Send to TV

Menu: –	
Shortcut:	**OS:** Windows
Version: 4	**See also:** Windows XP Media Center

One of the new output options in the revised Slide Show Editor is the Send to TV feature. When working on a computer with Windows XP Media Center Edition installed this option allows you to output your slide shows directly to an attached television (3).

Part of the output process is adjusting the slide show to suit different television standards. After typing in the name of the show you can choose from a range of formats. If you are unsure which to use click the Details button (1) to display an explanation of the video settings (2) used for the selection as well as the countries where the specific video format is most used. The options available are:

Standard Definition (PAL) – Optimized for TV in Europe and Australia.
Aspect ratio: 4:3
Resolution: 720 x 576 pixels
Frame Rate: 25 fps
Format: Windows Media Video 9

Standard Definition (NTSC) – Optimized for TV in the USA and Japan.
Aspect ratio: 4:3
Resolution: 720 x 480 pixels
Frame Rate: 29.97 fps
Format: Windows Media Video 9

Widescreen Standard Definition (PAL) – Optimized for TV in Europe and Australia.
Aspect ratio: 16:9
Resolution: 720 x 576 pixels
Frame Rate: 25 fps
Format: Windows Media Video 9

Widescreen Standard Definition (NTSC) – Optimized for TV in the USA and Japan.
Aspect ratio: 16:9
Resolution: 720 x 480 pixels
Frame Rate: 29.97 fps
Format: Windows Media Video 9

Enhanced Definition – Optimized for TV that is full screen (4:3) and Enhanced Definition (480p).
Aspect ratio: 4:3
Resolution: 640 x 480 pixels
Frame Rate: 30 fps
Format: Windows Media Video 9

Widescreen Enhanced Definition – Optimized for TV that is widescreen (16:9) and Enhanced Definition (480p).
Aspect ratio: 16:9
Resolution: 852 x 480 pixels
Frame Rate: 30 fps
Format: Windows Media Video 9

Widescreen High Definition – Optimized for TV that is widescreen (16:9) and High Definition (720p).
Aspect ratio: 16:9
Resolution: 1280 x 720 pixels
Frame Rate: 30 fps
Format: Windows Media Video 9

Before

After

Services pop-up

Menu: –	
Shortcut: –	OS: Windows
Version: 4	See also: –

New to the status bar of the Photo Browser is the Photo Services notification flag (1). The flagged mailbox appears in the status bar when a new Photo Services notification is received. The messages can be viewed by clicking on the Mailbox icon. This opens the Notifications dialog. Here the content of each individual message can be displayed in the description area by clicking on the entry in the Title box.

Depending on the nature of each message the upper button on the right of the dialog (2) will allow you to Update Elements with the contents of the message or View the notification in a new Web Browser window. Below this button is a Delete button (3) which is used to remove the notification entry from the list.

To turn notifications off adjust the settings in the Services section (4) of the Edit > Preferences dialog.

Set as Desktop Wallpaper

Menu: Photo Browser: Edit > Set as Desktop Wallpaper	
Shortcut: Ctrl Shft W	OS: Windows
Version: 3, 4	See also: –

Introduced in Elements version 3.0, the Set as Desktop Wallpaper takes the currently selected photo and creates a desktop wallpaper from the image. In the process Elements automatically stretches or compresses the photo to fit the screen dimensions and then automatically alters the Windows display properties to set the new wallpaper as the default option.

To make your own wallpaper locate the image in the Photo Browser workspace and then right-click on the selected photo. Choose the Set as Desktop Wallpaper option from the pop-up menu (1).

To remove the wallpaper or select one of the styles that ships with Windows right-click on the wallpaper and select Properties from the pop-up menu. In the Desktop tab of the Display properties dialog select a new option from the Background list (2).

Shadows/Highlights

Menu: Editor: Enhance > Adjust Lighting > Shadows/Highlights	
Shortcut: –	OS: Mac, Windows
Version: 1, 2, 3, 4	See also: Levels, Brightness/Contrast

Designed as a replacement for both the Fill Flash and Adjust Backlighting controls found in version 2.0 of Elements, this one little dialog contains the same power as the previous two features in an easy-to-use format.

The tool contains three sliders – the upper one is for Lightening Shadows (1), which replaces the Fill Flash tool, the control in the middle Darkens Highlights (2) and is a substitute for the Adjust Backlighting tool, and the final slider adjusts Midtone Contrast (3).

Moving the Shadows control to the right lightens all the tones that are spread between the middle tones and black. Sliding the Highlights control to the right darkens those tones between middle values and white.

The beauty of this feature is that, unlike the Brightness/Contrast tool, these changes are made without altering other parts of the picture. To fine-tune the tonal changes a third slider is also included in the dialog. Moving this Midtone control to the right increases the contrast of the middle values and movements to the left decrease the contrast, making the image 'flatter'.

Shape tools

Menu: –	
Shortcut: U	OS: Mac, Windows
Version: 1, 2, 3, 4	See also: Brush

Elements contains both painting and drawing tools. The Shape tools are drawing tools that, in contrast to the Brush, Airbrush and Pencil, are vector or line based.

The objects drawn with these tools are defined mathematically as a specific shape, color and size. They exist independently of the pixel grid that makes up your image until it comes time to print when they are simplified (rasterized).

They produce sharp-edged graphics and are particularly good for creating logos and other flat colored artwork.

The Shape tools include Rectangle tool (1), Rounded Rectangle tool (2), Ellipse tool (3), Polygon tool (4), Line tool (5), Custom Shape tool (6) and the Shape Selection tool (7).

Specific settings that control the way that each shape tool functions are available from the pop-up dialog in the Tool's options bar (8).

Share Online

Menu: Photo Browser:	
Shortcut: –	OS: Mac, Windows
Version: 3, 4	See also: Order Prints

Using the online resources of kodakgallery.com and kodakgallery.co.uk it is possible to share your photos with family and friends via the web.

After registering as a new user with KodakGallery, select the images to share from the Photo Browser and then choose the Share Online option from the Share button in the shortcuts bar. Select the recipients and add a subject and message in the dialog that appears.

Add new recipients if they are not already listed. After clicking Next the files will be uploaded and an e-mail message (1) sent to the recipients, letting them know that there are pictures to be shared now online.

The people receiving the e-mail need only click on the View Photos button to see the photos.

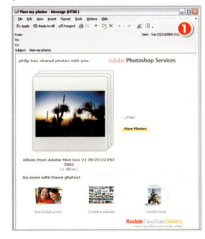

Sharpen, Quick Fix

Menu: –	
Shortcut: –	OS: Mac, Windows
Version: 1, 2, 3, 4	See also: Sharpen filters

The Sharpen option in the Quick Fix Editor uses the sharpening abilities of the Unsharp Mask filter but provides it with a single slider control. The Amount slider (1) determines the degree of sharpening that is applied to the picture. The Auto button (2) sharpens the picture according to a level determined by Elements. Apply the sharpening by clicking the Tick button.

Original Unsharpened

© www.ablestock.com 2005

After Sharpen More

After Sharpen

After Sharpen Edges

184

After Sharpen tool

Sharpen filters

Menu: Editor: Filter > Sharpen
Shortcut: – **OS:** Mac, Windows
Version: 1, 2, 3, 4 **See also:** Unsharp Mask filter

Elements provides a variety of sharpening filters designed to increase the clarity of digital photographs. The options are listed in the Filter > Sharpen menu (1) and include the Sharpen, Sharpen Edges, Sharpen More and Unsharp Mask filters. Here we will look at the first three options with the Unsharp Mask filter being handled separately under its own heading.

Digital sharpening techniques are based on increasing the contrast between adjacent pixels in the image. When viewed from a distance, this change makes the picture appear sharper. These Sharpen and Sharpen More filters are designed to apply basic sharpening to the whole of the image and the only difference between the two is that Sharpen More increases the strength of the sharpening effect.

One of the problems with sharpening is that sometimes the effect is detrimental to the image, causing areas of subtle color or tonal change to become coarse and pixelated. These problems are most noticeable in image parts such as skin tones and smoothly graded skies. To help solve this issue, Adobe included another filter in Elements, Sharpen Edges, which concentrates the sharpening effects on the edges of objects only. Use this filter when you want to stop the effect being applied to smooth image parts.

Sharpen tool

Menu: –
Shortcut: R **OS:** Mac, Windows
Version: 1, 2, 3, 4 **See also:** Blur tool

In addition to using a filter to sharpen your image, it is also possible to make changes to specific areas of the picture (1) using the Sharpening tool located in the Elements tool box.

The size of the area sharpened is based on the current brush size. The intensity of the effect is controlled by the Strength value found in the options bar.

As with the Airbrush tool, the longer you keep the mouse button down the more pronounced the effect will be. Be careful not to over-apply the tool as the effects can become very noticeable very quickly and impossible to reverse (2).

These features are particularly useful when you want to change only small parts of an image rather than the whole picture.

Shear filter

Menu: Editor: Filter > Distort > Shear
Shortcut: – **OS:** Mac, Windows
Version: 1, 2, 3, 4 **See also:** Filters

The Shear filter, as one of the group of Distort filters, creates a twisted and push/pulled version of the original photo.

The Filter dialog contains an interactive effect box (1) that contains a graph and a control line. Using the mouse the user can add control points to the line and push, pull and twist the line within the confines of the graph. The distortions are then reflected in the preview thumbnail at the bottom of the screen.

Also included are two options for controlling the way that the undefined areas (2), or gaps created by the distortions, are handled. Wrapping uses the picture parts on the opposite side of the frame to fill the space whereas the Repeat Edge Pixels option duplicates the color and brightness of the detail at the edge of the distortion.

Shortcuts bar

Menu: –	
Shortcut: –	**OS:** Mac, Windows
Version: 1, 2, 3, 4	**See also:** Menu bar, Options bar, Toolbar

The shortcuts bar provides quick and easy button access to regularly used functions in the Standard and Quick Fix Editor (1) and Photo Browser (2) workspaces.

Located at the right-hand end of each bar are 'Jump to' buttons that change the current workspace when clicked. The editor shortcuts bar jumps between Quick Fix and Standard workspaces (3) and the Photo Browser bar contains buttons for switching between Browser and Date Views of cataloged images (4). Change views with the Automatically Tile Windows buttons and Maximize mode (5).

Similar, select

Menu: Editor: Select > Similar	
Shortcut: –	**OS:** Mac, Windows
Version: 1, 2, 3, 4	**See also:** Expand, Contract

Listed under the Select and Select > Modify menus is a range of options for adjusting selections after they have been created.

The Select > Similar is one of these options. The feature looks for, and selects, pixels throughout the whole picture with similar color and tonal characteristics to those already included in the selection.

The tolerance settings used with this feature are based on those currently set for the Magic Wand.

The Select > Grow feature is similar to Select > Similar except that it restricts its selection of new pixels to only those adjacent to those currently selected.

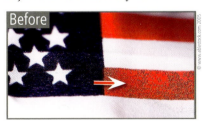

Before

After

Simplify Layer

Menu: Editor: Layer > Simplify Layer	
Shortcut: –	**OS:** Mac, Windows
Version: 1, 2, 3, 4	**See also:** Rasterize

The Simplify Layer command rasterizes vector-based graphics. In simple terms this means that selecting this option will convert shape, type, solid color, pattern fill and gradient layers into a standard image layer. This step needs to occur before the content of these layers can be filtered or painted on.

185

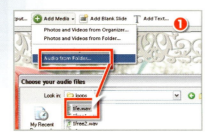

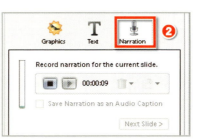

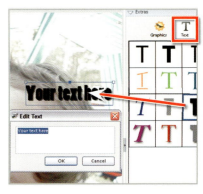

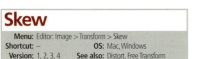

Skew

Menu: Editor: Image > Transform > Skew	
Shortcut: –	**OS:** Mac, Windows
Version: 1, 2, 3, 4	**See also:** Distort, Free Transform

The Skew feature is one of the distortion options available under the Image > Transform menu. Selecting the feature surrounds your layer with the standard Bounding box complete with corner and middle-of-edge handles. Click-dragging a handle creates a horizontal or vertical shift of the edge of the layer, producing a rhomboid or squashed box effect (1).

Double-click inside the Bounding box to apply the changes.

When using this feature with a background the layer will need to be converted to an image layer first. This is achieved via a Conversion confirmation dialog that pops up after selecting the Skew option (2).

Slide Show – Add Audio

Menu: Photo Browser: File > Create > Slide Show	
Shortcut: -	**OS:** Windows
Version: 4	**See also:** Slide show

Add music and extra audio to the show by clicking on the Add Media button and then choosing the music file to include from those saved on your computer (1).

You can also incorporate narration that you create with the built-in slide show recorder. Access this feature by selecting the Narration button in the Extras pane and then clicking the Record button.

Slide Show – Add Graphics

Menu: Photo Browser: File > Create > Slide Show	
Shortcut: -	**OS:** Windows
Version: 4	**See also:** Slide show

The Slide Show Editor now includes a variety of clip art that can be added to your presentations. Double-click or click-drag to place a selected graphic onto the current slide.

Slide Show – Add Text

Menu: Photo Browser: File > Create > Slide Show	
Shortcut: -	**OS:** Windows
Version: 4	**See also:** Slide show

Select from a range of text styles to add titles to your presentation with click, drag and drop convenience. Select the Text button in the Extras pane and then click-drag a text style onto the photo in the preview area. Double-click the Text box to display Edit Text dialog to change the text.

Slide Show – auto editing

Menu: Photo Browser: File > Create > Slide Show	
Shortcut: -	**OS:** Windows
Version: 4	**See also:** Slide show

Clicking onto the photo in the slide show preview area displays a series of auto editing options that can be quickly and easily applied.

Rotate, size, change to sepia, black and white or back to color, and apply Smart Fix and Red Eye Fix to your photos without leaving the Slide Show Editor. Remember to click the Preview image to display the Edit options in the Properties palette.

187

Slide Show – More Editing

Menu: Photo Browser: File > Create > Slide Show
Shortcut: - **OS:** Windows
Version: 4 **See also:** Slide show

The More Editing button is part of the general editing options that are displayed in the Properties pane when you click on the image preview. Clicking the button transfers the photo to the standard editing space where more complex image enhancement tasks can be undertaken. Saving and closing the edited photo then transfers the altered image back to the Slide Show Editor.

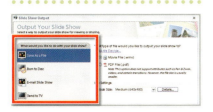

Slide Show – Output Options

Menu: Slide Show: File > Output Slide Show
Shortcut: - **OS:** Windows
Version: 4 **See also:** Slide Show, Send to TV

After putting together your presentation complete with titles, images, transitions, narration and music you can elect to output the show in a variety of formats. The options include:

Save As a File – This option allows for the creation of a movie file in the WMV format (Windows Media Video) or/and Adobe Acrobat presentation document (PDF).

Burn to Disc – Choose this setting to proceed directly to creating a DVD or VCD disc of your presentation that can be viewed on TV or a computer screen. DVD burning requires Premier Elements to be installed alongside Photoshop Elements.

E-mail Slide Show – Select this option to create smaller PDF and WMV files that are more suitable for e-mailing than the larger, higher quality offerings available with the Save As a File option.

Send to TV – When Elements is installed on a computer running Windows XP Media Center this setting allows you to output the slide show directly to television.

Slide Show – Pan and Zoom

Menu: Photo Browser: File > Create > Slide Show
Shortcut: - **OS:** Windows
Version: 4 **See also:** Slide show

Pan and Zoom is a new feature added to the revised Slide Show Editor in version 4.0 of Elements. By placing Start and End viewing frames onto a photo it is possible to create motion effects with your still slide show images.

To create a pan and zoom effect select the slide in the storyboard and then check the Enable Pan & Zoom option in the Properties pane. Click on the left thumbnail (Start) and set the starting marquee's (green) size and position, then switch to the right thumbnail and adjust the ending marquee's (red) size and position.

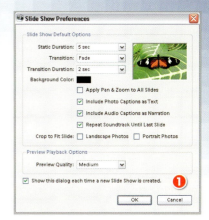

Slide Show – Preferences

Menu: Photo Browser: File > Create > Slide Show
Shortcut: - **OS:** Windows
Version: 4 **See also:** Slide show

When selecting the Slide Show option from the File > Create menu in the Photo Browser space a Preferences dialog is displayed before opening the Slide Show Editor itself. The options set here are applied to the whole of the slide show.

Select the 'Show this dialog each time a new Slide Show is created' option (1) to ensure that the Preferences dialog is displayed each time you start a new slide show.

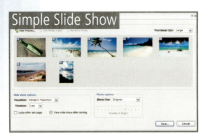

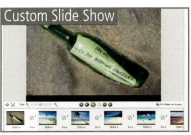

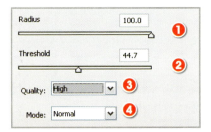

Slide Show – Quick Reorder

Menu: Photo Browser: File > Create > Slide Show
Shortcut: - **OS:** Windows
Version: 4 **See also:** Slide show

The Quick Reorder button (1) at the bottom left of the main Slide Show Editor workspace displays the slide show images in a new window (2). The position of photos within the presentation sequence can be altered by click-dragging an individual thumbnail to a new place in the group. To return to the main Slide Show Editing space click the Back button at the top left of the dialog (3).

Slide Shows – 4.0

Menu: Photo Browser: File > Create > Slide Show
Shortcut: - **OS:** Windows
Version: 4 **See also:** Slide show

Photoshop Elements 4.0 contains a new workflow for creating slide shows. Unlike in version 3.0 for Windows where you had to choose the type of presentation you wanted to create from the outset, the new approach centers all slide show activities around a single editor interface and it is only at the time of outputting that you choose the type of slide show that you want to create.

In this way you can create (and save) a single slide show project and then repropose the presentation in many different forms (online, DVD, PDF Slide Show or direct to TV) by simply selecting different output options.

Slide shows – 3.0/2.0

Menu: Photo Browser: File > New > Slide Show
Editor: File > New > Creation then Creation: Slide Show
Editor: File > Automation Tools > PDF Slide Show (Mac)
File Browser: Automate > PDF Slide Show (Mac)
Shortcut: - **OS:** Mac, Windows
Version: 2, 3 **See also:** Custom Slide Show, PDF Slide Show

Version 2.0 of Elements introduced a PDF Slide Show making option. The feature proved so popular that version 3.0 for Windows now has two Slide Show making options – Simple and Custom, both of which are accessible in the Photo Creations workspace.

With the **Simple Slide Show** option a selection of images can be ordered, transitions and timing applied between individual slides, and the whole sequence saved as a self-running PDF Slide Show. The finished show can be saved to disk or CD or uploaded to the web ready for online viewing.

The **Custom Slide Show** feature contains a host of options that allow users to create true multimedia slide shows, complete with music, narration, transitions and titles. The finished presentations are saved as a Windows Media Video file which can be shown on your computer or burnt to disc as a Video CD for displaying on television.

Macintosh users do not have access to the Simple and Custom Slide Show options, instead they are able to create **PDF Slide Shows** in much the same way as was possible with Elements version 2.0. The feature can be opened via the File > Automation Tools menu or from inside the File Browser using the Automate menu (after selecting the thumbnails of the pictures to include).

Smart Blur filter

Menu: Editor: Filter > Blur > Smart Blur
Shortcut: – **OS:** Mac, Windows
Version: 3, 4 **See also:** Filters

The Smart Blur filter, as one of the group of Blur filters, selectively blurs your picture whilst retaining the sharpness of edge details.

The Filter dialog contains several controls to adjust the strength and location of the blur. The Radius setting (1) controls the strength of the effect. The Threshold slider (2) determines where the blurring will occur. High values include more of the picture in the blur action.

The Quality drop-down menu (3) controls the image quality of the final result. When set to high the filter processing takes longer. The Mode option (4) is used to select other ways of applying the effect, including adding edge detection lines to the finished results.

Original – no blur

Smart Blur – 30% Threshold

Smart Blur – Edge Only

Smart Blur – 100% Threshold

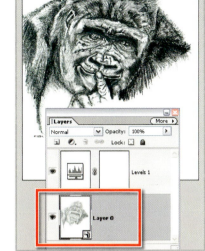

Before

After

Smart Objects

Menu: –	
Shortcut: –	**OS:** Windows
Version: 4	**See also:** –

Smart Objects is a new imaging technology available for the first time in Photoshop CS2. Using Smart objects it is possible to store vector and bitmap files within an open document and still maintain the integrity of these files throughout the editing and enhancing process.

To best understand the idea think of the technology as embedding one file within another. The embedded file is the smart object. It can be edited in its original form or non-destructively as part of the document it is embedded in.

For example, when placing an EPS vector art file in Photoshop CS2 it automatically becomes a Smart object and is represented in a single Smart Object layer.

Photoshop Elements 4.0 doesn't have the ability to create or edit smart objects but the program can open PSD (Photoshop) files that contain Smart Objects.

Smooth

Menu: Editor: Select > Modify > Smooth	
Shortcut: –	**OS:** Mac, Windows
Version: 1, 2, 3, 4	**See also:** Expand, Contract

The options in the Select > Modify menu are designed for adjusting selections after they have been created.

The Select > Modify > Smooth searches for unselected pixels within the nominated radius. If these areas are surrounded by selected pixels then they will be included in the selection; if the surrounding areas are not selected then they will not be included.

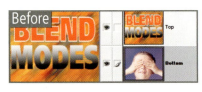

Before

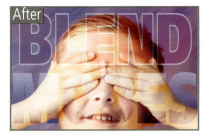

190

After

After

Smudge Stick filter

Menu: Editor: Filter > Artistic > Smudge Stick
Shortcut: – **OS:** Mac, Windows
Version: 1, 2, 3, 4 **See also:** Filters

The Smudge Stick filter, as one of the group of Artistic filters, recreates the photo so that it looks like it has been drawn with coarse pastels or crayons.

The Filter dialog contains several controls that adjust the look and feel of the effect.

The settings used for the Stroke Length (1) determine the strength of the effect. High values create a coarse result. The Highlight Area slider (2) sets the brightness of the middle and shadow areas. The Intensity option (3) controls how much of the original image detail is retained. Low values maintain much of the detail from the original photo.

Smudge tool

Menu: –
Shortcut: R **OS:** Mac, Windows
Version: 1, 2, 3, 4 **See also:** Liquify filter

The Smudge tool is used to push and blur picture parts by click-dragging the mouse cursor. The tool has been used to add speed lines to the running man in the example. Similar effects can be created with the Liquify filter.

Soft Light blending mode

Menu: Enhance > Adjust Lighting > Levels
Shortcut: – **OS:** Mac, Windows
Version: 1, 2, 3, 4 **See also:** Blend modes

The Soft Light blending mode is one of the group of Overlay modes that base their effects on combining the two layers depending on the tonal value of their contents.

This option is similar to the Overlay mode but produces a more subtle and sometimes less contrasty result. The content of the top layer is either Screened or Multiplied depending on its color and tonal value.

Blending with 50% gray produces no change.

S

Softening selection edges

Menu: Editor: Select > Feather
Shortcut: – **OS:** Mac, Windows
Version: 1, 2, 3, 4 **See also:** Feather

The Select > Feather feature softens the edges of existing selections by gradually mixing the edge pixels with transparency (1).

A soft edge can be applied before creating the selection by inputting a Feather value in the Selection tool's options bar (2).

Solarize filter

Menu: Editor: Filter > Stylize > Solarize
Shortcut: – **OS:** Mac, Windows
Version: 1, 2, 3, 4 **See also:** Filters

The Solarize filter, as one of the group of Stylize filters, recreates the look of when a color photograph is exposed to light during its processing. This traditional photographic effect is called Solarization.

The filter contains no controls to adjust the strength or look of the effect. The end result is based on inverting some of the hues of the unfiltered image and then adding them back to the picture in combination with the original colors.

Solid Color fill layer

Menu: Editor: Layer > New Fill Layer > Solid Color
Shortcut: – **OS:** Mac, Windows
Version: 1, 2, 3, 4 **See also:** Fill

The Solid Color fill layer option creates a new layer filled with a selected color (1). The layer's color can be altered at any time by double-clicking on the layer thumbnail (3) and selecting a new hue from the Color Picker palette.

Creating a new Solid Color fill layer is a three-step process. After selecting Layer > New Fill Layer > Solid Color input a name into the New Layer dialog and then choose a color from the Color Picker. New fill layers can be created via the option in the Layer menu or by pressing the Create New Adjustment and Fill Layer button (2) in the Layers palette.

Spatter filter

Menu: Editor: Filter > Brush Strokes > Spatter
Shortcut: – **OS:** Mac, Windows
Version: 1, 2, 3, 4 **See also:** Filters

The Spatter filter, as one of the group of Brush Strokes filters, repaints the colors and tones of the photo with a spattered spray paint effect.

The filter has two slider controls to adjust the way that the filtered result appears.

The Spray Radius slider (1) determines the strength of the effect and how much of the original photo detail is retained. Low values retain detail.

The Smoothness control (2) varies the way that the color is applied to the picture. High values create an almost watercolor-like effect, whereas low values produce a detailed spattered result.

191

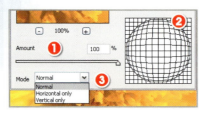

192

© www.allstock.com 2005

Click and drag the Crop tool so the marquee covers the whole of the picture. Click on the marquee corner handles in the top left and bottom right and drag these outwards beyond the edge of the picture. Double-click in the marquee to add the canvas space.

Specular highlights

Menu: –		
Shortcut: –	**OS:** Mac, Windows	
Version: 1, 2, 3, 4	**See also:** Levels	

Specular highlights are the very bright glints or sparks of light that reflect off very shiny gloss or silvered surfaces.

These highlights contain no detail and are completely white with tonal values of 256 for each of the channels. It is important to recognize these highlights and not tone them down when they occur in your pictures. They need to remain at the pure white level and shouldn't be adjusted back into the white highlight detail area of the tonal range with tools such as Levels or Shadows/Highlights.

Spherize filter

Menu: Editor: Filter > Distort > Spherize		
Shortcut: –	**OS:** Mac, Windows	
Version: 1, 2, 3, 4	**See also:** Filters	

The Spherize filter, as one of the group of Distort filters, shapes the picture onto either the ballooned outside of a ball or the concave inside surface.

The Filter dialog contains several controls that adjust the look and feel of the effect. The Amount slider (1) determines the strength of the effect. The wire frame thumbnail (2) provides an example of the distortion level associated with the amount setting. The Mode choice (3) allows the user to select to spherize the picture either horizontally, vertically or in both directions. The filter is useful for correcting barrel distortion.

Open the Spherize filter and adjust the magnification so that all the image can be seen. Drag the Amount slider to the left to remove the barrel distortion. Click OK to apply.

Use the Image > Transform > Perspective feature to align any converging verticals that are present in the picture. Next select the Crop tool and drag in the Bounding box borders to exclude the curved edges.

S

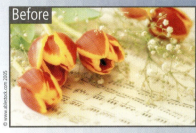

Before

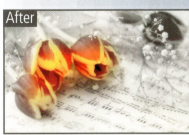

After

© www.ablestock.com 2005

Scanning resolution (samples per inch)	Image size to be scanned	Output size (pixels)	Output size (inches for print @ 200 dpi)	File size (Mb)
4000	35 mm film frame (24 mm x 36 mm)	4000 x 6000	20 x 30	72.00
2900	35 mm	2900 x 4350	14.5 x 21.75	37.80
1200	35 mm	1200 x 1800	6 x 9	6.40
600	35 mm	600 x 900	3 x 4.5	1.62
400	5 x 4 inch print	2000 x 1600	10 x 8	9.60
1000	5 x 4 inch print	5000 x 4000	25 x 20	60.00
400	10 x 8 inch print	4000 x 3200	20 x 16	38.40

193

SPI, samples per inch

Menu: –	
Shortcut: –	**OS:** Mac, Windows
Version: 1, 2, 3, 4	**See also:** Resolution

Scanning resolution, as opposed to image or printing resolution, is determined by the number of times per inch that the scanner samples your original image. The unit of measure for this is called Samples Per Inch or SPI.

The number of pixels generated by a digital camera has an upper limit that is fixed by the number of sensors in the camera. This is not the case for scanner capture. By altering the number of samples taken for each inch of the original print or negative you can change the total number of pixels created in the digital file. This figure will affect both the 'enlargement' potential of the final scan and its file size. The general rule is the higher the resolution the bigger the file and the bigger the printed size possible (before seeing pixel blocks or digital grain).

Does this mean that we always scan at the highest resolution possible? The intelligent answer is NO!

The best approach is to balance your scanning settings with your printing needs. If you are working on a design for a postage stamp you will need less pixels to play with than if you want your masterpiece in poster format. For this reason it is important to consciously set your scanning resolution keeping in mind your required output size.

Some scanning software will give you an indication of resolution, file size and print size as part of the dialog panel, but for those of you without this facility use the table above as a rough guide.

Sponge tool

Menu: –	
Shortcut: O	**OS:** Mac, Windows
Version: 1, 2, 3, 4	**See also:** Burning tool, Dodging tool

In addition to using the Hue/Saturation feature to adjust the vividness of color in your image, it is also possible to make changes to specific areas of the picture using the Sponge tool located with the Dodging and Burning tools in the Elements toolbar.

The tool can be set to either Saturate (make the colors more vibrant) or Desaturate (decrease the color strength until only the gray tone remains). The size of the area altered is based on the current brush size. The intensity of the effect is controlled by the Flow value found in the options bar. Repeated strokes over the picture to be enhanced gradually builds up the effect.

Just like the Dodging and Burning tools this feature is very useful for emphasizing a point of focus, but in this case it is achieved by increasing the area's color strength.

S

194

Spot Healing Brush

Menu: –	
Shortcut: –	**OS:** Mac, Windows
Version: 3, 4	**See also:** Dust & Scratches filter, Healing Brush

In recognition of just how tricky it can be to get seamless dust removal with the Clone Stamp tool, Adobe decided to include the Spot Healing Brush in Elements 3.0.

After selecting the new tool you adjust the size of the brush tip using the options in the Tool's option bar and then click on the dust spots and small marks in your pictures.

The Spot Healing Brush uses the texture that surrounds the mark as a guide to how the program should 'paint over' the area. In this way, Elements tries to match color, texture and tone whilst eliminating the dust mark. The results are terrific and this tool should be the one that you reach for first when there is a piece of dust or a hair mark to remove from your photographs.

Spotlight, Lighting Effects

Menu: –	
Shortcut: –	**OS:** Mac, Windows
Version: 1, 2, 3, 4	**See also:** Filters

Spotlight is one of the lighting types featured in the Lighting Effects filter. The Spotlight style shines a focused disk of light onto the main subject.

This light type is great for highlighting a specific part of a scene whilst reducing the brightness of the rest of the picture.

Move the position of the light by click-dragging the light's center. You can decrease or increase the size of the spotlight light source by click-dragging one of the light handles.

Adjust the characteristics of the light source by changing its properties. The brightness of the light is determined by the Exposure and Intensity sliders.

Sprayed Strokes filter

Menu: Editor: Filter > Brush Strokes > Sprayed Strokes	
Shortcut: –	**OS:** Mac, Windows
Version: 1, 2, 3, 4	**See also:** Filters

The Sprayed Strokes filter, as one of the group of Brush Strokes filters, combines the textured stroke appearance of filters like the Graphic Pen with the sprayed on approach of the Spatter filter.

The Filter dialog contains several controls that adjust the look and feel of the effect.

The Stroke Length slider (1) adjusts the look of the sprayed pattern from a dot, at low values, to a pen-like stroke at higher settings. The Spray Radius control (2) determines both the strength of the effect and the amount of original detail that is conserved. Low values retain more of the original photo and produce subtle results.

The Stroke Direction option (3) controls the direction of the line that is used in a repeated pattern.

Before

After Spotlight Lighting Effects

Stack

Menu:	Photo Browser: Edit > Stack > Stack Selected Photos
	Photo Browser: Edit > Stack > Unstack Photos
Shortcut: Alt Ctrl S (Stack)	**OS:** Windows
Version: 3, 4	**See also:** Version Sets

A stack is a way for you to group alike images in the Photo Browser workspace. Stacked photos are displayed with a single photo from the group showing on top and a small Stack icon in the corner (1).

The feature is designed for those times when you may have many pictures of the same subject taken at the same time – the kids playing in the back garden with the new puppy for instance. Of the many pictures taken on the day, you may only select one or two for printing or e-mailing to friends or family, but in the meantime the browser becomes full of multiples of the same sort of photo.

The Stack feature allows you to manage these files more easily by grouping the thumbnails of these images together in the one space. Stacking your photos doesn't restrict you from editing, changing or deleting pictures and you can unstack, display all stacked thumbnails, merge and add or remove photos to the stack at any time.

To add pictures to a stack, select them first in the Photo Browser workspace and then choose Edit > Stack > Stack Selected Photos. To unstack a set of stacked images choose Edit > Stack > Unstack Photos or choose the option from the Context menu by right mouse-clicking on the thumbnail.

The Version Set feature is a special type of stack that contains several different versions of the same picture that has been saved after a variety of editing sessions.

Stained Glass filter

Menu:	Editor: Filter > Texture > Stained Glass
Shortcut: –	**OS:** Mac, Windows
Version: 1, 2, 3, 4	**See also:** Filters

The Stained Glass filter, as one of the group of Texture filters, simulates the look of a stylized stained glass window by breaking the picture into colored cells and surrounding them with a thick black border.

The Cell Size slider (1) determines how large each individual 'glass panel' is. Higher values create bigger cell sizes and retain less of the original picture detail. The Border Thickness control (2) varies the size of the black edge that surrounds each colored cell. The Light Intensity slider (3) controls brightness of the center of the image.

Stamp filter

Menu:	Editor: Filter > Sketch > Stamp
Shortcut: –	**OS:** Mac, Windows
Version: 1, 2, 3, 4	**See also:** Filters

The Stamp filter, as one of the group of Sketch filters, converts the picture to just black and white areas and works like a sophisticated version of the Threshold filter.

The Filter dialog contains two controls that adjust the look and feel of the effect.

The Light/Dark Balance control (1) determines the tones that are converted to white and those changed to black. High values convert more of the tones to black. The Smoothness slider (2) varies the amount of edge detail retained in the picture. Lower values contain more detail.

S

Standard Editor work-space

Menu: –	
Shortcut: –	OS: Mac, Windows
Version: 1, 2, 3, 4	See also: Quick Fix Editor, Auto Fix Window

The Standard Editor is the most sophisticated of the three different editing approaches provided in Elements 3.0 for Windows.

The final group of tools are those designed to give the user professional control over their editing and enhancement tasks. Many of the features detailed here are very similar to, and in some cases exactly the same as, those found in earlier versions of Elements as well as the Photoshop program itself.

These tools provide the best quality changes available with Elements, but they do require a greater level of understanding and knowledge to use effectively. The extra editing and enhancement power of the tools comes at a cost of the user bearing all responsibility for the end results.

Whereas the automatic nature of many of the features found in the other two editing approaches means that bad results are rare, misusing or over-applying the tools found here can actually make your picture worse. This shouldn't stop you from venturing into these waters though, but it does mean that it is a good idea to apply the tools cautiously rather than with a heavy hand.

The other editing approaches in Elements 3.0 for Windows options are the automatic options provided by the **Auto Fix Window** and the middle ground between total user control and total program control over the

editing results contained in the **Quick Fix Editor**.

(1) **Toolbar** – Displays icons of tools available for editing and enhancement work. Can also be displayed in a two-column format.

(2) **Options bar** – Displays the available options for the currently selected tool.

(3) **Menu bar** – Contains features grouped in menus and sub-menus.

(4) **Shortcuts bar** – Displays buttons that provide quick and easy access to commonly used functions.

(5) **Palette Bin** – Used for storing palettes and is similar in function to the Palette Well in versions 1.0 and 2.0 of the program.

(6) **Image window** – Displays an open picture ready for enhancement and editing work. This window can be minimized, maximized and canceled using the buttons in the top right corner.

(7) **Photo Bin** – All opened files are displayed in the Photo Bin, whether minimized or not.

(8) **Viewing modes** – Clicking the Left icon puts Elements in Auto Tiled mode. All the open/unminimized images are tiled within the work area. If the Photo or Palette Bin is closed, the images automatically re-tile to fit the new space. Clicking the Right icon puts Elements in Maximize mode, where you see only the selected image, surrounded by gray work area. There are scroll bars, but there is no typical Image window with window controls. To view a different image, select it in the Photo Bin or from the bottom of the Window menu. This is the viewing mode that Quick Fix uses, but without the scroll bars.

Start From Scratch

Menu: –	
Shortcut: –	OS: Mac, Windows
Version: 3, 4	See also: Open File for Editing

The Start From Scratch option (1) located on the Welcome Screens of both the Macintosh edition of Elements 3.0 and the edition 4.0 opens the New File dialog box, which in turn is used to create a new blank document.

The option produces the same results as selecting File > New > Blank File.

Before

Before

After

© www.albestock.com 2005

After

5 items selected | 3365 items dated Jan 1998 – Dec

① ②

🖌 ✉ Click Here: Get 10 free Kodak prints

③ ④

Status bar

Menu:	–		
Shortcut:	–	OS:	Windows
Version:	3, 4	See also:	Shortcuts bar, Options bar, Toolbar, Menu bar

The status bar at the bottom of the Photo Browser workspace displays a variety of information that includes:

Selected Items – The number of items currently selected in the browser space (1).

Catalog Items – The total number of items currently being stored in the catalog (2).

View Notifications button – Displays the latest information on announcements, new services or updates provided by Adobe Photoshop Services (3).

Envelope button – Provides easy access from the status bar to the latest notification (4).

Straighten and Crop Image

Menu:	Editor: Image > Rotate > Straighten and Crop	
Shortcut:	–	OS: Mac, Windows
Version:	2, 3, 4	See also: Divide Scanned Photos

Extending the automatic squaring-off action of the Straighten feature, the 'Straighten and Crop Image' option adds an automatic removal of the white space surrounding the corrected picture to the process. The feature works by identifying the color that surrounds the straightened image and uses this as a basis of the ensuing crop.

Straighten Image

Menu:	Editor: Image > Rotate > Straighten	
Shortcut:	–	OS: Mac, Windows
Version:	2, 3, 4	See also: Divide Scanned Photos

Sometimes scanned pictures can end up being slightly crooked because the original was not placed squarely in the negative holder or on the scanning platen. The Crop tool or one of the Image > Rotate functions can be used to correct the problem. But if this all seems a little too complex, Elements also supplies an automatic 'Straighten Image' function. Designed especially for people like me, who always seems to get their print scans slightly crooked, these features can be found at the bottom of the Image > Rotate menu.

S

Before

After

Straighten tool

Menu:	–	
Shortcut: P	**OS:** Windows	
Version: 4	**See also:**	Vertical straighten, Straighten image

In Elements 4.0 a new tool has been added to the program to help you straighten the horizon lines in your photos. Called the Straighten tool, you can automatically rotate your pictures so that any line is aligned horizontally. Start by selecting the tool from the toolbar and then click-drag the cursor to draw a line parallel to the picture part that should be horizontal. Once you release the mouse button Elements automatically rotates the photo to ensure that the drawn line (and the associated picture part) is horizontal in the photo. When rotating the image, Elements can handle the resulting crooked edges of the photo in three different ways. The three approaches are listed in the drop-down menu in the options bar. They are:

Grow Canvas to Fit – The canvas size is increased to accommodate the rotated picture. With this option you will need to manually remove the crooked edges of the photo with the Crop tool.

Crop to Remove Background – After rotating Elements automatically removes the picture's crooked edges. This results in a photo with smaller dimensions than the original.

Crop to Original Size – The photo is rotated within a canvas that is the size of the original picture. This option creates a photo which contains some edges that are cropped and others that are filled with the canvas color.

To straighten a vertical line hold down the Ctrl key whilst using the Straighten tool.

© www.abletock.com 2005

Stroke Selection

Menu:	Editor: Edit > Stroke (Outline) Selection	
Shortcut: –	**OS:** Mac, Windows	
Version: 1, 2, 3, 4	**See also:** Borders	

Photoshop Elements has a function called 'Stroke Selection' which is often used to create simple line borders around photos. This command is used to draw a line that follows the edge of a selection.

So the process of creating a border requires the creation of a selection first and whilst it is still active, applying a stroke to the marquee's edge.

In the example below we simply select the whole image and stroke the selection with a line of a given color and pixel width.

Open a suitable image in Elements. Here we use a picture of a red Vespa. Make a selection of the whole photo using Select > All.

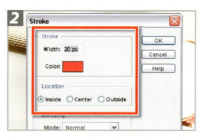

Now to draw a line that follows the selection. Using the Edit > Stroke (Outline) Selection feature we can trace the selection with a line that is the foreground color and a set number of pixels wide. Be sure to select the color of the stroke and 'inside' for the stroke location.

Style Settings

Menu:	Editor: Layer > Layer Style > Style Settings	
Shortcut: –	**OS:** Mac, Windows	
Version: 1, 2, 3, 4	**See also:** Layer Styles	

Layer styles can be applied very effectively to type and image layers and provide a quick and easy way to enhance the look of these picture elements. Everything from a simple drop shadow to complex surface and color treatments can be applied using this single-click feature. Each style is applied using the default values that were set when it was first created, but some of these attributes can be adjusted to suit the context in which you are using the effect.

The settings of individual styles can be edited by double-clicking on the 'f' icon (1) in the text layer and adjusting one or more of the style settings in the dialog that appears (2). Depending on the style selected different attributes will be available for adjustment. They may include:

Lighting Angle – The setting used to control the position of shadows and highlights.

Shadow Distance – Adjusts the space between object and its shadow.

Outer Glow Size – Determines the size of the outer glow.

Inner Glow Size – Sets the size of the inner glow.

Bevel Size – Adjusts the dimensions of the bevel effect.

Bevel Direction – Determines if the bevel is up or down.

Global Light – Determines the lighting direction for all styles in the document. Unchecking this option applies lighting changes just to the selected style.

S

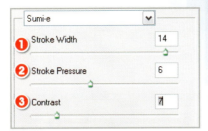

Styles and Effects palette

Menu: Editor: Window > Styles and Effects
Shortcut: – **OS:** Mac, Windows
Version: 3, 4 **See also:** Layer Styles

A collection of layer styles that are included in Elements can be found in the Styles and Effects palette (or Layer Styles tab in the Palette Well – version 2.0). A variety of different style groups are available from the drop-down list (1) and small example images of each style are provided as a preview of the effect.

Additional styles can be downloaded from websites specializing in resources for Elements users. These should be installed into the Adobe\Photoshop Elements 4.0\Presets\Styles folder. The next time you start Elements, the new styles will appear in the Layer Styles palette.

Sumi-e filter

Menu: Editor: Filter > Brush Strokes > Sumi-e
Shortcut: – **OS:** Mac, Windows
Version: 1, 2, 3, 4 **See also:** Filters

The Sumi-e filter, as one of the group of Brush Strokes filters, recreates the photo with softer hues in broad areas of color that are defined with a dark outline and small strokes to indicate texture.

The Filter dialog contains several controls that adjust the look and feel of the effect.

The Stroke Width slider (1) determines how fine the border and texture stroke will be. High values create pictures with strong edges and dark texture. The Stroke Pressure control (2) varies the strength of the texture as well as what proportion of the image it covers. The Contrast option (3) adjusts the overall contrast present in the filtered photo.

Swatches palette

Menu: Editor: Window > Color Swatches
Shortcut: – **OS:** Mac, Windows
Version: 1, 2, 3, 4 **See also:** Palettes

The Swatches palette houses the color swatch groups and color tables that are available for use in Photoshop Elements. The palette is displayed by selecting Window > Color Swatches. Swatch groups already loaded into the palette can be displayed by selecting them from the drop-down menu (2). Additional swatch groups can be loaded into the palette via the Load command in the pop-up menu accessed by pressing the More button (1). Customized swatch groups can be saved using the Save Swatches option also available in this menu.

S

Tags

Menu: –	
Shortcut: –	**OS:** Windows
Version: 3, 4	**See also:** Collections, Tags pane

Tags are special keywords that are attached to photographs and are used to help sort, organize and display sets of pictures.

The tagging features in the Tags pane (1) of the Photo Browser workspace allow you to create, manage and add and remove tags from pictures. Multiple tags can be applied to the one picture and then all the photographs in the browser can be searched for the individual images that feature a specific tag.

By default six different categories of tags are included in the Elements Tags pane – People, Places, Events, Favorites, Hidden and Other. New categories and sub-categories can be created via the New button in the top left of the pane.

Tags are applied to a picture by selecting and dragging them from the pane onto the thumbnail (2) or alternatively the thumbnail can be dragged directly onto the Tags pane.

Multiple tags can be attached to a single picture by multi-selecting the tags first and then dragging them to the appropriate thumbnail.

Tags pane

Menu: Photo Browser: Window > Tags	
Shortcut: Ctrl T	**OS:** Windows
Version: 3, 4	**See also:** Tags, Collections, Organize Bin

The Tags pane (1) stores all the tags used in Elements and sits to the right of the main thumbnail area in the Photo Browser workspace.

The pane is grouped together with the Collections and Properties panes in the Organize Bin. The whole Bin can be opened when you need to access the panes it contains and closed when you need to maximize the available workspace.

New Tags are created and added to the pane by selecting the New Tag option (2) from the menu displayed after pressing the New button at the top left of the pane. Next, fill out the details of the new entry in the Create Tag dialog (3), select a suitable icon for the tag label and click OK.

Grayscale Texture Fill file

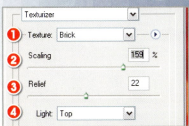

Text

Menu:	–	
Shortcut:	–	OS: Mac, Windows
Version:	1, 2, 3, 4	See also: Type

'Text' is often used interchangeably with 'Type' to indicate the Elements tool used for combining letters, words, sentences and phrases with your photos and illustrations (2).

Blocks of text can be selected in other programs, such as Microsoft Word (1), copied and then pasted into an Elements picture as a new Type layer.

Texture Fill filter

Menu:	Editor: Filter > Render > Texture Fill	
Shortcut:	–	OS: Mac, Windows
Version:	1, 2, 3, 4	See also: Filters

The Texture Fill filter, as one of the group of Render filters, fills a layer or picture by seamlessly repeating a selected grayscale picture.

The filter contains no controls for altering the strength or look and feel of the effect. After selecting the Texture Fill option a File Browser window is displayed. It is here that you locate the picture to be used for the effect. Clicking OK fills the current picture with a repeating pattern of the selected texture picture.

To make a color photo suitable for use as a Texture Fill file you must first change its color mode to grayscale (Image > Mode > Grayscale) and then save the image in the PSD format (File > Save As).

Texturizer filter

Menu:	Editor: Filter > Texture > Texturizer	
Shortcut:	–	OS: Mac, Windows
Version:	1, 2, 3, 4	See also: Filters

The Texturizer filter, as one of the group of Texture filters, recreates the picture to give the appearance that the photo has been printed onto the surface of a particular texture.

The base design is chosen from the Texture drop-down menu (1). The Scaling (2) and Relief (3) sliders control the strength and visual dominance of the texture, whilst the Light direction (4) menu alters the position of the highlight and shadow areas. Different surface types are available from the Texture drop-down menu.

The filter also contains the option to add your own files and have these used as the texture that is applied by the filter to the image. Use the steps below to create your own texture for use with the filter.

Shoot, scan or design a texture image and save as an Elements or Photoshop file (.PSD). Select the Texturizer filter from the Texture heading in the Filter menu.

Pick the Load Texture item from the drop-down list in the Texture menu. Browse folders and files to locate texture files. Click file name and then open to select.

Once back at the Texturizer dialog, move the Scaling slider to change the size of the texture. Adjust the Relief slider to control the dominance of the filter. Select a Light direction to adjust the highlights and shadow areas of the texture. Click OK to filter the photo.

T

202

3D Transform filter

Menu: Editor: Filter > Render > 3D Transform
Shortcut: C **OS:** Mac, Windows
Version: 1, 2, 3, 4 **See also:** Filters

The 3D Transform filter, as one of the group of Render filters, projects the photo onto either a cube, sphere or cylinder and then lets you move and rotate the object in three dimensions.

To the left of the Filter's dialog there is a toolbar (1) containing features used for defining and manipulating the three-dimensional objects that the picture is projected upon. The middle of the dialog is taken up with an interactive preview (2) that displays the original picture and the superimposed 3D object. The filter tools can be used to place, size and rotate the object within the boundaries of the Preview window. Clicking OK applies the transformation.

Threshold filter

Menu: Editor: Filter > Adjustments > Threshold
Shortcut: – **OS:** Mac, Windows
Version: 1, 2, 3, 4 **See also:** Filters

The Threshold filter, as one of the group of Adjustment filters, converts the picture to pure black and white, removing any tonal detail in the process. Tones darker than a selected point in the tonal scale are converted to black and those lighter than the selected value are converted to white.

The Filter dialog contains a single slider control that selects the precise tonal level, which marks the change point (1) between black and white. A histogram of the distribution of the pixels in the picture is also included.

TIFF

Menu: Editor: File > Save As
 Quick Fix: File > Save As
Shortcut: – **OS:** Mac, Windows
Version: 1, 2, 3, 4 **See also:** JPEG, GIF, PSD

TIFF or Tagged Image File Format is generally considered the industry standard for images destined for publishing (magazines and books, etc.). In its most basic form TIFF uses a 'lossless' compression (no loss of image data or quality) called LZW compression. Although preserving the quality of the image, LZW compression is only capable of compressing images a small amount.

Photoshop Elements version 3.0 as well as the more recent editions of Photoshop have included the ability to save in an upgraded TIFF format that contains a host of new options. These include the ability to include layers, save with a compression system other than LZW and the chance to specify how the content for individual layers is compressed.

Care should be taken when saving TIFF files using these new options as not all non-Adobe programs are completely 'savvy' with the changes in the new format. If in doubt, stick to TIFF with LZW compression and no layers.

Original photo

3D Transform – Sphere

3D Transform – Cube

3D Transform – Cylinder

© www.ablestock.com 2005

Before

Auto Tile - 4 photos

After Tile

Auto Tile - 2 photos

Tile

Menu:	Editor: Window > Images > Tile
Shortcut: –	**OS:** Mac, Windows
	See also: Tile Windows Automatically, Maximize, Minimize, Match Zoom, Match Location, Cascade
Version: 1, 2, 3, 4	

The Tile mode (6) is one of the many ways that open pictures can be viewed in Photoshop Elements. Selecting this option from the Window > Images menu will adjust the size of the pictures currently open in the Editor workspace so that they can all fit on screen (with no overlapping).

Other options for displaying open documents include:

Minimize (1) – Reduces open window to just a title bar but keeps document in the workspace.

Maximize (2) – Enlarges Image window to fill the whole of the workspace. This button is available on the Image window as well as the far right of the menu bar (Windows) or shortcuts bar (Mac), and can be easily confused with the Maximize button, which enlarges the Application window (Windows only) to fill the screen.

Close (3) – Closes the document.

Automatically tile windows (4) – Automatically resizes open windows to fit the workspace.

Multi-window mode (5) – Displays the document in its own smaller, movable window in the workspace.

Tiles filter

Menu:	Editor: Filter > Stylize > Tiles
Shortcut: –	**OS:** Mac, Windows
Version: 1, 2, 3, 4	**See also:** Filters

The Tiles filter, as one of the group of Stylize filters, breaks the photo into a series of same-size tiles that are then randomly offset.

The Filter dialog contains two main control areas. The number of tiles and maximum offset setting that is used in the filter are set in the first section of the dialog (1). Start with low values and then adjust if necessary.

The second area contains four options that determine what will be used to fill the vacant areas in the image that are created between the offset tiles (2).

· ·

In Multi-tile mode (Win)

① ② ③

In Maximize mode (Win)

④ ① ⑤ ③

Tile Windows Automatically

Menu: –	
Shortcut: –	**OS:** Mac, Windows
	See also: Tile, Maximize, Minimize, Match Zoom, Match Location, Cascade
Version: 3, 4	

The Tile Windows Automatically mode (4) is one of the many ways that open pictures can be viewed in Photoshop Elements. Pressing the button (4) in the top right of the document window will arrange the pictures in the same way as the Window > Image > Tile command. That is, all open pictures will be adjusted in size so that they all fit in the workspace without overlapping. But unlike the Tile view, as pictures are opened and closed, the displayed images are automatically resized to fit the space that is available.

Other options for displaying open documents include: Minimize (1), Maximize (2), Close (3), Tile (6) and Multi-window mode (5).

In Multi-tile mode (Mac)

③ ① ②

In Auto-tile mode (Win/Mac)

④ ②

© www.abletstock.com 2005

Tolerance setting

Menu: –	
Shortcut: –	OS: Mac, Windows
	See also: Magic Wand, Paint Bucket,
	Color Replacement tool,
Version: 1, 2, 3, 4	Magic Eraser,
	Background Eraser,
	Impressionist Brush tool

The Tolerance setting (1) is found in the options bar of tools that make selections or picture changes based on the color and brightness of a group of pixels.

Essentially it is a setting that determines how identical a pixel has to be to the original to be included in the selection (2) or pixels that are changed. The higher the Tolerance value, the less alike the two pixels need to be, whereas a lower setting will require a more exact match before a pixel is added to the selection or pixel group is to be changed.

Tools that have a Tolerance setting in their options bar include:

• Magic Wand
• Paint Bucket
• Color Replacement
• Magic Eraser
• Background Eraser
• Impressionist Brush; and
• Replace Color (Fuzziness slider).

Toolbox

Menu: –	
Shortcut: –	OS: Mac, Windows
Version: 1, 2, 3, 4	See also: Options Bar, Menu Bar

Tools interact directly with the image and require the user to manipulate the mouse to define the area or extent of the tool's effect. The tools in Photoshop Elements are all stored in a common toolbox (1), which is positioned on the left-hand side of the Editor workspace.

Some tools contain extra options which can be viewed by clicking and holding the mouse key over the small triangle in the bottom right-hand corner of the Tool button (2).

Alternatively the sub-menu may list a variety of tools related to the one currently selected. Selecting a new option from those listed will replace the current icon in the toolbox with your new choice. To switch back simply reselect the original tool.

The toolbox can be moved around the screen by click-dragging its title bar. In versions 4.0 and 3.0 moving the box away from the left-hand side of the screen will change it from a single to a dual column.

Tool Tips

Menu: –	
Shortcut: –	OS: Mac, Windows
Version: 1, 2, 3, 4	See also: Preferences

As part of the help system in Photoshop Elements, a Hyperlink button pops up (1) when you hover over a tool, command or feature. The button is called a Tool Tip. Selecting the link takes you directly to the Help entry relating to the tool or feature.

The feature can be turned off and on by selecting the Show Tool Tips (2) option in the Edit > Preferences > General dialog.

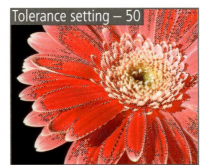

Tolerance setting – 50

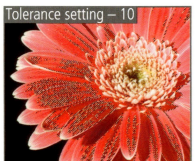

Tolerance setting – 10

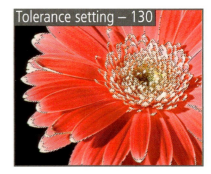

Tolerance setting – 130

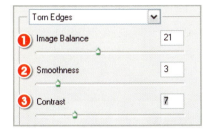

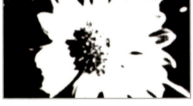

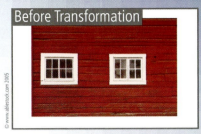

Torn Edges filter

Menu: Editor: Filter > Sketch > Torn Edges
Shortcut: – **OS:** Mac, Windows
Version: 1, 2, 3, 4 **See also:** Filters

The Torn Edges filter, as one of the group of Sketch filters, converts the picture to pure black and white shapes like the Threshold filter. Unlike this option though, the edges of the shapes are coarse and feathered and the dark and light tones contain a slight texture.

The Filter dialog contains three sliders to alter the look of the end result.

The Image Balance slider (1) selects a tonal level to act as a turning point between black and white. High values create large dark areas as more tones are converted to black. The Smoothness option (2) adjusts how rough the edge areas are. High values produce a sharp demarcation between black and white; low values create a more textured, 'torn' look.

The Contrast control (3) adjusts the starkness of the final result. High values produce a more contrasty result.

Trace Contour filter

Menu: Enhance > Adjust Lighting > Levels
Shortcut: – **OS:** Mac, Windows
Version: 1, 2, 3, 4 **See also:** Filters

The Trace Contour filter, as one of the group of Stylize filters, locates picture parts where there is a big change in brightness and then outlines these with a thin colored line against a white background.

The Level slider (1) in the Filter dialog sets the level of difference necessary to be outlined. The Lower and Upper options (2) nominate whether pixels with lighter values (upper) or darker values (lower) will be examined.

The end result is like a contour map of the contrast of the picture in a select tonal range.

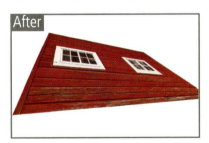
After

Transformations

Menu: Editor: Image > Transform
Shortcut: – **OS:** Mac, Windows
Version: 1, 2, 3, 4 **See also:** Free Transform, Distort, Skew, Perspective

The Image > Transform menu (1) contains four options that allow you to change the shape of your pictures from their standard rectangle format.

The **Skew** feature allows you to push and pull the sides of the rectangle to form diamond shapes.

The **Distort** allows you to move the corner handles of the picture totally independently.

You can correct or create converging verticals and other shape changes using the **Perspective** option.

The **Free Transform** feature combines all the above and can be used to scale, rotate, distort, skew or even apply perspective changes to your picture.

After selecting the feature that you wish to use you may be prompted to change the background to a standard layer ready for transformation. Click Yes in this dialog.

When completed either double-click on the transformed layer or press the Enter/Return key to 'commit' the changes. To cancel press the Esc key.

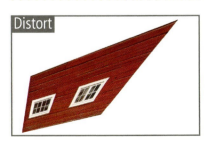
Distort

Perspective

Skew

T

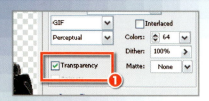

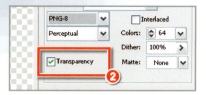

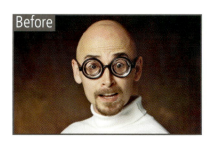

Before

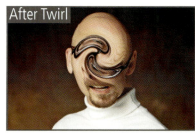

After Twirl

Transparency option, GIF and PNG

Menu: Editor: File > Save for Web
Shortcut: Shft Alt/Opt Ctrl/Cmd S **OS:** Mac, Windows
Version: 1, 2, 3, 4 **See also:** GIF

The GIF (1) and PNG (2) formats are unique among file types that are suitable for web use in that they both contain an option for transparency.

To ensure that the transparent component in your picture is maintained when saved select the Transparency box in the Save for Web feature.

The Transparency option is good when you are working with graphics that are meant to sit upon a textured background and blend in seamlessly.

Twirl filter

Menu: Editor: Filter > Distort > Twirl
Shortcut: – **OS:** Mac, Windows
Version: 1, 2, 3, 4 **See also:** Filters

The Twirl filter, as one of the group of Distort filters, twists the picture around a central point, creating a spiral effect.

The Filter dialog contains a single slider that controls the Angle of the effect (1). Movements to the right (positive values) create a clockwise rotation of the picture. Sliding the control to the left produces an anti-clockwise spiral (negative values).

The wire frame (2) and standard previews indicate the strength at the settings selected and predict the look and feel of the end results.

Twirl tool

Menu: Editor: Filter > Distort > Liquify
Shortcut: – **OS:** Mac, Windows
Version: 1, 2, 3, 4 **See also:** Liquify filter, Bloat, Pinch

The Twirl tools are two of the several tools in the Liquify filter that allow you to stretch, twist, push and pull your pictures. They spiral the pixels in a pivot around the center of the brush. The result is similar to that obtained with the Twirl filter.

To twirl your pictures, select either tool (Clockwise or Counter Clockwise) then adjust the brush size so that it is the same dimensions as the area to be changed and then hold down the mouse button until the picture has changed the required amount. You can drag the mouse across the canvas, twirling the pixels as you go.

To reverse the tool's effect either select the Revert button (top right) or paint over the surface with the Reconstruct tool.

206

Type

Menu: –
Shortcut: T **OS:** Mac, Windows
Version: 1, 2, 3, 4 **See also:** Type Editing, Type Masks

Photoshop Elements contains four different Type tools – two standard tools and two mask tools (1).

Of the standard Type tools (non-mask varieties), one is used for entering text that runs horizontally across the canvas and the other is for entering vertical type.

To place text onto your picture, select the Type tool from the toolbox. Next, click onto the canvas in the area where you want the text to appear.

Do not be too concerned if the letters are not positioned exactly, as the layer and text can be moved later. Once you have finished entering text you need to commit the type to a layer. Until this is done you will be unable to access most other Elements functions.

To exit the Text Editor, either click the Tick button in the options bar or press the Control + Enter keys in Windows or Command + Return for a Macintosh system.

Type editing

Menu: –
Shortcut: T **OS:** Mac, Windows
Version: 1, 2, 3, 4 **See also:** Type, Type Masks

All the usual text change options that you would expect to find in word processors are available in Elements.

It is possible to alter the size, style, color and font of your type using the settings in the options bar (2).

You can either make the setting selections before you input your text or later by highlighting (clicking and dragging the mouse across the text) the portion of type that you want to change and then altering the settings (1).

In addition to these adjustments, you can also alter the justification or alignment of a line or paragraph of type.

After selecting the type to be aligned, click one of the Justification buttons on the options bar. Your text will realign automatically on screen.

After making a few changes, you may wish to alter the position of the text; simply click and drag outside of the type area to move it around. If you have already committed the changes to a text layer then select the Move tool from the toolbox, making sure that the text layer is selected, then click and drag to move the whole layer (3).

Type Masks

Menu: –
Shortcut: T **OS:** Mac, Windows
Version: 1, 2, 3, 4 **See also:** Type editing, Type

The Type Mask tools are used to provide precise masks or selections in the shape and size of the text you input.

Rather than creating a new text layer containing solid colored text, the Mask tools produce a selection outline. From this point on, the text mask can be used as you would use any other selection.

Adding text to Indexed Color or Bitmap mode files (which don't support layers) automatically creates Type Mask text.

Underlining type

Menu: -	
Shortcut: -	**OS:** Mac, Windows
Version: 1, 2, 3, 4	**See also:** Faux Fonts

The Type tool's Underline option draws a straight line below the group of letters it is applied to (1). The thickness and color of the line are determined by the current font size and color.

To add an underline to existing text, start by selecting the letters (click-drag the type cursor over the letter group) and then press the Underline button in the Type tool (2).

To create underline text from the very first letter, select the Type tool and then press the Underline option in the options bar. Next click onto the canvas surface and add the text as normal.

Underpainting filter

Menu: Editor: Filter > Artistic > Underpainting	
Shortcut: -	**OS:** Mac, Windows
Version: 1, 2, 3, 4	**See also:** Filter

The Underpainting filter, as one of the group of Artistic filters, adds both texture and brush stroke effects to the photo.

The dialog contains several controls that adjust the painting and texture effects. The top slider, Brush Size (1), alters the broadness of the brush stroke used to paint the picture. The Texture Coverage slider (2) controls how much of the picture the texture is applied to.

Texture options are provided in the bottom section of the dialog (3). The Texture and Light drop-down menus found here, along with the Scaling and Relief sliders, determine the type and strength of the underlying texture effect.

Before Undo ②

After Undo ①

Undo Adjust Hue/Saturation Ctrl+Z

209

Undo command

Menu: Editor: Edit > Undo (last action)
Quick Fix: Edit > Undo (last action)
Shortcut: Ctrl/Cmd Z **OS:** Mac, Windows
Version: 1, 2, 3, 4 **See also:** Undo History palette, Redo

The Undo command reverses the changes made by the last action. In effect by selecting the Undo command you are converting the picture back to the state it was before the last action.

Located under the Edit menu, the actual Undo entry changes depending on the nature of the last action. In the example, the command reads 'Undo Adjust Hue/Saturation' as the last change to the picture was made using the Hue/Saturation feature. Selecting Undo reverses the changes (2) and restores the picture back to its state before the feature was applied (1).

Undo History palette

Menu: Editor: Window > Undo History
Shortcut: - **OS:** Mac, Windows
Version: 1, 2, 3, 4 **See also:** Undo, Redo, History

The Undo History palette stores the editing and enhancement changes you make to your pictures as separate steps or states in the palette. Clicking on a history state converts the picture back to the way it was at the time the change was made. Using the palette it is possible to step back (Undo) or step forward (Redo) through the enhancement steps. The earliest steps are at the top of the palette and the last change is added to the bottom of the list. Pressing the More button at the top of the palette reveals further history options, including deleting a specific state, clearing all states and current Undo and Redo options. The number of possible states is set in the Edit > Preferences > General dialog.

Ungroup command

Menu: Editor: Layer > Ungroup
Shortcut: Shft Ctrl/Cmd G **OS:** Mac, Windows
Version: 1, 2, 3, 4 **See also:** Group

To ungroup all layers in a clipping group select the base layer (the one underlined) and then choose Layer > Ungroup.

To remove a single layer from a clipping group, select the layer in the Layers palette and then choose Layer > Ungroup.

History state 1

History state 2

History state 3

History state 4

History state 5

History state 6

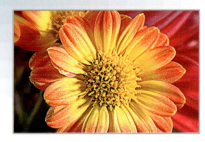

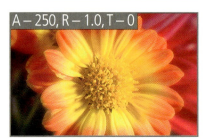

Unsharp Mask filter

Menu: Editor: Filter > Sharpen > Unsharp Mask
Shortcut: - **OS:** Mac, Windows
Version: 1, 2, 3, 4 **See also:** Sharpen, Sharpen More

Of the various sharpen filters that Elements contains the Unsharp Mask filter (Filter > Sharpen > Unsharp Mask) provides the greatest control over the sharpening process by giving the user three sliders which when adjusted alter the way the effect is applied to pictures. Though a little confusing to start with, the Unsharp Mask filter is the best way to make your scans or digital photographs clearer.

The **Amount** slider controls the strength of the sharpening effect. Larger numbers will produce more pronounced results whereas smaller values will create more subtle effects. Values of 50% to 100% are suitable for low-resolution pictures whereas settings between 150% and 200% can be used on images with a higher resolution.

The **Radius** slider value determines the number of pixels around the edge that are affected by the sharpening. A low value only sharpens edge pixels. High settings can produce noticeable halo effects around your picture so start with a low value first. Typically values between 1 and 2 are used for high-resolution images, settings of 1 or less for screen images.

The **Threshold** slider is used to determine how different the pixels must be before they are considered an edge and therefore sharpened. A value of 0 will sharpen all the pixels in an image whereas a setting of 10 will only apply the effect to those areas that are different by at least 10 levels or more from their surrounding pixels. To ensure that no sharpening occurs in sky or skin tone areas set this value to 8 or more.

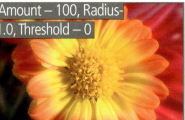

Amount – 100, Radius– 1.0, Threshold – 0

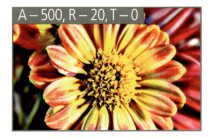

No sharpening

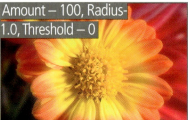

A – 250, R – 1.0, T – 0

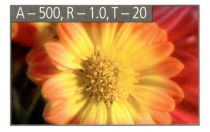

A – 500, R – 1.0, T – 20

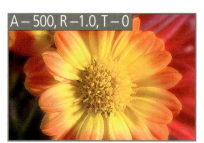

A – 500, R –1.0, T – 0

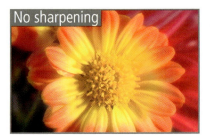

A – 500, R – 20, T – 0

A – 500, R – 5.0, T – 0

A – 500, R – 10, T – 0

Vanishing Point tool

Menu: -			
Shortcut: V (in Photomerge)		**OS:** Mac, Windows	
Version: 1, 2, 3, 4		**See also:** Photomerge	

When editing a panorama in Photomerge with the Perspective option selected, you can change the vanishing point from the default middle picture to any of the other source photos in the composition.

With a Photomerge composition open select the Perspective option from the settings on the right of the dialog (1). Next select the Vanishing Point tool (2) and click onto the picture in the composition to use as the new vanishing point. This photo will now be used as the basis for perspective in the panorama.

There can only be one vanishing point in any Photomerge composition and the Vanishing Point tool only works with compositions that cover less than 120° of the view.

Variations command

Menu: Enhance > Variations		
Shortcut: -		**OS:** Mac, Windows
Version: 1		**See also:** Color Variations (vers 2.0, 3.0)

This Variations feature first appeared in version 1.0 of Elements and now has become Color Variations.

It was based on a color wheel, which was made up of the primary colors red, green and blue, and their complementary colors cyan, magenta and yellow. Increasing the amount of one color in an image automatically decreases its complementary. Put simply, increasing red will decrease cyan, increasing green will reduce magenta and increasing blue will lessen yellow.

The feature is primarily used for reducing color casts in digital photos.

VCD with Menu

Menu: Photo Creation: VCD with Menu		
Shortcut: -		**OS:** Windows
Version: 3, 4		**See also:** Photo Creations

The VCD with Menu Photo Creation project saves your custom slide show productions onto a CD-ROM in a format that can be used by a standard DVD player. With this feature your productions can be viewed on any TV (linked with a DVD player) or computer monitor. Before you can create a VCD with a menu you must have at least one slide show saved into the Photo Browser. If you don't have a candidate slide show then, start the process by selecting the Custom Slide Show option and creating a multimedia presentation complete with sound. Save the project to the Photo Browser and then start the VCD with Menu option.

When Premier Elements is also installed users will have a second option of creating a DVD with Menu.

Select the slide shows that you want to include and then pick VCD with Menu from Photo Creations. Add or Remove shows from the thumbnail list and click and drag shows to new positions to adjust their menu position. The number in the top left of each thumbnail indicates the sequence. Click Burn to continue.

The burn step is a two-part process. First any show not in the WMV format will be converted. The conversion can be quite lengthy if you are burning slide shows containing many high-resolution files. To speed up this section of the process, convert your shows to WMV beforehand from inside the Slide Show project dialog.

The second part of the burn process is writing the CD itself. After converting the slide shows to WMV files a Burn dialog will appear. Make sure that a new blank CD is inserted into the CD writer and click the OK button to create the VCD.

211

212

Vector graphics

Menu:	-	
Shortcut: U (Shape tools)		**OS:** Mac, Windows
Version: 1, 2, 3, 4		**See also:** Shape, Cookie Cutter, Type, Bitmap, Pixel

Unlike photographs which are constructed of pixels, vector graphics are created with a series of lines and curves that are mathematically designed. Such pictures can be resized and moved with no loss in quality and print with no jagged edges.

Typically pictures created in drawing packages such as Adobe Illustrator are vector based. However, some tools in Elements, which is primarily an editor of pixel-based photos, do create vector graphics. The Shape, Type and Cookie Cutter tools all use a vector approach in the graphics and layers they create.

Some editing techniques require the conversion of the vector drawings to a bitmap picture. This process is achieved by selecting the layer with vector content and then choosing Layer > Simplify.

As computer screens display all picture content, both vector and bitmap, as pixelated images, enlarged versions of vector graphics will still show stepped or jagged edges that won't be evident when the picture is printed.

Version Set

Menu:	Photo Browser: Edit > Version Set	
Shortcut: -		**OS:** Windows
Version: 3, 4		**See also:** Stack

Photoshop Elements 3.0 extends the idea of image stacks in another new feature called Version Sets. This feature stores the edited version of pictures together with the original photo in a special stack or Version Set.

All photos enhanced in the Photo Browser space are automatically included in a Version Set. Those images saved in the Quick and Standard Editor spaces with the Save As command can also be added to a Version Set by making sure that the Save with Original option is ticked (1).

Edited files are not saved over the top of the original, instead a new version of the image is saved in a Version Set with the original. It is appended with a file name that has the suffix '_edited' attached to the original name. This way you will always be able to identify the original and edited files. The two files are 'stacked' together in the Photo Browser with the most recent file displayed on top.

When a photo is part of a Version Set, there is a small icon displayed in the top left of the Photo Browser thumbnail. The icon shows a pile of photos (2).

To see the other images in the Version set simply right-click the thumbnail image and select Version Set > Reveal Photos in Version Set. Using the other options available in this pop-up menu the sets can be expanded or collapsed, the current version reverted back to its original form or all versions flattened into one picture (3). Version Set options are also available via the Photo Browser Edit menu.

Version Set – Convert to Individual Files

Menu:	Photo Browser: Edit > Version Set > Convert to Individual Files	
Shortcut: -		**OS:** Windows
Version: 4		**See also:** Version Set

The Version Set feature in Photoshop Elements automatically stores a new version of the photo each time you save the edited file. Each of these versions is then stored together in a set.

Each version is a complete picture file and using the various options in the Edit > Version Set menu it is possible to display all the images in the set (2), flatten the set, revert back to the original photo, set a particular photo as the top most item and remove a photo from the set. In addition you can also choose to convert the pictures in the set to individual photos that will show in the browser space as separate thumbnails.

To do this select the version set and then choose Edit > Version Set > Convert to Individual Files (1). Now each of the set images will be included in the Photo Browser as a separate photo thumbnail (3).

Version Set – Remove Items from Version Set

Menu:	Photo Browser: Edit > Version Set > Remove Items from Version Set
Shortcut: -	**OS:** Windows
Version: 4	**See also:** Version Set

An individual version can be deleted from a Version Set by firstly displaying the individual photos (Edit > Version Set > Reveal Items in Version Set) and then selecting the item to be deleted before selecting Edit > Version Set > Remove Items from Version Set.

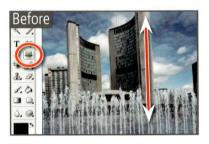

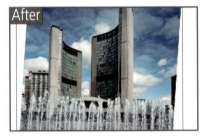

Vertical straightening

Menu: –	
Shortcut: P	**OS:** Windows
Version: 4	**See also:** Straighten tool

The Straighten tool in Photoshop Elements 4.0 is a great way to reorientate crooked horizons. Corrections are made by drawing a straight line along the demarcation point between sky and ground. But this is not the only way to use the feature. It can also be used to straighten vertical picture parts as well.

After choosing the Straighten tool, hold down the Ctrl key whilst drawing a line (click-drag the mouse) alongside a part of the photo that should be vertical. Release the mouse button and then the Ctrl key and hey presto the photo is automatically rotated to the precise degree. All that is left to do is crop out the unwanted edge detail.

Vertical Type tool

Menu: -	
Shortcut: T	**OS:** Mac, Windows
Version: 1, 2, 3, 4	**See also:** Horizontal Type tool

Along with the traditional Horizontal Type option, Elements also provides a Vertical Type tool that arranges the letters on top of each other rather than side by side.

Located in the same fly-out menu as the other Type tool options, the Vertical Type tool aligns the type according to the starting placement of the cursor (insert point) and the alignment option (2) selection in the options bar. The top align option adds letter shapes above the insertion point, the bottom align below the insertion point and the center align places the text so that it straddles the insertion point.

View by Folder Location

Menu:	Photo Browser: View > Arrangement > Folder Location
Shortcut: -	**OS:** Windows
Version: 4	**See also:** Version Set

As well as being able to display your thumbnails via Date and Import Batch you can now also show the photos according to the folder where the original image is located. You can adjust which folders are shown (all or just those containing imported photos) with the settings in Edit > Preferences > Folder Location View.

View Photos in Full Screen

Menu:	Photo Browser: View > View Photos in Full Screen
Shortcut: F11	**OS:** Windows
Version: 4	**See also:** Photo Review

Starting life as the Photo Review feature in version 3.0, the View Photos in Full Screen option provides an instant slide show of the files that you have currently displayed in the Photo Browser.

With the provided menu you can play, pause or advance to next or last photos, using the VCR-like controls. You can enlarge or reduce the size that the picture appears on screen with the Magnification slider (Zoom Level control). For quick magnification changes there are also 'Fit to Window' and 'Actual Pixels' buttons. But the real bonus of the feature is the list of actions that you can perform to pictures you review. You can automatically enhance, add and remove tags, mark the file for printing and add the file to a chosen collection using the choices listed under the Action menu. Specific picture properties such as tag, history and metadata are available by hitting the Alt + Enter keys to display the Properties window.

213

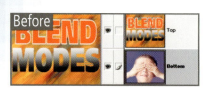

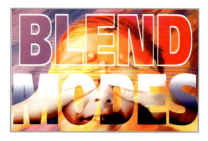

View, Quick Fix

Menu: —	
Shortcut: —	**OS:** Mac, Windows
Version: 3	**See also:** Quick Fix

The drop-down View menu (1) located at the bottom of the Quick Fix Editor workspace provides a range of options for displaying the picture you are currently editing.

The choices allow you to view the image in four different views: After Only, Before Only, Before and After (Portrait), Before and After (Landscape).

Vivid Light blending mode

Menu: -	
Shortcut: -	**OS:** Mac, Windows
Version: 1, 2, 3, 4	**See also:** Blend modes

The Vivid Light blending mode is one of the group of Overlay modes that base their effects on the differences between the two pictures.

This option combines the effects of both Color Burn and Color Dodge modes in the one feature. The effect is created by increasing or decreasing the contrast depending on the brightness of the top layer. If the tones are lighter than 50% then the picture is lightened by decreasing the contrast. If the top layer tones are darker than 50% then the picture is darkened by increasing the contrast.

The overall result is more contrasty and there is no effect if the top layer is 50% gray.

© www.ablestock.com 2005

Wall Calendar

Menu: Photo Creation: Wall Calendar	
Shortcut: -	**OS:** Windows
Version: 3, 4	**See also:** Photo Creations

The Wall Calendar project takes all the manual labor out of the process of creating calendars by not only providing some great templates for you to add your photos to, but also by including a date calculator built into the dialog.

Simply insert the start and end dates for your calendar and Elements works out the days and dates for whatever year you choose. The hardest task you have to perform in the whole process is choosing which pictures to include and which to leave out.

To create a calendar multi-select the pictures that you want to include from the Photo Browser and then choose the Wall Calendar option from the Photo Creations main screen. You can change feature images and add titles or descriptive text using the buttons provided in the wizard screens that follow.

As with other Photo Creation projects, this feature provides you with the opportunity to print the wall calendar, send it as an e-mail or save the whole project as a PDF file.

Warp Text command

Menu: -	
Shortcut: T	**OS:** Mac, Windows
Version: 1, 2, 3, 4	**See also:** Type

One of the special features of the Elements type system is the 'Warping' feature. This tool forces text to distort to one of a range of shapes. An individual word, or even whole sentences, can be made to curve, bulge or even simulate the effect of a fish-eye lens.

The button (1) for the option is found on the options bar of the Type tool. The feature's dialog contains a drop-down menu list of styles (2) and a choice between vertical and horizontal warping (3). The strength and style of the effect can be controlled by manipulating the Bend, Horizontal and Vertical Distortion sliders (4).

This feature is particularly useful when creating graphic headings for posters or web pages.

Warp tool

Menu: Editor: Filter > Distort > Liquify	
Shortcut: W (in Liquify)	**OS:** Mac, Windows
Version: 1, 2, 3, 4	**See also:** Liquify filter

The Warp tool is one of the specialized tools in the Liquify filter. The Warp tool is used to push pixels as you move the cursor.

After selecting the tool from the top left of the dialog carefully drag the cursor over the canvas surface. Use the Reconstruct tool to repair areas where the warping effect is too great.

The example shows how easily an existing photo can be drastically changed by warping specific picture parts.

The area that is pushed is determined by the brush size on the right of the dialog. To make gradual rather than abrupt changes use a lower brush pressure. To warp along a straight edge click to start the line and then Shift-click to mark the end.

Watch Folders

Menu: Photo Browser: File > Watch Folders	
Shortcut: -	**OS:** Windows
Version: 3, 4	**See also:** Get Photos

The Watch Folders feature is part of the automated cataloging system of the Photo Browser in the Windows version of Elements 3.0.

Essentially the feature is designed to keep an eye on changes that are made to folders or directories that you nominate on your computer. In most cases the folders nominated will be those that you download media files (pictures, movies and sound files) to on a regular basis. When a new file is added to the folder Elements either notifies you of the addition and queries if the file should be added to the catalog, or simply catalogs the file automatically. Once set up, the feature automates the 'Get Photos' part of the cataloging process.

The Watch Folders dialog is displayed after choosing File > Watch Folders (1) and contains settings to activate the feature (2), determine the folders to be watched (3) and the action to perform when a new file is detected (4).

Warp Text example

Watercolor filter

Menu: Editor: Filter > Artistic > Watercolor
Shortcut: -　　　　**OS:** Mac, Windows
Version: 1, 2, 3, 4　　**See also:** Filters

The Watercolor filter, as one of the group of Artistic filters, adds both texture and brush stroke effects to the photo.

The dialog contains three controls that adjust the painting and texture effects. The top slider, Brush Detail (1), alters the look of the painted areas. The Shadow Intensity slider (2) controls how much of the picture is converted to darker tones. High values mean more of the picture is shadowed. The final setting, the Texture slider (3), determines how detailed the painted areas of the picture will be.

Watermarks

Menu: Editor: Filter > Digimarc > Read Watermark
Shortcut: -　　　　**OS:** Mac, Windows
Version: 1, 2, 3, 4　　**See also:** –

Digital watermarks are slight, almost imperceptible, changes that are made to pictures to store copyright and author's details within the image. Photoshop Elements has the ability to detect and read the digimarc.com style of watermarks. These are created and added to images either by the stand-alone software provided by the company or via filter plug-ins in programs like Elements or Photoshop.

To check to see if a picture you are editing is watermarked, select Filter > Digimarc > Read Watermark (1). Marked pictures will then display a pop-up dialog with author's details and a linked website where further details of use can be obtained (2).

Note: The example pop-up dialog shown here is in Demo mode. Registered users of the Digimarc system can mark their pictures with name, address, e-mail and URL details.

Water Paper filter

Menu: Editor: Filter > Sketch > Water Paper
Shortcut: -　　　　**OS:** Mac, Windows
Version: 1, 2, 3, 4　　**See also:** Filters

The Water Paper filter, as one of the group of Sketch filters, simulates the look of the photo being painted on a very wet textured watercolor paper. The edges of the picture are very soft, with some details lost altogether. The colors and shapes blend into each other and, in contrast to these parts, occasionally the sharp texture of the paper shows through.

The dialog contains three controls that adjust the tone and texture effects. The top slider, Fiber Length (1), alters the sharpness and clarity of the painted image. Low values create a sharper picture with more of the original details preserved. The Brightness slider (2) works like a standard brightness control. High values produce a brighter picture, low values a darker one. The final setting, the Contrast slider (3), determines the overall contrast of the final result.

Watermarks, DIY

Menu: Editor: File > Process Multiple Files
Shortcut: -　　　　**OS:** Windows
Version: 3, 4　　　**See also:** –

Photographers can create their own watermarks by adding a text layer with low opacity to their photos.

Alternatively you can also use the Labels > Watermarks option in File > Process Multiple Files feature.

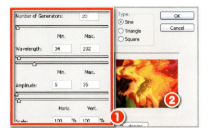

Wave filter

Menu: Editor: Filter > Distort > Wave	
Shortcut: -	**OS:** Mac, Windows
Version: 1, 2, 3, 4	**See also:** Filters

The Wave filter, as one of the group of Distort filters, breaks up the picture by pushing and pulling the pixels in the form of a series of vertical and horizontal waves. The end results can be subtle or extreme depending on the settings used.

The dialog contains several controls that are used to adjust the wave-like pattern created on the picture surface. These include wavelength, amplitude, scale, and number of wave generators (1). The effects of different settings for these controls can be previewed in the accompanying thumbnail (2).

Web Photo Gallery

Menu: Photo Browser: File > New > Web Photo Gallery File Browser: Automate > Web Photo Gallery (Mac)	
Shortcut: -	**OS:** Mac, Windows
Version: 1, 2, 3, 4	**See also:** Photo Creations

The HTML Photo Gallery, or Web Photo Gallery as it was previously called in Wizard, is an automated feature that takes a group of pictures that have been multi-selected in the Photo Browser and transforms them into a fully functioning website in a matter of a few minutes. The Photo Gallery feature can be found under the File menu in versions 2.0 and 1.0 as well as version 3.0 for the Mac, but has been moved to the Photo Creations workspace for versions 4.0 and 3.0 for Windows. The revised dialog contains an Add/Remove pictures section which displays a thumbnail list of those photos currently selected for inclusion in the website. In addition, the order that pictures appear in the web gallery can be changed by clicking and dragging thumbnails to new spots in the list. The website produced is made up of a main or index page, a series of small versions of your pictures called Thumbnails (1) and a page for each image containing a larger gallery picture (2).

Web Safe Colors

Menu: Editor: Window > Color Swatches	
Shortcut: -	**OS:** Mac, Windows
Version: 1, 2, 3, 4	**See also:** GIF format

The Web Safe set of colors is a group of 216 colors that can be accurately displayed by both Macintosh and Windows systems. Constructing your image of, or converting existing hues to, these colors will guarantee that they display predictably as part of a website on any system.

The Color Swatches palette (1) will display all the Web Safe Colors when the option is selected from the drop-down menu at the top left.

When choosing colors with the Color Picker a small Cube icon indicates the selected hue is not a web safe color. Click the cube to get Elements to find a web safe color that is nearest your choice (2).

When converting photos to the GIF format using the Save for Web feature you can elect to use the Web Safe palette (Restrictive option) for the conversion.

Select the pictures you want to include in the site from those thumbnails displayed in the browser. Choose Photo Browser: File > New > Web Photo Gallery and then pick the look that you want for your website from the options in the Gallery Style section of the dialog.

Under the Banner heading (tab) input the title and subtitle for the gallery as well as your e-mail address. Also select the font style and size to be used for the text included on the site. Select the destination folder to be used to store the files and folders created during the process.

Rearrange, add or remove pictures from the thumbnail list. Adjust the settings in the Large Photos, Thumbnails and Custom Colors tabs. Click Save to start the site construction process. When completed, the finished website will be displayed in the new Web Gallery Browser.

Welcome Screen – Mac

Welcome Screen – Windows

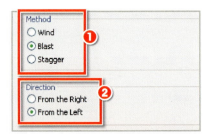

Welcome window

Menu:	Editor: Window > Welcome	
	Photo Browser: Window > Welcome	
Shortcut: -		OS: Mac, Windows
	See also:	Editor, Quick Fix Editor,
Version: 3, 4		Photo Browser, Photo Creations

When Elements is first opened, the user is presented with a Welcome Screen containing several options. The selections are broken into different types of imaging activities and, depending on where you are in the workflow, will determine your entry point into the program. The screen can be displayed at any time by selecting Window > Welcome. Below is a list of the Welcome Screen options for version 3.0 of the program.

WIA support

Menu: -		
Shortcut: -		OS: Windows
Version: 2, 3, 4		See also: Get Photos

The process of downloading pictures from your camera or scanner to the computer requires the installation of drivers before the transfer can begin. Installing the software that came bundled with your equipment usually also takes care of installing the drivers. Many cameras and scanners use a WIA or Windows Image Acquisition driver. Both Elements and Windows XP make use of WIA drivers to communicate with installed peripherals.

Wind filter

Menu:	Editor: Filter > Stylize > Wind	
Shortcut: -		OS: Mac, Windows
Version: 1, 2, 3, 4		See also: Filter

The Wind filter, as one of the group of Stylize filters, simulates the look of wind blasting across the canvas surface by adding trailing lines from the edge details.

The dialog contains two controls: Method or type of wind (1) and Direction (2). A Preview window is also supplied to help you judge the correct combination of settings for your photo.

Welcome Screen options:

Product Overview – This selection provides you with a description of how Photoshop Elements can be used to enhance and improve your digital photographs. It also contains an introductory movie and details of the differences between this and other versions of Photoshop Elements.

View and Organize Photos – Designed as the first point of call for downloading your pictures from cameras, scanners and mobile phones, this selection takes you to the Photo Browser component of the Elements system. Start here when first introducing your pictures into Elements.

Quickly Fix Photos – This selection takes you directly to the Quick Fix component of the Photoshop Elements system. This editing window provides more manual control than what is available with the Auto Fix Window but

less than that found in the more sophisticated Standard Editor.

Edit and Enhance Photos – Click here to take you to the Standard Editor. This window provides you with the most powerful enhancement and editing tools and features available in Elements. Users undertaking complex, multi-step alterations to their photographs should proceed directly to this workspace.

Make Photo Creation – This button takes you to the step-by-step interface that guides you through the production of items such as slide shows, album pages, greetings and postcards, web galleries, wall calendars and menu-driven VCD presentations.

Start From Scratch – As an alternative to commencing the editing process with an existing image you can select this option to create a new blank

document in the Editor workspace. This is a good place to start if you need to construct a picture from several other images or if you need to create a document of a specific size and format.

Tutorials – Select this option if you want to access the Photoshop Elements help resources. This includes the How To recipes, Help topics grouped around common activities, a glossary and an index.

Connect to Camera or Scanner – Mac users select this option to display a dialog that you can use to select an Import Source. From here you can download files from your cameras or scanners.

Open File for Editing – This option takes Mac users directly to the File Browser, where they can select a file for editing.

Windows XP Media Center support

Menu: –	
Shortcut: –	**OS:** Windows
Version: 4	**See also:** Send to TV

Photoshop Elements 4.0 provides extra options for users who are operating on a multimedia-equipped computer running on Windows XP Media Center 2005 edition.

Cataloged photos can be viewed and Elements' slide shows can be displayed with the enhanced options available within the Media Center. To use these options click the Media Center button on your remote control, select More Programs and then navigate to the Photoshop Elements option.

WYSIWYG font preview

Menu: –	
Shortcut: –	**OS:** Windows
Version: 4	**See also:** Text

The drop-down font family menu now displays a WYSIWYG (What You See Is What You Get) example of the font. The size of the preview font can be adjusted via the settings in Type section of the Edit > Preferences dialog.

ZigZag filter

Menu: Editor: Filter > Distort > ZigZag	
Shortcut: -	**OS:** Mac, Windows
Version: 1, 2, 3, 4	**See also:** Filter

The ZigZag filter, as one of the group of Distort filters, simulates up and down waves such as pond ripples.

The dialog contains controls that adjust the style and intensity of the effect. The Amount slider (1) alters the strength of the ripple effect, which basically translates to the depth and height of the resultant waves. Low values create shallower, more subtle effects, higher numbers produce more dramatic results.

The Ridges slider (2) increases or decreases the number of ridges used in the effect.

Three different types of ZigZag filtration are available from the drop-down Style menu (3) – Pond ripples, Out from the center and Around the center.

Also included is a simulated Preview window, where the filter is applied to a wire frame representation of your picture (4).

Zoom In/ Zoom Out

Menu: Editor: View > Zoom In/Zoom Out	
Shortcut: Ctrl/Cmd =, Ctrl/Cmd -	**OS:** Mac, Windows
Version: 1, 2, 3, 4	**See also:** Zoom tool, Navigator

The View > Zoom In/Zoom out menu options magnify and reduce the size of the on-screen image in a way that is similar to the Zoom tool. Each selection of the menu item (or keystroke combination) changes the magnification of the image by set increments between a minimum of 1 pixel (usually less than 1%) and a maximum of 1600%.

Zoom tool

Menu: -	
Shortcut: Z	**OS:** Mac, Windows
Version: 1, 2, 3, 4	**See also:** Match Zoom, Navigator

The Zoom tool is used to adjust the magnification of your picture on screen. After selecting from the tool, choose a mode, Zoom In (1) or Zoom Out (2), from the settings in the options bar. Next click onto the picture part that you want to magnify, or make smaller. The on-screen image will increase, or decrease, in size and the magnification value will be displayed in the options bar as a Zoom percentage (3).

Sections of a picture can be zoomed to fit the width of the program's workspace by click-dragging a zoom marquee around the area to be enlarged. Automatically the selected area is enlarged to fit the work-space.

More Elements titles by Philip Andrews

Do you need even more information on Photoshop Elements and crave for extra tips and techniques? Well, Philip Andrews is one of the world's most published Photoshop Elements authors and can extend your skills even further with the following two titles.

Adobe® Photoshop® Elements 4.0
A visual introduction to digital imaging

'...an unrivalled introduction to the budget imaging package, and an excellent overview of digital imaging.' What Digital Camera magazine, UK

- Save valuable time with this successful, ja~~~~ ~~~~~ ~~~~~~~~~~~~ ~~ ~~~~~~~ ~~~~~~~~
- Real-life examples
- Fully updated to cover all the new Elemen~~
- All new section on file management with t~
- Clearly shows you how to put each techniq~
- Full color, high quality illustrations visualiz~
- Dedicated website full of resources and vic~

This complete and easy-to-follow introduction to A~ Elements has been updated throughout to show al~ version 3.0 including the Photo Browser, Quick Fix~ Projects, the integrated RAW file editor and 16-bit~ Philip Andrews in his clear, no-nonsense style goes ~ in the broader context of digital imaging. He provi~ more than just an introduction to the software pac~ everything needed to ensure they can achieve prof~ looking results.

ldwide including: amateur
sumer level digital camera
digital imaging on art/media/
eaching basic digital imaging for

ments – gives all the tools needed
in the book are provided online
updates and printable lesson

ISBN: 0240519582 – $29.95 / £18.99 / €27.~

DATE DUE

GAYLORD #3522PI Printed in USA

Advanced Photos~
for Digital Photo~

'a beautifully rendered and compellin~ advanced features and techniques that c~~ ~~ ~~~~~~~~~~~~ ~~~~ Photoshop Elements.' Mike Leavy, Engineering Manager for Photoshop Elements, Adobe Systems, Inc.

- Provides tips from a pro to advance your Elements skills beyond the basics
- Step-by-step, color illustrated tutorials show you what can be achieved
- Full workflow coverage, includes digital cameras and web work

Philip Andrews shares his in-depth knowledge of Photoshop Elements in this advanced guide ensuring that you will achieve optimum results from this powerful software package. Once the basics of Photoshop Elements are mastered, this is the book to further develop your skills to get professional results!
Beyond exploring techniques, Philip addresses how to manage the digital workflow in general, covering scanner and camera capture techniques, advanced image changes, providing detailed information on

how to produce darkroom techniques digitally with Elements, as well as graphics capabilities and explaining how they all fit together.
Stay ahead of the rest with this full color, superbly illustrated guide, written in a no-nonsense style for ease of understanding. The book for the digital photographer who wants to stand out from the crowd!
The associated website – **www.adv-elements.com** – includes images featured in the book, so your new found skills can be put into practice.

ISBN: 024051940X – $29.95 / £19.99 / €28.95 – Paperback – 352pp

TO ORDER Adobe® Photoshop® Elements 4.0 or
Advanced Photoshop® Elements 4.0 for Digital Photographers visit: **www.focalpress.com**